Sinatra AND ME
THE VERY GOOD YEARS

BY TONY CONSIGLIO,
AS TOLD TO FRANZ DOUSKEY

A POST HILL PRESS BOOK
ISBN: 978-1-63758-407-1
ISBN (eBook): 978-1-63758-408-8

Sinatra and Me:
The Very Good Years
© 2012 Franz Douskey and the Estate of Tony Consiglio
All rights reserved.

Excerpts from *Sinatra and Me* have appeared in *Las Vegas Life*, *Down East*, *Elysian Fields*,
INK Magazine, and *Yankee Magazine*

Post Hill Press
New York • Nashville
posthillpress.com

Printed in the United States of America
1 2 3 4 5 6 7 8 9 10

Table of Contents

Sinatra and Me

TONY CONSIGLIO: THE LEGEND

What you are about to read is a firsthand account of the life of Frank Sinatra, as told to me by Tony Consiglio, Frank Sinatra's closest and most trusted friend.

It's the story of a man who wanted to sing and his best friend who went along for the ride. At its center, *Sinatra and Me* is about Frank—his music, his joys, his struggles, and all the things that made him great. But it is also the story of a deep, intimate, and enduring friendship that began when Tony and Frank were just two kids playing hooky and continued to grow as they traveled the road to fame and success. What shines through on each page is a bond between two men who valued, respected, and remained loyal to each other throughout a lifetime.

Unlike other Sinatra books, this one is not based on third or fourth party rumors that have been shaped into truths. This is the real Frank Sinatra story as told by the man who knew him best. It is a celebration of Tony and Frank that includes photos and documents never before published. Tony gives us an inside view of the highs and lows of Frank's exciting and glamorous life. Stories of infamous parties and notorious pranks that Frank was known to play on those in his inner circle fill the pages of *Sinatra and Me*.

My role in telling Tony's story began at Sally's Apizza, in New Haven, Connecticut. Sally's is often debated by pizza aficionados as the place to go for the world's best pizza and for good reason. Perhaps that's why it is not uncommon to see a celebrity like Andre Agassi, Garry Trudeau, Mi-

chael Bolton, Jackie Joyner-Kersee, and players from the New York Giants sitting at a booth next to you.

The walls are covered with photos of even more celebrities—including Larry Bird, Muhammad Ali, Ted Kennedy, Dean Martin, Jerry Lewis, and, most often, Frank Sinatra, all posing with a small, unassuming man, the legendary Tony Consiglio, who founded Sally's Apizza with his mother and brother.

I was aware of Tony's friendship with Sinatra and his reputation for not granting interviews about that relationship. Frank nicknamed Tony "The Clam," for good reason. Frank valued loyalty and people who kept their mouths shut, people like Tony. That's why I assumed that Tony's stories would never be told and would go to the grave with Frank and Tony.

Over the years writers constantly hounded Tony for interviews, but his answer was always no. Writers even sent checks with their requests, which Tony promptly sent back. Once a writer even threatened Tony stating he had tapes of Tony on the phone with Marilyn Monroe the night she died and would use them if Tony didn't consent to an interview. Tony told the writer to engage in a physically impossible act before throwing the phone across the room.

I initially became connected to Tony Consiglio through his niece Ruthie, who I befriended from spending time at Sally's. She told Tony I was a writer who had written a number of articles about baseball players, and Tony, who had been a batboy for the New York Giants, was a big baseball fan. She also told him that I was "all right," which meant I could be trusted.

Initially Tony and I talked on the phone, sharing stories and laughs. He eventually asked me over for coffee, and I couldn't say yes fast enough. I arrived at Tony's home—tape recorder in hand—where I met his wife, Mary, and their two sons. That day began a wonderful friendship between Tony and me that continued to grow. As I got to know Tony, I learned of his incredible capacity for telling a story. I listened, mesmerized, as I hung on every word of his adventures with Frank. During our time together, I

discovered how resourceful he could be. No matter how difficult a task, Tony knew how to get the job done, whether it was bribing Bozo the Clown, so that his niece Ruthie could win a bicycle or dealing with the difficult and uncomfortable situations that made up the day-to-day drama of Sinatra's life and his love relationships.

In their thirty years of traveling together, Frank and Tony went from dining in low-budget cafeterias to dining with the rich and famous—Prince Rainier, the Kennedys, Marilyn Monroe, Lady Astor, Ella Fitzgerald, Joe DiMaggio, Rocky Marciano, Humphrey Bogart, Lauren Bacall, Pierre Salinger, mobsters Sam Giancana and the Fischetti brothers, and many more.

Tony's day-to-day experiences with Frank are beyond what any of us could ever imagine or hope for. During the Kennedy years, Tony traveled with Frank during the campaign, watched JFK get elected on television as he sat with Joe Kennedy at the Kennedy Compound, and sat next to a famous world leader at JFK's funeral. Tony rubbed elbows with mobsters, movie stars, politicians, and royalty.

Tony was in his eighties when he told me these stories. He told them as he remembered them. His thoughts came out in a wonderful stream of consciousness expanding upon whatever he remembered at the time. For this reason the book is not structured chronologically and does not reflect upon many specific dates. Tony will show you what it was like to spend each day with Sinatra. You will learn things that may surprise or disappoint you, but in the end you will understand why Frank Sinatra is and always will be a legend.

Franz Douskey
November 2012

CHAPTER 1: THE BEST IS YET TO COME

I worked and traveled with Frank Sinatra for years, starting back in the late 1930s, and I was his friend when becoming a singer was just an idea to him. In the beginning of his career, we traveled on buses, and in the end, we traveled in limousines. In 1935, we dined on fifteen-cent dinners at an automat, and twenty years later, we dined with presidents and princes. I was his confidant during his rise in music and remained so through the tough times in the late 1940s and early 1950s when he lost his voice, his record contract with Columbia, and Ava Gardner. Some friends abandoned him, but I remain loyal to Frank to this day. Walter Winchell, Barbara Sinatra, and Frank's mother, Dolly, all agree that I was Frank's closest friend, and that I knew him better than anyone did.

Many books have been written about Frank, but because I like staying in the background, you won't find my name in most of them. Frank had nicknames for everyone; my nickname was "The Clam." I'm in Nancy Sinatra's book: *Frank Sinatra: An American Legend.* There is a photo of me with Frank's three children. Sammy Davis Jr. took that photo. I'm also mentioned in Judith Campbell Exner's book *My Story.* Judy was always a close friend of mine. I drove her to the White House a few times when she was visiting President Kennedy, and believe me, it wasn't Avon calling.

When I heard that Judith was writing a book about her simultaneous love affairs with Jack Kennedy and Sam Giancana, I called her and told her straight out, "Whoa. When you write that book, don't mention me in there, because Frank doesn't like me to be public in any way. I'm his behind-the-scenes guy, and I like it that way."

Judith said, "Okay, Tony, I'll keep you out of it."

Unfortunately, when her book came out, I was in there. Fortunately, I never gave her any inside stories about Frank, which is exactly why Frank called me "The Clam."

Frank never wanted to have his biography written. He had begun working with a writer on a book about his life when the writer died suddenly. Frank said, "That ends it. That's an omen. That means something is in the wind. No book. No movie. No nothing."

That was as close as Frank came to telling his own story. And believe me, he could tell some stories. Writers contact me all the time, trying to get me to tell them stories for their books and newspaper articles, but I know better. Frank hated two kinds of people: photographers and newspaper reporters. If I introduced a guy to Frank and the guy said he was a writer, forget it. Frank would have dumped me completely. Frank told me not to talk to anybody. What happened between, us stayed between us. If anyone asked me a question about Frank's personal life, I walked in the opposite direction. The reporters never got near me unless they were friends of Frank and could be trusted, like Walter Winchell, Jimmy Cannon, and Earl Wilson. Even with those writers, I never discussed Frank's personal life; if they wanted information, I told them to go see Frank, and that was the end of it.

I still don't talk to journalists and writers, out of loyalty to Frank, but it bothers me that all the books coming out about Frank are written by people who weren't part of his life. They didn't know Frank, Dean, or Sammy personally and had never even seen Frank perform. Still, they're writing books based on fragments and third-hand stories. What can they write about? They weren't there. Frank and I spent thirty years together. We lived together through the best years and the worst years, and I knew his every mood. Walter Winchell wrote in his column, "The closest person to Frank Sinatra is Tony Consiglio." Earl Wilson wrote the same thing about my relationship with Frank.

I knew when to talk to him, and I knew when to leave him alone. I knew Frank's first wife, Nancy, and we still write each other to this day. I

had the great privilege of being close to his three children: Nancy Jr., Frank Jr., and Tina. I was around during his days with bobby-soxers, and his marriages to Ava Gardner, Mia Farrow, and Barbara Sinatra. Through it all, I stayed with Frank.

I have traveled everywhere and dined at the finest restaurants. I partied until sunrise with Jackie Gleason, Dean Martin, Peter Lawford, Marilyn Monroe, President John F. Kennedy, Ambassador Joseph Kennedy, Jackie Kennedy, Kim Novak, Grace Kelly, Sammy Davis Jr., Sammy Cahn, Jimmy Van Heusen, Judy Garland, Rocky Marciano, Muhammad Ali, Toots Shor, Prince Rainier of Monaco, Tony Curtis, Janet Leigh, Natalie Wood, Robert Wagner, Pierre Salinger, Larry O'Brien, Jerry Lewis, and Joe Di-Maggio—just to mention a few.

Some writers come to me and want to know about Frank and Marilyn or Frank and the mob. Some of these stories I can tell. Everyone knew Marilyn was beautiful, but how many knew that she didn't like wearing underwear and often walked around our hotel suite naked? One afternoon when Marilyn came prancing by, Frank said, "Why doesn't she mix up another batch and have a snatch to match?"

At the time, I was so naïve, I didn't know what Frank meant.

I was with Frank and Joe DiMaggio when they broke into the wrong apartment because Joe's detective said that Marilyn was having an affair with some guy—but more about Frank, Marilyn, and Joe later.

Sam Giancana, sometimes known as Dr. Brown, would have me buy airline tickets for him in my name so he could travel without having the FBI on his tail, but because of Sam the FBI got on my tail.

Questions about Sam still linger: Did he help John Kennedy get elected, and did the CIA hire him to kill Fidel Castro? Yes to both. Was Sam involved in the assassination of John F. Kennedy? I don't know, although I overheard Sam talk about wanting to get rid of Bobby Kennedy.

I traveled with Frank, Dean, Peter, and Sammy during Jack Kennedy's presidential campaign, and I was at the Kennedy family compound, in Hyannis Port, Massachusetts, November 8, 1960, on the night that Jack Kennedy was elected president. I worked on Jack's inaugural celebration and

attended his funeral three years later, sitting next to the president of France, Charles De Gaulle. Over the years, I've worked with remarkable and legendary entertainers, athletes, and politicians. I have been at the right place at the right time so many times, and I have been fortunate to witness so many of our country's important historical moments as they happened—not from a distance, but from the front row.

After Frank retired for the first time in 1971, I served as an aide to Larry O'Brien, who held positions as the Postmaster General of the United States; the chairman of the Democratic National Committee during the 1972 presidential campaign and the Watergate break-in; and the Commissioner of the National Basketball Association (NBA). At various times Larry O'Brien was a confidant to President Kennedy. I worked by Larry's side until he passed away in 1990.

I was born during the Great Depression in New Haven, Connecticut, at the corner of Wooster and Chestnut streets, in the Old Italian neighborhood. My parents, Filomena and Gennaro, came from Maiori and Amalfi, Italy and, like so many people from their generation, they settled in New Haven. I was one of eight children—four sons and four daughters—and was baptized in St. Michael's Church. I went to Columbus Grammar School until 1933 and later to Hillhouse High School for one year before dropping out.

I grew up at a time when welfare, social security, unemployment compensation, and government-funded medical insurance didn't exist. You used your wits and made it on your own, or you didn't make it. It was a different world then. The government didn't help you. Money was tough to come by, so in the evenings my brother Sally and I worked at our uncle Pepe's restaurant on Wooster Street. Uncle Pepe started out as a baker but didn't do well in that line of work, so he decided to make pizza instead. Sally and I worked for him from 1926 until 1935.

One day in 1934 when I was working in Uncle Pepe's restaurant, a man named Floyd Neal came in wearing a sports jacket with WOR and a lightning bolt insignia on the breast pocket. I was fascinated by the insignia, so I asked him who he was. He told me he was a newscaster for WOR radio, based in New York City. We started talking, and I told him how

much I loved sports. Television didn't exist in those days, so if you knew a radio broadcaster, it was the same as knowing a movie star. Floyd and I got to be friends, and he invited me to New York to show me around the radio station.

During one of my visits to WOR, Floyd introduced me to Stan Lomax, one of the pioneers of radio sports, who broadcast on WOR every weeknight at quarter to seven. He would start his show by saying; "This is Stan Lomax with today's doings in the world of sports." When the New York Yankees or the Brooklyn Dodgers played on the road, there was no live feed from the ballparks. Instead, Stan sat in the studio and read the pitch-by-pitch account of the game from the Teletype machine. To make the action more realistic, if a batter got a hit or fouled a ball off, Stan would hit two pieces of wood together in an attempt to recreate the sound of the bat hitting the ball.

A sign outside the WOR studio read, QUIET PLEASE. ON THE AIR, which meant that when I was in the studio with Stan, I couldn't even breathe, because any sound I made would come over the air. Later, it was the same way whenever I was in the recording studio with Frank when he was cutting a record.

Stan took an interest in me and, in 1936, got me a job as the New York Giants' batboy. To show you how one thing leads to another, Stan Lomax had a friend named Ford Frick, who had also been a sportscaster on WOR radio before he became president of the National League. When Frick became president, Stan took his place as a sportscaster. Because of his friendship with Frick, Stan became friends with Eddie Brannick, who was the traveling secretary for the New York Giants.

The New York Giants played their home games in a huge field known as the Polo Grounds, right across the Harlem River from Yankee Stadium. I got to meet Mel Ott and Carl Hubbell, and that's how I met another life-long friend: Joe DiMaggio. The Yankees ended up playing the Giants in the 1936 World Series, and I got to be a part of that amazing season. Needless to say, the greatest experiences in my life have happened because of one coincidence after another.

When I became the Giants' batboy, I had hoped to make some money to help out at home. As the oldest child, I had a lot of younger brothers and sisters at home, and since my father wasn't working, money wasn't coming in. I was doing all I could to help, but as it turned out, baseball teams didn't pay batboys a salary. Instead, players gave batboys small change for doing odd jobs. When players came off the field after a game, they took off their shoes, and I cleaned the mud from their cleats using an iron trowel. If they threw their shirts down, I hung them up. If their uniforms had to be washed, I tossed them in the laundry bin. If I was lucky, a player might give me a dollar.

When a player cracked a bat, I taped it together, had one of the players autograph it, and then I sold it. If someone like Carl Hubbell or Mel Ott signed a bat, I could get a dollar and a half for it. Today a game-used, autographed Mel Ott bat sells at auction for tens of thousands of dollars. I also got old batting practice balls, washed the dirt off them, and had the players sign them; then I'd sell the baseballs outside the Polo Grounds for a dollar. That's how I made my money.

In 1936, the Giants and the Yankees faced each other in the World Series. The opposing pitchers were Carl Hubbell and Red Ruffing. Even though I was the Giants' batboy, I rooted for the Yankees. On the first day of the World Series, it poured rain. Kenesaw Mountain Landis was in the stands, but he wouldn't call the game because of weather. Landis was a former federal judge who had become the baseball commissioner after the 1919 Black Sox scandal when the Chicago White Sox intentionally lost the World Series to the Cincinnati Reds. If he had called the game, everyone in the stands would have gotten rain checks for the make-up game.

I can remember the first game at the Polo Grounds as if I were seeing it now. In the top of the eighth inning, the New York Giants were beating the Yankees 2–1. The first hitter for the Yankees was Frankie Crosetti. Never much of a power hitter, the "Crow" led off with a double to left field. The next hitter was Red Rolfe, the Yankees third baseman. He bunted, trying to move Crosetti to third, but he bunted the ball hard, right back to the Giants' pitcher, Carl Hubbell. Hubbell slipped and didn't play the ball cleanly, and

Rolfe beat it out. Joe DiMaggio came to bat; he was batting third in the lineup, and it was his fourth time up in the game. Joe had grounded out in the first to Dick Bartell, the Giants' shortstop. He gót a single in the third inning and then struck out in the sixth. Now Joe was up, with two men on and no one out. I'll never forget it. I was with the Giants, but I was praying for Joe to hit a home run or do something.

Instead, Joe hit a line drive to Whitey Whitehead—the Giants' second baseman—who threw the ball to Bill Terry, the Giants' player-manager at first base, doubling off Red Rolfe. Lou Gehrig came to the plate with Crosetti still on second base, but Hubbell decided not to take any chances, and he hit Gehrig with a pitch. The next batter, Bill Dickey, grounded out to first, and that was the ball game. The Giants scored four runs in the bottom of the eighth inning and won the game six to one.

Eventually, the Yankees won the World Series four games to two, and Joe hit .346, but that vision of Joe DiMaggio playing ball in the pouring rain is as clear to me now as it was when it happened. I asked Joe if I could take a picture of him, which I still have. That might be the only photo taken of Joe from his first World Series. After that, Joe and I became lifelong friends.

While I was a batboy, I became friendly with Timmy Sullivan, the batboy from the New York Yankees, who later became an executive with the Yankees. He's the person who took the photograph of Lou Gehrig and me in the Yankees' dugout the day Lou Gehrig made his famous farewell speech about being the luckiest man alive. That was July 4, 1939, and everybody in baseball was there; even Babe Ruth showed up to say goodbye. That was the last time Lou Gehrig appeared in a baseball uniform at Yankee Stadium. I used Stan Lomax's press pass to get into the Yankees' dugout, so Timmy Sullivan could take my picture with Gehrig. The *New York Daily Mirror* published the photo and sent me a huge framed print that now hangs in my living room.

I didn't make much money as a batboy, so I quit after the 1936 World Series and went back to New Haven. Two years later, my mother, my brother Sally, and I started Sally's Pizza in a bakery on Wooster Street, a block

away from Uncle Pepe's restaurant. The bakery owner wasn't doing enough business, so he asked my brother and me if we wanted to take over the bakery. My mother bought it for almost nothing—maybe $700 or $800—with a small loan she got from Anthony's Jewelers, on State Street, and in April of 1938, we took over the bakery. We kept the brick oven (which is still in use) and converted the retail space into a restaurant with fourteen booths.

While I was on the road with Sinatra, my brother Sally was working all hours to make the restaurant a success. I helped by inviting some of the stars I knew to come to Sally's. Besides Frank, over the years I brought in Louis Prima, Ernest Borgnine, Dean Martin, Jerry Lewis, Johnny Mathis, Buddy Rich, and so many others. When one of them showed up, I took a picture and had someone from the local newspaper—the *New Haven Register*—write an article about who ate at Sally's. That brought attention to the restaurant, but ultimately it was my brother's hard work that built up the business. I was happy because I was free to travel with Frank without worrying about the money situation at home. Stars tried the restaurant, but it was Sally who kept bringing them back for more. So that's how Sally's Apizza, the most famous pizza restaurant in America, got its name. On any night except Monday, when the restaurant is closed, you will find people standing in line, waiting to get in—even in the winter.

When you go to Sally's, you'll see some great pieces of history on the walls. There is a signed cartoon from Pulitzer Prize winning artist Garry Trudeau, along with signed photos of Michael Bolton, Florence Griffith-Joyner, Artie Shaw, Andre Agassi, and many others. But there are two pieces in particular that are very important to me. One is a signed drawing of John F. Kennedy inscribed by the president to me. The other is a painting of Frank that someone gave him during our first tour at the Paramount Theatre in 1943. When he gave it to me, he said, "Here, you hang this in the pizza restaurant."

"Frank, I can't hang it like this."

"Well, I'll autograph it."

He started to write, "In all sincer . . . " and then he stopped, because he wasn't sure how to spell "sincerity," so he asked me to go downstairs and

ask Peggy Lee how to spell it. Peggy wrote it down on a piece of paper, and Frank copied it. The only visible space on the painting was on the necktie, so that's where Frank wrote, "To Tony, in all sincerity, Frank Sinatra." If you look closely, you can see the date. That painting has been hanging in the restaurant ever since.

CHAPTER 2: FROM THE BEGINNING

Frank was born in a tenement house at 45 Monroe Street, in Hoboken, New Jersey on December 12, 1915. I often heard that Frank was given up for dead when he was born. The doctor thought that Frank was stillborn and started to take care of Dolly, Frank's mother, who was hemorrhaging and could have died. Frank's grandmother picked him up and brought him to the kitchen sink where she ran cold water over him, which revived Frank. Frank weighed around thirteen pounds when he was born.

From Monroe Street, the family moved to Hudson Street—still in Hoboken—where Frank's parents stayed until Frank bought them a home in Fort Lee, New Jersey, years later. That was the last house they owned, because that's where Frank's parents were living when Marty, Frank's father, died of asthma in 1969; Frank's mother died in a plane crash eight years later.

I had relatives living in Hoboken, and every time I went to visit my cousins, Frank would be the only kid in the neighborhood hanging around, and so we became friends. I don't know what it was, but I just liked him as a person. Frank and I liked doing the same things—playing hooky, taking a bus into New York City, and walking around or taking in a movie, just two bums in the midst of the Great Depression.

By late afternoon, after we listened to some great band on stage or watched a movie, Frank and I would get on a bus back to Hoboken. We enjoyed being together and hiding out together, but we didn't do anything to hurt our families. Frank, about seventeen at the time, was thinking about becoming a singer. You know how kids dream, but Frank believed in him-

self. He was a tough kid who had fought to stay alive from the moment he was born—and he never stopped fighting to live his dreams. Like me, Frank never finished high school.

Frank got kicked out of school because of pigeons. He and three other kids bought pigeons for twenty-five cents apiece, put them under their jackets, and went to see a school play called *Cleopatra*. During the most serious part of the play, Frank and his pals opened their jackets, and the pigeons went flying. They flew all over the auditorium, while kids ducked and screamed. That was the end of the play and the end of high school for Frank. The principal threw him out. In those days, either you behaved or you were booted out. But you never know how things are going to work out. One thing is certain: if Frank had finished high school, he wouldn't have become a singer.

As for me, I got thrown out of school in New Haven because of something I did in Italian class. Something went wrong, and I said, "God damn it!"

My teacher said, "Consiglio, you know what you did now? You go home and bring your parents to school or don't come back anymore."

I never brought my parents to school, and I never went back. After that, I couldn't hang around New Haven. I was afraid of a truant officer named Mr. Healy. Even all these years later, I still fear him. If he caught you, he would grab you by the back of the neck and literally drag you back to school. If he happened to accidentally hit or kick you on the way, that was just part of the job.

Instead of hiding out in New Haven, I started to hang around Hoboken, where there was no Mr. Healy. I knew a driver with Rupolo's Trucking Company that made deliveries to New York every day. I caught a ride with him, and he left me off near the port authority. From there, I took a bus to Hoboken, where I ran into Frank in my cousins' neighborhood.

"Aren't you going to school?" I asked him.

"No. My friends and I got in trouble," he said, and that's how Frank and I hooked up with each other.

Frank and I would go to an automat in New York called Horn &

Hardart, a fascinating place. It was an automated cafeteria with sandwiches, desserts, and salads behind little windows. For under a dollar, you could get a plain meal by putting nickels in a slot next to your choice, which unlocked the window so you could reach in and get your food. Frank and I would buy two French rolls for five cents and two cups of hot chocolate for a nickel apiece. For fifteen cents, we'd both eat like kings before we had to hide out.

We often went to the Paramount Theatre and sat in the last row way up in the balcony, where it was so dark we looked like shadows. The theater was so big; we had to take an elevator to get upstairs—way up high in the nosebleed section—where we could hide. If anyone came up, Frank and I would slouch down in our seats so we couldn't be seen.

In 1935, Frank and I went to see Bing Crosby in *Pennies From Heaven* several times. We also heard Artie Shaw's band perform live on stage at the Paramount Theatre for fifty cents. That's how they did things then. When you went to see a movie, you also got to see a live band. We saw Benny Goodman, Charlie Barnet, Charlie Spivak, and even Bunny Berigan, big names at the time. Artie Shaw's band sold millions of records like "Begin The Beguine" and "Back Bay Shuffle." Those days at the Paramount really influenced Frank. I remember him watching Bing Crosby and saying, "Someday I'd like to sing like that guy."

Bing Crosby was hot in those days, selling millions of records and starring in hit movies. Of course, I wanted to encourage Frank, but I didn't believe he could pull it off. I told him, "Great, Frank, I hope you do."

But who could have possibly known that Frank had that much desire and talent and would work so hard to make it? Now, this was the same Paramount Theatre where—six years later—in late December of 1942 and into early 1943, Frank would be singing on stage with girls screaming and fainting because of him, and there would be thousands of people standing in lines that circled the block just to hear his voice. But in the early days, Frank and I were two kids hiding from the truant officer. Of course, later on Frank would have other truant officer problems, when he was blamed for kids staying out of school and spending days watching and listening to him at the very same Paramount Theatre.

I remember being backstage at the Paramount, looking up at the exact seats in the balcony where Frank and I used to hide out, as I watched Frank sing on stage while girls yelled, screamed, and passed out. It was an amazing experience for me and for so many others who witnessed the chaos in the theater whenever Frank performed. Larry King is one of the people who told me he remembered seeing Frank perform at the Paramount.

Vic Damone, who went on to become a great singer, was an usher at the Paramount at that time. I'm sure that seeing kids yelling and screaming whenever Frank sang might have influenced him into becoming a singer. He probably thought he could do what Frank did.

CHAPTER 3: THE THREE FLASHES

In September of 1935, Frank performed on *Major Bowes and His Original Amateur Hour*, a popular weekly radio show on NBC before it moved to CBS in 1936. In the late 1940s until 1960, the show was a mainstay on primetime network television. People who thought they had talent would go on the Amateur Hour and compete against each other. It was something to see. Every act imaginable came across that stage, and some were good. People yodeled and some made music on carpenter's saws by drawing a violin bow across the back of the saw.

Listeners from around the country were encouraged to call in or send postcards with the name of their favorite performer. The act with the most votes won, the same way it works with *American Idol* now, seventy years later. Frank appeared there with his Hoboken friends: the Three Flashes. Originally, Frank was going to do a solo act, but he ended up joining the group and became the lead singer. The group changed its name from the Three Flashes to the Hoboken Four and ended up getting the most votes during their showing.

After their initial victory, the Hoboken Four appeared on the Original Amateur Hour using several made-up names. Instead of being the Hoboken Four, they became the Jive Four, or the Jolly Jersey Gypsies of Song. Any name would do. Each week that they came back, they won.

After proving to be so popular, the Hoboken Four made dozens of appearances around the country with one of Major Bowes' touring companies. Of the thousands of amateurs to appear on the Original Amateur Hour, only Frank Sinatra and Pat Boone became major stars. After Frank

toured the country for several months with Major Bowes, the Major took Frank aside and said, "Frank, you've got the talent, and you're the one carrying this group. If you're smart, you'll go out on your own." Frank took Major Bowes' advice, and that was the last anyone ever heard of the Hoboken Four.

After Frank decided to leave the group, he sang at the Rustic Cabin, a small nightclub just outside of Hoboken, and was backed by the Al Donahue Orchestra, which was the house band at the time. Frank stuck with the job at the Rustic Cabin because it had a radio line, which meant that every night, part of Frank's performance was broadcast over the air to different cities around the country—a huge feat in those days.

In 1939, Harry James heard about Frank's singing and stopped by the Rustic Cabin to see him perform. Harry James was an extremely popular bandleader and trumpet player who had just left the Benny Goodman Orchestra. He had also married Betty Grable, the most popular pinup girl during World War II. At one point, Betty's legs were considered so valuable that her movie studio had them insured for a million dollars.

Harry James saw Frank and said, "Jeez, I'd like to hire that guy."

Harry hired Frank for seventy-five dollars a week during the Great Depression when 25 percent of the population couldn't find work. Seventy-five dollars a week was big money—especially for the newly married Frank.

During his days with the Harry James Orchestra, Frank sometimes got paid and sometimes he didn't, but he was pretty much broke all the time. Whatever money Frank had, he sent to his wife, Nancy. Nancy would often cook for the band when they played in the New York area.

Frank never wrote his parents about his money situation, because he didn't want them to know how difficult things were financially. Dolly and Marty were always telling Frank to give up the music business, because they did not think he was going to make it. Nancy was a good cook and took care of everything. She encouraged him all the time, even when there was no money. If it made Frank happy, Nancy was all for it.

CHAPTER 4: DORSEY MOVES IN

In 1940, World War II was going on in Europe. The French government had been taken over by the Germans, and England was being fire bombed every night. America wasn't in the war yet because the Japanese hadn't attacked Pearl Harbor. That would happen on December 7, 1941.

Jack Leonard, Tommy Dorsey's lead male singer, decided to leave the band to try to make it on his own. A few months later, Leonard was classified 1-A by the draft board or the Selective Service System, as it was called back then, and ended up fighting in the war. Leaving the very successful Dorsey band was a terrible decision, because he never made it as a solo artist. Jack did record some great records, including one I still love to hear called "Marie," but when he left Dorsey his career was over. Tommy needed a male singer to go along with Jo Stafford and the Pied Pipers, and he liked the way Frank sang. Tommy went to Harry James and said, "You know, I'm established. You're just starting out. What do you pay Frank?"

Harry told Tommy that he paid Frank seventy-five dollars a week.

"I'll give him one hundred and twenty-five a week," Tommy said.

So Frank latched on to Tommy Dorsey, even though he was under contract to Harry James. Harry could have kept Frank in his band, but he knew that this was a major opportunity for Frank, so Harry tore up the contract and never asked for a dime.

During the war, the songs that made Frank famous with the Dorsey band were "I'll Never Smile Again," "This Love of Mine," "There Are Such Things," and "Oh! Look At Me Now."

Those are the ones that really blossomed for him. During World War

II, Frank was the only young male singer around; so all the girls followed him. When Frank left Harry to join Tommy, Connie Haines went with him. Connie's real name was Marie Antoinette JaMais, shortened to Marie JaMais.

Harry said, "We can't keep saying Marie JaMais. It doesn't sound right."

Harry liked names people could easily spell and pronounce, so he came up with Connie Haines. Frank and Connie went from recording with Harry James to becoming featured vocalists with Tommy's orchestra, along with Jo Stafford and the Pied Pipers. What a collection of great voices.

Tommy Dorsey was tough, but he was also a great musician and a smart businessman. Jimmy Dorsey was just the opposite of his brother when it came to money and was more relaxed. I didn't get to see Jimmy very often, because when he was in town, Frank usually sang on the Astor Roof Garden with Tommy's band, and Jimmy played at a different hotel. We never got together unless we met at Danny's Hideaway after a show. At that time, Tommy and Jimmy Dorsey were feuding and had split up. I never saw them together until years later, in the fifties.

In the fall of 1940, Tommy Dorsey was signed to play at the annual Musician's Ball held at the Goffe Street Armory in New Haven. The Musician's Ball was where a number of swing bands got together and played. Tommy's band was featured that night. I sat with Frank when he wasn't singing, and we talked the night away. After the band finished playing—around one o'clock in the morning—Frank told me that the band was hungry because they had come directly from Providence and didn't have time to stop for dinner.

"Jeez, where's a good place to eat at this hour?" Frank asked.

I told Frank I'd take care of everything and called my brother Sally.

"For them, I'll keep the fire going in the ovens, and we'll make whatever the band wants. Just tell them to come and I'll have everything ready," Sally said.

When we got to Sally's, my brother had half-a-dozen pizzas ready for

the fifteen people in the Dorsey band plus the singers, Frank, Connie Haines, Jo Stafford, and the Pied Pipers—twenty-two total—and he kept the pizzas coming. The band got to Sally's at quarter to two and stayed until about four thirty in the morning. We had a ball.

When the band finished eating, Frank went up to the counter to pay the bill. My mother said, "Frank, we love you. There is no charge. I'm glad you came down and enjoyed it." And that was it. Frank never forgot that night.

Years later, in 1962, my mother and father celebrated their fiftieth wedding anniversary at Conte's Restaurant. Frank sent a waiter from the Waldorf-Astoria in a cab with twenty-four bottles of champagne. Frank had that kind of a heart. He never forgot people. If you did right by him, he'd do right by you. If you crossed him, it was a different ball game.

At some point, Frank wanted to break away from Tommy Dorsey and try his hand at going solo, but he had a contract with Tommy that you wouldn't believe. If Frank quit Tommy's orchestra, he would have to pay Tommy one-third of his earnings for the rest of his life. Some people say it was 40 percent and others say it was 30. I remember distinctly that it was one-third of Frank's income—not for one year or five years, but for the rest of his career. Any way you look at it, it was one hell of a contract, because Tommy was a shrewd businessman in every way.

Tommy wouldn't release Frank because he knew what he had. He knew he wouldn't find another singer with Frank's style or one with such a large following. Tommy was the kind of guy who looked down the road. He knew that eventually Frank would want to go out on his own, so he had Frank sign that lifetime contract. He knew that if Frank made it on his own, he would make it, too. If Frank didn't make it as a solo artist, he would disappear the way Jack Leonard had. Frank would be a bum, but Tommy would still be on top. Either way Tommy had all bets covered.

With the war on, Frank was one of the few male singers around, and Tommy was determined to hold Frank to their contract. That was about the time when Frank hooked up with Manie Sachs at Columbia Records. Manie hired a lawyer and Frank sued Tommy. Then Tommy sued Frank.

There are these stories about the mob moving in, paying Tommy a visit, and holding a gun to his head. I was there. It happened in Room 215 at the Hotel Astor.

Frank's uncle did pull a gun on Tommy, but getting out of the contract was more involved than that. People from the recording industry and the radio industry talked with Tommy and told him that because of Frank's popularity, it might look as though Tommy wanted to capitalize on Frank's success. It was mentioned that Frank's fans might boycott the sale of Tommy's records. If there was a boycott, Tommy would not only lose royalties from lost record sales, but he'd lose bookings, which were his main source of income. Both parties continued to argue back and forth.

In the meantime, Frank stopped appearing with Tommy and was replaced by Dick Haymes. At his farewell concert with the Tommy Dorsey Orchestra, September 3, 1942, Frank introduced Haymes as his replacement, saying that he knew Dick would be great. Haymes said that he knew he could never replace Frank as a vocalist, and he was right. He lasted only six months with Dorsey, and then he was gone and forgotten. On stage, Frank's farewell performance seemed friendly, but Don Lodice, who played alto sax, told me that as Frank left the stage for the last time with the Dorsey band, Tommy said, "I hope he falls on his ass."

The argument over the contract Tommy had with Frank went on for over a year and was constantly reported in the papers. To make a long story short, someone got involved and offered Tommy a sum of money in the $30,000 range. Frank had to borrow some of the money from Columbia Records as an advance against future royalties, but Tommy released Frank from his contract.

Once Frank was free from the Dorsey contract, Manie Sachs became Frank's record producer at Columbia Records. He went on to advise Frank about which songs to record, and they became close friends. Even though Manie was Jewish, he became godfather to Frank Sinatra Jr. This caused a problem with Frank's family because they were all Catholics, but Frank didn't care. He trusted Manie, and that's all that mattered to him.

When Frank married Ava Gardner in 1951, the ceremony was held in

Manie's brother's apartment in Philadelphia. Frank and Manie stayed close until Manie left Columbia Records and moved to RCA Records, a move that was a disaster for Frank. By then, his recording career was in shambles, and he had no one at Columbia he could trust or who would support his ideas. He was stuck with Mitch Miller who forced Frank to sing terrible songs like "Mama Will Bark."

When Frank left the Dorsey band in the fall of 1942, I told Frank that I'd like to go with him on the road. Frank said there wouldn't be enough money, but I told him that I would meet him at different clubs on my own, and that's how I became his traveling companion.

The first band Frank appeared with after leaving Dorsey was Tony Pastor's, and Frank appeared not as a singer for the band, but as an added attraction: a separate act. Our first stop was in Providence, Rhode Island. I helped Frank get organized on my own: no salary, no promises, and no contracts. At that time no one could have imagined how great an entertainer Frank would become. I cared about him and just wanted to help. That's how we started out.

After performing with Pastor, Frank hooked up with Ziggy Elman's band at the State Theatre in Hartford, Connecticut, a popular music venue in those days. Ziggy had played trumpet behind Frank when they were both members of Dorsey's band and had written a song called "And The Angels Sing," which became a big hit for Benny Goodman. At that point, Ziggy thought he could make it on his own by plugging his song and left Dorsey's band. So many musicians decided to leave their steady gigs with well-known, big bands to start groups of their own during that time. Harry James, Gene Krupa, and Lionel Hampton were part of Benny Goodman's successful orchestra, but by the early forties, those musicians had left Benny Goodman and formed their own, very successful bands as well.

I was not on Frank's payroll because, believe me, in those days there was no payroll. It was while Frank was touring as a special added attraction with Tony Pastor and Ziggy Elman that I could see a difference in the way the audiences reacted to Frank, who was feeling more confident and being much more himself on stage. That's when the kids—you know, bob-

by-soxers—started going crazy. We were appearing at the State Theater in October 1942 with Ziggy when two major breaks came.

First, Frank got an offer to become a regular performer on *Your Hit Parade*, sponsored by Lucky Strike cigarettes. *Your Hit Parade* was a popular weekly radio show on NBC, which featured singers performing the best-selling records for that week. Frank was with *Your Hit Parade* from 1943 until 1945, when he was replaced by the operatic tenor, Lawrence Tibbett.

Sometime in 1946 or 1947, *Your Hit Parade* moved to California, which worked out perfectly for Frank because he had started making movies. He rejoined the show in 1947, and he stayed until 1949. Soon after Frank left *Your Hit Parade,* the show became part of regular Saturday night network television.

The second piece of good news came when Frank signed a contract to play at the Paramount Theatre. I told Frank that I'd go to New York with him to help out. Frank said it would be great for two hooky players to return to the scene of their crimes—the Paramount Theatre—but this time as paid guests.

At the time, we thought that the Paramount booking would be just another job, another few weeks in another theater. But that appearance at the Paramount changed everything.

CHAPTER 5: THE VOICE AND THE CLAM RETURN

Frank was originally booked to play the Paramount for one month, but we ended up playing there for three months. I'll never forget it. We opened December 30, 1942, and stayed for twelve solid weeks, changing bands every two weeks. We had Dolly Dawn and her Dawn Patrol, and then Raymond Paige. Jimmy Dorsey played without his singer, Bob Eberle. Tommy Dorsey and Benny Goodman each played for two weeks. In fact, Goodman was the bandleader during Frank's first two weeks at the Paramount.

Benny was "The King of Swing," and the first jazz musician to play Carnegie Hall. Bob Weitman, the manager of the Paramount Theatre, decided to put Frank on as an added attraction backed by Benny's band. Benny was a major recording artist and had no idea who Frank was. Frank was popular with the dance band set, and Benny was deep into swing, a more intense music form. Unlike the dreamy ballads of the Pied Pipers, Jo Stafford, Connie Haines, and Frank, Benny played music with an edge—a meanness and a toughness.

Frank sang sweet romantic songs like "Violets For Your Furs" and "Be Careful, It's My Heart," while Benny Goodman's singer Peggy Lee sang "Why Don't You Do Right?" The dance-band vocalists tended to sing about the first blushes of love, while the swing-band vocalists leaned into songs about what comes after love.

The first night of Frank's engagement at the Paramount we were both nervous. This was the big time. Before Frank went on stage, we both watched from the wings. Frank was really tense. He had never sung with Benny Goodman, and Benny had a reputation for being tough to work for,

a perfectionist. Benny stood in front of his band, baton raised—with his back to the audience—ready to give his band the downbeat for this new, unknown singer. As Frank came out from the wings and walked across the stage, girls started screaming like hell. Usually, Benny was unflappable, but not this time. Benny turned around and said, "What the # # was that!" And he didn't say hell.

The musicians were so surprised by Benny's reaction that they began to laugh, and Frank started laughing too, which broke the tension. The kids in the audience couldn't care less what Benny said. They came to hear Frank, "the Voice."

Frank sang four songs, but you couldn't hear him sing. You could barely hear the orchestra. The musicians kept playing louder so they could hear each other above the screaming, the stomping feet, and the applause. I looked out at the audience and saw girls with tears pouring down their cheeks. Girls were shrieking, screaming, pulling their hair, sobbing and applauding—but applauding what? You couldn't hear Frank sing! You saw his mouth move, and you might catch a note here and there and maybe a word or two, but that was it. I knew every song in Frank's repertoire; there weren't that many back then, and even I couldn't figure out which song he was singing. It was wild!

When Frank finished his set, the stage went down, and the musicians and Frank disappeared while the kids stomped and yelled for more. The movie *Star-Spangled Rhythm* came on, but the girls kept calling for Frankie. Gradually, they calmed down and some in the audience left, but not many. Some watched the movie while others fell asleep, saving their energy for the next show. The management made a huge mistake: instead of clearing the theater after every performance, they let the kids stay.

Very few people left the Paramount. Bob Weitman could have made more money, but who would have figured that the kids would sit through the eleven o'clock in the morning show, sleep, then wake up for Frank's next show. They stayed in the theater until Frank's last show ended at eleven o'clock at night.

And that's how it went that first day and for the rest of Frank's twelve

weeks at the Paramount. I used to go outside the Paramount and watch the guy who changed the names on the marquee. Every two weeks he would change the lineup, but Frank's name always stayed: "Now Appearing, Frank Sinatra, with . . ." Then the name of a new band would appear. And that was my happiness. Later on, Bob Weitman had a picture of Frank, two stories high, mounted above the marquee.

Frank and I got to the Paramount Theatre at about nine thirty each morning, which gave Frank time to relax and have a cup of hot tea with honey to open up his vocal chords. Fans lined up around the corner at five o'clock in the morning. I wasn't there, but I asked one of the cops who walked the beat from twelve to eight in the morning, and he told me that kids started arriving at four thirty, and by five the lines were six abreast going around the block. By nine thirty, there were a lot of cops—hundreds of them—in front of the theatre, including patrol cars, mounted police, and ambulances. They needed to have emergency vehicles near the theater because girls kept passing out. Some of it was because of the anticipation of seeing and hearing Frank, but a lot of it was the result of people standing in line for hours in the cold and then passing out from exhaustion and exposure. And here's another thing: if five-thousand people stood outside the Paramount, maybe twenty or thirty would be men, and all the rest would be teenage girls.

Occasionally we heard about crowds getting out of control outside on the street, but Frank and I never saw it. We were backstage getting ready for another long day of doing seven shows each weekday, then going over to CBS radio studios and doing *Songs by Sinatra* each weeknight and *Your Hit Parade* every Saturday night.

Backstage, Frank would sip his tea and read the daily papers while I got his clothes ready. We seldom left Paramount the entire day. Lunch and dinner were often brought in from Sardi's, which was next to the theater. Sometimes food came from the Stage Door Delicatessen. Frank and I had our routine down. While Frank focused on his next performance and which songs to sing, I made certain that his clothes and props were ready. Frank didn't like to think about details. That was my job in those early days. I would never let him wear the same outfit for two performances in

a row. I rotated his suits, sports jackets, and shirts. If Frank had ten shows to do in a day, he had at least ten different outfits. If Frank wore a suit for the first show, he wore a sports jacket and slacks for the next show, and a different suit for the third show.

The outfit Frank wore for the last evening show was the first outfit he wore the next day. Of course, every crease had to be sharp, with no starch in the shirts. If something needed to be altered, we brought it to the tailor who had a workroom on the third floor of the theatre. I had everything ready a half hour before each performance, and if Frank wanted a cup of tea, I would make certain he had it.

I was with Frank when his career really took off. We lived across the street from the Paramount, at the Hotel Astor in room 215, a room I'll never forget. When we left our room, we'd walk down two flights of stairs or take the elevator, go out the side door, walk across the street, and go into the theater's stage entrance. It took us about five minutes. But once the kids learned where we were staying, they crowded around the hotel entrances, and we couldn't get out of the hotel and across the street.

That's when we moved into the Waldorf-Astoria. Frank and I had to get up a little earlier to get through town. At first, we drove to the Paramount in a taxi, but you couldn't rely on them. You didn't know when one would come, and it would have been a disaster if Frank didn't get to the Paramount in time to do his shows. Frank couldn't go anywhere without being mobbed.

Sometimes kids would push each other, knocking each other down, just to get close to Frank. That's when Bob Weitman provided Frank and me with a limousine to take us from the Waldorf-Astoria to the Paramount every day. There were times when mobs of thirteen- to fifteen-year-old girls tried to tear at Frank's clothes. I always walked behind Frank to make sure no one got to him, and I can't tell you how many times I got fingernails dug into the back of my neck when I tried to protect him from girls. Two, and sometimes four, policemen would walk alongside Frank to keep the girls away from him.

One time, several girls grabbed my neck with their fingernails so hard that my neck began to bleed. Frank was worried, but I told him that it was nothing and not to give it a thought. Frank liked that. Rather than moaning and groaning, I never complained because I was living a life that was exciting, with something new happening every day. When Frank and I got to the Paramount, I went to the tailor on the third floor. e washed out the cuts, bandaged my neck, and that was that. When the kids became more aggressive, we had police escorts from the limousine into the Paramount. After that, it became standard procedure to hire police to protect Frank from crowds. The mere sight of him could start a stampede. It was a lot of fun to see all the excitement, but there were times when the situation got to be dangerous. Other times, there was nothing we could do but laugh.

One time at the Paramount, Frank was upset about something—I never knew what. But I knew I had to get him out of his mood. When he performed, he always had a cigarette in his right jacket pocket and a lighter in the left. When he'd sing, "One For My Baby," he'd take out the cigarette and light it. But this one day, I put a walnut in his pocket instead of a cigarette. Frank began the song and reached into his right jacket pocket for a cigarette, but instead he found the walnut. I was standing in the wings watching him, which is what I always did. Frank smiled and flipped the walnut across his body to me. Then he smiled and shook his finger at me, which meant that when he got off stage, he'd fix me.

There was such a demand for Frank's autograph—I mean, a thousand requests a day. Mailbags arrived daily and were piled up everywhere. One day, between shows I wrote Frank's signature five hundred times, and then I compared what I wrote with his. It was very close. I knew that Frank didn't have time for autographs because he was doing seven shows during the day and one or two radio shows at night. So I started putting his signature on sheets of paper and handing them out to the fans that crowded around the dressing room door. That way I got them to leave, and Frank and I had an easier time getting into the limo on our way to the next performance.

One day when I was on the second floor of the Paramount autographing pictures, Frank came by and wanted to know what I was doing. I

told him that I was signing sheets of paper and photographs for him because requests were arriving by the thousands, and he couldn't possibly answer even one-tenth of them because of his hectic schedule. I told Frank that I just wrote his name and sometimes "Best wishes," but I never personalized any by adding names like "To Mary" or "To Jane."

Frank looked at the ones I had signed and said, "Oh, wait a minute. Tony, now that I see the way you sign my name, from now on keep away from my checkbook."

People were sending us handkerchiefs, photos—anything we could write on. I wrote Frank's signature when he was busy or sleeping, so his fans wouldn't be disappointed. When he didn't want me to autograph things, he did the signings, and believe me, Frank must have signed hundreds of thousands of things in his lifetime. After a time, people wanted my autograph too, which I gave them. Then, if they wanted me to put Frank's name down, I wrote, "Tony Consiglio, for Frank Sinatra."

Once, I saw a vendor selling pillowcases with a life-size picture of Frank's face on both sides, which, in those days, probably cost the vendor ten cents to make. He was selling hundreds of them at two dollars apiece to girls who would then put them over their pillows, so they could hug the pillows while they waited in line. I saw hundreds of those pillowcases in the theater. Girls would fall asleep while the movie played, hugging their pillows with Frank's picture against their cheeks. And that's how things were. People sold anything connected with Frank, including photos, sheet music, and pin-on buttons.

Girls fought over those things. There were no marketing plans or copyrights. People saw an opportunity to make a few dollars and took it. If Frank or Bob Weitman had thought about it, they could have made more money from selling photos and pillowcases than they made from the thousands of kids who paid to see Frank sing.

Girls kept lining up to see Frank's shows, and some actually fainted on the sidewalk, while others faked it so they would be taken inside the theater and out of the cold. If Frank happened to glance in the direction of the girls as he hurried into the theater, some would pass out. For the seven shows we

did each day, rows of ambulances stood parked across from the theater, while forty or fifty cops patrolled the front of the theater just to make certain that the crowds lined up around the block didn't get out of hand.

After the final show at the Paramount, Frank and I drove to CBS Studios on W. Fifty-Seventh Street to film *Songs by Sinatra* live. Audiotape wasn't around in those days, so if we didn't make it to the studio on time, the audience would have heard nothing but dead air. For *Songs by Sinatra* just two people would be in front of the microphones: Frank and the piano player, Milton Gross. They performed every night for fifteen minutes, which gave the fans who couldn't see Frank at the Paramount a chance to hear him on the radio.

I always stayed in the wings when Frank performed in case something went wrong or he needed a glass of water. He always told me he wanted me to stay in the wings, so I did. I watched every move he made. I remember one time being in the wings at the Paramount and watching Frank sing a love song. He kept staring at one girl until she suddenly passed out— went right over. The other girls started screaming and yelling and some of them started passing out too. It was the strangest chain reaction I've ever seen. Frank felt so bad that after that he tried to avoid focusing on any one person while he was singing.

Another time, when Frank was singing "This Love of Mine," he had an itch above his left eye. When he rubbed his eyebrow, hundreds of girls started screaming. No matter what he did, girls would get all excited and start screaming and crying. It was amazing.

One afternoon, Frank's mother, Dolly, decided she would surprise Frank and go to see him backstage at the Paramount. When she got to Times Square, the crowds were so big that she couldn't get near the theater. She saw a cop and said, "I'm Frank Sinatra's mother . . . "

That's all she had a chance to say before the mob started pushing toward her. The kids shoved the cops out of the way and blocked the stage door. They pulled on Dolly's coat and tore at her hat, and the police weren't much help in protecting her. When she finally made it backstage, she was furious.

"What do I have to do, fly a plane and land on the roof?"

She looked like she had been through the cyclone in *The Wizard of Oz*. Dolly was an absolute wreck. The crowd had torn her coat, and the beautiful floral hat she was wearing now had broken flowers and a brim that was bent in twenty different directions. She took her hat off and threw it in the garbage pail. Even all the security people couldn't protect Dolly. Frank told her that she should have called, but she wasn't listening. Frank told her not to worry, that he'd get her a new hat.

Dolly stayed for the show and afterward Frank had the limousine take her back home to Hoboken. Dolly came to several more shows, but Marty, Frank's father, came to the Paramount only once, and it wasn't to see Frank perform. Marty needed a radio tube, which was hard to come by during the war, so Frank used a connection and got the radio tube for Marty. When Marty came backstage, he didn't ask Frank how he was or how the shows were going. The first thing Marty asked was, "Did you get the radio tube?" Even at that point, Marty wasn't so sure that Frank had made the right decision and thought maybe Frank should go back to work at the shipyards, where he had once worked for a few hours before quitting. Physical work was not on Frank's itinerary. That was for other people.

In March 1943, toward the end of Frank's run at the Paramount, he decided to throw a party to celebrate his success. Frank invited a few friends and his parents to go to Patsy's Restaurant for dinner. We went upstairs to the second floor where there was a small dining room for private parties. Everyone was sitting down, but I was standing.

"I know why you're not sitting down," Frank's mother said to me. "You want to sit next to that bum!" She knew I wanted to sit next to Frank. "Go ahead. There's room for you," she said. So I sat next to Frank. She added, "You know, one of these days you've got to remember, if you hang around with someone that limps, eventually you will limp."

When she called Frank a bum, and said that one of these days he and I would both become bums, I felt awful, and a tear started to come. Frank saw it, got up, and walked away from the table.

"Come here," Frank said. I went over and Frank spoke softly. "I'm go-

ing to tell you now and I'm not going to tell you anymore. She loves me. She also knows how much you love me, and she's teasing you. So don't take her seriously. I'm not going to tell you anymore. And remember, every knock is a boost."

From that point on, whenever Dolly tried to knock Frank down with her comments I didn't say a word and I didn't react. I kept still. I remembered what Frank told me about not getting mad. We had a hell of a time that night at Patsy's and not long after that, Frank bought his parents a house in Fort Lee, New Jersey.

CHAPTER 6: IT'S IN THE BAG

Within a few weeks after opening at the Paramount, huge sacks of mail began to arrive, all addressed to Frank. Some days the post office made four deliveries. It all came to the Paramount because early on very few people knew which hotel Frank was staying at. The bags of mail became an impossible situation. Frank didn't have a secretary or business people to handle his mail the way he did later in his career. However, Frank used the Barton Music Company for an office, and they did have a secretary. Barton Music was the publisher of "This Love of Mine" as well as most of the sheet music for Frank's songs, so they were making money, but there was no way that one secretary could handle those sacks of fan mail, and there was just Frank, me, and Hank Sanicola.

I don't know what happened to all that mail. There were so many sacks of mail coming in every day that if Frank had quit singing right then and started answering each letter, he would still be answering them today. You know that scene in *Miracle on 34th Street* when the mail carriers haul all those sacks full of letters into the courtroom? That's what it was like at the Paramount every day. In 1942, Frank hired Gloria Lovell and set up an office in Beverly Hills to take care of his personal correspondence.

Frank often went to New York on the spur of the moment. He didn't want to figure out where he was going to stay, so he rented a suite year-round on the twenty-third floor in the Waldorf Towers at the Waldorf-Astoria. He never called ahead because he wanted to arrive quietly without anyone knowing when he was going to show up. General Douglas MacArthur also had a suite in the Waldorf Towers and, at some point, so did Lucky

Luciano. Can you imagine people more dissimilar living in such close proximity? We never ran into either one of them, but Frank met Luciano when he was performing in Havana, Cuba, years later—a chance meeting that Frank couldn't avoid. Fortunately, I didn't go on that trip. Some of those people were involved in gambling and drugs and would just as soon shoot you as look at you. I had enough problems just taking care of Frank. Imagine Frank, MacArthur, and Luciano as neighbors at the Waldorf. What a country!

Frank wanted to stay at the Waldorf Towers because he couldn't hear voices or street traffic from up there, and Frank needed his sleep. The suite cost him around $25,000 a year. One year, Frank had Gloria Lovell come to his suite and change all the furniture and the rugs to fit with a Japanese style. I don't know where Frank got the idea. He didn't like Japanese food, but he loved Japanese furniture.

Metronome and *Billboard* named Frank the Best Male Vocalist in 1943. In their articles, they published the address of Frank's office in California, and that really increased the mail. When Gloria Lovell came on board, all the fan mail went to her. Frank read only the telegrams. If anyone sent him a registered letter, he would never sign for it. No one—not Gloria, Hank, or I—was allowed to sign for registered mail. The only way you could get to Frank to tell him what you wanted was through a telegram.

In those days, Hank Sanicola made arrangements for Frank's public appearances at things like war bond drives, where Frank would sing a few songs. We visited wounded GIs in hospitals, or Frank appeared on Jack Benny's radio show. Frank always told Hank, "Good, keep it going."

Remember, the war was on, and Frank was the only famous male singer not in the service. Singers like Ray Eberle appeared with Glenn Miller, and his brother, Bob Eberle, with Jimmy Dorsey, but Frank made hit records, appeared on victory drives, performed at the Paramount Theatre, and did no less than six or seven radio shows each week. You could hear Frank on the radio all across the country every night, and he drowned out all the other singers. As good as they were, other singers didn't have a chance. All

you had to do was mention you needed someone to put on a show for the troops, and Frank was right there, performing for free. Some GIs were getting ready to ship out to Guam or France, and Frank knew some of them weren't coming back. Even though Frank couldn't go into the service because of his punctured eardrum, he took every chance he had to give an awful lot.

At the Paramount, Frank did a show every two hours up until eleven at night, and whenever he headlined there, kids skipped school. It was a problem, but it wasn't Frank's fault, and there was nothing he could do about it. We seldom left the theater during the day for the three months Frank performed.

Food was even brought in. Kids stayed for show after show and would not leave the theatre for anything. Frank gave me money to go out and buy boxes of Hershey bars, and I'd pass them out because the kids were hungry. Kids came in at eleven in the morning and stayed until eleven at night. I don't know what it was about Frank, but bobby-soxers were devoted to him.

I still hear from people who tell me they remember how we passed out those Hershey bars. Frank had to eat too, so every now and then, he would tell me to drive to New Haven and pick up a few pizzas from Sally's. If I had a particularly busy day at the Paramount, we would have our limo driver make the hour-and-a-half drive to pick up the pizzas. The tailor on duty at the Paramount full time had a small electric oven in his workroom that Frank and I would use to heat three or four slices of Sally's pizza. Once the slices were hot, we would go back to his dressing room and go at our pizza. Mozzarella with pepperoni was his favorite, but once in a while, he'd have one with clams or sausage.

The most important thing I took care of was Frank's clothing. Frank was very particular. He didn't like starch in his shirts, and he didn't like them folded. He liked soft collars and cuffs. Frank had his shirts custom-made with wide collars to go with his big, floppy, bow ties. We always had eighteen to twenty-four shirts ready at a time. Frank changed for every performance and would wear six or seven shirts a day. I would take the shirts

across the street to our hotel, the Astor, where the shirts got laundered. I made sure they came back on hangers; otherwise, the shirts would come back folded with a lot of wrinkles. If you knew Frank, one wrinkle would set him off.

Later, when Frank's shows were drawing around-the-block crowds, I had a problem because we moved to the Waldorf-Astoria, which was farther from the Paramount. When Frank was sleeping, I would get all the shirts on hangers and take a cab to the Paramount, so Frank and I would not have bundles of shirts in our arms when we took a cab at show time. That way, we had our hands free in case we needed to keep some of the more zealous fans at a distance. Frank didn't like distractions, so I took care of all the details while he slept. Later, we hired people who handled the small jobs, and instead of jumping into a cab, we had a limo take us everywhere.

Early on, Frank loved to wear bow ties. If you look at a photograph of Frank, Ziggy Elman, and me at the State Theater in Hartford, September 1940, you will see that I was wearing a bow tie and Frank was wearing a regular tie. Frank picked up the bow tie habit from me. One of the tall tales about Frank is that Nancy made his bow ties. Nancy was a great wife, but she didn't make Frank's bow ties. Frank bought his bow ties from a clothing store called Cy Martin's.

From time to time, a man from the store would come to our dressing room at the Paramount with a suitcase lined with two hundred bow ties, and Frank would pick out the ones he wanted. But after a while, when the bow tie thing got around, Frank started wearing regular neckties again. He liked ones with little painted birds on them or musical symbols.

Frank and Jackie Gleason had been pals through the lean years. The day Frank opened at the Paramount Jackie sent a long trailer truck and had it park alongside the stage door where Frank and I went in. On the roof of the trailer, in big letters, Jackie had written, "Hi ya, Cheech!" Frank's dressing room was on the third floor, and when Jackie came backstage he said, "I think I'll look out the window." Jackie had the message printed on top of the trailer, so we could see it when we looked down from the window.

The people who came backstage early in Frank's career were Jackie Gleason, Spike Jones, Red Skelton, and George Raft. After his shows, Frank always went to Danny's Hideaway, where a lot of other performers gathered after one or two in the morning and stayed until seven. Danny was a nice guy who did his biggest business from midnight until eight in the morning. Whenever Frank played in Vegas, Danny came out with a group of people. He and Frank helped one another, and Frank always remembered it. That's how people got to be successful.

When Frank was in New York, he enjoyed eating at very few places, because he always had to worry about creating a scene. When he was in the mood to go out to eat, he would call me and tell me to make reservations at Patsy's, La Scalla, the Villa Nova, or the Villa Penza, in Little Italy, on the corner of Mulberry and Grand Streets. The Villa Nova and La Scalla had great food, but once his fans knew that Frank was dining there, they would come right up to the table. At the Villa Nova, which was on W. Forty-Sixth Street, between Sixth and Seventh Avenues, our table was in the corner. No one could get behind Frank because he had his back up against the wall. There were two captains at the restaurant stopping people from coming to ask for autographs, so Frank could eat peacefully. At some point the fans got out of hand, and there was no protection, so Frank said, "Let's quit this place."

That's when Frank began to go to Patsy's. Frank became friendly with the owner; he knew how to handle things. Patsy's had a private room upstairs, so we didn't have to worry about people coming in and out. I didn't have to tell Patsy how many people were going to be in our party because the room was large enough to hold fifty people, but Frank would never take that many to just go out for dinner. Our limo would pull in by the side door, and we'd go upstairs where it was comfortable, away from everyone. Nobody knew we were there, and nobody knew when we left. We would have a leisurely dinner, and Patsy would stay open later than usual just for Frank. When Frank went to a restaurant, it was to eat and get out. The restaurants weren't all-night hangouts like Danny's Hideaway and Toots Shor's. Danny's had the late-night, after-theater, sophisticated crowd, while Toots Shor's had a rougher sports crowd.

I always worried about everything and Frank was always relaxed. It was my job to anticipate and avoid problems and to make sure we always had a way out. One late Sunday afternoon, Frank and I decided to go to Little Italy in New York for Italian food. Frank wanted to go to Umberto's, so I made the reservations under my name to avoid any hassles. If I said I wanted to make a reservation for Frank Sinatra, it was guaranteed there would be a crowd waiting outside the restaurant and people lined up at our table inside for autographs. We slipped into Umberto's without being seen and got a table in the back of the dining room, away from the main entrance and near the kitchen in case we had to leave quickly.

It was a quiet place, with nice soft music on the jukebox—usually Tony Bennett, Jerry Vale, and Frank. We ordered our food, and then I went to the men's room. For some reason, I pushed the curtain aside and looked out the window. I couldn't believe it. A hearse was parked out back, and there was no funeral parlor in the area. I came out of the bathroom, sat near Frank, and said, "Frank, I don't want to worry you, but I looked out the men's room window and there's a hearse parked in the back."

Frank buttered the heel of his Italian bread and said, "Tony, when you see someone walk behind the jukebox and turn it up loud, that's when we duck under the table." A few weeks later, I unfolded the *Daily News* and there on the front page was a story about "Crazy" Joey Gallo and a couple of his local mobster friends. They had been bumped off while having a nice, quiet dinner at Umberto's. So I guess the hearse came in handy. The next day, when room service showed up, at four in the afternoon, with Frank's breakfast, I put the *Daily News* right next to his coffee and walked away.

A few minutes later Frank called me over. "Tony, what's this? You trying to tell me something?"

"Yeah, Frank, that hearse was trying to tell us something."

"It's all in the timing. Everything is timing. It wasn't our time," Frank said.

"Yeah, Frank, and to make sure it's never my time, next time I see a hearse in the back of a restaurant, I'll say to you what Jesus said at the last supper."

"And what was that?"

"When Jesus looked at who was sitting around the table with him, all he said was, 'Separate checks.'"

Frank hit the floor laughing. The chair went flying, and I don't know how the coffee missed him. It took Frank about fifteen minutes to recover from that one.

CHAPTER 7: NIGHT OWLS

Frank and I never went to bed before dawn. No way. People knew Frank would be up and around, so friends like Jackie Gleason and George Raft knew they would run into us at Patsy's before we headed over to Toots Shor's. Toots would come by our table and call Frank a few names like "crumb bum," and they would insult each other. That's how old friends like Toots, Frank, and Jackie got along. We stayed at Toots's until 6:00 a.m., surrounded by smoke and booze. Until we went outside and saw it getting light, we had no idea that we had talked and joked the night away.

Toots always faced toward the front door so he could see who was coming in and going out. One night, Frank and Jackie came in together, and Toots shouted, "Anybody who wants any more drinks better get them now, because here comes two bums. They're going to finish off whatever's left at the bar. Order up or you won't have a drink left."

Frank said, "Who's a bum? You're a crumb bum yourself."

That's the kind of relationship Frank, Toots, and Jackie had. And people would laugh. As long as you used the word "bum," everyone was having a good time.

Toots was a nice guy, especially when he got a few drinks in him. He was a lot of fun when he got stoned, and he was stoned most of the time. Jackie and Frank used to run up tabs at Toots Shor's before they made it big, but Toots was always there. He didn't care if you had money. If you were fun, could trade insults and—most of all—stay up all night and drink, Toots was happy to have you around. Toots had mostly a nighttime crowd. Musicians, Broadway people like George Raft and Lee J. Cobb, and sports

figures like Joe DiMaggio, Whitey Ford, Billy Martin, and Mickey Mantle would show up. Famous people who came to the restaurant didn't want to sign autographs, so Toots made sure they weren't bothered. If you weren't invited to sit down at Frank's table, Toots's waiters, who doubled as bouncers, made sure you didn't.

Even in those days, Frank hated to go to bed before the sun came up. And he always had to have people around him. Being alone scared him. He wanted to be surrounded by music, friends, and life. That made him happy. Alone, Frank would become sullen and introspective. I never knew why. He didn't like to be left alone to think, so Frank always had people around who could make him laugh. He was always under a lot of stress and had a lot of nervous energy to burn off before he could go to bed. Frank was his own manager, his own agent, and he alone controlled the money. He didn't trust banks, which is why I always carried thousands of dollars in cash: fifties and hundreds.

When Frank did a show, he knew every word of every song, and he always took on new material, which meant he had to memorize fifteen songs for each performance. After the stress of putting on sometimes eight different shows a day, Frank had to do something to calm down. He couldn't go to a park, and he didn't like playing sports. So to unwind he stayed up all night with his friends, which was his way of relaxing—it made him feel safe and comfortable. He could finally stop performing and be himself. Performing made him nervous, and it took years for him to learn to breathe and pace himself. That's how he developed his habit of stopping after eight songs in a performance and talking with the audience. That would relax him enough to sing the final seven songs in his set.

Frank did the same thing when he recorded an album, which usually took three days. He would record four or six songs each day. Of course, there would be retakes and on-the-spot rearranging, but rarely would he sing more than four. He had Nelson Riddle or Billy May bring the charts for six songs, just in case the recording sessions took less time than he thought. Or, if the band was swinging just right and Frank didn't want to lose that edge, everyone would stay and record a few additional songs. But

most often, Frank took his time. He picked the songs, selected the arranger, and contacted his favorite musicians. Frank controlled what went in each album, and then, to top it off, he checked out all the artwork and selected which painting to use on each album cover.

If you look at the way Frank worked and how carefully he handled each aspect of his career, you could understand the stress he constantly lived under. This is why we stayed up all night, burning off energy, and went to sleep when most people were just getting up.

In 1945, when we were back at the Paramount, Frank was still doing a fifteen-minute, live radio show called *Songs by Sinatra*. When we drove from the Paramount to the radio show, Frank's vocal chords were still loose from singing all day and all night. He ended the radio show by singing "Put Your Dreams Away," which more or less became his theme song.

In those days, Frank had a full-time limousine driver because he didn't like to wait. He liked service, and he didn't mind paying for it. He was like that all his life. It didn't matter if he paid Bob, our driver, to sleep half the time. Frank had to do his eight or ten shows each day, and after that, he had a tight schedule. Nobody worked the way he did. When Frank had to be at the radio station or at a war bond drive, he wanted to make sure that he didn't waste time waiting for a cab.

Frank did a lot of radio shows. First, there was *Broadway Bandbox, Vimms Vitamins Presents The Frank Sinatra Program, Old Gold,* then *Your Hit Parade, Max Factor Presents The Frank Sinatra Show*—both starting in 1942 or 1943—then *Old Gold's Songs by Sinatra.* There was *Light Up Time*, which ran every day for fifteen minutes, starting at seven o'clock; that lasted from the late forties into 1952. You name it, and Frank was on it. Frank was hot and people wanted him on their shows. He had a hard time saying no, and in those early days, we didn't have a manager who took care of things and made sure Frank wasn't scheduled in two places at once. At one time early in his career, he did a radio show with Dinah Shore, and later he did a talk show with Rosemary Clooney. I remember her show distinctly, because one time she was mad because the show was about to begin and Frank was late.

In the mid-1940s, Frank was on stage a dozen times a day, appearing at the Paramount, doing guest shots on the Bob Hope, Fred Allen, Lux Radio Theater, and Jack Benny radio shows, while doing his own radio shows. People heard his music in record stores, on radio, and on jukeboxes that had been installed in restaurants. When Frank started to make movies, it seemed that everywhere you went, he was there.

I remember that Frank was not only blamed for truants but also for the sudden increase in runaways. Once, when we played the RKO Theater in Boston, two girls stayed in the theater for nearly a week. Their parents reported them missing and thought they might be runaways. The Boston Police Department asked Frank if he would please announce that if these two girls were in the audience they had won a prize. So Frank interrupted his show, made the announcement, and the two girls jumped up and screamed with excitement. That was their mistake, and they were taken home. But before they left, Frank signed some record albums for them.

I remember kids trying to get backstage by bringing pies and gifts or saying they were related to Frank.

"Jesus," Frank said. "When I was with Tommy Dorsey I had no relatives. All of a sudden I've got millions of cousins."

At that time, it was Sinatra, Sinatra, Sinatra. When Frank wasn't on the radio, he was at the Paramount in New York or the Chez Paree in Chicago. It seemed that Frank and I were traveling in a huge loop from New York to Miami, Chicago, Las Vegas, and finally to Hollywood, to sing at the Hollywood Bowl. That was a big deal.

Frank sang "Ol' Man River" wearing a tux that was so white, you could have gotten snow blindness from looking at it. From then on, Frank was either on the road, on the radio, or in the movies. No matter what he was doing, he was always in the news.

CHAPTER 8: THE EARDRUM

In January 1944, Jan Savitt and his Top Hatters played behind Frank at the RKO Theater in Boston. While we were playing there, Frank Jr. was born in New Jersey. When I got the call, Frank was on stage.

"Is Mr. Sinatra available?"

"No, he's not. He's on stage right now."

"Will you tell him that he's the father of an eight-pound baby boy?"

When Frank came off stage after his first show, I said, "Frank, the Hague Maternity Hospital called. Here's their number. You have a son." Frank was so excited he did the next show in double time.

A few years earlier, in 1943, while we were in Boston at the RKO Theater, Nancy and my parents each got telephone calls saying that Frank and I had to report for induction into military service. Frank had to report to Islip, New York, for his induction examination. From there, we were going to meet in Pittsburgh, and then go to the Earle Theater in Philadelphia. I had to go to the armory in New Haven for my examination.

Frank said, "Whatever happens to you and me, let's keep in contact. If we don't have to go overseas right away, we'll meet in Pittsburgh or Philadelphia. If not, we'll just forget about everything."

We both figured that when we got into the military, we would get shipped to different places, and that would be the end of music and traveling until after the war. I went through my examination and the doctor scratched me because I had a duodenum ulcer. I called Frank and told him I was rejected because of my ulcer.

"Well, I guess we both can meet," he said.

"What happened to you at your exam?" I asked.

"They don't want me in the service because I've got a punctured eardrum."

After we had been passed over for military service, Frank and I planned to meet in Pittsburgh. I was so excited that Frank and I would still be together. I went to Union Station and got in line to buy my ticket. In front of me was this tall, gorgeous woman. I mean she really had a body. She kept turning around to look for someone, and because I'm a fairly short guy, I had to keep ducking out of the way because she had these really large tits. We stood in line for about ten minutes—she kept turning around, and I kept ducking. If I wasn't on the ball, I could've lost an eye.

Finally, I got to the window and the clerk said, "What do you want?"

"One one-way ticket to *Titsburgh*."

"What are you, a wise guy?" he said and almost closed the window on my fingers. I caught the train and met Frank in Pittsburgh.

While we were there, Edythe Wright, the main girl vocalist with Tommy Dorsey's band before Jo Stafford and Connie Haines, came backstage and brought Frank, me, and the musicians a big pot of spaghetti and meatballs. After Frank and I hooked up in Pittsburgh, we began touring hard. First, we were at the Earle Theatre in Philadelphia, then the Chez Paree, then the Meadowbrook, and finally the 500 Club in Atlantic City.

One night Frank, the band, and I walked out of the 500 Club after we finished the midnight show, and we saw a long line of kids waiting outside. Frank said, "Go and find out from Skinny what the problem is."

Skinny was Skinny D'Amato, owner of the 500 Club, and the world's worst poker player. He was always heavily in debt with the mob. I found Skinny and brought him to Frank. Skinny D'Amato, may he rest in peace, said, "Frank, I hate to ask you, but these kids paid big bills to see you."

Skinny D'Amato had oversold the club to make a few mob payments, and these kids were stuck out in the cold at two-thirty in the morning, hoping to see Frank. When Frank saw them standing in line, he said to his musicians, "Okay, let's go back inside," and we went back and did another show.

We went to the 500 Club at least once a year. Frank didn't say any-

thing to Skinny about overbooking the club because Frank knew that Skinny was in and out of financial trouble, from spending too much time in Miami where Sam Giancana ran the games. Whenever Skinny lost a bundle, enough to lose the 500 Club, Sam would ask Frank to help bail Skinny out. So Frank performed several times at the 500 Club for free. When Sam asked you to do something, you didn't say no. He was one of those guys who would shoot his grandmother just to make book on which way she'd fall.

Frank liked Skinny, so he took care of him. But I think what was more important to Frank was that his fans were outside, and he didn't want them to go home disappointed. Frank didn't get any extra money for doing a third show, but he cared how people were treated. In fact, Frank lost money that night because he ended up paying the band to do the third show. Frank went on around 2:30 a.m. and finished at around 4:00 a.m. If he could sing a few songs and make a few hundred kids happy, Frank would do it. It really didn't matter to Frank. He wasn't going to bed any time soon anyway. But you can bet that Skinny didn't try to overbook the club again, at least not while Frank was performing.

I have a photo of Frank, Skinny D'Amato, and me at a table at the 500 Club. Frank had just finished performing, and he and I were heading from the dressing room to the table when I saw this beautiful, tall, dark-haired woman backstage. She had everything in the right place.

"I gotta have that girl," I told Frank.

"Tony, who's the star?" That was enough for me, so I backed off. And what do you think? Frank got the gorgeous doll, and I ended up with another dog. That's how Frank would work it to win a woman away from the rest of us. When I look at the photo now, the woman I ended up with wasn't bad looking, but if you put a glass of water next to her, it would turn into an ice cube in five minutes.

We were at the 500 Club doing shows on Friday, Saturday, and Sunday—two shows a night: one at nine and another one at midnight. After the late show was over, Frank always wanted to have friends around for a little gathering. Our suite was on the first floor of the Hotel Claridge. One night

there were a lot of close friends around and a couple of girls that neither Frank nor I knew. After a while, one of the girls went to use the ladies' room. As the night turned into morning, I didn't think about the girl because the party was going on. When we didn't see her, Frank and I assumed that she had left mad because she couldn't get close to Frank.

After the party, Frank went into his bedroom. In a few minutes, he called me, "Tony, come in here right away. I hear noises."

When I went to his bedroom, Frank told me to help him look around. We looked in the closets and in the bathroom and couldn't find anything. Then I looked under the bed and found this girl hiding. I got down on my hands and knees and said, "Honey, look, either you come out by yourself, or I get security and you'll be in deep trouble."

When she came out, I said, "Look, don't be mad. I'm going to talk to Frank and have him invite you back, just you and Frank and a few other friends."

"No other girls," she said. "I appreciate that."

But I never did. I just said that to get her out quietly without any problems. That was the first and last time anyone was able to sneak into our hotel room. We beefed up security after that. Some people made a big deal about Frank always having Hank Sanicola, Jilly Rizzo, and other friends running interference for him, but we had been clawed and had our clothes torn. Frank could never sign just one autograph. One autograph would lead to a stampede. I don't know what it was, but people always wanted to get close to Frank.

After a while, whether we were in the hotel or in his car, people could not get close because we always had security around. It wasn't what Frank wanted; it was just self-preservation.

Another time when Frank was performing at the 500 Club, Frank, Jack E. Leonard, and I were sitting around our suite at the Claridge. I don't know why Frank liked to do this, but one thing that amused him was throwing cherry bombs under the chairs his friends were sitting on. Frank never threw a cherry bomb at a stranger or at someone he didn't care about. This time, the victim was Jack. Frank winked at me, his signal for me to go

to our attaché case and bring him a cherry bomb. We carried cherry bombs with us wherever we went. I gave the cherry bomb to Frank; he lit it and tossed it toward Jack, who was sitting in a large, upholstered chair. The cherry bomb passed between Jack's legs, rolled under the chair, and exploded. I'll never forget what Jack said to Frank.

"Good, you bastard. Now I'm finally a member of the firecracker club."

After a few hours, Jack left, and when I moved the chair, I saw a big hole in the rug. I said, "Frank, we're in trouble here."

"No, we're not."

"What do you want me to do?" I asked.

"Take that chair and you put it in the corner. Then you and I get the long sofa and put it over the hole."

And that's what we did. I don't know whether the management ever discovered the hole in the rug, but by Monday afternoon, we were gone and wouldn't be back for another year.

One of the first clubs I remember Frank appearing at was the Riobamba. The place was in financial trouble, so Frank sang there for a week trying to boost it up. After Frank sang there, the Riobamba went under, but that marked the end of Frank doing one-nighters and performing in twenty cities in twenty nights. It was hotels and nightclubs after that. After all, Frank and I were getting older—almost in our thirties.

CHAPTER 9: THIS LOVE OF MINE

In 1940, Frank met Hank Sanicola, who would later become Frank's body-guard, semi-booking agent, and enforcer. Frank was still with Tommy Dorsey when Hank visited him at the Hotel Astor. I was in the room with them. Hank was a hustler "from the word go," and tried to sell Frank on recording a song he wrote called, "This Love of Mine." He told Frank that if he recorded it, he would sell a million records. Frank said that he had already sold a million records, and he didn't need Hank to do it, but he read the lyrics and liked the song. Hank had written the song with his partner, Sol Parker.

"Okay. If I record this song, what songwriter credits are going to appear on the record label?"

"Sanicola and Parker," Hank said.

"No. It's going to be Sanicola, Parker, and Sinatra," Frank said.

If you take a look at the names of the composers of "This Love of Mine," you will see Frank's name. Frank had nothing to do with writing the song, but because Frank's name was included as one of the composers, he got a percentage of the royalties. A few other songs that Frank didn't write but got credit for writing were "Sheila," "Peach Tree Street," "Take My Love," and "I'm a Fool to Want You," which he recorded in 1951 while he was fighting to hold onto Ava. Frank learned early that being a good businessman was as important as being talented. After all, Frank had worked for Tommy Dorsey, and they didn't come any smarter than Tommy when it came to controlling the flow of money. Frank knew that any song he recorded would bring in a lot of money, and he wanted a share of the royalties.

Hank agreed to add Frank's name to the writing credits because he knew that with Frank singing "This Love of Mine," the song would become a hit. Without Frank, who knows what would have happened to the song. After they worked out a deal to share the royalties, Frank recorded the song and pushed it so it would be successful.

The night Frank sang "This Love of Mine" for the first time; Hank came up to our suite in the Hotel Astor. Frank was performing with Tommy Dorsey on the Astor Roof Garden. Hank didn't know if Frank would sing the song that night, but he brought the charts for all of Dorsey's band members just in case Frank gave him the go-ahead. In those days, the big bands were broadcast live across the country from various hotels and nightclubs. You could hear Glenn Miller live from the Glen Island Casino, Gene Krupa from the Steel Pier in Atlantic City, Ella Fitzgerald from the Savoy Ballroom, Jimmy Dorsey from the Café Rouge, Harry James from the Palladium, or Stan Kenton from the Meadowbrook. All night long, you could listen, right in your home, to this incredible live music coming from all across the country. If you didn't want to hear Xavier Cugat, all you had to do was turn the radio dial and get Count Basie or Duke Ellington.

As Frank and I waited backstage on the Astor Roof Garden, we talked to Buddy Rich, the drummer for the Dorsey band, Ziggy Elman, and the saxophone player, Don Lodice, who was a good friend of mine. Don was from Rhode Island and played behind Frank. Frank loved the way Don played. Don had a soft touch and never played loud, so Frank didn't have to strain his voice to be heard.

Frank had looked at "This Love of Mine," but he didn't have time to rehearse it or to learn the words, so Hank had the lyrics written on a big card. That night, Frank sang the song with the Dorsey band for the first time on live network radio. I stayed in front of the microphone where Frank stood, as people crowded around the bandstand behind me, waiting for Frank to sing. Frank had an incredible memory. When he saw the first two lines of a song, he'd instantly memorize them and look down at the next two lines. I faced Frank with my back to the audience holding up the big card on which Hank had written the lyrics, so Frank could read them.

No one knew what I was holding up. Frank looked down at me and began to sing "This love of mine . . . "

That was the night Hank Sanicola and I became good friends. After that, Hank started working as Frank's business manager, but in name only. Frank called the shots. If Hank booked Frank at a club without talking to him first, Frank would say, "Who told you to book me there? I don't want to work there."

If Ben Novack contacted Hank about Frank appearing at the Fontainebleau and said, "I want Frank here from March first to the twenty-fifth," Frank would say, "No, I only want to work five days." and that would be it. Hank had nothing to say about it.

Frank wanted no contracts. After his battles with Tommy Dorsey, Frank was careful about signing anything. All his booking arrangements were by word of mouth. When Frank said, "I'll be there," Frank would be there. Frank's word was gold unless he got ill or had another reason for not performing.

Frank would have Hank take care of things he didn't want to get involved in. Instead of Frank telling a club owner that he didn't want to play that club, he would have Hank tell the club owner that Frank was solidly booked and couldn't perform at such-and-such a time. If the club owner didn't like it, Hank was there to make him understand. Frank would give Hank the words to say, but it was Hank who made the phone calls.

Hank also had an interest in Barton Music, owned by Ben Barton, who had taken Hank in because of the popularity of "This Love of Mine." The Barton Music office was located on the sixth floor in the Brill Building at 1619 Broadway in New York. A classy restaurant called The Turf Club was located downstairs and about a block away was Jack Dempsey's Restaurant. Most music publishers had offices in the Brill Building. If you stopped in The Turf Club or Jack Dempsey's at lunchtime, you could run into songwriters and publishers having lunch. In the evening, a lot of sports figures and entertainers dined at Jack Dempsey's.

Because of his relationship with Hank, Frank got involved with Barton Music. When "This Love of Mine" became successful, Frank, Hank, and

Ben Barton made a lot of money. Later, Ben's daughter, Eileen, had a huge record with "If I Knew You Were Comin' I'd've Baked a Cake." Frank seldom went up to the office himself, so whenever someone wanted Frank to record a new song, the composer usually had to go through Barton Music.

I don't know how successful the publishing company was, or what Frank's interest was in royalties, but I know Frank was helping musicians. He gave Buddy Rich $25,000 to start a new band. Buddy, who had been Tommy Dorsey's drummer when Frank sang with the band, couldn't believe Frank would give him the money. He was so grateful, but, of course, with Buddy on the road, Frank could spend time with Buddy's wife, who had a serious thing for Frank.

There were three great drummers at that time: Gene Krupa, Buddy Rich, and Louie Bellson. Gene Krupa had energy and a huge following, and Buddy Rich had reflexes you wouldn't believe. Buddy had a thing for Lana Turner, but who didn't? Buddy bought a Lincoln Continental that was silver and gold just to impress her, but Lana couldn't have cared less—Frank told me. Buddy's attempt to start a new band didn't work out. He was an exceptional drummer, but he had a terrible temper. He'd fire a musician while on the bus because he didn't like a guy's beard. Buddy would tell the guy to shave it off, or get off the bus. There were times when a band member found himself standing in the dust, suitcase in hand, wondering what had just happened. Buddy was a great drummer, but he couldn't come close to Gene Krupa. Buddy said that himself. Frank's $25,000 couldn't keep Buddy's band together, and there was no one who wanted the band to succeed more than Frank unless it was Buddy's wife.

CHAPTER 10: HANK MUSCLES IN
AND GETS MUSCLED OUT

The reason Frank latched on to Hank Sanicola was because he was a rough, tough guy. Not very bright, but a very honest, loyal gorilla, and loyalty went a long way with Frank. Frank needed someone around to protect him from the crowds and to keep people out of the dressing room before and after he appeared on stage, and it wasn't going to be me. I was five foot six and weighed a hundred and forty pounds. I didn't like hurting people and liked even less the idea that someone was going to get hurt, especially if that someone was going to be me.

Back in 1943, when Frank was singing at the Paramount, he wanted to see a show at the Onyx Club, so Hank and I went with him. While we were sitting, two guys kept standing up in front of us and blocking our view of the show. After a few minutes, Frank got a little impatient and asked one of them, "Why don't you sit down so we can watch the show?"

One of the two bums said, "Maybe we would if someone else was behind us."

The other guy said something about Frank being a Dago wop, and Frank said, "You mother ass." But before Frank could throw a punch, Hank slugged one of the guys and knocked him out cold.

Fortunately, I always made a dry run of every place Frank went. For example, if Frank told me we were going to go to a certain club at night, I would go there during the afternoon when things were quiet and take a look around. I'd tell the club's manager I was with Sinatra, and that Frank was planning to come to the club.

I'd explain that because of the crowds that followed him, he liked to know how he could get out fast. The manager would tell me the best way out and who to see when we had to leave so the way would be clear. That helped me to know the best way out and where to park our car to avoid a crowd.

Frank never had to worry about getting out. I'd say, "Let's go," and led the way. I always made the dry run and always had a plan. Later, when I worked for Larry O'Brien, I did the same thing for him. That night at the Onyx Club, Frank, Hank, and I went into the kitchen and out the back door where our limousine was parked, then drove off.

The next day I picked up the *Daily Mirror* and showed it to Frank. The headline read:

SINATRA FLATTENS TWO AT THE ONYX CLUB

But Frank never threw a punch. Hank wasn't mentioned once, even though he was the guy who threw the punches. That was the kind of reporting that really angered Frank. Stories like that set the stage for Frank avoiding reporters altogether. If Frank said yes about something, a reporter would make a paragraph out of that yes. It really bothered him. The press blew up a lot of things about him because he was a star and that sold newspapers, so Frank did his best to keep the press at a distance.

In addition to their music holdings, Hank and Frank got into other businesses. They bought the Cal-Neva Lodge together, which bordered two states. When you swam across the pool, you started in California at one end and ended up in Nevada at the other end. It was over the Cal-Neva Lodge that Frank and Hank ended their friendship and their partnership in the early 1960s.

Sam Giancana, one of those guys with "crooked noses," showed up at the lodge as Hank's guest. Sam was there because his girlfriend, Phyllis McGuire—of the McGuire Sisters—was performing at Cal-Neva. Bobby Kennedy, the new attorney general in Jack Kennedy's administration, called Frank and told him that all undesirable characters had to go. This really upset Frank.

First of all, Frank loved and admired Jack Kennedy. But Frank didn't hide his feelings about Jack's brother Bobby.

"Look you little rat bastard, after I went through hell with your brother's campaign, getting him elected, you're doing this to me?"

"I have to follow the regulations on this . . . "

Frank didn't let Bobby finish. "Good, I'm no longer a Democrat."

And that broke Frank's friendships with Bobby and Hank. To end his relationship with Hank, Frank gave Hank total control of Barton Music, which by then was worth a few million dollars. Hank and Frank had been good friends just as long as their business dealings were split up equally. Those close to Frank knew that once you crossed him he might talk to you as though he liked you, but if you invited him out to dinner, he would never go. Over time, you would notice that you saw less and less of Frank, and that he had stopped calling. And that's what happened between Hank and Frank. I don't know why Frank was that way, but I know that Frank loved Cal-Neva, and it hurt him to have to give it up. He blamed Hank for some of the problems, and he also blamed Bobby Kennedy. After that deal, he didn't want to see either of them again.

Frank and Hank eventually sold Cal-Neva Lodge. Frank washed his hands of the property, even though it was a place Frank wanted to develop into an important club. Tina Sinatra, Frank's daughter, produced a movie about her father's life, which has a true-to-life scene with Frank and Hank. I'm driving the car while Frank is arguing with Hank in the back seat. Frank says, "Tony, stop the car and give Hank his bags." I stop the car, give Hank his bags, and we leave him in some small town near a railroad station. And that was the last time Frank had anything to do with Hank.

Working out the logistics of getting in and out of places was my job. I can't forget the times when Frank and I were living at the Waldorf-Astoria. Usually I called down to the front desk and asked whoever answered to find out from the doorman what was going on outside the hotel and if there were a lot of kids waiting for Frank.

If the manager told me there was a huge group of kids waiting for Frank at the Park Avenue entrance and it was a real mob scene, Frank and I

would go out the back door that led to the hotel garage. If there were kids there, we'd go to the exit with the smallest crowd, get into the limousine, and be at the Paramount in a few minutes.

No matter which exit we took, we ran into a wall of girls screaming and crying who wanted to touch Frank and get him to sign autograph books, photographs, or a piece of clothing. Frank didn't mind signing autographs, if it took a half hour or an hour, as long as he didn't have a show to do. But if there were thousands of fans causing problems, Frank didn't want to sign just a few autographs and hurt the rest of his fans. If a girl came on stage and gave Frank a rose, he would take the handkerchief out of his jacket pocket, give it to the girl, and put her flower on the piano. I always had two or three handkerchiefs on the piano in case another girl came on stage. But, surprisingly, the kids were very well behaved in the theater.

Once, when we were at the Waldorf-Astoria, Frank wanted to take a date to the Harwin Club and go by cab. He didn't want to be seen with this particular woman, so when a photographer got in front of the cab to take a picture, Frank said to the cabbie, "Run him over!" Did Frank really mean, "Run him over?" Maybe he did, or maybe he just wanted to scare the photographer so he would get out of the way and leave him alone. The photographer ended up on the ground with a broken camera, and the cab driver pulled away.

The next day the story was in the papers, and two detectives came to our suite at the Waldorf-Astoria, looking for Frank.

"Is Mr. Sinatra in?" one of them asked.

"No, who are you?" He showed me his badge from the New York Police Department. "He's not in."

"Well, get Sinatra out of his crib," the detective said, loud enough for Frank to hear, so Frank stayed in the bedroom. I told them again that Frank wasn't in, and I closed the door on them. When they left, Frank came out and said, "You were smart not to call me."

The detectives wanted to arrest Frank for knocking down the photographer. They tried to serve papers, but they never got to Frank and nothing ever happened. Frank couldn't let photographers near him, because one

picture was never enough. They always wanted more. And they were seldom polite always pushing against the limousine so none of us could get out. And when we finally did get out, they blocked the way to the club or to the hotel, dozens of them coming at us like locusts. Once you said yes to one, you were dead.

Frank was that way with the press throughout his career, even when Frank Jr. was kidnapped. That was in late 1963. Frank Jr. was playing at a club in Nevada. I only know what Frank told me, because I wasn't there. Two men went backstage, kidnapped him, and said they wanted $240,000 for Junior's safe return. Frank got involved right away and contacted two people: Bobby Kennedy and a mobster. Frank even delivered the ransom money himself. Then Frank waited for Junior's return with his ex-wife Nancy at her house in Beverly Hills.

When Junior was brought in, the first person he approached was his father. They hugged and kissed each other. The photographers wanted to have Frank, Nancy Sr., and Frank Jr. pose for pictures hugging each other. Frank didn't want any pictures taken, so he went out the back door where the limousine was waiting and left.

After Frank left, the press began asking Nancy questions about the kidnapping. She knew how to handle things. She said she didn't want to talk about anything and was just happy that Frank Jr. was safe. That was the end of the interview. But the press kept going back to Nancy's house and asking her what she thought should happen to the kidnappers.

Nancy said, "I don't want to talk about anything. I'm just happy I've got my son back in my arms," and she went back into the house. After that, when someone rang her doorbell, Nancy looked through a peep hole in the front door to see who was there before she answered. Gloria Lovell, in Frank's Beverly Hills office, screened all telephone calls to Nancy's house during and after their marriage. If someone wanted to talk to Nancy, they knew they would have to ask Gloria first if Nancy was available. Gloria would then call Nancy to see if she wanted to talk to that person. If calls were not screened, everyone would be after Nancy for interviews or loans, or to get information about how to contact Frank. No one had Nan-

cy's phone number except Frank and Gloria. That is how protective Frank was of his family.

A few days after the Harwin Club flap about running over a photographer, Frank and I had to leave New York and go to Florida. When we got off the airplane in Miami, there was a photographer at the bottom of the ramp wearing a catcher's mask, headgear, a chest protector, and shin guards. He had heard about what happened to the other photographer in New York, and he was ready for the same treatment. Instead of confronting the photographer, Frank walked back up the ramp, went back into the plane, and had the captain call security. Soon, a limousine drove up to the plane to get Frank and me, and the photographer was escorted back to the gate. The airport police rode alongside us all the way to the Fontainebleau to make sure no one bothered us. After that, Frank and I never went into an airport terminal. A limousine pulled onto the tarmac and picked us up.

On the planes, Frank and I always had the front seats so we could see who was coming in and going out. We were always the last ones to get on the plane, once everyone was seated, and the first ones to get off. That way, no one could ask him for his autograph or try to start a conversation. Frank and I were on a few flights where we experienced sudden 500-foot drops, but nothing close to crashing. Frank and Peter Lawford always checked the cloud ceiling before they booked a flight, and if the visibility and the ceiling were clear, they took the flight. If not, they waited until the weather cleared.

For a while, Frank flew on his own plane, rather than fly on commercial planes. He named it "The Dago." His plane had a piano, a bar, and a nice solid table bolted to the floor where people could play cards. The seats could be turned around and reclined in case someone wanted to catch some shuteye during a flight. Problem was, some of his friends and hangers-on wanted to use the plane or rent it, and Frank always found it hard to say no. Frank went along with that for a while, but it got to be a hassle. Rather than turn his friends down when they wanted to use his plane, he got rid of the plane. Frank was the kind of guy who would buy something, like a plane or a new yacht, and think of it as a toy. He would play with it for a while and

then get rid of it. Frank didn't like to hold onto things. Once he was tired of something, he moved onto something else. I guess you could say that about Frank and his women as well.

The early years of Frank's career were the toughest. He loved his fans and his strained relationship with the press hadn't yet begun. It was difficult to balance the constant crush of fans and the people who tried to take advantage of Frank's lack of an entourage to protect him, which started at the Paramount and continued after Frank decided to do what no other singer had done before—play long engagements at nightclubs like the Riobamba, the 500 Club, and the Meadowbrook. Frank had gotten tired of doing one-night stands and riding all night to the next city. We never slept right, and I didn't always know where we were. When we landed in a city, I sometimes had to call downstairs to the bell captain and ask what town we were in.

But Frank was different. He had a great mind and was very organized. He knew where everything was. If Frank wanted me to call somebody, he would tell me to call Jack so-and-so, in East Cupcake, Missouri, and he would give me the number. He didn't have to give me the area code, because area codes didn't exist then.

Without looking it up, Frank would say, "Dial this number," and I would get the person Frank wanted to talk to. Frank kept all the information he needed in his head. And remember, he also knew the lyrics to hundreds of songs by heart. Maybe it was because of his love for crossword puzzles and his habit of always looking things up in a dictionary. I don't know. But he had a phenomenal memory.

In the years that I spent with Frank, I never made notes, but thank the Lord I can remember the cities and places. Frank and I did so many one-nighters that we traveled all the time, and every stop began a new adventure. That's why I married late. Girls followed and surrounded Frank, and sometimes I'd get lucky.

Following the war, around 1947, everyone worked and inflation went wild, especially the price of meat. One particular day I was down in the dumps.

"What the hell is eating you?" Frank asked.

I told him I couldn't remember when I'd been with a woman. The more I moaned about it, the more Frank laughed. He really pissed me off.

"What's so damn funny?" I asked.

I'll never forget this. Frank put his arm around my shoulder and said, "Tony, everywhere the price of steak is going up every day, except for you. Your meat hasn't gone up in a month."

Okay, we had a good laugh, and I was tempted to say, "Yeah, Frank, but I don't pay broads a hundred dollars a night like you do." If I had said that, it would have been over. Frank could say what he wanted, but I had to be careful.

Another time, I told Frank about a woman I wanted to get close to, but I wasn't getting anywhere.

Frank said, "You want to win this girl? Do what I tell you. Send her eleven long stem roses. Not twelve. Send only eleven. And on the card you send with the roses you write: 'Roses are red, violets are blue, here are eleven roses, the twelfth rose is you.' Do that, Tony, and you'll never miss. A few days later follow up the flowers by sending a candy gram. Send a woman flowers, then a box of candy. It works every time."

In those days, you could send a box of candy through Western Union. I followed Frank's advice—it never missed. Of course, being Frank Sinatra's traveling companion might have had something to do with any success I had with women.

In every town we toured, I'd see a pretty girl, fall in love, and say to Frank, "Boy, I'm really in love with this girl."

Frank would say, "Good for you, Tony." He knew better.

When we got to the next town, I'd fall in love with someone else and forget the girl from the last town. This went on year in and year out until finally I met the real one: Mary, my wife. In 1974, before I married Mary, I invited her and some of her friends to see Frank perform at the Civic Center in Providence, Rhode Island. I brought the group backstage to meet Frank. When I told him, "There's one girl in that group I really love," Frank talked with Mary.

After a while, he said, "Tony, you've been around a long time with a lot of girls. This one is the right one."

Frank was right, because I'm still with Mary. I knew a lot of beautiful women, but I must say this: since I met Mary, no woman—as pretty as she might be, or whatever she might have—has ever turned my head. When Mary and I got married in 1977, I was in my fifties. It was my first marriage. As long as I was traveling with Frank, I had no reason to get married.

When I stood in front of the priest at our wedding instead of answering, "I do," I said, "I'm done."

The priest said, "You're supposed to say, 'I do.'"

I told the priest, "Believe me, I'm done."

CHAPTER 11: ENTER GEORGE EVANS

At some point, George Evans, a genius at promoting, came into the picture as Frank's publicity manager and took over before Frank was a big name. We would be booked to go to a city and before we got there, George would have large signs printed up and posted around that city: "Hollywood star coming to the railroad station tomorrow at ten o'clock, on track 29," which was not exactly true since Frank was not famous yet, and he hadn't come close to making a movie. The kids didn't know who was coming. When Frank got off the train, he walked into the middle of the crowd and waved. George Evans would have a photographer stand on a six-foot stepladder and take dozens of photos of Frank, surrounded by a thousand people. He would then blow up shots and use them for publicity with the words, "Sinatra mobbed by thousands." The truth was that all those people surrounding Frank were there to catch the train or to go home, or catch a glimpse of the non-existent Hollywood star. At that time, nobody knew who Frank was. It was George Evans who named Frank the Voice.

Here's how unknown Frank was in those days. One time Frank and I were playing at the State Theater, in Hartford, Connecticut. That was in November 1942, just two months after he left the Tommy Dorsey band, and about six weeks before Frank's major opening at the Paramount Theatre. In between the shows, Frank wanted to buy his mother a present. We walked through G. Fox & Co., which was a huge department store right in the center of Hartford. Frank still had his stage makeup on.

We walked through the store with hundreds of people milling around. Do you think anyone said, "Look, Sinatra's here"? Nobody knew who he was.

When we left the State Theater and went to the Paramount Theatre in New York, Frank starred on *Your Hit Parade* and became the biggest star anywhere. His photos appeared in all the papers, and his records sold like crazy. But two months before that, walking through downtown Hartford, nobody knew who Frank was.

Years later there were articles written about how George Evans hired girls to start screaming at the first Paramount concerts when Frank came on stage, to instigate other girls to swoon and scream. Hundreds—not just dozens—of girls swooned, screamed, and passed out, as ambulances waited in front of the theater. No one had seen teenage pandemonium like that before, and no one could have planned or arranged it. By then, Frank Sinatra hysteria had caught on. Believe me, it was real!

In 1948, George Evans became the press agent for Dean Martin and Jerry Lewis, and he made them into the most popular comedy team of the time. In a matter of months Dean and Jerry were doing radio shows, movies, and starring on the *Colgate Comedy Hour* on Sunday nights opposite Ed Sullivan's very popular TV show, *The Toast of The Town.*

In 1942, there was a musicians' strike by the American Federation of Musicians. When the musicians' strike started, companies knew they couldn't sign new talent. Jimmy Petrillo, the president of the American Federation of Musicians at that time, saw a trend that he thought was dangerous to professional musicians.

Instead of featuring live music, more and more radio stations were playing recorded music. Petrillo knew that if he didn't try to stop the trend, recorded music would take over the radio completely, and that would mean no more high-paying, late-night live remotes of bands coming from the Steel Pier, the Glen Island Casino, or the Savoy Ballroom.

Instead of paying musicians to play live, the radio stations hired the first wave of disk jockeys. Radio stations no longer had to pay a complete orchestra. Instead, they paid one person to spin records. That's why Petrillo called the musicians' strike. In the end, Petrillo was right. Recorded music would put a lot of musicians out of work. As more and more radio stations gradually moved from live to recorded music, big bands found it harder to

keep their musicians together. The end of World War II marked the end of the big dance bands and those live, all-night remotes.

With the strike still on and the ban on musicians still in effect, Manie Sachs dug into the Columbia Records' vault and found an old recording from 1940 that Frank had made during his time as a singer with Harry James. Manie was the boss and a smart man. He knew that Frank was hot, but without a record, he didn't know how long Frank's fame would last. So in 1943, Manie reissued "All or Nothing At All," and it became a hit. Manie knew then that he couldn't let months go by. He knew he had to keep the Frank Sinatra name going.

After "All or Nothing At All" became a hit, Manie still had a problem. The musicians' strike was still going on, so he recorded Frank with The Bobby Tucker Singers and the Ken Lane Singers without instruments to get around the ban on the use of musicians in the studio.

Here's another story: Frank made a record without Tommy Dorsey's band on Bluebird Records, a subsidiary of RCA and used Axel Stordahl as the arranger. Axel had worked with Frank in Tommy Dorsey's band and did most of Frank's arrangements while Frank was under contract at Columbia Records. Axel Stordahl was also the music director on *Your Hit Parade* during the years when Frank was the featured vocalist.

When Frank began his network television show in October 1950, Axel was Frank's musical arranger, just as he had been for most of Frank's radio shows. Frank's Bluebird record had "The Night We Called It A Day" on one side and "The Lamplighter's Serenade" on the other. I was so excited about the record that I stopped to buy a copy at Sam Goody's record store in New York on my way to Hoboken, where I was having dinner at Frank's parents' house. I walked in with the record, and Dolly asked what I was carrying. I respected her, so I never called her Dolly. At first, I called her Mrs. Sinatra, but then she told me to call her "Ma."

"Ma, I've got the first single Frank made on his own without the Tommy Dorsey band."

"How we gonna play it? By putting it on your fingernail and spinning it?" she asked.

"We'll put it on the record player."

She looked at me with the same unblinking stare she used when she was angry and said, "Who's got a record player? You tell that bum if he wants me to hear his record to buy me a record player."

When I went back to the Waldorf-Astoria, where Frank and I were living at the time, Frank asked what happened at his mother's. I told him the story about his mother telling me to spin the record on my fingernail, and he laughed like hell. A few minutes later, Frank got on the phone and had a record player sent to his mother.

Frank's next record was "Night and Day" and his last for RCA. Frank went with Manie Sachs to Columbia, where he had all the freedom he wanted. Manie understood that when Frank moved to Tommy Dorsey's band, he had to fit in with Tommy's established formula. Now Frank could experiment with songs and arrangements. Manie stayed in the background and organized the sessions, but it was Frank who selected the songs and the musicians. They worked well together.

When Manie left Columbia in 1950, Mitch Miller took over as the A&R (artist and repertoire) man. He had a different style than Manie. First of all, Manie loved Frank. Mitch saw Frank as just another pop singer—one who wasn't selling a lot of records at the time. Miller insisted on having control over the recording studio. He wanted to select the songs, make the arrangements, and pick the musicians—all the crucial elements that Manie Sachs had allowed Frank to control to express his artistic sensibilities. Suddenly, under Mitch Miller, the walls went up and Frank found out exactly who was the boss.

In the early 1950s, Manie, who had moved to RCA, tried to get Frank to come over to his new label, but it didn't work out. Frank still owed Columbia Records money from the advance Manie gave him to sign with his label. Manie was directly involved with Frank's recording career for only six or seven years, but they were pivotal years. After Manie left Columbia, and Frank had to deal with Mitch Miller, it was war all the time. But to give Mitch Miller his due, he brought Frankie Laine from Mercury Records and made him a major selling artist.

Of course, Frankie Laine had to sing "Mule Train" and "The Cry of the Wild Goose," but he became very successful. Miller developed other stars such as Rosemary Clooney, Tony Bennett, and Guy Mitchell. It seemed to me that Mitch Miller liked to have whistling in his songs, like "Heartaches By The Number," "The Yellow Rose of Texas," and "The Colonel Bogey March." He reached for the common denominator in popular music and found it. So although he wasn't successful with Frank, he was successful with other stars, eventually building Columbia Records into the most profitable recording company in the early 1950s.

Frank's parents were still convinced that he was making a mistake. Dolly was very involved with Frank, and she knew every move he made. If she didn't like his music or the people he hung around with—those men with "crooked noses"—she told him so. Dolly really didn't want Frank to become a singer. I don't think she believed he had the talent to pull it off. I know that every time I talked about Frank and his singing, both Dolly and Marty would get upset. If I mentioned anything about show business, they would change the subject. They thought that Frank was throwing away his life. The irony of ironies was that Dolly wanted Frank to become a newspaper reporter—the one group of people Frank learned to hate the most. Dolly always called him "that bum." She'd say, "Become anything but a singer." Frank did go to a business school for a while to please Dolly, but he knew that music was his life.

Frank's father, a fireman, was more or less the background guy. Later, he ran a tavern called Marty O'Brien's, the name he used during his brief career as an unsuccessful prizefighter. If Dolly said to Marty, "Don't talk," he didn't talk. I lived with them. I saw it all. Dolly got Marty his job with the fire department. She was a ward healer for the Democratic Party and had strong political connections with every elected official in Hoboken.

One thing I could never figure out was why, during the Great Depression, Dolly had a monkey when she lived in the tenement on 45 Monroe Street in Hoboken. Don't ask me how she got him. The monkey was closer to Dolly than he was to Marty, and no matter where Dolly went in the

house, the small, brown, dwarf monkey stayed on her shoulder—and it was beyond protective of Dolly. The monkey might have been nice and friendly when it came to how he felt about Dolly, but to everyone else it had the temperament of a crazed Tasmanian devil. When Dolly did housework or prepared dinner, the monkey was there—perched on her shoulder.

I don't remember if the monkey had a name or not, but it didn't matter because Dolly didn't have to call it; it was always with her. Whenever Marty tried to talk to Dolly or tried to go near her, the monkey took a swipe at him and tried to jump at him. This made Marty mad.

I was there one time when Marty said to Dolly, "We've got to get rid of this damn monkey, because I can't talk to you or nothing. He wants to eat me alive!" They always fought because of that monkey.

One Sunday afternoon I was having dinner with them, and Dolly left the table to get something. Marty whispered to me, "Whatever you do, don't talk because the damn monkey will think you're trying to harm Dolly. You can't talk and neither can I, so don't be mad if I don't talk to you." After he alerted me, we sat there like dummies.

Frank's uncle Vincent—we called him Jidoe—lived with Dolly and Marty. He worked in the Brooklyn Navy Yard, where he had once gotten Frank a job. I think Frank lasted three or four hours before he quit. Jidoe was having dinner with us, and we couldn't say anything, not even "Pass the potatoes," or reach for anything near Dolly without that mean-eyed monkey glaring at us, just waiting for the chance to take a swipe at one of us. We were operating under monkey alert. That monkey sat hunched on Dolly's shoulder, just waiting for one of us to reach for the potatoes. When I told Frank about the dinner, he laughed like hell.

"Frank, if there's something I want to tell your father, I can't speak unless your mother goes out of the room. Even if I look at your mother, the monkey starts getting upset."

"Why don't you tell her to get rid of the monkey?"

"Why don't *you* tell your mother to get rid of it?"

"Not me," he said. "I'm not going to tell her because I don't want her to jump at me."

Make no mistake about it. Frank was deathly afraid of his mother. Not his father, but his mother. She loved Frank, but if he did something she didn't like, she became hell on wheels. Frank didn't want to get on the wrong side of the monkey argument, so the monkey stayed, and Marty and Jidoe lived in terror.

Dolly was always after me to get things for her. She used to play the numbers, and one time she was in the hole for $1200. She wouldn't dare tell Frank and Marty, but she told me. To stay on her right side, I went down to Seaboard and got a loan. One day Dolly was telling me how hard it was to get silk stockings during the war, and I told her, "Ma, don't worry. When you need them, just tell me."

My brother's wife, Flora, worked at a store in New Haven called Kresge's. She had a connection at Lerner's, which was a clothing store that sold stockings and lingerie. They kept the silk stockings hidden in the back, because during World War II, you couldn't find silk stockings, and nylon for stockings hadn't been invented yet. Pantyhose you can forget about. Those wouldn't exist for thirty more years. I got her the stockings through Flora, who charged me only a $1.40 a pair, and brought them with me the next time I went to Hoboken. If you told somebody you had silk stockings, they'd shoot you to get them.

When Frank began making enough money, he bought Dolly and Marty a beautiful home in Fort Lee, New Jersey that was small, comfortable, and perfect for them. He hired a cleaning woman to take over the housework for Dolly, and, of course, he took care of them financially. By then, Marty had very bad asthma. He used a pipe that was hooked up to a machine that pumped oxygen into his lungs whenever he got out of breath. I couldn't understand the asthma thing, because I never saw either Marty or Dolly smoke. His condition kept getting worse as the asthma turned into emphysema. Frank sent him to Houston, Texas, where Dr. Michael DeBakey tried to help Marty, but it was too late. I wasn't with Frank when his father died in 1969, but I heard that Frank never left his father's side during the last few days of his life.

Frank and Marty had spent their lives dominated by Dolly, and because of that, Frank and Marty were never very close while Frank was growing

up. Everything had to be what Dolly wanted. However, when Marty was slowly dying from emphysema, Frank and Marty had time to be together and they became very close. Marty seldom took an interest in what Frank was doing. He believed that Frank was ruining his life because he was pursuing a singing career. Marty wanted Frank to keep that job in the Brooklyn Navy Yard, have a family, and live near his parents.

Neither Dolly nor Marty liked the idea of Frank being on the road, especially after he married Nancy. They wanted him to find work somewhere around town. Frank had worked at a newspaper to become a reporter, but then he got a job as a singing waiter at the Rustic Cabin and that changed everything. His parents never gave Frank any encouragement, but somehow Frank believed in himself, so he stayed with the music. I hate to think what Frank's life would have been like if he had stayed in Hoboken. Marty rarely came to one of Frank's performances, even when Frank started to really make it big, had records out, and was making thousands of dollars a week. No matter what, he thought Frank was making a big mistake. On the other hand, Dolly would come to the Paramount once in a while. But Marty and Dolly never came to a place like the Copacabana. They weren't the kind of people that spent time in a nightclub.

Some Sinatra biographers who weren't there say that Marty was a boxer. In New Haven, we had a place on Court Street known as the Music Hall that had boxing matches. Marty came up to New Haven and had one fight. He stumbled around the ring, swinging at the air as though his gloves were filled with helium. If Marty had stayed in boxing, he would have spent more time on canvases than Picasso. He wisely packed it in, and that was the end of that deal.

I was like another son to Marty and Dolly. When I went to visit, Dolly would ask, "How's the bum?" referring to Frank. I was still a young kid and I thought she really was mad at Frank. Tears would come down my face.

Then Marty would kick me under the table and say, "She's only teasing you."

Dolly adored Frank. If anyone said anything bad about Frank, she would get furious. As his mother, she believed she was the only person

who had the right to say anything against her son—her only child. Believe me, every time Frank made a move, Dolly made sure she knew what was going on. She was the boss.

Dolly was heavily into Hoboken politics. When she went out campaigning for the Democrats in her ward, she carried a rolling pin and shook it when she talked to people. "If you don't do what I tell you, you know what this is for."

That's the kind of woman she was—tough. Believe me, she was tough! It was because of Dolly's influence that Frank was a Democrat in his early years.

Franklin Delano Roosevelt invited Frank to the White House in 1943, and Frank had the president's wife, Eleanor Roosevelt, on his radio shows and on his television show. Frank campaigned for John F. Kennedy's run for the presidency in 1960, but there were some disagreements, especially with Bobby Kennedy. Like I said before, because of Bobby, Frank swore he would become Republican, which he did, and in the 1980s, he became a strong supporter of his long-time friend, Ronald Reagan.

Without Dolly's early involvement in politics, Frank wouldn't have gotten involved. Dolly was the main influence throughout Frank's life. Then Dolly died tragically in that terrible plane crash. That was in January 1977. Dolly had moved to Palm Springs after Marty died, maybe in 1969, to be near Frank's home. Frank was performing in Vegas, at Caesars Palace, and he sent a limousine to take Dolly from Palm Springs to Las Vegas, so she could spend some time with Frank and take in a few shows. Dolly decided not to take the limo because it was a long drive. Instead, she took a plane, and the plane never made it. It hit the top of the San Gorgonio Mountains. The ceiling was so bad that the pilot probably never saw the mountain.

The mountain was covered with deep snow, making the task difficult for search parties. His mother meant the world to Frank, and he never got over her sudden death. She was someone Frank both loved and feared all his life. She was buried in Palm Springs, next to Marty, who was originally buried in New Jersey. At Dolly's request, Marty had been dug up, flown to Palm Springs, and buried next to her.

CHAPTER 12: OFF THE ROAD

Right up until 1944, Frank was doing a lot of one-nighters that were wearing him out. That's when Frank decided to play clubs and hotels like the Fontainebleau and the Wedgwood Room in the Waldorf-Astoria. These were places where he could play for at least a week at a time without being on the road. Frank had plenty of one-nighters when he was with Harry James and Tommy Dorsey. With Tommy Dorsey, it was buses every night after doing a show. They would finish the gig and travel to the next theater. Frank would sleep and eat on the bus, inhaling the fumes. I didn't ride on the buses when Frank was with Tommy. I wasn't a part of the Tommy Dorsey organization, but if I knew where Frank was going to be singing—either in Hartford, Boston, or Philadelphia—I'd drive up to the theater on my own to help Frank out.

I spent more time with Frank than any other human being. I knew his schedule, and I knew his moods.

His mother said, "I put Frank on this earth, but you know him better than I do."

The truth is, she was right. I could tell a lot about Frank by the way he got up in the morning—or rather the afternoon—as Frank was a man who tended to get up around 4:30 p.m. I would watch the way he walked out of the bedroom and if I didn't like it, I'd say, "Frank, I'll be right back."

His walk told a story. Maybe something had happened in the night. If it was during his marriage to Ava Gardner, maybe Frank had endured another fight with her on the phone. I couldn't really know because my room was on the other side of the house; but when Frank came out of his bed-

room I could tell just by his walk if we were going to have a good day or bad day. If I saw that Frank was unhappy, I wouldn't say, "Frank, what's wrong?" I simply never asked.

Frank would always say, "Tony, if I want you to know something, I'll tell you. Don't ask." And I would go along with him.

I had been around Frank since we were teenagers, so I knew what Frank liked and what he didn't like. If Frank was on the phone and I needed to get something from his bedroom, I wouldn't go in. I always waited until Frank finished talking.

I had a system worked out for the days that Frank got up in a bad mood. I'd go downstairs to the hotel lobby and get the newspapers and the mail. Then I waited a few minutes until he calmed down before I went back upstairs to give him the newspapers. The mail was my job. If there were telegrams, Frank wanted them right off the bat. Any mail he didn't want to look at went in a large manila envelope that we mailed to Gloria Lovell, his secretary in California. She handled the leftovers. In the end, Dolly was right; I did know Frank better than anyone did.

I often asked Frank what he wanted for breakfast, and if he didn't answer, I waited because I knew he wasn't ready to face the day. When he felt better Frank would say, "Tony, get me two scrambled eggs, dry rye toast, and a cup of tea." I would call room service and have it delivered. When the waiter brought the food, instead of letting him bring the serving table into our suite, I signed the check in the hall and rolled the table into our living room. That's how Frank wanted it. The fewer people he had to deal with when he got up, the better. I would take the cover off the scrambled eggs to make sure they were cooked right.

While Frank ate breakfast, I restocked the bar and made sure there was enough ice. I made Frank's life as easy as I could. If a visitor came to our suite, I always stayed behind the bar or near the piano. I made sure to stay far enough away so Frank and his visitor could talk in private, but close enough so that if Frank needed something, he didn't have to chase around for it. If I noticed that Frank was whispering, I excused myself and headed into my room. If Frank didn't want me to go to my room he would say, "I

want you to stay here." It was better to disappear when Frank wanted to talk about something that was none of my business. I didn't want to hear it anyway. I knew when to be around and when to get lost. Frank never had to say, "Tony, what are you hanging around for? Can't you see we're having a conversation?" He never had to do that because I knew Frank. I knew his moods, and I knew how to react to them.

Frank was very passionate about everything he did, especially his music. He made sure that each record was exactly right. Frank chose the songs, selected which musicians he wanted for the sessions, and except for a brief time at the end of his contract at Columbia Records, Frank chose his arrangers. Frank compressed more great records, more living, and more fun, into one life than anyone I can think of. All he wanted to do was perform, party with friends, talk about music, and tell jokes. That was Frank's style. He would stay up late and spend the entire next day making up for it. He would go to bed early in the morning, sleep until late in the afternoon, then get up, eat breakfast, read the paper, and perform two shows that night. When Frank got through performing at one thirty in the morning, the party would start again. That's how it was, day in and day out.

Life with Frank wasn't always perfect. Once, Frank got really angry with me, and the funny part was that it really had nothing to do with me at all. He might have been angry because he had just talked with Ava, or later with Lauren Bacall. Usually that was enough to set him off. Frank never wanted to talk about what was on his mind. He kept everything inside. Honestly, I never did find out what the problem was that particular time. Frank never carried his troubles to Dolly, to Nancy, or to me. On this occasion Frank was yelling and screaming so much that I finally went into my room and started packing my bags. About a half hour later, he came into my room and wanted to know what I was doing.

"Frank, I'm packing."

"Tony, you're not really mad, are you?"

"Well, Frank, I feel bad, especially because I haven't done a thing and I got screamed at."

Frank sat on the bed next to my suitcase and said, "To be truthful with

you Tony, if I can't blow my steam off with my best friend, who am I going to do it with?"

I realized in that moment that whatever Frank might say, I couldn't let it faze me, because I knew he didn't mean it. He had to blow off steam. This became especially true when Frank started to fall in love with Ava Gardner in the late 1940s.

Around this time, during the late 1940s and early 1950s, many things were going on in Frank's life and just as many things were going wrong. His records weren't selling well, and movie roles were very thin. Frank did a movie called *The Kissing Bandit,* and at the premiere he turned to me and said, "I think only my relatives are going to see this one." He began having issues with his voice, and he was dealing with the fallout over his romance with Ava. His booking agency, MCA, released him. After that, MGM released him from his movie contract. Believe me, it was a difficult time. Yet through it all, Frank kept working. While the money was there, he had people hanging around him, but as things began to fall apart, some of these same friends took off.

Frank took smaller club dates. Things were changing, and the biggest change of all was that World War II was over, and the screaming bobbysoxers were gone. They had grown up, gotten married, and had children. Frank had very few close friends who stuck with him through the changes but, as always, those who cared about him—Hank, Nancy Sr., Dolly, Marty, and I—were always there. Of course, Ava was in love with Frank, but she wasn't always his friend.

People often talk about Frank not serving in World War II, but fighting a war would have been easier to handle than fighting with Ava Gardner. It was a rare occasion when Frank and Ava were at peace. When they fought—and some of their fights were very public—you didn't want to accidentally get between them. Large objects would fly around the hotel suite and if you got in the way, well, that was your problem.

Ava was gorgeous. Wherever she went, heads turned. Some might say she was a Hershey bar with the nuts in all the right places. Even Dolly, who realized that Ava Gardner would eventually break up Frank's mar-

riage to Nancy, seemed to like Ava. In fact, they got along very well. Ava was a lot like Dolly. They both always said exactly what was on their minds, and Dolly liked that. When Ava called Dolly, their conversations would go like this:

"You know what that son of a bitch of yours did. He's been banging some other broad."

"Well, I agree with you. That bum is no good."

The language exchanged between these two women was unbelievable. They could out-swear each other and then invent new words and contexts that would embarrass Lenny Bruce. These were not quiet, polite conversations that occurred between Ava and Dolly. I was always nearby and could hear everything. They talked so loudly that even if you were next door you couldn't avoid hearing.

Ava and Frank were too much alike to ever survive together. I know. I lived with them at the St. Moritz on Central Park South. Let me put it this way: if Frank and Ava argued and Frank threw a cup at Ava, Ava threw something bigger at him. If she threw a book, Frank threw a chair. Flying objects would get bigger and bigger and bigger. There was no stopping it. They both had violent tempers, but Ava's was stronger than Frank's. The only way to stop it was through distance. Someone had to move away or something really lethal was going to happen. That's how bad it was.

Frank and I were in Miami when Chief Fox, head of the Miami Beach Police Department, gave Frank a small nickel-plated, pearl-handled, snub-nosed handgun that could fit in a suit pocket. I don't know why he gave it to him because Frank had no interest in guns, but that was the gun Frank used when he decided to scare Ava. It happened at the Hampshire House. Frank and Ava were having another of their many fights when Frank went into the bedroom, took out the gun, and fired it. I think he must have fired the gun into a pillow or toward the floor, because when I went in, there wasn't a hole in the wall or any place visible. I was just happy that there wasn't a hole in Frank. Ava immediately thought Frank had shot himself. Luckily, that would never have happened.

Frank and Ava always did things to anger each other. Ava looked at

other men to make Frank jealous, and Frank responded by looking at other women. Eventually it went beyond just looking. One time at the St. Moritz, Ava got so mad she threw her wedding ring out the window during one of their knockdown, drag-out battles. What did I do? I got out of the way and went to my bedroom. Early on, I tried to talk to them, tried to reason with them, but as soon as the barrage of words turned into a barrage of flying objects, I was gone. Scenes like this often included coffee cups, whiskey glasses, and books flying across the room, as well as the usual slaps, recriminations, and insults. The result was broken chairs, a coffee table tilting on a broken leg, and then finally hugs, apologies and kisses. After this particular fight was over, Frank came into my room.

"Tony, you have a problem."

"Frank, why do I have a problem?"

"Tony, Ava threw her wedding ring out the window and she feels bad. I'm going to stay with her to make her feel better, and I need you to try to find the ring. Jeez, the thing cost me $10,000."

"Okay, Frank. I know what it means. But, Frank, we're fourteen stories up and it's four in the morning in New York." I said.

What were the odds of finding it? With Frank, the odds for everything were fifty-fifty. Either it would happen or it wouldn't.

Frank said, "Just find it."

Frank went back to making Ava feel better, if you know what I mean, and I went downstairs and got a flashlight from the doorman. I searched around, starting from the gutter. I looked up at fourteen stories of Hampshire House and tried to figure which way the ring might have bounced and rolled—that is, if a bum hadn't come along and picked it up. I crawled around on my hands and knees, wondering why I was looking for something I didn't lose and hoping some cop didn't come by and ask why I was crawling around at four in the morning.

I knew if I didn't find the ring, I'd have to face Frank just after he and Ava made up. If I didn't find the ring, they would start in again and who knows what would go sailing out the window next. After about an hour and a half, the sky got lighter and I got lucky. I spotted the ring by

the fire hydrant. I couldn't believe I had found it. It must have hit the hydrant and stopped. I returned the flashlight to the doorman and gave him a C-note for a tip. I went back to our suite. Frank was through making Ava feel better. I handed Frank the ring. All he said was, "Great," and I went back to my room. Frank didn't give out rewards or bouquets, so I never waited for Frank to pat me on the head. He knew he didn't have to praise me every time I did something. I was just doing my job.

I knew for sure that Frank would never try to kill himself. The story about Frank taking an overdose of pills at the Cal-Neva could never have come to anything fatal. Frank hated taking pills, he hated being around doctors, and he hated going to hospitals. When it came to medication, Frank was a stickler. Even when he was having headaches, Frank never took an aspirin. The only time Frank took pills was when Dr. Burke, the house doctor at the Fontainebleau, told him to take a few cold pills so he could perform well. Before he took the pills, Frank always wanted to know what possible reactions he could have. He was concerned that a medicine might interfere with his performance, and he didn't want to open himself up to the slightest possibility of a problem on stage. I was with him for years, and he never trusted medicine.

Both of Frank's phony suicide attempts came at low points in his personal life and musical career. Believe me, Frank never put himself at risk. He was, however, after attention. He wanted to make Ava come running to him, care for him, and find a way to not fight with her all the time. In all the years I spent with Frank, I believe his one insecurity was named Ava.

CHAPTER 13: FRANK AT THE MOVIES

Frank signed with RKO Pictures in 1943 to make his first movie, *Higher and Higher*. At that point, Frank and I went to Hollywood. I'm an extra in five movies with him: *The Joker Is Wild, Pal Joey, Robin and the 7 Hoods, Ocean's Eleven,* and *Some Came Running.* I'm also in a movie with Peter Lawford and Bette Davis called *Dead Ringer.* I drive the death car, but I don't have any lines. I drop Peter Lawford off at the house where he's going to murder Bette Davis's twin sister. I didn't belong to the Screen Actor's Guild, so they didn't allow me to talk. I was also in *Advise & Consent*, where I played a member of the jury. We made *Some Came Running* in Madison, Indiana. That was the first time Frank and Shirley MacLaine worked together in a movie, and that's how they got to be good friends. Any time he had a show closing or a party, Frank made sure that Shirley was there. She was a wild, joyous presence. That was before she discovered this was only her latest life.

In *Some Came Running,* all I had was one stinking part. I go to a game of chance stand in an amusement park, and I win a pillow by throwing nickels and dimes. I walk toward the Ferris wheel as someone shoots Shirley MacLaine. She falls off the Ferris wheel and is lying on the ground. I run toward Shirley and, according to the script, I'm supposed to take a pillow and put it under her head while she's dying. As chance would have it, Frank was up to his old tricks. During one shoot, Frank had someone hide the pillow. I couldn't believe it. I couldn't find the pillow so I ran up to Shirley, leaned over, and whispered to her, while trying not to move my lips.

"Pretend my jacket is the pillow."

While she's supposed to be dying she asks, "Where's the fucking pillow?"

"I can't find it. Frank took it." She almost lost it. I leaned over her until she stopped laughing, then I put her head back on the ground, so she could die.

After we finished filming *Some Came Running*, we went back to the house that the studio rented for us, and Frank started to shoot fireworks off to celebrate the end of a job. After a few hours of fireworks and drinking on the front lawn, the cops showed up. I didn't notice it, but most of the people went back into the house.

One of the cops came up to me and said, "You all stop or we're going to pinch yous."

When the cops left, the cast members and Frank came out of the house and the party started up again. After a while, the same police car came back.

"Frank, I hear the sirens," I said. "Put the bags in the back of the limousine. The bags are already packed."

Frank, Shirley, Dean, and Hank got in the limousine and took off. I was the only one left, so the cops pinched me. Hank eventually came back to the house to look for me. When he couldn't find me, he asked around and found out that I had been arrested for disturbing the peace. I wasn't part of the noise, but when the police got to the house, I was the only one there, so they had to do something. At the police station, Hank paid five hundred dollars and the charges were dropped. The cops were happy with the money, and Hank and I left the jail on good terms with everyone.

It wasn't unusual for me to take the heat for Frank. If he wanted to get rid of someone, he had me take care of it. If he wanted to dump some doll, he would have me break the news to her. Most of the time, Frank would give me a ring or some other piece of jewelry to give the girl to ease the anger. What did it matter to Frank? He had thousands of dollars in jewelry. Giving away a bauble was a fair enough price to pay for getting rid of someone.

Shirley became part of the Vegas crowd that included Judy Garland, Ernie Kovacs, Edie Adams, Peter Lawford, and Dean and Jeanne Martin. Shirley and Frank were the best of friends, but they did have a falling-out. Frank didn't like what she wrote about him in one of her books, and he made it a point to tell her. "It's amazing what a broad will say to make a buck," he told me.

Frank liked people to be loyal, and once someone started telling stories that he thought were too personal, he would get quiet and move away. Until then, Frank and Shirley cared about each other the way a sister and brother would. He would never bang her because he thought she talked too much. And boy, could Shirley swear. You never knew what she was going to say next, and Frank liked that about her.

There were some very important people connected to Frank's acting career and, of course, that included Ava. When Frank was down in the late 1940s and early 1950s, it was Ava who talked Harry Cohn at Columbia Studios into giving Frank his role as Maggio in *From Here To Eternity,* a movie about World War II that came out a few years after the war in 1953. Without Ava, it never would have happened for him. Even with all their fights, there was never a more romantic and passionate relationship than the one between Ava and Frank. Even if you were to go back, recount his true loves, and put them all together, you would find that his one real passion was always Ava Gardner. I don't care what anyone says, if you could open up his heart, it would say, "I love Ava." That was it. The lengths he went to for Ava, he wouldn't have gone to for anyone else. He chased her all over the world just to bring her a $10,000 necklace. He neglected concerts to meet up with Ava, and paid a big price for loving her.

A lot of Frank's loyal fans were pissed off when Frank, the family man and all-around good guy, left Nancy. They saw her as a great wife who had worked hard and encouraged Frank every step of the way. After that, the Catholic Church began to condemn his movies. On top of everything, he had a problem with his recording career, which was being orchestrated by Mitch Miller. In the end, Frank didn't care about anything other than Ava. Frank didn't just sing "All or Nothing At All." He lived it.

People came in and went out of Frank's life over the years. Lauren Bacall and her husband, Humphrey Bogart, had been Frank's friends for years. They were part of a circle known as the original Rat Pack made up of Hollywood stars. This was long before Frank, Dean, Peter, and Sammy became known as the Rat Pack. Frank would often go to Bogart's house. They were great drinking buddies, and it was Bogart who essentially taught Frank how to act. Bogart wasn't a teacher, but he gave Frank little tips. When Frank had a question about acting, he would go see Bogart or call him up.

Once, Frank and I went to Bogart's house and the conversation got around to movies. Bogart was a pro, but Frank was just starting out, so Bogart gave him some advice.

"Look, when you get a script, if you don't like it, send it back. Forget about the money or hurting someone's feelings. If you don't believe in it, don't bother with it. Send it back. If you know you can do it, remember to be yourself. Be natural. Don't try to fake it. You'll never make it. If you want to laugh, laugh. If you don't feel like laughing, don't laugh."

Frank loved and respected Bogart, and he was the reason Frank was so dedicated to his acting. He didn't want to do something in a movie that would embarrass him in Bogart's eyes. Frank was so dedicated to Bogart that he wanted to take care of Lauren Bacall, Bogart's widow, when Bogart died.

Gene Kelly was another important person to Frank. Gene worked with Frank to teach him how to dance in *Anchors Aweigh* and *On the Town*. Gene and Frank would stay up all night working on various routines.

Frank had never danced a step in his life, and suddenly he was in a major film with one of the greatest dancers in film history. Gene was a selfless, patient teacher, and Frank turned out to be a gifted dancer. Gene and Frank made three or four movies together and became life-long friends. You can see the enjoyment on their faces and in the way they worked together.

Frank and I never went to Gene's house for dinner, because Gene and Frank didn't travel in the same social circles. Gene was never an all-

night-party type, and he didn't care to drink. However, Frank and Gene stayed very close throughout their lives. If Frank was going to do a TV special, he made sure he contacted Gene. Overall, Frank had a lot of people working with him who cared about him. When Frank had a question about acting, he asked Bogart. When he needed ideas about dancing, he asked Gene. When Frank wanted to learn how to tell funny stories, he listened to Dean and Joe E. Lewis. Dean had little jokes that were out of this world. Where he got them, I still don't know.

In 1949, there was a premiere for *On the Town* starring Frank, Gene Kelly, and Ann Miller. Talk about great dancing. It's a film about three sailors on a twenty-four-hour leave in New York. That's the movie to see if you want to know what New York City looked like in 1949. It has terrific shots of the Empire State Building, Battery Park, and Coney Island. It also has great songs written by Betty Comden and Adolph Green.

Frank and I went to the premiere together. You had to be invited to see the screening of the movie, which kept the theater from being flooded with bobby-soxers. Ava Gardner was there with her sister. Frank put Ava's sister next to me. What a difference between Ava and her sister. One was beautiful, and the other . . . well, let's just say that if she went to the Bronx Zoo, all the animals would hide.

Before filming of *On the Town* started, the producers and directors didn't see Frank as an actor. That would come later on. They were interested in Frank only as a singer, so every movie had to have two or three songs. The producers knew that as long as Frank sang, the bobby-soxers would come to the movie and make it a success.

Frank never had acting, dance, or voice lessons, so don't let anyone ever bullshit you into thinking that Frank was a trained vocalist. He learned everything he knew about music on his own. I'm happy about that because what you hear as a result is Frank's natural voice. Frank's parents didn't own a phonograph when Frank was growing up, so he never played records or sang along with other singers. He was just gifted with that voice. Still, if it weren't for the war, Frank would never have made it.

If Jack Leonard had not left the Dorsey band, Tommy wouldn't have

needed a male vocalist who could fill the open spot. Tommy picked Frank as soon as he heard him sing "All or Nothing At All" with the Harry James Orchestra, and the rest is history. Right off the bat, Tommy had Frank record "I'll Never Smile Again" with the Pied Pipers backing him up. It became a huge hit. Soon after that, Frank had another hit with Hoagy Carmichael's "Star Dust." Everybody in the music business was recording "Star Dust," but it was Frank who made it his own and shot it to fame. Keep in mind that most male singers at that time had been drafted. The world was marching to war, and there was a genuine fear that we might lose. Hitler had taken over most of Eastern Europe in only four short years. German forces already occupied France. England was under constant air raids, and London was going up in smoke. By December 7, 1941, the Japanese Air Force had bombed Pearl Harbor and killed more than seventeen hundred Americans. There was a lingering fear that one day we'd all wake up speaking German or Japanese.

Frank provided an escape from all the fear. He was a diversion from everything pertaining to the war. Bobby-soxers fell all over Frank because he was skinny, and looked like he needed to be fed and cared for. He had dark, bushy hair and wore bow ties. And he had a great voice that appealed to them.

When Frank sang, he took their minds off the war and their husbands, sons, and brothers who were serving in Italy, Iwo Jima, Bataan, Africa, and France. Of course, it is well known that Frank's forte was love songs such as "This Love of Mine," "All or Nothing At All," and "Everything Happens To Me." These were all sentimental songs, and that's exactly what the public wanted to hear during those early war-torn years. Frank had been married just a few years and had a young daughter named Nancy that he loved to talk about on stage. He captured the bobby-soxers' hearts when he said things like, "I hope the boys come back home soon, because I miss them as much as you."

When Frank said things like that, he made the fans with loved ones fighting in the war feel that Frank was connected to them. He gave them the impression that he was sharing in their emotions. Frank would sing a

popular song at the time called "There'll be A Hot Time In The Town of Berlin When The Yanks Go Marching In." Frank would tell his audience that the song was for the boys fighting the war. Frank was always looking for what the public wanted to hear.

Don't think that Frank didn't take plenty of heat for not being in the service. He looked young and healthy, but what could he do? He had a punctured eardrum, and the army didn't want him. That's why Frank worked so hard during the war to raise money for war bonds and to visit wounded GIs in various army hospitals. At one point, Frank gave a benefit performance at Hunter College in New York for the Women's Army Corps (WAC). Then immediately after, Frank got into his limousine and went off to do another benefit. Sometimes Frank would do two or three benefits a day. Frank was constantly booked, and the poor guy didn't know if he was coming or going. However, in many ways, it worked to Frank's benefit, because he was out trying to capture all the publicity he could get. Sometimes Frank didn't take me along because Hank and Ben Barton would be with him. When Frank got to a hospital or to a war bond drive, he was usually already dressed and the music was there, so he didn't really need me.

Frank did everything he could for the GIs because he knew what they were up against. The truth was, many of them would never come back. I know Frank didn't feel good about being rejected by the army, so he figured he could support the troops the best way he knew how. So Frank went to Europe with Phil Silvers and other performers and traveled from camp to camp, entertaining troops. Phil Silvers co-wrote one of Frank's favorite songs, "Nancy (with the Laughing Face)," a song written for his daughter Nancy's seventh birthday. Phil Silvers had a great nightclub act and eventually had a hit television show called *You'll Never Get Rich.*

Frank and Phil went on the USO tour late in the war. I didn't go overseas. At that time, you had to get various vaccinations to protect you from malaria and other diseases. I honestly didn't want to get stuck with a bunch of needles. To this day, I still hate needles.

Frank said, "As long as you don't want to take the shots, you stay behind."

While Phil and Frank were in Italy, Frank adopted six war orphans. He took care of them from the time they were infants until they finished their education. He paid for absolutely everything. Frank and Phil toured several countries and then returned home. After that, Frank took off for Greenland to entertain troops. For his fans in other countries, these benefit concerts were incredible, but for his critics in the press, they were never enough. Crowds came running when sponsors of war bond drives announced that Frank Sinatra would perform. A piano player or a three-piece band would back Frank up, and he would sing two or three songs. People would buy bonds, and Frank would leave for his next commitment. I normally didn't have to be there because by then we had a limousine. Frank wanted Bob, our driver, available twenty-four hours a day. Bob parked the limo outside the Waldorf-Astoria and waited with a phone. When we needed him, we'd call from the hotel and tell him to get the limo ready. Sometimes Bob waited eight or nine hours and even slept in the limousine, but Frank paid him as though he were driving him around all day. When Frank needed to go somewhere, he didn't have to wait for a cab. The guy was there and ready, exactly the way Frank liked it. It was an important service for Frank and worth the investment.

When Frank made *The Man with the Golden Arm* in 1955, I was on set, just as I always was. It was a movie based on Nelson Algren's novel about a heroin addict. Frank was nominated for an Oscar as best actor. I wasn't in that movie, but before Frank left the house I always had to put drops in his eyes so that by the time he got to the studio, he looked like the dope addict that he had to portray. I drove him to the studio every day.

We were on the set of one of Frank's films in 1956 when I got a phone call that Tommy Dorsey had died. The news really broke Frank up. Some people have written that Tommy took advantage of Frank's lifetime contract. Ultimately, Frank loved the man and respected him, which was definitely not always the case with Frank. Tommy gave Frank the biggest break of his life and Frank never forgot that.

When Frank got the news that Tommy had died choking on a piece of steak, he quit filming for an entire day. He stayed quiet and went off to be

by himself for hours. A similar tragedy happened in 1957 when we were on the set of *The Joker Is Wild*—the biography of the nightclub comedian Joe E. Lewis, who happened to be a very close friend of Frank's. The movie was shot in Hollywood, because I remember going to the commissary one afternoon and buying the paper. There on the front page, just below the fold was the headline,

AVA FLIES TO MEXICO TO DIVORCE FRANK

Can you imagine how that went over? Frank is working on a movie, he's got a lot of things on his mind, and I'm the guy who has to give him the bad news. I couldn't let him hear it from anyone else or on the radio.

When Frank came off the set, I took him aside.

"I don't know if you're going to want to continue to work the rest of the day or not."

"What's the problem?"

"When you read the article I just read, you might want to call it a day." With that, I showed him the paper. Frank read the article.

"Tony, you're right. Forget it. I'm not working."

That was it for him.

Frank told me to tell Charles Vidor, the director, he wasn't feeling well and was going home. When we got home, I made Frank some tea and gave him some of the Italian cookies that he loved to dunk. Then he went to bed. He stretched out with his shoes on, put his hands behind his head, and gazed at the ceiling. When he was like that, I never said a word to him until he said something first.

Ava was the only woman Frank would chase around the world. The problem was that they were both too passionate and too strong-willed to make it work. Their emotions, especially jealousy, were most often the controlling force between them. They kept in touch years after the divorce, once Ava gave up the movies. Ava died in her apartment in London with a photo of Frank next to her bed. I'm certain that when Frank passed away, Ava was still the main love in his heart.

When Frank was filming *Johnny Concho* and *The Kissing Bandit*, he had to be at the studio at seven in the morning. Frank hated to do movies like these because the story lines didn't exist. The studio made them to promote Frank as the star to guarantee the movie a large fan base. Frank later became more serious about making movies and also became more selective. If the script didn't intrigue Frank, he sent it back. Early on, the rules were different; Frank was under contract to MGM, and what Sam Goldwyn said went or Frank was out.

When Frank went to Hollywood to make movies, he was the one who forced the studios to have better hours. He told me how he wanted things to work.

"Look, no way! We've got to change the working hours around. I'm going to bed at six in the morning, and they want me to make movies at seven in the morning."

Frank went directly to the studio and talked with the producer. "If you want me to make movies, we are going to start at twelve noon and go until eight at night, or let's forget it."

And that's when they began shooting later. All the other stars loved the idea because they were now able to stay out until all hours of the night, then sleep in late to nurse their hangovers. Frank never had a meal during the hours he was on set making a movie. He would eat a Hershey bar and drink a bottle of Coke. He said that gave him all the energy he needed. When he was through working for the day, we went home, and washed and dressed. Then Frank would be ready for a good meal. One of his favorite restaurants was Casa De La Morra. The owner had a special table in the corner just for Frank, out of the way of everybody else.

When Frank and I were on the set of a movie, I'd be in trouble if I ever moved a prop. The union would jump all over me. One day Frank dropped some prop money that I was about to pick up when I remembered I had been told not to touch anything. A stagehand came over and picked the money up. The union people were looking for problems. A lot of them were mad because Frank had changed production schedules.

Before Frank came along, the working day was from six in the morn-

ing until four in the afternoon. With that schedule, the technicians and the prop workers were free to be with their families or go to a ball game during the evenings. The filming for Frank's movies—noon until eight—broke up everybody's day. But that's the way Frank wanted it, and he was such a hot ticket at that time that the producers and the film crew had to go along with him.

Frank was eventually scheduled to make *Carousel* at Booth Bay Harbor, Maine, in 1956. Frank, Hank, and Jimmy Cannon, who was a writer for the *New York Post,* flew in from New York for production. I drove up to Booth Bay Harbor in my powder-blue 1953 Coupe DeVille.

When we met up Frank said, "Don't unpack the bags. Let's see if we're going to stay or not." I thought, *What the hell is going to happen here?*

"Before you unpack, get in the car and go down to where we're going to shoot the movie," he said. It was around 2:00 a.m. and still dark.

"How am I going to get there?"

"There are going to be arrows on the trees to show you how to get there."

Frank had heard that the movie would be shot using two different cameras, one for movie theaters with regular screens, and one for theaters with CinemaScope screens. Frank didn't want that. He wanted only the best equipment and filming techniques to be used. He was worried that with the two different cameras, the same scenes would not come out perfectly. When I got to the set it was dark, but I found the cameras covered with canvas. I lifted the canvas off one of the cameras and checked it out. While I was I lifting the canvas off the second camera, a guard spotted me, and I was arrested for trespassing. By then, I had already found out what I needed to know. The security guard, who was in charge of protecting the movie equipment, asked what I was doing lifting the canvas off cameras at 2:30 a.m.

"I'm here with Mr. Sinatra," I said.

"You're one of those guys, huh?"

He called the cops, and they brought me to the police station. I told them I was with Frank Sinatra, but they didn't believe me. I told them I

could prove it if they let me call Frank. I eventually called Frank and told him that there were two cameras on the set, one standard, and the other CinemaScope.

"That's great. Come back and we'll leave." Frank said.

"Frank there's a problem. I'm in jail for trespassing."

In a very loud voice Frank said, "You tell those Mickey Mouse cops to let you go! You're with me."

The cops heard Frank, and one of them said, "Oh, he called us Mickey Mouse cops. Now that he said that, you better get used to being here."

There I was, a jailbird. Hank eventually called and explained everything to the police, but they weren't ready to let me go. They wanted to wait until either Frank or Hank came down to the station with some identification to prove who we were and that we were involved in making the movie. Several hours later, Hank came to the police station, just like he had to do when I got pinched after the *Some Came Running* party. I don't know what Hank told the cops because I was still in lockup. Hank worked something out; the police dropped the charges and released me.

"We're not doing the film," Frank said when I got back to the house the studio had leased us. "That's why I didn't tell you to unpack."

Frank then called the director in California. "Don't bother bringing your crew here or anything, because I'm not doing the movie."

None of us went to bed that night. Around eight o'clock in the morning, I drove Hank, Jimmy, and Frank to the Portland airport in my car. It was raining like hell. A crowd, including photographers and reporters, were all over the airport.

"What are all these people waiting for?" Frank asked.

I told him I didn't know.

"Get out of the car, Tony, and see what you can find out."

I got out of the car, worked my way through the crowd, and asked a woman who was standing in the crowd what was going on and what people were waiting for.

"We're waiting for Sinatra. He's leaving town. He's not going to do the movie."

"Oh," I said, "that would never happen."

They didn't know I was connected with Frank. Somehow, word had gotten around that Frank was in town and was heading for the airport. I went back to the car.

"Frank, the crowd, the photographers and the reporters—they're all waiting for you."

"Good. Now you've got a job. Find the manager of the airport and take care of him. You know what to do. Tell him we don't want to get involved with the crowd and that you want to drive your car across the airfield; right up to the door of the plane when the plane is ready to take off."

I got out of the car, found the manager, and definitely took good care of him—I handed him a hundred-dollar bill. When I explained the situation to him, he said, "Follow me. I'll drive ahead of you in my car. When I blink my lights, you take a right."

I thanked him and went back to my car. I told Frank about the plan and he nodded, "Okay. Then don't leave the airport until you see our plane in the sky."

Because of the bad weather, Frank figured he might have to come back and there would be no one at the airport to drive him away. I followed the manager's car around the airport and drove my car right up to the plane, but somehow a photographer got close enough to take a picture of Frank getting on. After Frank boarded with Hank and Jimmy, I followed him, but only up two steps. Then I weaved back and forth to make sure that the photographer didn't get any more pictures. They did get a picture of me driving the car, which appeared in the *Portland Press* the next day.

I waited at the airport for about a half hour before I drove back to the house. I had started to put the luggage in my car when I found the most important thing that Frank always carried with him. It was the little attaché case that contained between forty and fifty thousand dollars in jewelry. Believe me, I waited at the house for three or four hours to give Frank enough time to fly into New York and get back to our suite at the Waldorf before I called him.

"Frank, don't worry about the attaché case, I have it here."

"Good. Bring it to New York."

To honor his contract, Frank made *Pal Joey* with Rita Hayworth and Kim Novak in place of *Carousel*. Eventually, *Carousel* was made with Gordon MacRae and Shirley Jones. *Pal Joey* was a great success. Some fantastic songs came out of that movie, including "There's a Small Hotel" and "The Lady Is a Tramp," which made *Pal Joey* a far better movie for Frank than *Carousel*.

I'm reminded of another time when Frank was doing a movie called *None But The Brave,* in 1965 with Clint Walker, Tommy Sands, and Brad Dexter. Clint Walker had done a successful TV western called *Cheyenne,* and Tommy Sands was married to Frank's daughter Nancy at the time. The movie was shot in Hawaii. In one scene, Frank had to swim out into the ocean. The sea was rough, and there was a strong undercurrent. Frank was in the ocean getting ready to do the scene when the undertow suddenly pulled him down and carried him farther out. He almost drowned that day. Brad Dexter managed to swim out and save Frank's life, but it was a very serious situation. Frank said that he had given himself up for dead. It took him several days to recover because he had swallowed a lot of salt water and struggled against the current for a half hour. If Brad Dexter hadn't been there, there is no question that Frank would have been a goner. Frank was so grateful that he made sure Brad Dexter got his fair share of roles in his movies as well as the opportunity to produce a few. The bum had it made after that.

Frank's movies always seemed to produce some sort of off-camera drama or controversy. Often it surrounded news about Frank and Ava, Frank's near-death experience in Hawaii, or the long-suppressed *The Manchurian Candidate*, a film about brainwashing and the assassination of a president. However, not everything was this serious.

One time we were in California and Frank, Frank Jr., and I were having dinner together. Frank asked me to take Frank Jr. to see *The Pride and the Passion,* a movie Frank had done with Cary Grant and Sophia Loren. This was in 1957, so Junior was twelve or thirteen years old. There is a scene in *The Pride and the Passion* where a cannon is stuck in the mud.

Miguel, Frank's character, wants to use the cannon to drive the French out of Avila, Spain. As it turns out, this is a massive cannon and Miguel needs help to pull it out of the mud. Miguel knows there is a large gathering of people in the stadium, so he goes in to ask for help. There he learns that no one wants to help him. In fact, the people boo Miguel. In response, Miguel spits at the crowd. Frank Jr. got so excited watching that he said, "Look at my daddy. He spit at all the people!"

That was all it took. Everyone in the theater looked around. Some people began to yell, "Sinatra's son is here." The lights came on and people started pushing toward us. Finally, the manager squeezed through the crowd and told Junior and me we had to leave.

On our way, home I said, "You see, you can't speak too loud because everybody knows you."

"Well, that was my daddy," he said.

When we got back home early, Frank wanted to know what happened so I told him. Frank told Frank Jr., "From now on, when you're out in public, don't open your mouth."

Another time, Frank got a call from the police department. He came into my room and said, "Go look for Junior. You know how far he can go on a bicycle."

"What happened, Frank?"

"Go look for him. He's on his bicycle with a BB gun shooting out street lights."

When I found Junior, I said, "Your father is right behind me."

Junior said, "You're kidding."

He was so scared that he raced home on his bicycle. That's how it was for Junior. Sometimes it was tough being a child of someone like Frank. People might envy you, but they didn't understand how hard it could be. There were times you couldn't do the simplest thing, like going to a movie.

When Frank Jr. was ten years old, he used to hang around in a toy store to keep busy. I think it was called the Buster Keaton Toy Store in Beverly Hills. Buster Keaton was a great silent screen actor. I don't know if he owned the store or whether the storeowners paid him to use his name. They

had amazing toys in that store. One day I asked Nancy where Junior was. She told me he was at the toy store, so I drove there.

"What are you doing?" I asked him.

"I'm selling toys."

Just to kid him along I asked him, "What do you have to show me that I could buy?"

"Something good that makes a lot of noise," he said and proceeded to show me a cannon that exploded and made a *POW* sound when you put powder in it and pulled the firing mechanism.

I wanted to buy it but Frank Jr. said, "You're not going to buy it until I show you what it does."

That's when Frank Jr. set it off in the store. The owner came running to where we were and said, "You know you're going to have the police coming here, Frankie. You can't shoot off a cannon in the store."

"Well, I wanted to show him what it does before he bought it." Frank Jr. said.

Junior got yelled at for setting off the cannon. Junior had the cannon and Frank had the cherry bombs. Like father, like son. In the end, I bought the cannon, and every time I see Frank Jr., I remind him about the cannon and he laughs and says, "I don't forget that day."

Frank was very selective about the movies he made. He always wanted to make films with other stars that were hot on the scene. In the 1940s, Jimmy Durante was a rising star and he and Frank made *It Happened in Brooklyn* together. Gene Kelly was a top box office draw also, so Frank made *Anchors Aweigh, On the Town,* and *Take Me Out to the Ball Game* with him. Frank made *From Here to Eternity* with Montgomery Clift, Burt Lancaster, Deborah Kerr, and Ernest Borgnine, all big names in the industry at the time.

When the studios sent Frank scripts, sometimes three and four at a time, he carefully looked them over. If Frank didn't see big names with roles in the movie, he passed the script up right away. If Frank saw names like Sophia Loren, Spencer Tracy, Edward G. Robinson, or Bing Crosby, he took the time to read the script. Frank carried a dictionary with him

wherever he went. When he ran across a word in the script he didn't know, he'd stop reading, look the word up, and then continue reading. That's how Frank expanded his vocabulary. In fact, Frank was entirely self-educated. He didn't finish high school, go to college, and he never had a tutor.

When Frank worked on a movie, he spent a lot of his free time learning his lines. At times, he was involved in two or three projects at once, especially early in his career, but he was always serious about memorizing his lines. The last thing he wanted was to go to a shoot and not be ready to perform. Even when there was a prompter nearby, Frank didn't use it, because he usually had his part down pat. Remember, Frank didn't like to waste his time on anything. He wanted to get whatever he was working on right, get it over with, and move on.

As soon as Frank finished a scene, he always looked at the rushes. He didn't want to wait until the end of the day or the next day to look at them. He wanted to see them immediately after shooting the scene. That way, if there was anything wrong, they could go back to the set and shoot the scene again. As soon as the director yelled, "Rushes," we would go into this little room where they projected the scenes onto a screen, and the director and Frank would check them out together. If Frank liked what he saw, he would say, "Okay, tomorrow we can continue." If he didn't like what he had just done, he'd say, "Okay. Let's go back and do it over." Frank remembered what it was he didn't like about his performance and corrected it. He was a perfectionist by nature.

We did *A Hole in The Head* with Edward G. Robinson, Eddie Hodges, and Keenan Wynn. Frank's name in the movie was Tony, and he told me, "It's bad enough I'm making a movie. Now I have to be called by your name all day."

My role in the movie had me dancing by the diving board with all the girls. We were shooting in California, which was a tough place to make a movie because union stewards were everywhere. When we shot movies outside of California, we had more freedom to fool around because we didn't have all the union guys around.

In 1959, Frank was doing a movie with Shirley MacLaine, called *Can-*

Can. That film involved a lot of legs and beautiful women dressed in very revealing costumes—revealing, at least, for the standards of the times. Nikita Khrushchev, the premier of the Soviet Union, showed up on set one day. Khrushchev had once stated that all our grandchildren would live under Communism, and everyone started building bomb shelters in their back yards. Khrushchev had caused quite a scene at a gathering at the United Nations when, in response to America installing missiles near Cuba, he took one of his shoes off and started banging it on the table in front of all the assembled world leaders.

We knew that Khrushchev was coming to Hollywood and was coming to visit our set. We were hoping to meet with him and have a friendly gathering, but when Khrushchev showed up, he was already in a bad mood because he was told that he wasn't going to be allowed to go to Disneyland. Khrushchev was insulted and angered by what he considered to be a snub. When he got to the set and saw the studio filled with dozens of half-naked women, he began to yell about how immoral America was and how decadent we were. He went on to predict that we were all going to disappear like the Roman Empire.

Don't ask me why, but the studio heads selected Frank to greet the Russian premier. The moment I heard about it, I knew it was a bad idea because Frank was too unpredictable. He could be very dignified or he could be full of hell, and believe me, you never knew which one you were going to get. The time finally came for the Premier Khrushchev's introduction. Frank went up to the podium to welcome him, but instead of saying, "How nice to see you, Mr. Khrushchev," he said, "All right, all right," in a phony Russian accent. Then, Frank started beating on the podium, imitating Khrushchev's display at the United Nations. Khrushchev got the message and was furious. As a world leader, he expected to be treated with dignity and respect. Instead, he got Frank Sinatra banging on the podium. Khrushchev got up and stomped out of the studio, and that was the last time we saw him. As history would show, the Russians didn't bury us after all. They discovered capitalism and that was the end of the Soviet Union, the Berlin Wall, and the Cold War.

On another occasion, when Frank was in Spain, he was introduced to President General Franco. This man was a particularly brutal dictator who had sided with Germany and Italy during WWII. Frank didn't like Franco because of the way he had slaughtered thousands of his own countrymen as a way to stay in power during the rebellion in the 1930s. Frank was told not to say anything, and I believe he tried. However, when Frank boarded the plane to leave Spain, Franco saluted him. Frank took off his necktie, waved it and yelled out, "Goodbye, Franco, you rat bastard!"

CHAPTER 14: IT MIGHT AS WELL BE SWING

In 1953, Frank signed with Capitol Records, which was founded by successful songwriter Johnny Mercer. Johnny wrote the lyrics to "Moon River," "Autumn Leaves," "Ac-Cent-Tchu-Ate The Positive," "Laura" and "On The Atchison, Topeka and The Santa Fe," among others. He also had a string of hit records he sang with the Pied Pipers. Frank later recorded a lot of Johnny Mercer's songs, including, "One For My Baby, (And One More For The Road)," "When the World Was Young," and "That Old Black Magic."

Johnny Mercer wasn't part of the negotiations to bring Frank to Capitol Records. That was a job that was handled exclusively by Alan Livingston. As I mentioned, Frank owed Columbia Records a lot of money because of years of advancements against record sales that had fallen off dramatically.

Meanwhile, Manie Sachs had moved to RCA and tried to take Frank with him; however, there was no support from RCA management because Frank's career was on life support. If he wasn't successful at Columbia, which had a list of stable best-selling artists like Rosemary Clooney, Tony Bennett, Guy Mitchell, Frankie Laine, and Doris Day, how could Frank do better at RCA Victor?

Also, there was a new heartthrob on the scene that was making young girls squeal with delight. He was tall, thin, and awkward, and he wore a hearing aid. When he sang he would break down and cry on stage. Johnnie Ray was a most unlikely candidate to be the new Frank Sinatra, but he had a string of hits for Okey-Columbia, including "Cry," "Just Walking In The Rain," and "The Little White Cloud That Cried."

Needless to say, things were not going so well for Frank during this time in his life. He was pissed that Johnnie Ray had the screaming girls, and that he was outselling him with records as well as outdrawing him. MCA had just canned Frank, and he was staggering around aimlessly because of the terrible reviews for his most recent movie disaster, *Meet Danny Fisher*. Things were not about to turn around quickly. This was most evident when Frank was performing at the Paramount where ten years earlier he had the bobby-soxers screaming and crying. This time, no one was screaming and crying and there was more trouble on the horizon.

Johnnie Ray showed up backstage with his manager to say hello to Frank. To make matters worse, Ava was there, too. Everything was edgy but polite for the most part. Trouble began when Frank left his dressing room, and Ava went over to sit on Johnnie's lap. I was telling myself that it was going to be trouble. Ava was always a hot number and always used other men to make Frank jealous. Now she was at it again. Ava started kissing Johnnie and in spite of the rumors that he was gay, Johnnie joined in. They were kissing each other while Ava wiggled her beautiful ass into Johnnie.

Naturally, this is when Frank came back into the dressing room. Frank turned white, as if all the blood had rushed out of his face, and he didn't say anything. He grabbed Ava off Johnnie's lap and dragged her out of the dressing room. He slammed her against the wall and pointed his finger in her face. I got up, closed the dressing room door, and looked over at Johnnie. He was trying hard not to laugh and, instead, he just smiled. Actually, it was more like a smirk. That was the last time I saw him. In a year, his career was down the toilet, and Frank had signed with Capitol Records and Nelson Riddle. Sinatra was on the scene stronger than ever before.

Frank was thrilled with the idea of leaving Columbia Records and the overbearing controls of Mitch Miller. It got so bad at Columbia Records that if Mitch Miller entered the recording studio, Frank would simply walk out.

Five years earlier, record companies would have fought to sign Frank to a ten-year deal, but times had changed. When Alan Livingston offered Frank

a twelve-month contract, Frank took it. That's when Frank began a long, successful relationship with Nelson Riddle.

Early on, Frank told Nelson, "Look, any way you make this arrangement, I'll follow it through." Nelson was a master at writing arrangements for a full orchestra, especially for Frank. Nelson and Frank were a good team. Frank, of course, had his choice of great songwriters, but his favorites were Sammy Cahn and Jimmy Van Heusen. They wrote "Love And Marriage," "Come Fly With Me," "High Hopes," and "All the Way." When these guys wrote a song, Frank never said, "I don't like it. Forget it!" Frank would always record it. Frank loved to go into a recording studio at two or three in the morning, get all the musicians together and record until daybreak. Most of his best songs were recorded that way. While everyone else slept, Frank worked.

Frank recorded many novelty songs, one of which, "The Hucklebuck," became a minor hit in 1952. Frank liked singing "The Hucklebuck" at certain shows. It was recorded by a lot of jazz musicians including Charlie Parker, but when Charlie Parker played it, it was called "Now's the Time." Mitch Miller, who, as a respected oboe player, recorded with Charlie Parker when Norman Granz was producing "Bird," suggested the song to Frank. It was a rocking number that became a dance craze in the late 1940s. It was a funny song with lyrics like, "Wiggle like a snake, waddle like a duck, that's what you do when you do The Hucklebuck." Frank did so many ballads that when he threw in a song like "Ol' MacDonald Had A Farm" or "The Hucklebuck," it would change the pace.

There was a time and a place for those funny songs. For example, Frank would never sing one of them as part of his show at the Copa or the Sands. A more sophisticated audience came to those venues to hear Frank sing ballads. Frank included novelty songs when he played at the Paramount or on one of his radio shows, because he had a younger audience listening to him.

At Capitol Records, if Frank wanted to cut some brassy, swinging numbers, he worked with the arranger Billy May. Nelson Riddle had a quieter, more romantic approach to arranging, but Billy had an edge to his

work. Nelson dealt in pastels, but Billy's arranging was loud and vibrant. Listen to any of Frank's songs closely, and you can hear the difference between the two arrangers.

One thing about Billy—he wasn't very organized. Sometimes he'd write out the arrangements during the recording sessions when he was completely bombed. I don't mean he was slightly tipsy. Those guys never did anything in moderation. But Billy always came through with brilliant ideas, and Frank loved his ability to put each instrument together in a new way. Billy had the type of mind that could function under pressure, and the drinking didn't seem to bother him when he had to create an arrangement or think of a song that would work for Frank during a session. Maybe the booze even helped. It might have taken the pressure off of arranging for a tough ass like Frank, who was absolute hell in the studio.

Billy and Frank never socialized. I don't think they ever saw each other outside the recording studio. I do recall that Billy's wife and Billy's manager would hang around together from time to time. Billy's wife divorced him and later went on to marry his manager. Billy eventually ended up marrying his manager's ex-wife. These guys had a way of keeping things interesting. That's what I loved about show business. You never knew who was doing what to whom.

Later in his career, Frank used Don Costa, Gordon Jenkins, Quincy Jones, and Ernie Freeman as arrangers. Ernie and Frank really clicked. Ernie was the arranger for "Strangers in the Night" and "That's Life," two of Frank's big sellers. Ernie was a great arranger. He had the rare quality of knowing Frank's taste and singing range at age fifty, and he also had a keen sense of what would make a hit record. In all Frank's years of recording, he only had one serious regret: he wanted to record an album with Ella Fitzgerald and never did.

Back in the late 1930s, Ella started out with Chick Webb and recorded "A Tisket, A Tasket" around the same time Frank recorded "All or Nothing At All" with Harry James. Ella had the most distinct swing voice of her time. With "A Tisket, A Tasket" she became a major star and remained so until she died. Frank loved the way she sang. While he was with Capitol

Records he tried to arrange for Ella to record with him, but Decca Records wouldn't let her out of her contract. She owed them a lot of money. Decca wasn't going to release her to Frank's label and let them make all the profit. The two companies couldn't strike a bargain, so the album was never made. If Frank and Ella had ever recorded the album he wanted, it would have sold a million copies. After Frank left Capitol Records and started his own record company, he tried to get Ella to record with him, but the world can be a strange place. Ella moved from Decca to Capitol Records, and the deal fell through.

Frank told me several times, "That's the one thing I missed out in this world, making an album with Ella."

Eventually, Frank did a TV special and he put Ella on with him. She sang a few numbers, and you could see Frank sitting in the background with his legs crossed, clapping to the music. Eventually, he sang a duet with her, which I have on tape. Frank always sent me tapes of all his shows. The last package he sent included a note:

"When you get lonely, sit down, watch the tapes, and remember when we were young."

Frank sang each word in his songs clearly and distinctly. His diction was out of this world. Every time he made a record and finished recording, he'd look in the booth and signal that he wanted to hear it played back. When the engineers played the song back, if just one word wasn't clear, Frank would say, "Cut it!" and they'd record it again.

Of course, Tommy Dorsey influenced Frank an awful lot, especially when it came to his breathing and phrasing. Tommy played the trombone, while Frank watched and listened carefully. Frank followed the phrasing of the trombone and that helped him throughout his career. That's one thing I'm positive of. He wanted to learn the ease and continuity of Tommy's phrasing, but Tommy had spent years building it up. Frank was very thin, somewhere between a hundred and thirty or a hundred and thirty-five pounds. Frank worked on his phrasing over the years, and he developed the ability to sing without taking a breath during long passages.

Here's a story no one else knows about. Frank knew that breathing was

the key to Tommy Dorsey's success. Tommy could play twenty bars without taking a breath, and Frank wanted to be able to do the same thing with his voice. So many people talk about Frank's phrasing, but they don't know the exercises he did to build up his lung capacity.

While Frank was at the Paramount Theatre (December 1942 until March 1943), a fighter named Tami Mauriello, who was about six feet tall and weighed about 240 pounds, was there with his trainer, Al Sylvani. Frank arranged for Mauriello's trainer to come by and work on Frank's breathing for about a half hour every other day. Frank and Al couldn't work together more often than that, because it took Frank time to recover, and he had shows to do. Al and Frank would go upstairs to a spare room on the fourth floor at the Paramount where they wouldn't be interrupted and no one would know what they were doing. Frank's dressing room was on the third floor, and Peggy Lee's dressing room was on the second. Al and Frank would do their exercises between Frank's shows.

Usually, Frank had an hour and a half between performances while the movie played. They did the exercises when the theater showed an additional fifteen minute segment called *The News Of The Day* and a couple of cartoons, which usually gave them an additional half hour. These meetings happened around three o'clock in the afternoon, which gave Frank time to come downstairs, take a shower, and relax before the next performance. When he came to see Frank, Al would bring his folding massage table. Frank would lie on the table and take deep breaths while and Al pressed down, for various lengths of time, on Frank's body to see how long Frank could hold his breath. First, Frank would lie on his stomach and take a deep breath, and Al would press down on Frank's back, just above his kidneys. Then, Al would have Frank lie on his back and take a deep breath, and he would press down on Frank's stomach. They would time how many seconds Frank could hold his breath. This way, if Frank sang a song that had twenty bars and it took two minutes to sing, he knew he had the strength and the air in his lungs to last for two minutes without taking another breath. Frank would hold his breath and let it out slowly as though he were singing a song.

When Frank didn't have any more air in his lungs, he would say, "Okay," and Al would remove his hands. If Frank didn't have enough air in his lungs to speak, he would wave his hands and, more than once, he would kick Al. They would wait a while and do it all over again. They did this for a half hour, every other day, and in those three months at the Paramount, Frank built up his lungs in a way that changed the way he sang for the rest of his life.

Al used a little wind-up alarm clock to time Frank's breathing. When they started, maybe Frank could hold his breath for forty seconds. His lungs just kept getting stronger, so he knew how long he could sing without taking a breath. Frank was so grateful to Al for strengthening his lungs that when Al came out to Hollywood, Frank asked him to appear in some of his movies. In *The Joker Is Wild,* Al plays a corner man in the fight scene, which is what he was in real life. Frank saw to it that Al had enough film work to keep him going, because Al had strengthened Frank's lungs and really made a difference in the way Frank phrased a ballad.

While we're talking about phrasing, there was one particular night that Frank and I were in our suite—the presidential suite, at the Fontainebleau Hotel—when the doorbell rang. It was Tony Bennett. Frank absolutely loved him. I'll never forget this as long as I live. Frank and Tony were standing on one side of the bar, and I was behind it pouring drinks. Frank had a shot of Jack Daniels with three ice cubes, and Tony had a glass of ginger ale.

"Tony, I've got to tell you something," Frank said. "You have the best vocal chords in the business, including mine."

I thought Tony was going to fall over. He stood there for about ten seconds, speechless, before he talked.

"Frank, coming from you, that's the greatest compliment I've ever received."

This is written about once in a while, but if anyone wants the truth, Frank told Tony that at the Fontainebleau. Every time I see Tony, he still tells me he hasn't forgotten that night.

In July of 1956 or '57, I went with Frank and his daughter Nancy to Hollywood, where Frank was going to cut some Christmas songs at Capitol Records. The studio was located in Capitol Towers in a new building that was round, like a record, located on the corner of Hollywood and Vine. Frank sang Christmas favorites, including "White Christmas" and "Silent Night," as Nancy and I waited.

"Why is my father singing Christmas songs now when it's not Christmas?" she asked as we sat and listened.

I told her that her father was recording Christmas songs now so they could press the records and print the album jackets in time for Christmas. Nancy felt confused because we were in Los Angeles in July, and Frank was singing about snow, sleigh bells, and Santa Claus. That turned out to be the album called *A Jolly Christmas from Frank Sinatra.* What a beautiful time that was, and what beautiful children Frank had.

CHAPTER 15: SOME BUMPS IN THE ROAD

Life after WWII was a tough time for Frank—very tough indeed. His records weren't selling and he owed Columbia a lot of money. Even today, I believe they hold back royalties. The problem dates back to his early days at Columbia Records with Manie Sachs. They used so much money to get Frank out of his contract with Tommy Dorsey that some of that money was given in advance against future royalties.

Another problem for Frank was Ava. When things were right, everyone was happy, but when Ava and Frank fought, it affected his morale and his singing. He didn't feel like singing anymore. He was doing a lot of radio shows and two or three concert performances every night. One night, right in the middle of performing, his voice was gone. He literally couldn't sing a note. He had a lot of things working against him at the time. The record sales had cooled off, the movie parts were weak, and then there was Ava. Nothing that should have gone right did. Moreover, he never told you when anything went wrong with him. Frank said more than once, "Tony, don't ask questions. If I want you to know, I'll tell you."

Whatever Frank wanted, that was it. I just had to stand by him and watch his moves—that's all. I learned that when he was ready to talk about something, he would. No one was working harder than Frank in those days. And he could feel his career sliding away, so he took on more concerts and radio performances. Frank didn't lose his voice over night. He couldn't get himself together to hit certain notes. When you sing, you have to be relaxed and in control. This was especially true for Frank, who relied so heavily on breath control.

Frank always kept a lot of things private, things that his mother, father, and Nancy didn't know. If there was a problem, it belonged to him. Frank handled it. He didn't want anyone else involved. When he came out of that bedroom, I wouldn't ask him what was wrong, but I could tell by his walk if there was a problem: He might have been talking to Ava, Juliet Prowse, or Lady Adele Astor. Whoever it was, Frank might have been upset because he asked one of them over, and she couldn't make it. I wasn't going to go in and ask Frank what happened during the night. If he wanted to tell me, fine.

Frank went through a lot of rough times, and I think they made him stronger. The beginning of Frank's career had been so easy, but by the end of the 1940s and early 1950s, the world had changed. As for Ava, if there had been TV in those days, and they showed weather maps, Ava would be on those maps every day as a storm front. You knew there would always be turbulence, but along with the turbulence, you didn't know whether you were going to get a cold front or a heat wave. And every day was different. Some days you would get both the heat wave and the cold front. Ava's three husbands—Mickey Rooney, Artie Shaw, and Frank—made it into their eighties. That was a testimony to Ava; if you could survive Ava, you could survive anything.

When Frank divorced Nancy, they had an agreement that Frank would pay one-third of his earnings to her until all the children reached the age of twenty-one. That was in early 1951, and I think Nancy was eleven, Frank Jr. was six or seven, and Tina was about three. Ava Gardner never told Frank that he should divorce Nancy. I know that for a fact. It was Frank who wanted to show Ava how much he loved her by divorcing Nancy. Ava was not involved in any way. She never told Frank what to do or what not to do, because that would have worked against her. Frank never liked people telling him what to do or how to do it. Ava was smart enough to know that. During that time, a lot of freeloaders and business associates dropped Frank because his career was coming apart. But his real friends stuck by him, and they got to be a small, tight circle. Through the years, it was almost impossible to break into the circle, which later became known as the Rat Pack.

Every one of Frank's friends had a nickname. Frank was "The Chairman of the Board," a name given to him by long-time friend and disc jockey William B. Williams. Dean Martin was "Shot Glass." Some people think that Dean pretended he drank a lot. Believe me, it was no act. Sammy Davis Jr. was "Smokey the Bear," because he constantly had at least one cigarette going, and sometimes two at once.

I remember Frank and I going to Joe Fischetti's house in Miami. Joe had interests in a few clubs in Miami and was Al Capone's cousin. I remember a limousine parked out front, and a speedboat tied up in the back of the house, just in case someone had to leave in a hurry. There was a huge game room filled with mounted deer heads, bear heads and huge game fish. Frank and Joe Fischetti were having a serious financial discussion, so I walked away. If Frank wanted me in on something, he would tell me to stick around, but I knew when to keep out of things, and this was one of those times. Up on the wall I saw this twenty-foot-long sailfish. It was absolutely amazing. My father was an angler, so I was interested in what Joe used to catch the fish. After a while, Frank and Joe finished their conversation and they came over to where I was standing.

"How did you catch this fish?" I asked Joe.

"He opened his mouth," Joe said, in an ominous tone, and with that, I walked away. After that, I became "The Clam."

DownBeat magazine used to pick the top musicians and the top vocalists, like MTV and the Grammys do now. 1949 was the first time in years that Frank wasn't listed as the most popular male vocalist. Before then, Frank won all the music awards. He would give me his DownBeat Awards and his Metronome Awards—plaques with Frank's picture on them for Best Singer, 1944, 1945, 1946—and I would take them home. He gave me the brown corduroy jacket that he wore in one of his first movies, *Higher and Higher*. I have no idea where that jacket is today. Some friends would come up and ask me for something from Frank, and I'd give them a signed photo or one of his awards. I kept a lot of things Frank gave me, but I gave away so many things I wish I had kept.

One thing that I have is an Omega wristwatch that Frank gave to me at

the Copacabana a few months before Bogart died. Frank had it inscribed to say, "To My Dear Friend, Tony, From Frank, 1956." You don't wind it. It runs by the pulse of your arm.

"Tony, someday you'll look at your watch and if you see that it's not running, that means you're dead." Frank said.

Frank not being named most popular vocalist should not have come as a surprise to anyone. Frank's records weren't selling, and he was no longer a hot singer on the charts. Lawrence Tibbett, who couldn't swing to save his soul, replaced him on *Your Hit Parade*. Now, Frank had a problem. He had bought a house in Palm Springs and owed a lot of money. He was trying to do too much. That's when he lost his voice. He was his own manager, and everything was by word of mouth. If Frank told Ben Novack, who owned the Fontainebleau, "I'll be there April 10–21," that was it. On the tenth, Frank would show up—no signed contracts or anything like that. Frank did have a manager in name only in Hank, but he was just there to catch flak and to push people out of the way. He was the bodyguard-bouncer. Hank had the title of manager, but no one could tell Frank, "You're going to sing at Oakdale Theater on such and such a date." No. Frank was the boss. He always knew what he wanted. If Frank didn't want to sing somewhere, that was it.

But Frank must have been doing something right, because he was always the best—the honors, the gold records—he won everything. But he didn't care. I don't know what his angle was, but in life, he wanted to be number one. That's all. And he'd go after it. And somehow, through all the emotional highs and lows, Frank got to be an absolute legend. I never remember him playing anywhere—and I'm talking about thousands of shows—when the room was half empty or three-quarters full. It was always full. I'd be backstage and I'd look. The room was always packed to the gills no matter where we went. It was amazing.

CHAPTER 16: RING-A-DING DING

In 1960, Frank started Reprise, his own record label. He brought Dean Martin from Capitol and Sammy Davis from Decca to record for his label. Reprise Records was going great in those early years, so whatever happened I don't know. There was a problem with one of his partners. Hank wanted to pull out. As I said, when Frank had problems, he made sure that no one else was involved. Everybody else had to stay out of it. Frank had a deal to merge with Warner Brothers Records, which would pay Frank millions for his label. That way, he wouldn't have to worry about running a record company. He could retain an executive role in the company and still have absolute artistic freedom with his recordings.

There was one major hitch to the deal, and that was Cal-Neva. Jack Warner wanted Frank to get rid of his interest in Cal-Neva, the resort Frank owned with Hank. Frank didn't want to get rid of Cal-Neva, but there were some problems connected with the resort, including pressure from Bobby Kennedy, the attorney general, because of what he called "undesirables" inhabiting the club. By referring to undesirables, Bobby Kennedy meant Sam Giancana. Sam would hang around the club when his girlfriend, Phyllis McGuire, performed at Cal-Neva. But Sam was a known mobster, so Frank risked losing his casino license from the Nevada Gaming Commission.

Sam was such a powerful mobster that the CIA hired him to take out Fidel Castro. So one branch of the United States government was condemning Sam for his various underworld connections and another branch of the United States government was hiring him because of those same underworld connections. Go figure.

Frank wanted out of day-to-day management of Reprise Records. It was just another toy that Frank enjoyed and then got tired of. So Frank got rid of Cal-Neva and Hank and completed the deal with Jack Warner to make Reprise Records a subsidiary of Warner Brothers Records. Warner Brothers would take care of the distribution of Reprise Records, and Frank would still have artistic control. A lot of beautiful records came out of that deal.

Frank selected the songs and decided which musicians he wanted for a particular album. And he had a sense about which arranger to use for each song. For example, he wouldn't use Count Basie as arranger for "Three Coins In The Fountain." For a romantic sound with lots of strings, Frank would choose Nelson Riddle or Don Costa. He might even consider using Gordon Jenkins. For his last album for Capitol, *Point of No Return*, Frank brought in his old friend Axel Stordahl as arranger and conductor. It was a poignant time. Frank was leaving the label that revived his recording career. Axel was Frank's first arranger, going back to their days with Tommy Dorsey, and when Frank moved to Columbia Records, Axel moved with him. Later there was some grief between Frank and Axel's wife, June Hutton, and slowly Frank stopped working with Axel. Frank was at the end of his contract with Capitol when he learned that Axel was dying of cancer at age forty-eight. "Point of No Return," it turns out, had a lot of hidden meaning in it. This was Frank's last session at Capitol Records, and this would be Axel's final session on the planet.

It's difficult to imagine Frank with more artistic freedom than he had at Capitol Records. Frank also selected the photos and illustrations for the album covers. When the art directors at Capitol Records came up with a concept for one of Frank's albums, they would bring Frank ten or fifteen different sketches, and he would pick the one that he thought would fit with that album. Look at the album, *In the Wee Small Hours Of The Morning*. Frank is standing in front of a lamppost, and the light and shadows are just right. He did all that himself. No one told Frank, "Take this one." He had to do it all himself; that was it. Eventually, Frank painted one of his own album covers. Frank also decided what songs to perform in concert. It

was always fifteen songs. He would go through a stack of sheet music and decide what mood he wanted to project. No one told Frank to take out "Chicago" and put in "It Happened in Monterey." No way. You don't tell Frank what to do.

Frank never put two fast songs in a row. And he never recorded an album in one day. Usually, it took three days. Of course, in Frank's case, it took three nights. Maybe four songs tonight, four songs tomorrow night, and whatever they needed for the third night. And before they got started on the second four songs, Frank wanted to hear the first four songs. After three nights, Frank would listen to the whole album. If he liked the recording, he would let it go to press. But a lot of times Frank heard something wrong that no one else heard—a reed player coming in late, or a note not sustained—and the song would be rerecorded until he felt it was absolutely right.

Frank also liked to record songs he could sing in different ways. For example, Frank recorded "Day In, Day Out" as a ballad with Axel Stordahl's arrangement, and then he recorded it as a swing number with Billy May's band. He must have recorded "Night and Day" seven different ways. When Frank sang "Night and Day" at the clubs, he would start it off softly, and then all of a sudden the big band would blast in. That would really wake the audience up, and after that, they were with the music. But Frank would never change the arrangement of "One For My Baby, And One More For The Road." That was perfect. Just Frank, sitting in a blue light, smoke rising from his cigarette, and Bill Miller playing behind him on the piano. That was a classic.

At Capitol Records, Frank would pick a week when he wasn't booked to perform at a club to record. Usually, he liked to start recording around eight o'clock, and work into the early morning.

The musicians were always the best and most diligent. If Frank thought the session was really going well, he would tell the musicians to stick around and do additional songs for the album. It all depended on how the music felt.

Early on, I'd say in 1951, Frank needed a piano player after his regular

piano player, Graham Forbes, quit. This was during Frank's rough time. Maybe Graham thought that Frank was never going to get out of his tail-spin, so he hooked up with some other band. In any case, Graham didn't come to Vegas with us. We were in Las Vegas, at the Desert Inn, and in the lounge of the hotel was a man playing the piano. Frank listened to him a long time and loved the way he played. After a while, Frank asked the hotel manager if he could talk to the piano player.

"Sure, he's looking to get a permanent job," the manager said.

The man got a permanent job, all right. His name was Bill Miller, and, at the time, Bill owed so much money to the hotel that he was playing for next to nothing. Frank talked to him and then paid off Bill's debt to the Desert Inn. That's how Frank and Bill Miller started out together. Frank hired Bill, and he stayed with Frank right up until Frank stopped singing. He was Frank's pianist and music caretaker. Frank would tell Bill which songs he wanted to sing on a given night, and Bill was in charge of distributing the music to the musicians and collecting the charts when the show was over. Frank and Bill worked together for nearly fifty years. Now Bill is Frank, Jr.'s accompanist. We called him "the Suntan Charlie," because he was whiter than Wonder Bread. No matter how long we were in Vegas or Miami, Bill never looked tanned. I think he only came out at night.

Around 1953 or '54, Frank began playing at the Sands. Jack Entratter was the manager and president of the Sands at the time. Jack and I were close from the early days when Jack was the manager at the Copacabana, in New York. When Jack went to work at the Sands he asked Frank to sing there, because wherever Frank sang, the other guys followed—Sammy Davis, Dean Martin, and Peter Lawford. Jack didn't care what Frank and his friends did, because he knew that they were bringing in crowds and making money for the hotel. That's why Frank got a 2 percent share of the Sands Hotel while he was performing there. After he left the Sands, and began to perform at Caesars Palace, that 2 percent continued. Frank played the Sands three times a year. He brought in the big rollers, a lot of oil money from Texas. After Frank finished a two-week stint at the Sands, all the oilmen and the high rollers left Vegas. No performer wanted to follow Frank.

A lot of jokes and antics went on when people met in the steam room at the Sands Hotel. Even performers who weren't working on the strip would gather in the steam room to talk. That was a constant Rat Pack meeting place, and Jerry Lewis, Steve Lawrence, and Don Rickles would join in. One time Frank and some people were in the massage room right next to the steam room. The man in charge of the massage room was named Neal. The massage room had a TV set, but it was blurry and out of focus, so Frank and some of his friends unplugged the television and carried it outside to the swimming pool.

"Move back, move back," Frank yelled to everyone in the pool area, and the guys threw the TV into the pool.

Jack Entratter didn't care because he knew it was all in fun. Jack also knew that if he asked Frank to pay for the TV, Frank would pay for it, but he wouldn't perform at the Sands again. The place was a meeting place for a happy bunch of misfits and pranksters. That's how the Sands got to be the most popular place in Vegas. Because of his long affiliation with the Copacabana, Jack Entratter named the Sands' main nightclub area the Copa Room.

Frank wasn't much of a gambler. I never saw him at a craps table. At the Sands, Red Norvo played in the lounge as an added attraction, while the main show with Frank went on in the Copa Room. After Frank finished performing for the night, a band played in the lounge to keep the people eating and drinking. Frank would go to the lounge and Red would yell out, "Hello, Pops." That's where Frank and a few friends gathered for dinner at two or three in the morning. They had three or four tables pushed together, and Jack Entratter put security people around to make sure customers didn't come around and bother performers for autographs. If Frank wanted to gamble, instead of going to the roulette table, he would call out to the man in charge of the wheel.

"Bob, five hundred on the red."

Bob would put five hundred on the red for Frank, and when the wheel stopped, Bob would yell back, "Frank, it landed on the black."

"Okay. Put five hundred on the red again."

"Black again, Frank," Bob yelled back, and that's how Frank gambled, because if Frank went to a table out on the floor, forget it—it would be a mob scene.

One time Frank decided to go into the casino and play blackjack. It was about three-thirty or four o'clock in the morning. The place wasn't that crowded, and Frank figured he would be able to play for a while. Ernest Borgnine was with Frank at the time. At the beginning, there was Frank, Ernest, and a couple of other people at the table. The other people were nice enough to play and not bother Frank by asking for autographs. Then word got around that Frank was playing blackjack, and a crowd started to form. As the crowd grew, they started to shove and push. Suddenly, there was a mob. No one could move. Frank said to the pit boss,

"I want this table and the dealer brought into my room."

So that's what they did. They picked up the table and brought it into Frank's suite, which looked like a cottage and was located on the main floor. To get to Frank's suite, we had to walk from the back entrance of the Sands, past various cottages, to the other side of the pool and then across a little lawn. Frank and Ernie Borgnine played blackjack the rest of the night and had a ball. It was an exclusive event for Frank, Ernie, Jack Daniels, and the dealer in Frank's suite.

I'll never forget that night. Imagine, moving the whole table and the dealer to Frank's suite. They wouldn't have said no to Frank, because before Frank played in Vegas, the Sands was a mud hole. Frank made the Sands into the most important casino on the strip. Up until they knocked it down, Frank made it the number one showplace in Las Vegas. Wherever Frank played, other stars like Sammy Davis and Nat King Cole followed Frank into the Sands as well. So no one was going to refuse Frank anything, at least not as long as Jack Entratter ran the show.

Years later, in 1967, Vegas began changing. Howard Hughes had bought the Sands, and Jack Entratter was out. One night Frank decided he wanted to play *chemin de fer*. I stayed in my room because I wasn't interested in the casino. There were maybe five or six players at the table. Frank liked that game because only a few people were permitted to play at one

time. They blocked the table off with a red velvet rope, and they had security guards posted so people wouldn't duck under the rope and get close to the game. With *chemin de fer*, dealers have a box out of which they dispense the cards. Frank was playing with some people and lost $75,000. Losing the money didn't bother him; what bothered him was that Frank didn't like the people who won. He asked for a marker, but Carl Cohen, now the vice president of the Sands, told Frank he couldn't front him a loan and cut off his credit. Frank didn't yell. He just walked away from the table.

Carl Cohen called me right away. He was talking so loud and so fast that I could barely understand him.

"Tony, Frank is on his way to the room. Get away from him. He just lost $75,000, and he's got a face as blue as the moon."

Carl was right. Frank came in cursing, slamming doors, and throwing newspapers into the air. He was pissed. Wasn't he the guy who transformed the Sands from a roadside gambling dump into the hottest place in town?

When Frank had asked that his marker be raised to more than $75,000, Carl Cohen had to say no, because Jack Entratter was only the front guy. By this time, Howard Hughes, a successful movie producer and director, owned the Sands Hotel and just about everything else in Las Vegas. He also owned RKO studios and designed airplanes. Hughes had established a record for flying around the world in less than a hundred hours and had been awarded the congressional medal for his aviation skills as a designer and a pilot. Somehow, Hughes started buying up Las Vegas. One story goes that when he slept in the Desert Inn Hotel, the lights from the neon rotating shoe sign in front of the Golden Slipper Casino kept him awake, so he bought the Golden Slipper and had the sign turned off. Hughes also had a lot of women and saw Frank as competition. It wasn't Carl Cohen who refused to raise Frank's marker. He would never do that to Frank. Carl was following orders from Hughes.

Frank threw his wallet and keys onto the coffee table, but I didn't say, "What's wrong, Frank? What happened?"

Frank said, "Get me a drink."

I got him a drink and stayed nearby in case he wanted to talk, but I stayed far enough away so he could think and get what was bothering him out of his system. I don't know exactly what happened between Frank and the Sands, but it wasn't long after the night he lost the $75,000 that he stopped performing there. When Frank quit the Sands and went to Caesars Palace, Sammy Davis, Dean, and Peter stopped performing at the Sands and moved to Caesars with Frank. However, throughout the years, Frank and Jack Entratter remained very good friends. Frank knew that Howard Hughes was now in control of the Sands and not Jack.

CHAPTER 17: BOGIE, THE COPA, AND THE GIRL WITH PURPLE HAIR

Speaking of Jack Entratter reminds me of the time we were playing at the Copacabana, back in 1957. At four o'clock on a cold, dark, January morning, the phone rang in our hotel room at the Hampshire House, which was where Frank and I stayed when we were at the Copacabana. The Hampshire House was about 500 feet from the Copa and within walking distance. Frank and I had a two-bedroom suite with a living room between them. Frank had the big bedroom and I had the little one.

When I answered the phone, a woman asked if Frank was there, and I told her that he was resting.

"Tell him Bogart just died," she said. I don't know if the person was Lauren Bacall, because she gave me the message and hung up.

I gave Frank the news about his good friend and drinking buddy.

"Okay," Frank said, "That cures me for tonight. You got a problem."

"What problem do I have, Frank?" I asked.

"It's up to you to fill in my two spots for tonight at the Copa. I'm not singing tonight."

I called up Julie Podell, who was in charge of the acts at the Copacabana. He was a heavy-set man with a low, gravelly voice that sounded like coal tumbling down a metal drainpipe.

"Yeah, whadaya want?" he asked. I told him that Frank was not feeling well and wasn't going to appear that night. I found out that Sammy Davis was doing *Mr. Wonderful* on Broadway. Frank knew where Sammy was living, so I called and told Sammy's conductor that we had a problem and

wanted to know if Sammy would be kind enough to do the midnight show. I told him that Bogart had died and Frank was in no mood to do any shows.

Sammy's conductor said, "Tell Frank, there is no problem. I don't even have to ask Sammy. We'll call Julie Podell and take care of everything."

Sammy said he would do the midnight show because his play got out at ten thirty or so, and that gave him plenty of time to get to the Copa. Then I got hold of Jerry Lewis, who was at the Palace Theater. He wanted to talk to Frank, but I told him Frank wasn't in a good mood. Jerry said that he'd work out his schedule and stand in for Frank at the early show.

When I went into Frank's bedroom, he was stretched out on the bed looking up at the ceiling, with his arms behind his head.

"Frank, I'm only going to take a couple of minutes to tell you that we're all set for tonight. Jerry Lewis will do the first show, and Sammy will do the midnight show. If there is anything you want me to do, I'm right here."

"You did a great job, but the way I feel, you and I are going to be stuck in here all day," Frank said.

"We lost a great friend today. Is there anything I can do to cheer you up?" I asked.

"You can cheer me up by sitting here with me."

"Don't worry, Frank. I'm staying here."

"We're going to watch so much television, we're going to end up with CBS eyeballs," Frank said.

Frank eventually went to sleep and woke up in the late afternoon. He turned on the TV, and we watched Dick Clark's *American Bandstand*. Frank and I had never seen the show before, which had originated in Philadelphia and gone nationwide. Kids went on the show and danced to the latest hit records, mostly early rock 'n' roll by Elvis Presley, Buddy Holly, Chuck Berry, and Little Richard. The dancing was similar to the Lindy and swing that started when Frank first came on the scene in the early 1940s. But the music was different, with a strong beat, mostly guitars, and drums.

It was a strange sight, as though we were seeing into the future. We watched it for an hour before Frank turned the TV off.

A few months later, I got a call from Dick Clark. Frank was playing at the Copa, and we were staying at the Hampshire House.

"This is Dick Clark from *American Bandstand*," he said. "I'm in Philadelphia. Is Frank Sinatra available for me to talk to him?"

"No. He's getting ready to go on stage."

"Well, I want him to return my call because I want to ask him if he would appear on my show, *American Bandstand*."

I told Dick Clark that I would talk to Frank, which I did. Then I called him back and told him that Frank would think about it and get back to him, which Frank never did. Frank didn't want to come right out and say that he didn't want to appear. Saying that he would call back was the polite way of getting rid of the problem.

The day Bogart died, we stayed in all day. We talked a little that afternoon, but mostly Frank was very quiet. About eight-thirty, Frank ordered some dinner. Two waiters brought it up, and Frank and I ate together. After that, a jazz singer came by. She had called from the front desk earlier and said that her name was Abbey Lincoln but I didn't know who she was at the time.

I told Frank, "There's a broad on the phone . . . Abbey Lincoln or something. What do you want me to tell her?"

"Invite her up."

Maybe she didn't know that Bogart had died. I don't know.

When she came in, Frank came out of the bedroom and sat in the living room. I ordered a drink for her, and I went to my bedroom. She stayed until the next day and then left when Frank and I had to get ready for the Copa. She was a good-looking woman and a great jazz singer. I heard her on records but never live, because when I was with Frank I was always backstage, and if he was going out for the night with a woman, I seldom went with them.

As people walked into the Copacabana the day Bogart died, they saw a sign out front:

"Frank Sinatra will not appear tonight. Jerry Lewis will appear in his place."

Joey Bishop, who was Frank's opening comedian for years, opened Frank's shows at the Copa. Joey, a great opening act, would get the crowd revved up and make everybody crazy. The audience was already excited by the time Frank hit the stage.

Sometimes Joey opened for Sammy Davis, like the night Sammy performed at the Copa when Hank Bauer, Mickey Mantle, Yogi Berra, Johnny Kucks, and Billy Martin got into an argument with a few customers. They were at the Copa celebrating Billy Martin's birthday. One guy was heckling Sammy, saying racial things, and some of the Yankees didn't like it. A few of them told the guy to shut up, but the guy kept taunting Sammy. Hank Bauer, the Yankee right fielder, was a tough ex-marine, and he invited the heckler to join him downstairs. Hank and the guy went downstairs, but only Hank came back up. The word got around that Hank Bauer beat the guy up, but it was one of the Copa bouncers who decked the heckler and then threw him out. The next day the newspapers had four-inch headlines, "YANKS IN BRAWL AT THE COPA." No Yankees were involved in any fight. However, several of the Yankees were fined $200 each by George Weiss, the president of the ball club. Soon after the incident at the Copa, Billy Martin, who had a reputation for being a tough guy, was traded to the Kansas City A's.

One night after Frank's show was over, I heard a new act singing in the Copa lounge. I remember telling Frank that I had to go to the lounge because I heard this "woman" singing and she was good.

"Go ahead," Frank said.

The "woman" singer turned out to be Wayne Newton. I didn't meet him or get to know him because Frank didn't want me hanging around the lounge when there were all kinds of people there.

Later, Newton became one of the hottest performers on the Las Vegas strip. Eventually, he owned a few casinos, Arabian horses—you name it. He was a talented singer, and I don't think there was an instrument that he didn't know how to play. Jackie Gleason brought Newton on his Saturday night TV

show and he became such a hit that he was invited back week after week. After that, Wayne Newton had it made.

The Copa had very strict rules. Copa girls, chorus girls, and dancers could not leave the Copa with customers when they got through working. They weren't allowed to hang around in the lounge or anywhere else. I know this because I dated one of the Copa girls. I brought her to New Haven to meet my mother, may she rest in peace. At that time, all the Copa girls had purple hair. When I walked in and introduced the Copa girl to my mother and my sister-in-law Flo, they laughed. Remember, my mother was a good Catholic from Italy, whose prayers for me probably never included my bringing home a girl with purple hair.

"What the hell is this?" my mother asked.

I explained to her and to Flo that Copa girls had to wear purple-colored hair when they performed. Today, when I see tattooed kids on the street with purple hair, I just think back fifty years when purple hair was really something new.

That's why I married late. I had a girl at the Copa, I had a girl in Texas, and then I'd meet another girl at the Chez Paree, in Chicago.

Frank and I once went to a club in New York called the Ha-Ha Club. Inside, it was just like every other nightclub I had been in—lots of music, smoke, and beautiful women. The women were tall, gorgeous, and friendly. Frank saw that I was starting to get interested in one particular girl, so he leaned over and told me to take it easy.

"What's the problem, Frank?"

"No problem, Tony, except none of the women are women."

I didn't get what Frank was talking about. Frank and I knew people who were gay, but a whole nightclub full of them was something new. These were dancers who put on a show just like the one at the Copa, with sequined costumes, crazy hairstyles, and great dance routines. They were actually making fun of the famous Copa girls, but I didn't understand it.

"These can't be men. These are women." I told Frank.

"Believe me, Tony. Just stay near me and don't get involved."

The performers sang and put on little skits and added some dialogue. It

was meant to be two women talking about men, and it was so believable. Finally, I listened to them talk. Only from hearing their voices—or if you happened to notice their Adam's apples—could you tell these were not women. I don't know about Frank, but that was the first and last time I went to the Ha-Ha Club.

Gay people were not that unusual in New York or in Hollywood. Once, Frank came back to our place on Mulholland Drive and was really shaken up. He went into his bedroom, closed the door, and didn't come out for hours. This was in late 1949, when Frank was still seeing Lana Turner, but things were cooling down. Lana was known as "the sweater girl" not because of her acting ability, but because she filled out her sweaters. She was one beautiful woman, and it was Frank's relationship with Lana that caused the split between Frank and Nancy.

From time to time Frank would let Lana stay at the Palm Springs house when he was in New York or Las Vegas for an extended time. When Frank came back to Palm Springs, he went to Lana's house and called out her name to let her know he was back. Evidently, she was too involved to hear him. He went upstairs and put some things in his room. As I said, this was after their romance was over, but somehow Frank always maintained friendships with the women in his life.

Frank opened the door to his room, and Lana was in bed, but it wasn't with another man. It was with a woman, and what a woman she was. Frank was really shaken, and instead of quietly reclosing the bedroom door and backing away, he said, "What the hell is going on here?"

Lana looked up and then covered herself. She yelled, "And what the hell are you doing in my home?"

Frank apologized and walked out. Lana kept calling our house for days and days after that. I would always tell her that Frank was rehearsing or away on business. In reality, Frank was usually standing right next to me, waving his hands, which was the signal to stall her and tell her he was out. Frank told me the name of the woman Lana was with. I had never heard of her. Ava something.

If Frank couldn't do a show, he'd call Sammy, and believe me, paying

customers wouldn't say, "We want our money back." They would stay. Sammy was a great entertainer. He carried the whole show himself. He sang, danced, played the drums, and led the orchestra. Frank had known Sammy since 1947, and he was a good man to have around. Frank was close to all those guys. You know, the Rat Pack—Sammy Davis, Dean Martin, Joey Bishop, and Peter Lawford. I never smoked or drank liquor in my life. When we had a party in our suite with Frank and his friends, I was the bartender. I'd pour the drinks for Frank, Sammy, Peter, Dean, Jimmy Van Heusen, and Jackie Gleason—all of them. Frank would be at the Sands; Dean was at the Riviera, and Sammy was at the Star Dust.

After their shows were over, they would congregate at the Sands. I'd pour drinks throughout the night until they left, which was about five in the morning, I was as groggy as they were because I had been inhaling fumes from pouring liquor. Frank would turn around and say, "Fellows, drink it up. There'll be one guy who'll be sober and that's Tony. He'll make sure that we're okay."

And that's the truth. I made sure that they all got to their own rooms and that Frank was taken care of. And that's why these guys loved me. They knew I thought of them as much as I thought of Frank. I would actually walk Dean, Sammy, and Peter to their rooms, at the Fontainebleau and at the Sands, and wait until they had gotten into bed. The next morning or afternoon I knew what time they all had to get up, so I would call each one and make sure they were ready for their shows. Then I would order breakfast for them. I told the waiter to open the door, roll the food in, and then come to my suite, so I could sign for their breakfasts. "TC for PL," "TC for DM," "TC for SD." It was all on Frank's tab. Any of Frank's friends who stayed at the hotel where Frank was performing were on Frank's tab.

I never drank because I was always interested in taking care of my friends who were great drinkers. Sammy, Peter, and Dean were the best. You could never keep up with them. Frank wasn't much of a drinker. For every drink he had, Dean had ten. I would stay up all night with Frank, Dean, and all their friends, and then go to bed when the rest of the world

was getting up. I'd go back to our suite, wait until Frank went to sleep, and then go across the living room to my bedroom. They drove me crazy.

By noon, I had to get up. Before Frank got up, I had to have the maid come in with a very quiet vacuum cleaner to vacuum the living room and my bedroom. I had the bar refilled and made sure everything came back from the cleaners. When Frank got up, I had the housekeeper take care of his bedroom while Frank was having breakfast in the living room.

When the housekeepers were through, they would knock on the door to indicate that they were going. That way if Frank wanted to go into his bedroom, they wouldn't startle him. The housekeepers left through the same door they came in. They would never come through the living room while Frank was in there. Frank never had to ask where his tuxedo was or why his shoes were not polished. He knew that when I was around all he had to do was remember the words to his songs. I took care of the rest, and I enjoyed it.

CHAPTER 18: TRAVELING LIGHT

When Frank got up at four in the afternoon, I'd ask, "What do you want to eat?"

"Make me a couple of scrambled eggs, dry rye toast, and a cup of coffee," Frank said.

When I asked Dean, "What do you want for breakfast?" his choice was much different.

"Ah, get me a bowl of shaved ice," Dean would say.

Early on, I thought he was kidding. He had just gotten up! I'd get him a bowl of shaved ice, and he would start drinking. That's why the guys nicknamed him "Shot Glass." He was an amazing man. Dean didn't like flying, so he would have to have a few drinks in him before you could get him on a plane.

Otherwise, he'd travel by train. When Frank and I lived on Mulholland Drive in Beverly Hills, I was always afraid to have Dean drive up there. Ours was the last house at the top of a hill with a very sharp left hairpin turn that wound down the steep hill. If Dean drove down the hill and missed that turn, he faced a drop of 1500 feet. There was no wall, no fence, nothing. If you missed that turn, you were done. If Dean got drunk and wasn't paying attention, it would have been over.

I was driving a Thunderbird in those days. Whenever Frank finished a movie, the studio would give him a new car. That's how Frank got the Thunderbird. He didn't like to drive it, but I loved that car. Years later my son, Anthony, called to tell me he had seen a Thunderbird that was owned by Frank Sinatra being auctioned off for hundreds of thousands of dollars.

126

"If it's Frank's Thunderbird, it's gray." I told my son.

"You know, Dad, you're right," he said.

There were so many things I should have kept, but didn't. We were young then and thought we had forever, but forever can come at you all of a sudden, and it's not what you thought it would be.

Frank and Peggy, who started out years ago working at the Paramount Theatre, doing ten and twelve shows a day, both ended up at the top of Mulholland Drive in Beverly Hills. Peggy Lee lived with her husband, Dewey Martin. Her house was the one just below us before you got to Frank's. Once in a while, Frank's dog, Ring-a-Ding Ding, would run down to Peggy's house and scratch up her lawn. That little white dog got me into more trouble than I could ever have planned for. Peggy would call and say, "Come down and get your mutt. He's scratching up my lawn!" I would have to go down there, get the dog, and bring him home. If anyone wants to know how Frank came up with the title for his first album with Reprise, he named it after his dog, Ring-a-Ding Ding.

When Frank decided to sell the Mulholland Drive house, he sold it to his jeweler. With all the money Frank spent on watches, cuff links, and gold cigarette lighters made by Dunhill—which he constantly gave away to his friends and musicians—that jeweler paid for the house with the money Frank spent on jewelry and still had plenty left over.

After Mulholland Drive, Frank decided to move to Palm Springs. I don't know how it happened, but Nancy and the children got hold of the real estate agent and had a set of keys gold plated for Frank as a house-warming present. Even though Frank and Nancy hadn't been together for a number of years, there was still love between them. At the Palm Springs house, Frank had a sign put up above the doorbell at the gate that read:

IF YOU HAVE'NT BEEN INVITED. YOU BETTER HAVE A DAMN GOOD
REASON FOR RINGING THIS BELL! (Sic)

The street Frank moved to in Palm Springs was called Wonder Palms Road, and was later changed to Frank Sinatra Drive. He had the first house

near the first tee on the golf course. But Frank didn't play golf all that much. Dean was the guy who was crazy about golf. Frank and I weren't interested in playing sports. Years earlier Frank put together a baseball team of musicians, and they played musicians from different bands, but that was the end of Frank playing sports.

In the Palm Springs house, Frank had a stereo in the wall and a TV that rotated in every direction so wherever you sat, you could see the screen. When Frank wanted to relax while he was having his coffee, he would listen to one of Jackie Gleason's recordings, especially *Music for Lovers Only* and *Music To Make You Misty*. No one has heard this before, but one of Frank's favorite bands was Spike Jones's. It was crazy music with washboards, pistols going off, and kazoos. Name a weird instrument and Spike Jones's band played it. On stage, violins would bend and water would shoot out of a tuba. One of the band's biggest records was called "Der Fuehrer's Face." The opening line of the song went, "When der Fuehrer says we is de master race /we heil, heil, right in der Fuehrer's face." This was a very popular song during WWII.

Frank wouldn't play Spike Jones every day, but when he did, he would turn the sound up so loud that the house would shake. But more often than not, Frank would listen to Jackie Gleason. He would just sit there and relax. That's what he liked. Frank would never listen to his own recordings. When he was at a place where someone played one of his records, Frank would go into another room. He didn't like listening to his songs, because he was afraid he would hear something wrong and wouldn't be able to change it.

The Palm Springs house was where Frank invited friends for home-cooked dinners. Frank loved to go in the kitchen and cook spaghetti with meatballs. He would invite Angie Dickinson, Shirley MacLaine, and Dean Martin over. The food was just an excuse to get together, have a few laughs, and have a good time together. Frank wasn't a great cook. When he had a large number of people over, or had people over he didn't feel comfortable with, he would have the dinner catered. Frank would call the owner of the Villa Capri, Patsy D'Amore, and have the chefs prepare and de-

liver the food piping hot. Patsy would have little Sterno candles under the food trays so Frank wouldn't have to reheat the dinner. It tasted like the food had been baked right in the kitchen.

Frank would tell Patsy that he wanted the food served at a certain time, and a waiter from the Villa Capri would show up and serve the food just as though we were in the restaurant. And you could bet that everything was done just the way Frank liked it. Otherwise, Frank would have sent everything back.

Here are two stories about what these guys would do for fun. Frank and I were in New York at the Waldorf-Astoria. Frank called up Dean in California and told him that I wasn't feeling well and wouldn't be able to help Frank for a couple of days. None of that was true—I was fine. Frank told Dean he needed somebody to help him and asked Dean to send his valet, Mack Gray, to New York. So Dean sent him. I'll never forget this day. I didn't know what was going on when I opened the door to our suite in the Waldorf-Astoria and saw Mack Gray standing in the doorway holding his suitcase. Mack and I had known each other from the 1940s when he worked for George Raft. I was surprised to see him, especially without Dean.

"What are you doing here?" I asked him.

"Frank sent for me."

I was amazed and a little shook up. "For what?" I asked. I thought that maybe I had done something wrong and gotten fired. Then Frank came to the door.

"What are you doing here?" he asked Mack. You could see Mack Gray's eyes start to glaze over. "Dean said that you needed me."

"You're out of your mind. What's wrong with Dean? I got Tony. What do I need you for? Go back home!" Frank told him.

Mack Gray stood there for a while visibly rocking on his heels, and then he said, "Okay, I'll go back to California." Would you believe he had to turn around and go back to California?

A few days later, Dean called Frank, "You know, Frank, I've been laughing for two days. That guy is still so upset."

Mack was Dean's right-hand man, like I was to Frank, so I couldn't figure out what was going on, and neither could he. Why Frank did it, I don't know. The guy had to travel thousands of miles across the country for nothing, but those were the kind of pranks that Frank and Dean played on each other.

One time Frank got through playing at the Sands Hotel. Normally, when there's a singer like Frank on the Strip, the hotel doesn't follow him up with another singer because they figure the high rollers have come to see Frank and leave town after. Maybe the hotels will feature Jimmy Durante or Shecky Greene. This time Dean followed Frank into Las Vegas but stayed at another hotel. Dean's valet was sick, and Frank heard about it, so he came to me and said, "Tony, I know this is a lot to ask, but Dean is at the hotel for a week. Could you give him a hand?"

I did and worked with him for the week. I enjoyed being around Dean. He was relaxed—easygoing. At the end of the week, Dean told me he was going to fire his regular valet and hire me.

"Dean, don't hurt me. Don't even think about it. I love you and I love Frank, but you know I've got to stick with Frank."

Dean went back to Frank and told him that any time Frank didn't want me to work with him, Dean would take me and double my salary.

Frank told Dean, "Even if you triple Tony's salary, he wouldn't come because he wouldn't leave me." And it was true.

The difference between Dean and Frank was like the difference between night and day. Dean was much easier to prepare for going on stage than Frank was. With Frank, you had to be very careful that everything was A-number one. I remember the time when one of Frank's shirts came back from the laundry. One of the cuffs was ironed under slightly so it wasn't exactly straight all around. You wouldn't notice it even if you were looking for it, but with Frank, that was a serious thing. Dean, on the other hand, wouldn't have noticed it.

If Dean didn't have a tuxedo to wear onstage, he would say, "Okay, give me the sports jacket and shirt. That'll be good enough. If they don't like it, let them go. Who cares?" Dean was that type of guy.

Frank had to have everything he wore on stage a hundred percent right, just like when he made a record and had to listen to each cut played back. If one word sounded slightly indistinct, that version would be scrapped and rerecorded until Frank was satisfied. When Dean went into a recording studio, it was a different story. Sometimes he wouldn't stay around for the playback.

"Don't worry about it. It'll sell," he'd say.

That was the difference between these two close friends. You wouldn't think they would get along, but they loved each other and were inseparable. When something bad happened to Dean, Frank felt it, and when something went wrong for Frank, Dean was right there.

I met Dean when he was starting out with Jerry Lewis, in New Haven, in 1947. They were the hottest comedy team around. They performed in nightclubs, had a weekly radio show, and made about six movies together. When television became an important form of entertainment, Martin and Lewis were featured on the *Colgate Comedy Hour* on Sunday Nights, opposite Ed Sullivan's top-rated *Toast of the Town.* Dean and Jerry were the only performers who regularly outdrew Ed Sullivan's show.

It was Skinny D'Amato who decided to make Dean and Jerry into a team. Jerry Lewis and Dean Martin were appearing as separate acts at Skinny's 500 Club. Jerry would open the show with jokes and a few imitations of current stars. When Jerry finished his act, he would leave, and then Dean would come on stage and finish the show singing ballads. That was the era of crooners that started with Rudy Vallee, Bing Crosby, and Russ Columbo. Those were the singers who influenced Dean and Frank. Finally, Skinny D'Amato told Dean and Jerry that they weren't doing enough business for him to pay both of them.

"I think you better get together and see what you can do," Skinny told them.

So Dean and Jerry decided that they would go on stage at the same time; Jerry would tell a few jokes, Dean would sing a song, and Jerry would interrupt Dean's singing and tell a few more jokes. And that's what happened. They were very spontaneous and worked off each other ex-

tremely well. Word started to get around about this new comedy team playing at the 500 Club. Skinny began to see crowds coming in to see Dean and Jerry, and that's how Martin and Lewis began as a team. They started as a team at the 500 Club. No other place. Dean and Jerry were solo acts before that.

The team didn't last because of the basic differences between Dean and Jerry. Dean was laid back, and Jerry was a businessman. One time Jerry wanted to open up mini-theaters around the country, and he wanted Dean to go in with him. Dean said he didn't want to be bothered, that he would rather go out and play golf. Dean used to play golf for big stakes. A thousand dollars a hole was not out of the ordinary. Eighteen holes could easily add up to eighteen thousand dollars. So Jerry told Dean that if he just wanted to fool around, they no longer had to work together. And that's how the team broke up. That breakup really shook the entertainment world. As a team, Dean and Jerry had it made. After the breakup, everyone thought that Dean would disappear because he was the straight man who sang songs, and that Jerry would thrive because he was the comedian.

For a while, things didn't work out for Dean. To make it more interesting, Jerry signed with Decca Records and had a huge hit single with "Rock-a-Bye Your Baby with a Dixie Melody," the old Jolson song. Meanwhile, Dean's records were going nowhere. But he hung in there. Things slowly began to turn Dean's way. He had huge hits with "That's Amore," "Memories Are Made of This," "Return to Me," and "Volare." Then Dean became a successful actor, especially with the Matt Helms series. He had a great weekly TV show, sold millions of records—especially, "Everybody Loves Somebody"—and starred in movies with John Wayne and Frank. He even worked with Marilyn Monroe in a movie that was never finished, *Something's Got To Give*, which was a remake of the Cary Grant movie *My Favorite Wife*. Because Marilyn was having pill problems, showing up late or not showing up at all, she was fired. A short time after that she died.

Just like Frank had Bill Miller as his piano player, Dean Martin had Ken Lane. They were together for years, right up until the end. Ken Lane

also had a singing group called the Ken Lane Singers, and they made a lot of records with Dean. This was the same group that sang behind Frank when he was at Columbia Records during the musicians' strike. For a while, Ken worked on *Your Hit Parade* while Frank was performing on that show. Ken loved Dean, even when Dean would sit on the piano, cross his legs, sing, and tell jokes. Dean wouldn't go anywhere without Ken. He was Dean's songwriter, arranger, and road manager. He took care of everything so Dean could drink and play golf.

One night Dean invited Frank and me to his home in Beverly Hills for dinner. Frank and I got there about seven-thirty. We had a nice dinner, and Dean told us this story about his recent trip to Spain:

One night he walked into a restaurant and saw this man with a plate in front of him. What was on the plate looked like two mounds the size of inverted grapefruit halves, covered with tomato sauce and cheese.

When Dean walked past the table, the food smelled so good that he decided to order the same thing. But when he told the waiter what he wanted, the waiter told Dean that the dinner was a special order and they were out of the meal the man had in front of him. Dean ordered something else, and then asked the waiter if he could order that dish for the next night. The waiter said yes, and Dean reserved the meal for the following night. All the next day Dean savored the thought of that meal.

When he got to the restaurant he ordered the dinner he had seen the night before, but when the plate arrived at his table the portion was significantly smaller—about the size of two halves of a plum covered with cheese and tomato sauce. Jesus, Dean was disappointed, and he called the waiter over.

"How come last night the dinner filled the other guy's plate, but tonight the dinner hardly covers half the plate?" Dean asked.

The waiter looked at Dean, then at the plate, and said, "Mr. Martin, sometimes the bull wins."

With that, Frank fell on the floor and couldn't stop laughing. Where Dean got these stories, I don't know. And Frank was his perfect fall guy.

That's how the evening went, a quiet dinner with a lot of laughs, until

around ten-thirty or eleven when more people arrived, and the small dinner started to mushroom into a full-blown party. It looked as if it was going to be another all-nighter. We were having a good time and no one noticed that Dean had disappeared. The next thing I know, the doorbell rings. I go over, open the door, and see cops.

"What is it, officers?" I asked.

"There's a complaint because there's a lot of noise going on around here. Next time I have to come back, we're going to pinch everybody in here," one of the cops said.

Frank was in another room. After the police left, I found Frank and told him we had a problem.

"What happened?" he asked.

I told him what the cop said, especially about all of us going to jail if they had any more complaints about the noise.

"You're kidding. Nobody's making any noise." Then Frank asked, "Where's Shot Glass?" I told him I didn't know. So Frank waved for me to follow him.

We went through the house and finally found Dean upstairs, sitting on the edge of his bed in his pajamas.

"Hey, Dean, who called the cops?" Frank asked.

"I did."

When Frank heard that Dean had called the cops, he started to get angry. "Why did you call the cops? You invited us to dinner and now you call the cops—for what?"

"Frank, let me tell you the truth. The way you were getting on together, the way it was turning into a party, it was going to go on until four or five in the morning. I've got a golf match at six in the morning. I've got to play some guy who's been beating me up badly financially, costing me a lot of money. I wanted to get a good night's sleep so I can be in some kind of shape to beat him tomorrow. So that's why I called the cops. That way, everyone would leave and I would get some sleep."

Frank was really pissed with Dean, which rarely happened and told him, "You don't have to worry about calling the cops anymore."

Without giving Dean a chance to say anything else, Frank and I left Dean sitting in his pajamas on the side of his bed. It was about eleven thirty, and we were gone out of there. When we left, everybody else left. Why Dean invited us to dinner I don't know. He knew that Frank loved to have dinner at eight-thirty or nine, and that Frank stayed until morning. Dean should have said, "Look. Frank. Come on by and we'll have a quiet dinner, but no all-night partying because I'm going to get some sleep."

If Dean had told Frank the story, then Frank could have told him to forget it and said we could do it another night, or that just he and I could come for dinner, and then leave. But Dean didn't explain. Instead of being direct about the situation, Dean called the police to stop his own party. Frank was hot because he was looking forward to a long night of partying.

Frank and Dean had their row on Tuesday night. The following Sunday I was at the Palm Springs house when the telephone rang about five in the afternoon. I answered it and talked for a while.

"Who the hell are you talking to?" Frank asked.

Dean was on the phone. "I'm talking to the Shot Glass," I said.

"What does he want?"

"Frank, I don't know. You talk to him."

They talked for a while, and then Frank hung up and said, "Dean just bought a new car and he wants me to take a ride with him. Take care of the house. I'll go see what this bum wants to do."

Frank didn't want to go, but he went anyway. He was still angry with Dean for calling the police five nights before, but it was really impossible to stay mad at Dean for very long, even for Frank, who made a career out of being angry with people. Once you crossed Frank that was it for the rest of your life. But Dean showed up and you would have thought Tuesday night had never happened.

"Tony, I'll see you in an hour," Frank said, and then he and Dean went out the door. Frank got back about two-and-a-half hours later and when he came through the door he said, "What do you think happened with that bum and me?"

"I don't know, Frank. You two were together."

"We stopped at this bar and had a drink, then we stopped at another. Before you know it, Dean got woozy, and he started to go pretty fast. Behind us were red lights, so I said to Dean, 'Slow down. There's a red light behind us.'"

Dean said, "Don't worry. When we come to them, we'll stop."

"No," Frank told Dean, "Not the red light in front of us, the one behind us."

Dean pulled over, and the cop asked Dean if he had been drinking. Dean said, "Naw."

The cop told Dean to get out of the car and when he did, the cop got in front of Dean's car and got up on the curb. He walked a few steps along the curb, and then got off the curb.

The cop called Dean over and said, "Now, let me see you walk a straight line on the curb like I did."

Dean looked at the curb and looked at the cop, and then he looked at the curb again and said to the cop, "I'm not walking that until you put a net under it."

The cop busted up laughing and told Frank, "Either you drive this car home, or I'm going to pinch both of you."

Frank drove Dean home and drove the car back to our place in Palm Springs. The next day I drove the car to Dean's house and Dino, Dean's son, drove me back home.

Frank was a great friend. If he liked you, he would do anything for you. He would give you presents, welcome you into his house, or pick up the tab at a nightclub. The person we were closest to was Dean. One of the greatest things Frank did was bring Dean and Jerry back together again. It happened when Jerry Lewis was been doing his annual telethon, which he did every Labor Day weekend for years to raise funds to research muscular dystrophy. Frank wanted to be a part of the event that raised millions every year, because he thought it was a great charity. Frank would come on, sing a few songs, and clown with Jerry.

Dean and Jerry hadn't seen each other for more than thirty years. The

anger was so deep that these close friends hadn't been in touch since their breakup. One year during Jerry's telethon, Frank came on stage and joked around with Jerry. Then Frank told Jerry that there was an old friend backstage who wanted to see him. Frank disappeared offstage, and a few minutes later walked back on stage leading Dean Martin by the hand. What a moment! Then Dean went over to Jerry, and they hugged. I mean they hugged each other for dear life. And they were crying—and the audience was crying.

"Why did we ever split up?" Jerry asked.

They kept hugging and you could see Frank in the background wiping away tears. Frank did it because he really cared about people, and he always knew the right thing to do and how to make things happen. That was a rare moment—making peace with an enemy that you loved.

Sometime after that reunion, Dean's son, Dino, was killed in a plane crash. He was thirty-five when his plane crashed into the same mountain outside of Palm Springs that took Frank's mother's life. Dino was part of the Air National Guard. He was a smart kid. Dino had enough speed to clear the mountain and then glide on into Las Vegas. What happened is unclear, but it was either snowing or foggy, and somehow Dino thought he had cleared the mountain. Half of Dino's plane went into the mountain, and the other half landed on the other side.

When Jerry Lewis heard about Dino, he called Dean and they talked for hours consoling each other. That was a rough time for Dean and something he never recovered from. Although Dean loved all his children, I think Dino was his favorite. Dino's death destroyed him. Dean started to drink harder to forget, but eventually the drinking caught up with him. Frank thought that Dean would get over Dino's death after awhile, but Dean never did. After that, hearing news of plane crashes really destroyed him. If Dean had to do a show and heard about a plane crash, he would cancel the show.

Other than the night of the dinner party at Dean's, the only time Frank got mad at Dean was when Dean backed out of a tour. That was in early 1988. Frank, Sammy, and Dean had decided to do a reunion Rat

Pack tour. They had done a lot of publicity and booked many cities, and no matter where they went, it was going to be a guaranteed sellout. I'm not sure which town they were in, Minneapolis or Chicago, but Dean walked on stage and he wasn't just a little tight—he was stoned. There was a time when Dean could have been stoned and still able to perform, but not anymore. That was maybe six months after Dino was killed. After the show, Frank took Dean backstage and talked with him.

"Dean, look, these people pay big, big money to see us perform. If you're going to keep drinking that way, do yourself a favor, do me a favor, and get off the show, because I know what you're going through."

"You know, Frank, I got a problem."

"Why don't you go home, and we'll fill in for you."

"You're right, Frank."

So Dean left the show. Instead of letting the press know about the drinking problem. The media announced that Dean's stomach was hurting so badly that he went back home and checked into a hospital—all because he had lost his son. Dino meant everything to Dean, the same way Nancy Jr. was the apple of Frank's eye. With Dean out of the tour, Frank and Sammy had to find someone to replace him. I can't remember if Liza Minnelli, Judy Garland's daughter, signed on right away, but I do recall that Steve Lawrence and Eydie Gormé were mentioned as Dean's replacement. What started out as the Rat Pack Tour was renamed the Ultimate Event.

Dean had a way of always making Frank feel good. They pulled pranks on each other, and they really took care of each other. If Dean needed Frank to appear somewhere, Frank would be there. When Frank needed Dean to appear somewhere, Dean would be there. They were great friends. They also had an amazing ability to stay up all night. If Frank went to bed at four thirty in the morning, I would call the house doctor. Something had to be wrong with him. When we went to Florida, year after year, I never got sunburned. Do you know what I did get? Moonburned! I had to wait until Frank, Dean, and the rest of the guys went to bed, so I didn't get to bed until eight in the morning. Then I would sleep until noon, get up, have the maids straighten out the suite, and then we'd start all over again.

One time when Frank got through playing at the Sands, he knew I had put in a long stretch. He was going back to Palm Springs, and I told Frank I didn't want to go back right away. We had a week off between engagements and Frank said, "If you want to hang around Vegas for two or three days to relax and have a few laughs, be careful. When you get tired, come back home."

That was fine with me. Frank said he was going to relax for a few days in Palm Springs and forget about everything until I got back home. Then we could work out plans for the next engagement. Frank left and I stayed in our suite at the Sands. One morning, about three o'clock, I was in the casino watching a gambler called Nick the Greek shoot craps. Nick didn't gamble with his own money. People gave him money to gamble for them. When they won money, they gave Nick the Greek a percentage of their winnings.

I was amazed at the way he gambled. Nick had rows and rows and rows of white chips, worth five hundred dollars apiece, in front of him. He must have had fifty thousand dollars. There was a huge crowd around Nick, and since I knew the pit boss, he put me at the front of the table. I watched Nick the Greek's incredible run of luck, and someone must have called Frank and told him that I had been at the craps table for two hours. The person who called Frank didn't tell Frank that I wasn't gambling. He just wanted Frank to know I was at the tables early in the morning just to stir something up.

Before long I heard, "Paging Tony Consiglio. Paging Mr. Consiglio." The pit boss had a phone near him, so he told me to take the call there. I got on the phone. It was Frank.

"Tony, what the hell are you doing at the craps table at three o'clock in the morning?"

"Frank, I'm watching Nick the Greek shooting craps and how he's winning. You should see all the five hundred dollar chips he has lined up. And I can't figure out how he does it."

"You shouldn't be around there. Go back to your room."

I think Frank was worried that I might be gambling, but I was just

amazed at how Nick the Greek was beating the house. But Frank was my boss. No one stayed with Frank longer than I did, because I cared about him and he cared about me. That's how we lasted as friends for more than sixty years. I went back to the suite.

When I got there, I called Frank and told him I was in my room. Within a half hour, a tall blonde knocked on my door.

"I'm here to keep you company and make sure you don't go back to the craps table."

That's how Frank did things, to make sure I didn't brood. I would never argue with Frank. I wouldn't have said, "No, I'm staying at the craps table to watch Nick the Greek." When Frank wanted something, I'd be there in ten minutes. If Frank had called the room that night, I would have been there. But because he knew I would be there, he didn't have to call.

The blonde was a young actress from Sweden. She stayed with me for three days. The first morning I pulled up the shade and looked out the window. When I saw the rain, I went back to bed with the blonde. We stayed in bed all day and all night. I don't think we even took time out for room service. On the second day, I pulled up the shade and saw that it was still raining, so I went back to bed. The blonde didn't care, because the longer she stayed, the more Frank paid her. Again, we stayed in bed all day and all night. The next morning I pulled up the shade, and I had lost so much weight in the past two days I went up with the shade.

Here's another Vegas story. One night I had a date. I never wanted to ask Frank for money. I carried ten or twenty thousand dollars of Frank's money in cash all the time, but I would feel guilty if I spent any of that money. Usually, all I had to do was sign, "TC for FS," at any of the hotels or stores. If I wanted to have dinner at the Star Dust, the pit boss at the Sands would call the pit boss at the Star Dust, and he would arrange to have a table ready for me and for whoever I was with, and the check would be taken care of. One pit boss would help the other pit boss.

I had enough cash of my own, but for some reason this night, I had only a few dollars. I had this date with a gorgeous woman, and I wanted to

take her here and there and show her a great time. I wanted a limousine to pick her up, so I needed extra money.

I said to Carl Cohen's brother, "Jeez, I'd like to play one of these machines to win a few dollars."

"Tony, don't worry. I just got through taking care of the slot machine across the aisle. Go to that machine before anyone gets to playing it," he said.

He had just gotten through repairing it. He must have looked in the back and saw that in another fifty turns the buckaroos would come out. But he didn't tell me what was going to happen. So I went over and played the slot machine

I don't remember how much I put in, but I know it wasn't much. Next, I see four buckaroos and lights flashing. About ten dollars in coins came out, then one of the floor men who go around checking the machines for payoffs gave me the other one hundred and ninety dollars, and that's what I went out with that night. I thanked Carl Cohen's brother for letting me beat the machine.

"Don't worry about it. You didn't beat me," he said.

The pit boss's job is to oversee his area, which could have a craps table or a blackjack table. He is there to make certain the game is running right. If there's an argument, he steps in and settles things quietly so the game isn't interrupted. Years ago, when a player gave a dealer a tip at the end of the night, usually in silver dollars, the dealer motioned to the pit boss before he put the tip in his pocket. If the dealer put money in his pocket without signaling the pit boss, the dealer was violating house rules and could be accused of stealing from the casino. Now they have slots for dealer's tips. When a dealer gets a tip, he or she still has to signal the pit boss, but the money goes into the slot. At the end of the night, whatever money is in the tip box goes to the dealer. But when dealers are working, they are never allowed to touch money. And with all the cameras in casinos today, if you took in too much oxygen, someone would know about it. If a dealer or any employee of a casino sees a coin on the casino floor and picks it up, they get fired. No questions asked.

Every now and then Frank and Dean would take over the casino tables at the Sands. When Dean dealt blackjack, he drew so many people from the Copa Room and the lounge into the casino.

Before Dean got into show business, he had been a dealer in a casino. So when Dean got behind the table, he knew what he was doing. Frank had never been dealer.

When Dean got a few drinks in him, he would say, "I want to be the dealer," and the pit boss would let him because Dean was a headliner and drew people. If a customer had twelve and Dean had nineteen, he'd say that twelve won and give the chips to that player. If someone had twenty-eight Dean said it beat everyone and pushed the chips to that player. Dean gave money away. If you lost, you won. If one player had twenty-six and another player had twelve, Dean told them, "You both win." People loved it. Dean did that for a half hour or so, just to make people laugh. Carl Cohen, who was vice president of the Sands, got upset and tried to stop Dean, but Jack Entratter, who was the president of the Sands, didn't care, because Frank and Dean drew so many players to the tables.

As soon as Dean left the table, the pit boss moved in and closed the table, so no one could play. The pit boss had to figure out how much was missing, so the dealer wouldn't be accused of irregularities. Even back then, in the 1950s and 1960s, there were TV cameras over each table, just to make sure that the games were on the up and up. That way, a dealer couldn't take care of a friend by saying that his hand won. Everything was on camera, and the dealer would be caught. Today, you'll never see two entertainers take over a casino. Frank and Dean were remarkable people, and their fans loved them. Believe me, they lived life to the fullest.

Photo Insert

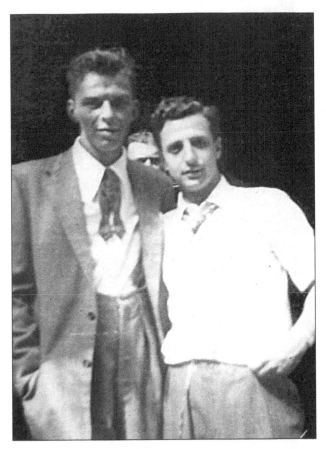

One of the earliest photos of Frank and Tony, circa 1940.

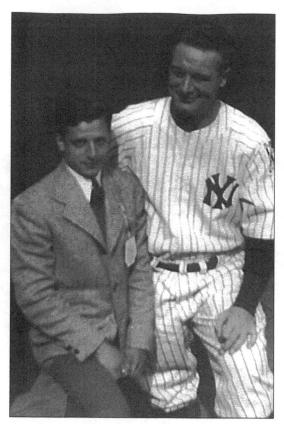

Tony with Yankee great Lou Gehrig on the steps of the Yankee dugout on July 4, 1939, the year Gehrig gave his farewell speech.

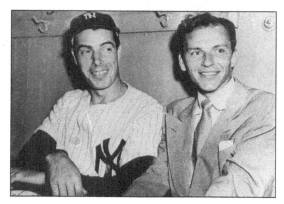

Tony snapped this shot of Frank and Joe DiMaggio in the dugout before a game at Yankee Stadium in the early 1940s.

Left to right: Tony's sister Sara, Frank, and Tony, relaxing at the Astor Hotel during the early 1940s.

Frank and Tony looking dapper circa 1945.

Tony, center, with Frank's father, Marty, and Frank's mother, Dolly. Frank's parents were visiting Tony's house in New Haven, Connecticut.

Tony with Frank's first wife, Nancy, in the early 1940s in Hoboken, New Jersey.

Tony helping guide Frank's daughter Nancy on her tricycle in the early 1940s in Hoboken, New Jersey.

Tony plays with Frank's dog, Ring-Ding-Ding.

Frank, Tony, and Ziggy Elman at the stage door of the Capitol Theater in Hartford, Connecticut, in October 1942. Frank had left Tommy Dorsey's band only a few weeks earlier.

Tony with drummer Buddy Rich outside of Tony's New Haven, Connecticut, home. Buddy Rich was a member of Tommy Dorsey's band, and Frank helped him get out of his contract with Dorsey.

Three rare photos of Frank in uniform. Frank was designated as 4-F and could not serve in the military. But he performed with the USO entertaining troops during the war. These photos were taking in 1945 in Newfoundland.

On many occasions, Tony would watch Frank's kids. Here he is in the 1950s watching Nancy, Tina, and Frank Jr. on a New Jersey beach while Frank sleeps.

Tony backstage with singer Edythe Wright in the early 1940s.

Tony, circa 1954, with actor Don Ameche and New York Yankee greats Yogi Berra and Tommy Henrich.

This photo was taken in the early 1950s at the 500 Club. Tony, second in back from the right, along with Skinny D'Amato, Frank, and an assortment of "friends" and female companions.

Tony clowning with Dean Martin (left) and Jerry Lewis (right) at the Paramount Theater in New Haven, Connecticut, at the height of the comedy duo's popularity in the 1950s.

Tony with Kim Novak on the set of *The Man with the Golden Arm* in 1955. She slipped her hand under Tony and said, "It's more interesting this way."

Tony poses separately with Bud Abbott and Lou Costello backstage before an Abbott and Costello performance in the late 1940s. By this point in their career, Abbott and Costello no longer spoke to one another offstage and refused to be photographed together.

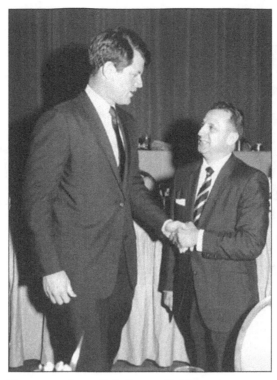

Tony greets future U.S. Senator Ted Kennedy at a campaign stop during the 1960 JFK presidential campaign.

Tony with Pierre Salinger at a JFK campaign event in Las Vegas in 1960. Salinger would become JFK's press secretary after the election.

On election night, 1960, Tony was at the Kennedy compound in Hyannis, Massachusetts. Early in the morning after election night, when results showed that Kennedy was the victor, Tony wanted to capture the moment. Here he is with Joseph Kennedy, who is still wearing his sleeping robe.

Roger Eden, Frank, and Tony aboard the JFK campaign plane "Caroline" in 1961 heading to Washington, D.C., to plan the JFK inauguration.

Tony in the White House library on one of his
many visits to the White House during JFK's
presidency.

Tony boards the Kennedy plane "Caroline" on his way to
return some of JFK's shirts.

THE WHITE HOUSE

WASHINGTON

February 20, 1961

Dear Tony:

It was so nice to meet you yesterday
and the President appreciated very much your
bringing his shirts to Washington.

I hope the next time you are in Wash-
ington you will stop by the White House to
see me.

Sincerely,

Evelyn Lincoln

Evelyn Lincoln
Personal Secretary to
the President

This letter was sent to Tony by JFK's personal secretary, Evelyn Lincoln, thanking Tony
for returning JFK's shirts.

Tony with JFK and Sam Giancana mistress Judith Campbell Exner.

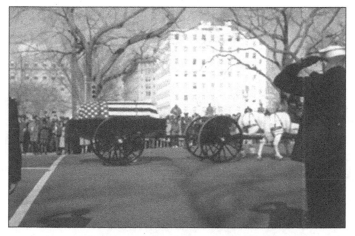

Because of Tony's friendship with Peter Lawford, he was able to get a special pass during the Kennedy funeral procession allowing him close access. This is a photo Tony snapped as JFK's coffin passed by.

Frank and Tony backstage
before one of Frank's shows in
the early 1960s.

Tony with actress Juliet Prowse.

Left to right: Hotel magnet Barron Hilton, Tony, boxing champ Rocky Mar-
ciano, and Toots Shor circa 1960.

Tony poses with singer Tony Bennett back-
stage before one of Tony's concerts in Miami
during the 1960s.

Tony overseeing Frank Sinatra, Jr.,
as he practices his piano.

Frank and Tony backstage at one
of Frank's concerts in Providence,
Rhode Island, in the early 1980s.
Frank is saying, "How long is this
going to take?"

FRANK SINATRA

June 17, 1985

Dear Tony,

So happy to hear from you...delighted you're raising a wonderful family. I'm well and everything going fine.

I often think of you and the wonderful times we had together...think of your Mom and Dad with fond memories.

Sending you much love and wish you and your family the very best of luck always.

Take good care of yourself.

Warmest regards,

Frank

One of the many letters Frank sent Tony.

Tony with Frank's daughter, Nancy, after one of her concerts at
The Sting in New Britain, Connecticut.

Tony with heavyweight champion
Muhammad Ali in the late 1990s.

Tony with NBA great Larry
Bird in the early 1990s.

Whenever Frank performed at Foxwoods Casino in
Connecticut, the casino would commemorate the event by
issuing special gambling chips with Sinatra's portrait and
famed signature.

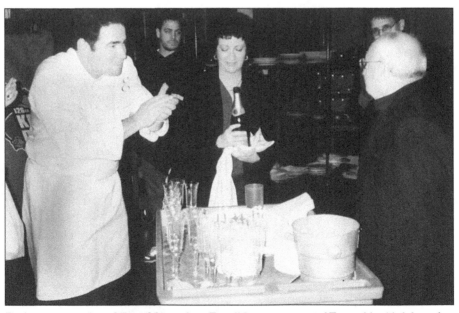

Backstage at a taping of *Emeril Live*, where Emeril Lagasse presented Tony with a birthday cake.

CHAPTER 19: THE FONTAINEBLEAU: JACKIE, JOE, AND MARILYN

Another amazing man was Jackie Gleason. Jack and Frank went back to the days when they were both starting out, running up tabs at Toots Shor's restaurant. One Friday the bell rang at the Japanese-style house Frank had built at the end of Mulholland Drive. It was a very small house, only two bedrooms—one for Frank and one for me. There was another building off to the side with a projection room in it so Frank could show movies whenever he had people over. At the end of the driveway, there was a gate. Frank didn't like surprises.

Whenever someone approached the gate, an electric sensor triggered a bell that rang in the house. One afternoon the bell went off, and Frank told me to see who was there. When I got to the gate, I saw a big limousine with Joe DiMaggio, Jackie Gleason, and two gorgeous dolls inside, already semi-stewed. We had a phone at the gate so I told Frank who it was, and I opened the gate so the limousine could drive up to the house.

This was Jackie and Joe's first trip to Frank's house. When they came in, they admired the house, but they didn't see many rooms. Jackie and Joe might have brought the women thinking that they could stay the weekend and have a ball. But they could see that there just wasn't enough room. Frank knew what was going on, so he said he would order some food and they could have a good time.

Jackie turned to Frank and said, "No, Frank. Joe and I just came up to see the house and wish you luck with it." They had a few drinks and

Jackie, Joe, and the two women left. Another time when Jackie showed up Frank and I were staying at the Fontainebleau.

By this time, Jackie had moved his top-rated TV show from New York to Miami. That was unheard-of at the time. New York was the show business capital, but Jackie didn't care. He hired an entire train and moved his show, including actors, dancers, and writers to Miami. I'll bet that was one crazy train ride to remember. When you spent enough time with Jackie, you kept experiencing the unheard of. Not only was he a great comedian and the creator of *The Honeymooners*, he was a successful music conductor and composer. And some people forget what a powerful dramatic actor he was. He starred opposite Anthony Quinn in *Requiem for a Heavyweight,* and he played Minnesota Fats in *The Hustler,* starring Paul Newman. In that movie, Jackie does all the pool shooting. No stand-in for him. He was quite a man.

Jackie was in our suite at the Fontainebleau and said he wasn't feeling well and wanted to go back to his apartment. This was at three-thirty in the morning and Frank wanted to keep going. Frank tried to talk Jackie into staying, but Jackie didn't keep the same hours as Frank did. Frank was disappointed because he thought Jackie would stay the whole night, and we'd have a few laughs. Frank told Jackie to go ahead and Jackie left. But Frank was still a little upset. Around five-thirty in the morning, Frank told me to call the switchboard, tell them not to allow any calls through to our suite, even if it was an emergency, and shut the phone off completely.

When that was done, Frank said, "Call up Gleason. Tell him to get up right away. Tell him to turn the TV to channel 4. Something really exciting happened in the country."

So I called Jackie, who was still half in the bag, half asleep, and hungover. He said that he'd been asleep, and I could tell by his grunting that he wasn't too happy to hear my voice before the crack of dawn.

Jackie growled into the phone, "Whaddaya want, Dago?"

"Jack, get up. Something really exciting happened in the country. Frank and I are watching it. Quick, put on channel 4. You'll love to see what happened."

"You sure?" Jackie asked.

"I'm positive," I said then hung up the phone. Jackie got up and turned on the TV.

Television wasn't like it is now, going twenty-four hours a day with two hundred channels. If you lived in a big city, there were four or five channels that shut down around one in the morning and came back on at six. The only thing that was on the TV screen after sign-off was a test pattern with the call letters of the channel and a high-pitched hum from the transmitter. When Jackie turned on the TV, he found nothing but test patterns. Jackie knew he had been had, so he tried to call Frank and tell him a thing or two, but he couldn't get through. He called the switchboard.

"I'm Jackie Gleason and I've got to talk to Frank."

The operator on duty, following Frank's instructions, said, "I'm sorry. I can't get through."

The next day Jackie saw me and said, "Dago, I'm not blaming you, but I know that skinny guy did it. He's the one. I'm going to get him. Believe me, I'm going to get him." But nothing ever happened because Jackie loved Frank. They went back a long a way.

Frank and I spent a lot of time at the Fontainebleau. It was really a palace. Nothing like that had been built in Miami before then. It took more than a thousand men to build it. In those days, it had a 17,000-foot lobby and a grand staircase that didn't lead to anywhere, but it looked great. Ben Novack built the Fontainebleau. His mother had operated hotels in the Catskills, so he more or less grew up in the hotel business. Ben outfitted the Fontainebleau with statues and antiques from all over the world, and the place looked like Xanadu from *Citizen Kane*.

Ben was a very sweet man, so you know Frank was going to screw around with him and drive him crazy. Ben was thin and pale. He looked old when he was born, so he looked like a wreck at thirty-five. He had a hearing problem and wore one of those big hearing aids with the wire running up from the small, black amplifier in his starched, lily-white shirt pocket. I was very close to him. Every year Frank and I went there, Ben would say, "Anything Frank wants, call me. I'll take care of it." At various

times, Jack Benny, Joe DiMaggio, Muhammad Ali, Bob Hope, and Marilyn Monroe lived there.

No sooner had work on the Fontainebleau finished when somebody bought the land next door and built the Eden Roc, another gorgeous hotel. Ben wasn't getting much business because people were flowing into the Eden Roc since it was new and different. But Ben hadn't been born yesterday. To get the business away from Eden Roc, Ben built a seventeen-story addition to the Fontainebleau that cut off the sun from a large section of Eden Roc's windows and cast a shadow over the Eden Roc swimming pool. That was back in the 1950s when Miami was known as the American Riviera.

When Frank played at the Fontainebleau, we stayed in the presidential suite. When Ben built his addition, Frank and I stayed in the penthouse suite. Frank got paid a certain amount, and then above that, Ben picked up the tab for all our expenses. That was the deal. He took care of our housing, our food, and the tabs for our friends when Frank performed at the Fontainebleau. Ben didn't mind because he knew in Frank he had the hottest star at the greatest hotel in Florida. The two things went together: Frank Sinatra and the Fontainebleau. Frank always played there for two weeks in early March. That way the people who had come to Miami for the winter would stay an extra two weeks. Frank would play there until March 15 or 20, bringing in money that Ben would have lost without Frank keeping the snowbirds in Miami for an extended stay.

Frank performed at the Fontainebleau in the La Ronde Room, which was an elegant dining room. But it wasn't small. The La Ronde Room had a seating capacity of at least eight hundred, maybe a thousand people. At the time, the maître d' was named Cookie Goodwin. Frank had a rule that when he was on stage: no food or drinks could be served during his performance. He didn't want to put up with distractions of any kind. You could be lying on the floor dying, but you would have to wait until "Come Fly With Me" was over before you could get ambulance service. If you ordered a drink and the cocktail waitress had not brought it to you before Frank started singing, no way would you get the drink. If you suddenly had

to use the men's room or the powder room, you didn't dare get up and attempt to leave the La Ronde Room and incur insults from Frank. You scrunched your ass and waited till intermission. But the La Ronde Room is no more.

In contrast to all the elegance of the Fontainebleau and Eden Roc, down the street from both of them was the Broad Ripple. You paid ten dollars for the room, but you stayed up all night. You had to. This and that came crawling in and out of the walls and up through the plumbing. It was a flophouse surrounded by elegance, an impacted tooth in the mouth of opulence. But a lot of entertainers stayed there because they couldn't afford other places.

When Frank and I were staying at the Fontainebleau, the sun came blazing through our windows. Of course, that was a problem for Frank because he usually didn't get to sleep until dawn. I got hold of Ben Novack and told him to install thick, black drapes behind the curtains in Frank's bedroom, so at eight o'clock, Frank's bedroom would look like midnight. It had to be pitch black or else Frank couldn't sleep. Frank didn't have to say to me, "Tony, I can't sleep." I took care of things before they became a problem. I would know what to do before we got there. Sometimes I would go to the Fontainebleau two days in advance to set everything up: the black drapes, the flowers, whatever Frank needed. When Frank walked in, it would feel like his home. He didn't have to worry about the details; instead, he could concentrate on getting ready to perform.

At the Fontainebleau, we had a door with a compartment inside. I could open it from inside, put Frank's tuxedos in, and then close it. The valet in charge of dry cleaning could open the door from the hallway. He would take Frank's tuxedos, dry-clean and press them, and put them back in the compartment without bothering us.

We always had three tuxedos. That way, if I sent two tuxes to be cleaned and pressed and neither of them came back in time for Frank to do his show, we always had the third one ready. I gave instructions that Frank's shirts were not to be folded, but put on hangers so there wouldn't be any wrinkles. Frank would tell me which set of cuff links he wanted to

wear. I would go to the jewelry box in the attaché case, get the cuff links, and put them in his shirt. When Frank put a shirt on, everything was ready. All he had to do was button it. Frank didn't like to waste time and these were the things he didn't want to think about. I had everything ready. All he had to do was perform and remember his songs, and that was it.

One time I made a mistake. I gave Frank a shirt in a hurry so he could get ready for his show. I didn't notice that the bottom of the right cuff wasn't pressed right. Part of the cuff had been folded over about a quarter of an inch and then pressed. Frank called me into his bedroom where he was getting dressed.

"Come here, Tony. Look out the window."

I looked out and saw people by the pool down below. They looked like little ants, that's how high up the presidential suite was.

"I'm going to tell you once. Next time a shirt comes back like this and you hand it to me to wear, you're going to be among those people by the pool." You can bet I never let that happen again.

Another time, Frank asked me to call Gloria Lovell in California and have his golf clubs sent to the Fontainebleau in Miami. This surprised me because I had never seen Frank play golf. A few days later, I went in to see Frank.

"Frank, the golf clubs came in. What golf course are we going to?"

"The one right here."

"Where?" I asked.

"Right here, in the living room," Frank said.

I had to move the piano into the corner and move the coffee table back. We had a long, large living room at the Fontainebleau. Frank would putt the ball from one end of the living room to the other, which was about thirty-five or forty feet. He would do that just to relax himself. I would pick up the golf balls and bring them back to him, and he kept putting. We were playing golf in the suite. Would you believe it? But what was Frank going to do? He couldn't go to a golf course. Ben Novack had asked Frank to go golfing several times. He thought it would be good for business. Ben told Frank that he was going to make special arrangements so no one else

would be around, but Frank knew that wouldn't be the case. Frank got up late in the afternoon and got himself ready for his shows. Ben suggested that Frank get up at eight o'clock to play golf right around when he would normally get to bed. You can bet he wasn't going to stay up all night, play a round of golf, then go to bed. If Frank had gone out to play golf, he would have gotten mobbed and never would have gotten off the course. Then he'd be too exhausted to put on a good show. Frank told Ben to forget about it. All Frank could do was putt back and forth in the presidential suite.

Frank and I were at the Fontainebleau one day and a fellow who ran a nice bar stopped by. His place was in downtown Miami. He asked Frank to please stop by his place. Frank didn't like to travel in Miami because wherever he went there would be a hassle, but the man kept pestering Frank, so Frank said, "Let's go."

On the roof of his restaurant, the man had a beautiful billboard about twenty feet high with a picture of Frank wearing his fedora at a jaunty angle with his arms reaching out. There was a floodlight shining on the billboard so people could see it at night.

Frank and I walked into the restaurant. There was a long bar, and all along the bar the man had displayed all the albums that Frank had made on the walls. He had a jukebox with nothing but Frank's records in it. This place was like a Sinatra museum. Frank and I sat at the bar. I ordered a coke and Frank ordered a drink. The place was perfect, except for one mistake, which is why Frank and I didn't stay and why we never went back.

At that time, comedians were making jokes about Frank's thin body and how he needed to eat Wheaties, the "breakfast of champions." On his best day, Frank hated those jokes. This guy had a big box of Wheaties on top of his cash register. Frank saw the box of Wheaties and didn't like it. The guy had everything right, except for this box of Wheaties. Frank didn't finish his drink.

Frank put a hundred-dollar bill on the bar and said, "It was a pleasure stopping by your bar and seeing you. I'll be back again."

"Thanks for stopping by, but I thought you and Tony were going to stay for dinner," the guy said. The owner didn't get why Frank and I were leaving.

"I'd like to, but we have other plans," Frank said, and we left.

Another restaurant owner came up to Frank after a show and said to Frank, "Why don't you come into my bar, just say hello, and I'll give you five thousand dollars, and you can leave."

Frank said to me, "Call that guy up. Tell him for five thousand dollars, we're going to drive by his restaurant in a convertible with the top down at a hundred miles an hour."

One afternoon I ran into Joe Fischetti, Al Capone's cousin, in the lobby of the Fontainebleau Hotel. I said hello, and he waved me over. He said he wanted to ask me a favor. Well, with these guys, you had to be careful. They didn't go about things the way most people do. If you caused a problem, you were gone.

"Sure, Joe. What can I do for you?" I said.

"Tony, I like the dishes here. They have 'F' on every dish, and 'F' is the first letter of my last name. What I want from you is to get me a complete set of dishes, you know, cups, saucers, dinner plates. The whole works. Okay. So how long would it take?"

What the hell was I going to say? "Sorry, Joe, I can't do it." That wasn't even part of the question. Joe didn't ask if I could do it; he asked me *when* I was going to do it.

"Joe, I'll get it done, but it'll take a while."

"Great, I'll see you by the end of the week. So long," Joe said.

I went upstairs and told Frank what happened with Joe. Frank gave me a lot of comfort. He said, "That's your problem, Charlie. You're going to be very busy the rest of the week."

Frank was right. I was very busy. Every time I ordered breakfast or dinner from room service, I asked them to send up extra plates, silverware, and napkins, because everything had an "F" on it. I wrapped the extra dishes and cups in newspapers and packed them in boxes that I got from the stores in and around the Fontainebleau. I told the owners I needed the box-

es because I was moving across town. I knew if I didn't get all the dishes that Joe wanted, I really would be moving—not across town, but straight down.

By the end of the week, I told Joe that I had the dishes ready, and he sent one of his mugs to pick up the boxes. An hour later, I got a call from Joe telling me I hadn't sent enough dishes, cups, saucers, and silverware. I sent over only enough place settings for three or four people. Joe wanted place settings for twelve. It took a few more weeks, but I got all the dinnerware and dinner napkins Joe wanted. Here was a guy who had Cadillacs, a villa, a speedboat, and millions in loose cash, yet he was too cheap to buy dishes. I wondered what was going on in the kitchen in the Fontainebleau, while the waiters wondered where all the dishes had gone.

One Tuesday afternoon, I got a call from Joe asking to meet me by Beau Jack's shoeshine stand outside the Fontainebleau. Great, I thought, he's going to thank me for all the dishes and maybe lay some money on me. But I was wrong. Joe was not happy.

"Tony, you really fucked up big time."

"Jesus, Joe. What's the problem?" My knees were shaking. You don't play around with these guys. Screw up and you're gone.

"I counted everything, Joe. There was twelve of everything. Twelve dinner plates, twelve soup bowls, twelve cups and saucers, twelve knives, forks, and spoons."

"Jesus, Joe, knowing it was for you, I was very careful."

"You screwed up, Tony."

"Joe," I said, "whatever the problem is, I'll take care of it."

"You bet your ass you will."

"So Joe, what's the problem?"

"Tony, I opened all the boxes, I took care of it myself, and everything is there, but there are no luncheon napkins. How is that going to look?"

"The Fontainebleau has luncheon napkins? What's a luncheon napkin?" I asked.

"Tony, you asshole, a luncheon napkin is like a dinner napkin but smaller, *Capisce?*" And he knocked me on my forehead.

"Jesus Christ, Joe, Frank and I don't get up early enough to have lunch."

"Okay, Tony," Joe said. "Get me the fucking luncheon napkins, and I'll forget there's a problem. And another thing, I don't like it when you take the Lord's name in vain. You know that's a very big sin."

"Okay, Joe," I said, "I'll watch it, and I'll get the napkins by Friday."

"Just make sure they're luncheon napkins, twelve of them." And with that, Joe walked into Beau Jack's to get his shoes shined. I went back to our suite to change my pants.

Joe DiMaggio had a cabana out on the beach at the Fontainebleau. It was set up permanently just in case Joe needed it, but he seldom used it. Whenever Frank played the 500 Club or the Fontainebleau, Joe was always around. Some mornings, even though I was up at nine thirty or ten, I knew Frank would sleep until four. We had strict orders with the management that no phone calls or messages were to come to our suite until four. With that in mind, I had enough time to visit with Joe on the beach. I had known Joe since 1936, his first year with the Yankees. I have a bunch of photos of Joe, from his first World Series when I was a batboy for the New York Giants and from our days together in Florida.

When anyone talks about a graceful ballplayer, Joe DiMaggio's name always comes up. He played with the New York Yankees from 1936 until 1951, except for three years during World War II. In 1941, Joe hit in fifty-six consecutive games, which is still a record. After his career was over, Joe married Marilyn Monroe. Their marriage didn't last a year, but Joe's love for Marilyn lasted until he died. Joe had flowers sent every day to her gravesite. When she died, Joe took over the funeral. He kept it dignified and paid for everything. That's just how he was—quiet, distant, and dignified until he knew you.

For a long time Joe was a close friend of Frank's. Whenever Frank played at Skinny D'Amato's 500 Club, Joe would come by to watch the show. Frank made sure that Joe had a suite all his own at the Claridge. Frank put Joe's suite on his tab, but Frank never paid for it. Either Skinny D'Amato or the Claridge took care of the bill. Frank never had to pay for

anything while he was there. I would sign, "TC for FS," but we never saw the bill. It never came to Frank because I would have seen it. Everything had to come through me before it went to Frank.

One night Frank, Joe, and I were having dinner at the Villa Capri, in Los Angeles. They talked business at one table while I sat at another table. Joe received a phone call, and in those days, the waiter brought the telephone attached to a long cord to the table and plugged the phone into a phone jack in the wall. I could hear Joe say, "Yeah," and "Okay," and then he hung the phone up. Joe was excited about something and I heard him ask Frank if he'd take a ride with him. Frank loved Joe, so he said okay.

Joe said, "Let's go see what's happening."

Frank wanted to be a big shot, so he went. Frank knew Marilyn. She was afraid of him, just like a lot of people were. That was his wall. He created a barrier of self-defense to keep people away. Oh, yeah. She loved Frank. Frank came over to my table and said, "Let's go. We're going somewhere."

He didn't say anything else. As I drove the car, Joe would be giving me directions: Take a right, take a left, another right. I was driving a Lincoln Continental, and it was like steering an ocean liner. It didn't do well taking corners at high speeds. We drove about four or five minutes and came to some buildings.

"Wait here, and keep the motor running," said Frank.

I turned off the headlights and waited in the car. About twenty minutes later, Joe and Frank came running back to the car.

"Let's go, Tony, back to the restaurant," Frank said.

I didn't know if they went to visit somebody. I didn't care. I knew better than to ask Frank what happened. Nobody said anything.

In the rearview mirror, I could see Joe shaking his head back and forth. Two days later I read in the *Los Angeles Times* that Joe and Frank had broken into someone's apartment, thinking Marilyn was in there, but she wasn't. Joe had hired someone to keep an eye on Marilyn, and Joe was given the word that she was in the apartment with some guy. The problem was that Joe and Frank had broken into the wrong apartment. Instead of

Marilyn, they found an old woman asleep in her bed. Imagine what that was like. You're asleep in your apartment, and suddenly Joe DiMaggio breaks down your door. And standing next to him is Frank Sinatra.

With their reputations and their money, they took care of the situation. They hadn't hurt anybody. Whatever damage had been done was paid for. Joe figured that the person who called and told him that Marilyn was in an apartment with someone else was sincere and had the right information. Maybe the information was right, and Marilyn left before Joe and Frank got there. We didn't know. Just like Frank loved Ava, that's how Joe loved Marilyn. Frank would fly halfway around the world to see what was going on with Ava. If he heard that Ava was seeing a bullfighter in Spain, Frank would drop everything and fly to Spain. Frank had that kind of passion for Ava. And Joe would break down doors if he thought something was going on with Marilyn.

At one point in their lives, Joe stopped being friends with Frank. Joe believed that it was Frank who had introduced Marilyn Monroe to President Kennedy, because Joe knew that Frank had introduced Jack Kennedy to a lot of showgirls when Kennedy was a senator hanging around Las Vegas. But Joe was wrong. It was Peter Lawford who introduced Marilyn to the president and to the president's brother, Bobby Kennedy. Because Joe knew how Jack and Bobby treated Marilyn, he hated the Kennedy crowd. Marilyn was defenseless and easily led, and Joe believed Jack and Bobby were using her when she was having emotional problems. Because Frank was a friend of the Kennedys, Joe figured that Frank was part of the problem when it came to Marilyn. Joe was so in love, so wrapped up in Marilyn, that he couldn't see the whole picture. He didn't realize that Frank was no longer deeply involved with the Kennedy family, especially after Frank had a blowup with Bobby Kennedy over Cal-Neva.

Jack and Bobby were interested in Marilyn for only one thing. But they were Catholics. No matter what, neither Bobby nor Jack would ever dump their wives for Marilyn Monroe. No way. At one point, Frank saw how troubled Marilyn was, so he brought her to the Cal-Neva Lodge. He

was a compassionate person, especially when one of his friends was having problems. Marilyn was way down. She had been fired from *Something's Got To Give*, the movie she had been making with Dean. She was late quite often. One of the times Marilyn didn't show up on the set, she was in New York, at Madison Square Garden, singing "Happy Birthday" to President Kennedy. When the people at Twentieth Century Fox found out, they didn't fine or suspend her; they went ahead and fired her.

Marilyn was a major star and an icon. Even so, in those days, when an actress who had relied on her face and figure got to be in her mid-thirties, the studios pushed her aside and started promoting young starlets they had under contract such as Elke Sommer, Anita Ekberg, and Ursula Andress.

That's what happened with Marilyn. She was thirty-six, out of work, and essentially unemployable in Hollywood. So many other things seemed to tumble down around her. A lot of her friends saw trouble, and they were gone. But Frank wasn't like that. He remembered how things were for him in the early 1950s when he lost both his movie and recording contracts. He thought he could help Marilyn. But, really, there were too many pieces to put back together. All the compassion in the world couldn't bring her back.

A month after Marilyn had sung "Happy Birthday, Mr. President," she was dead, and Frank was down. Frank felt terrible, helpless, and even worse when he found out Joe DiMaggio had made all the arrangements for the funeral, kept it very private, and didn't invite him. If Joe had known what Frank went through to help Marilyn, he would never have kept Frank away from the funeral. He would never have spent all those years blaming Frank for introducing Marilyn to the Kennedys. The tragedy within the tragedy is that Joe and Frank never got to be friends again.

When Marilyn died, Joe wouldn't let anyone connected to the Kennedys or to the Hollywood crowd attend the funeral. That especially hurt Frank because he had become very close to Marilyn and had tried to bring her out of her battle with depression. Frank was her best, most caring friend toward the end of her life. Years later Joe understood that, but while he was filled with anger and bitterness over the loss of Marilyn, he

couldn't see it. And Frank, who had been through it all, understood what Joe was going through but couldn't do a thing about it.

Before Joe married Marilyn, he was married to Dorothy Arnold, an actress, and they had one son, Joe DiMaggio Jr. Joe and Dorothy were divorced in the late forties, a few years before Joe met and married Marilyn. Joe Jr. went to Yale for one year, and Joe asked me to keep an eye on his son whenever I was in New Haven. Joe Jr. started at Yale in September of 1960. On one of my trips back to New Haven, I visited Joe Jr. at his dorm room. He had nothing. No couch. No furniture. So I went to Lincoln Furniture on the corner of State and Elm streets and bought Joe Jr. a couch, a bureau, a couple of chairs, and a few other things to make his dorm room livable. I paid for everything and had the furniture delivered. Joe Jr. said that he'd have his father take care of the bill, but I told the kid not to worry about it. I never saw the money, which I didn't care about because I loved the kid and I loved Joe. I don't know what it was, but Joe and his son were never very close.

Joe Jr. was a small kid. He played only one sport at Yale: football. All he did was come out after Yale scored a touchdown to kick the extra point. That was it. He was Joe's son, and they had to play him somewhere. He never got his uniform to look like he played in a game. What he majored in, I still don't know.

One night in Miami, Frank invited Leo Durocher, Jackie Gleason, Sammy Cahn, Jimmy Van Heusen, Joe DiMaggio, and me to see the third Floyd Paterson–Ingemar Johansson fight. At ringside, I sat next to Joe. Before the fight started, Joe asked me how Joe. Jr. was doing.

"Joe, when I go back to New Haven, I check up on Joe Jr., and I don't like what I hear. I hear that he's never in his room and that he's hanging around with the wrong people. They are not people you can trust, and because he's got a famous father, I'm afraid something could go wrong. They take him here and there, and he's not paying attention to what he's supposed to be doing at Yale." Then I told Joe to check into it before he took my word for it. Joe asked what he should do, and I told him, "If I were you, I'd take him out of there, because he doesn't know

what he's getting into. The people he's with are not the right people he should be hanging around with. But check with Joe Jr. before you take my word for it. Talk to him."

That was enough for Joe. Sure enough, when the end of the school year came around, Joe had his son moved out, and Joe Jr. didn't go back to Yale for his sophomore year. I haven't seen Joe Jr. since then. I never saw him with his father in the years when Joe would pal around with Frank and me. I don't know what happened between Joe and Joe Jr., but they never saw each other. I heard Joe Jr. ended up working in a junkyard in New Jersey and never got together with his father. Joe died on March 8, 1999, and then a few months later his son Joe Jr. died. Joe Jr. was only fifty-seven, so whatever happened had between them, it was too late to resolve.

CHAPTER 20: FRANK, THE PIANO, AND
THE MAD BIRD

When Frank and I were at the Fontainebleau, we always had a piano in our suite so Frank could practice at any time. When Frank woke up at his usual time, the first thing he'd do was have breakfast. Then he would go to the piano and sing, "Come and take a walk with me," over and over to loosen up his vocal chords. He did that every day over the years when he had a show to do. "Come and take a walk with me." "Come and take a walk with me." Over and over every day without fail, maybe a hundred times, and I would sit there, sort the mail, and listen.

When Frank finished his vocal exercises, I would bring him a hot cup of tea with honey in it. Then one day there was a problem. When you have a piano by a window near the salt water, the keys go bad, the frame holding the strings begins to warp, and the piano goes out of tune. At the Fontainebleau, we had the windows opened much of the time. The salt air, over a period of a few years, ruined the piano.

This was a grand piano. So Frank opened the piano and fit the prop stick onto the back lid so the lid would stay open. He looked in and he saw two huge cockroaches walking along the strings. Frank winked at me and that always meant one thing. He wanted cherry bombs, something we always carried with us for the hell of it. *Holy Jesus Christ*, I said to myself, *What's Frank going to do now*? I went over to the attaché case, got two cherry bombs, and gave them to Frank.

"Stand back!" Frank said, as he lit the two cherry bombs, tossed them into the piano, and then lowered the piano lid. *VaBoom!* Smoke rose from inside the piano and out the bottom of the frame.

"Now what?" I asked.

"Now you've got a job. Call Deafy." Deafy was Ben Novack, who managed the Fontainebleau and had trouble hearing. "When you get him on the phone, say, 'Mr. Novack, turn up your volume control.'" Frank said.

I got Ben Novack on the phone and said, "Mr. Novack?"

"Yes, Tony. What can I do for you?"

"Mr. Novack, we've got a problem."

"What's the problem, Tony?"

"Can you hear me, Mr. Novack?"

"I sure can."

"Mr. Novack, the piano in our suite is out of tune. Frank says if we don't get a new piano up here in a half hour, we're not going to do the show tonight."

Sure enough, a new piano was up in our suite within a half hour. One of the hotel people asked me what was wrong with the piano.

I told him, "It's out of tune."

The guy lifted the piano lid, looked inside, looked at me, and said, "Out of tune? This piano has got to go to the dump!"

All the hammers were blown up, the strings were bent in every direction, and you could still smell the sulfur from the two cherry bombs.

I always carried the attaché case with the cherry bombs with me and the other attaché case with the thirty to forty thousand dollars in jewelry. We also carried a round hatbox containing ten to twenty thousand dollars in cash everywhere we went. After Frank made it big at the Paramount Theatre in 1942, I never saw Frank with a five- or ten-dollar bill. He carried only fifties and hundreds.

Frank told me once, "You don't wear a hat, but don't ever let go of the hat box. You go to the men's room, you take it with you no matter where you go."

Every time Frank wanted a pack of hundreds, I would open the hatbox and give it to him. He knew he could trust me. He would go out at night and come back with nothing. He would give a hundred to a door-

man, a hundred to a waiter. You name it. Anybody who did something for him, he gave money.

Here's another cherry bomb story that took place at the Fontainebleau. Jimmy Durante was playing next door at the Eden Roc. Jimmy came up to see us one afternoon and said to Frank, "I've written a new song called "The Mad Bird," and I want you to tell me what you think."

"Okay, let me hear it." Frank said.

Frank and I sat on the couch and Jimmy stood at the piano with his back to us, playing and singing about the "mad bird." At the end of each chorus, Jimmy kept on playing and would ask in his raspy voice, "How do you like it, Frank?"

"Very good, Jimmy. Keep playing it." Frank said and gave me a wink

Oh, Jesus. Now what, I thought, knowing that wink meant for me to get a cherry bomb.

I got up from the couch, walked by Jimmy, and went to Frank's bedroom. I got a cherry bomb, came back, and gave it to Frank. Meanwhile, Jimmy was standing at the piano, still singing about "the mad bird." I don't know how he did it, but Frank lit the cherry bomb and managed to roll it right between Jimmy's legs while he stood playing the piano. It stopped right under Jimmy, and then it exploded.

Jimmy turned to Frank and said, "Okay, Frank. That's the end of 'The Mad Bird.'" Jimmy walked out, and we didn't see him for days. I tell you, Frank laughed, and I was laughing like hell.

"Frank, maybe that song could have been a hit."

"Don't worry about it. It happened, he's gone, but he'll be back," Frank said. That wasn't the last time Frank played a trick on Jimmy. When Frank, Jimmy Durante, and I were in San Francisco doing a show, we had trailers instead of dressing rooms. Frank came into our trailer carrying a hammer and one nail. Where he got them, I don't know.

"Tony, Jimmy's trailer is unlocked but he's in there sleeping. I want you to go in there and nail one of his shoes down." Frank said.

"Frank," I said, "it'll wake him up."

"Don't worry, nothing wakes Jimmy up."

So I went into the trailer and nailed one of Jimmy's shoes to the floor, and I left. When Jimmy got up in the afternoon, he opened the trailer door, and yelled in that gravelly voice of his, "Dago. Hey Dago!"

I went out and asked, "What do you want, Jimmy?"

"Come over here," he said.

"Jimmy, I can't. I'm busy with Frank."

"Come over here!"

So I went over to Jimmy's trailer.

"Pick up that shoe."

I pulled on the shoe and said, "What's wrong with the shoe, Jimmy? It won't come up?"

"That's why I called you. It won't come up. It's nailed down. You know what happened! Don't tell me. You're with that guy!"

I started laughing and went to get the hammer. Now Jimmy had a shoe with a nail hole in the center of it. Poor Jimmy, what we didn't do to that poor guy. All the stuff that Frank wanted done for fun, he had me do, so I could take the heat, but his friends knew it wasn't my idea. And even though everyone knew Frank was behind the prank, no one would ever try to do something to him. They would take it as a joke because they knew if Frank pulled a prank on them, he really cared about them.

When Frank worked with Durante in *It Happened in Brooklyn,* in 1947, Frank always had trouble finishing a scene with Jimmy. Frank would work with other actors and they would finish a scene with one or two takes. But with Durante, they had to shoot scenes five or six times, because the minute Jimmy would look at Frank, Frank would start laughing. There was one scene they had to shoot about fifteen times. Frank was lying in bed, talking to Jimmy. Jimmy's back was to the cameras and the director. Jimmy would do something weird, like roll his eyes or stick out his tongue while Frank was saying his serious lines. He would do anything to break Frank up.

The director had finally had enough and said, "If we don't do it now, let's cut it." Frank couldn't do a straight scene with Jimmy around. It was impossible.

Jimmy, a devout Catholic, was not like most of the people in entertainment. After he did his show, he didn't stay up with the crowd. Instead, he went back to his suite and went to bed. He loved life and enjoyed every minute. He used to be at the Eden Roc, right next to the Fontainebleau. When I had the chance, I'd watch him perform. After the show, members of the audience would talk to him.

Some guy might say, "Gee, Jimmy. It's been a long time."

Jimmy would ask me who the guy was, and I'd whisper in his ear, "Jimmy, that's Mr. Crawdad."

Jimmy would say, "It's great to see ya, Mr. Crawdad."

The guy would get mad and say something like, "My name isn't Crawdad, it's Brown."

I'd walk away and laugh like hell. Then Jimmy would follow me and say, "That's the last time I trust you."

Then a week later, someone would come up to Jimmy like he was his long-lost relative and Jimmy would ask me, "Tony, who's this guy?"

"Jimmy," I would say, "It's Mr. Bivalve."

Jimmy would say, "How ya doin' Mr. Bivalve?" The guy would walk away furious, and Jimmy would spot me laughing and give me hell again. Even though he knew that I was setting him up, he never stayed angry.

Jimmy got up late and was a very sound sleeper. If a war started in the suite next door, Jimmy wouldn't hear it. He also ate corn flakes for breakfast every morning.

One time Frank said, "I want you to do something. Go to Jimmy's room, empty his box of corn flakes into this paper bag, and come back here."

I went into Jimmy's suite and, sure enough, he had a box of corn flakes on the table. While Jimmy was sleeping, I filled the empty bag with corn flakes from Jimmy's new box and left two corn flakes at the bottom. Then I left. A half hour later Jimmy called.

He growled, "Tony, come over here."

"Jimmy, I can't. I'm busy with Frank."

"You know what you did," Jimmy said.

"What'd I do, Jimmy?"

"How can I have breakfast with two corn flakes? You emptied the whole box out."

"Jimmy, I wasn't in there."

"There are no mice around here. Where are my corn flakes?"

"Jimmy, what are you talking about? What corn flakes?" But he knew who did it.

Frank said, "Okay, bring him his corn flakes."

When I saw Jimmy, he said, "I'm not blaming you. I'm blaming that other guy. From now on I'm going to bolt up these doors while I'm here."

One time at the Fontainebleau, Frank threw a firecracker at a chair. It missed the chair and got me in the leg. I still have a scar from it. Frank got really upset and said, "Tony, I'm sorry."

"Frank, don't worry about it. I'm not going to die. It happened. So what?" I said.

Frank was so upset he wanted me to go see the house doctor at the Fontainebleau, Dr. Burke, but I told Frank it was nothing. Frank called Dr. Burke, and he came up to our suite and bandaged my leg. He was a very thorough doctor. Sometimes Frank would get a sore throat or a stomach pain, and Dr. Burke would drop everything and head up to our suite. He made certain that Frank was taken care of so he could go on stage. Without Frank, the Fontainebleau would have lost a lot of money, even if it were just for one night.

There were a few times when Frank got angry and blew his stack with me. He would say, "God damn it. One of these days . . . " It could have been about the way things were going with Ava, Mitch Miller, or some reporter. I knew how he was, so I wouldn't say a word. A half hour later Frank would come out of his room.

"Tony, you know what? That's why I love you. I had to blow steam off with somebody, and if I can't blow steam off with my friend, who am I going to do it with?"

And I'd tell him, "Frank, it doesn't bother me. I love you too much. You can yell twenty-four hours a day, I'll stay right here and take it." Frank knew that.

Whenever he was mad at Ava, or someone, he'd say, "God Damn women."

The first time it happened, I wondered why my friend was jumping all over me. And I wasn't the type to say, "Frank, I don't want to work for you anymore." I wasn't built that way. I waited and listened. I knew sooner or later Frank would be himself. Sometimes he got a call in the night, or he remembered something that wasn't right that happened during the day. He would be upset and I would wait for him to sit down. I wouldn't start a conversation. I would wait for him to say something. After a while, I'd ask Frank if he wanted breakfast. If he said, "Yeah, okay," I'd call room service and order breakfast. But if Frank didn't answer me, I'd wait until he said, "I'll have breakfast." If Frank didn't want to talk, the worst thing you could do was try to get him to talk. I'd sit by the piano, away from him and go through the mail. When he needed me, he knew I was there.

I did the same with Larry O'Brien. I met Larry through Frank during the early days of John F. Kennedy's presidential campaign, in 1959, when the Rat Pack went on the road to get Jack Kennedy elected. Larry was the director of John F. Kennedy's presidential campaign, and then he was President Kennedy's Special Assistant for Congressional Relations during the Kennedy years at the White House. Frank was very close to Larry because of the connection with the Kennedys. When Jack Kennedy became president, Larry was Jack's right-hand man, along with Kenny O'Donnell, Kennedy's Chief of Staff. The two of them practically ran the show. If either one of them told President Kennedy not to do something, the president wouldn't do it. And when Frank wanted anything, rather than contact the president, he would call Larry, who would talk to the president and get whatever Frank wanted done.

When President Kennedy was killed, Vice President Lyndon Johnson became president. Johnson appointed Larry postmaster general in 1965. He kept that position until 1968 and was the man who introduced the zip code. In 1972, Larry served as the Democratic Party National Chairman, during Watergate and Richard Nixon's re-election.

During the Kennedy presidency, I always kept in touch with the Kennedy family. It was around this time, I got tired of the day-in-and-day-out travel demands of working with Frank. I don't know what it was. I was forty-four years old, and I wanted something stable. I told Frank that I wanted out and that was that. He asked what I was going to do for money, and I told him the truth: I didn't know. Frank got hold of Larry O'Brien. Between Frank and Larry, I was made supervisor of transportation for the Boston office of the United States Postal Service. It was a great job. I never showed up in Boston once, but the checks kept coming.

One time when Larry O'Brien was still postmaster general, he was going somewhere to make a speech. His personal secretary, Jan Akerhielm, asked if I was available to go along with Larry and look after things as I had done for Frank. I told her I'd be happy to help out, but I told her that I didn't want any money. From then on when Larry was speaking somewhere, Jan Akerhielm would call and ask if I would meet Larry somewhere and go with him. We would hook up with each other every couple of weeks.

Larry and I got to know each other very well. In the early 1970s, Frank had also gotten tired of the traveling and gone into retirement. And I was beginning to feel the need to have some roots, start a family, and find something that I could do back home in the Northeast. When I mentioned to Larry that Frank had retired and I didn't want to travel as much as I did with Frank, Larry asked me to travel with him on a permanent basis. Any time Larry appeared to speak, he asked me to go along with him and took care of all my expenses, no matter where we went. Food, hotel, you name it.

Traveling with Larry was a lot different from traveling with Frank. There were no nightclubs, no late hours, and there was no traveling all over the country. After Larry finished his business day, we went back to the hotel and ordered dinner. Sometimes Mrs. O'Brien—her first name was Eva—was there with us. There were no outsiders, and no one stopped by late at night to go out on the town. I was Larry's regular traveling companion maybe one night every other week when he had a speaking engagement. Sometimes when I was with Frank, we would wear slacks and a sport shirt. With Larry, it was always jackets and ties. Larry

was more businesslike than Frank and always operated on a formal level. He was a very thorough and conscientious man at all times.

I traveled with Larry to the Democratic National Convention in Miami in 1972. Of all places, I was back at the Fontainebleau. It was strange to be back at the Fontainebleau without Frank. I went to some of our old haunts and met with a few old friends. Ben Novack was still there, and he introduced me to his son, Benji.

Larry and I didn't stay in the presidential suite. We stayed in the executive suite, which was like a self-contained house, with a living room, dining room, bedrooms, and a kitchen. The candidates who were running for president, including George McGovern and Hubert Humphrey, sat around a big table in Larry's hotel suite talking strategies. Larry and other party leaders were deciding who was going to be the Democratic candidate for president. While they were talking, I knew that it was none of my business, so I got up and started to leave like I normally would with Frank.

"Where are you going, Tony?" Larry asked.

"Mr. Chairman, you're talking private and so . . . " I said.

"If I wanted you to leave, I would tell you. You sit here with us," he said. So I sat there and watched how candidates are selected.

When Larry finished his gin and tonic, I added a little more, but not enough to get him loaded, just a taste. Then I asked if anyone else wanted another drink. Larry liked that. Everyone was arguing over who would be the strongest candidate against Richard Nixon.

"Do you think I came all the way from Minnesota to hear this and go back without the nomination?" Hubert Humphrey asked.

Humphrey didn't get the nomination; George McGovern did. And Nixon wiped out McGovern in a landslide. If I had used a tape recorder then, that conversation would make a hell of a story.

A lot of the Kennedys were at the 1972 Democratic National Convention. Ted Kennedy, for some reason, didn't want to be on the convention floor; instead, he wanted to watch what was happening inside the convention from a trailer. But the trailer didn't have a TV set, so Kennedy told me he needed one.

"You've got one, Senator," I said, and within a half hour, I had Ted Kennedy hooked up so he could watch the convention from his trailer.

I also rounded up about twenty boxes of Kentucky Fried Chicken for Larry and the Kennedy family. The boxes were put on the chairs for the Connecticut delegation, but it was too early for them to show up. So I gathered the boxes and brought them to Larry's area.

"Tony, you really work fast. We need to keep you around," Larry said.

Over the years, Larry and I became as close as brothers. He eventually became commissioner of the National Basketball Association on April 30, 1975, and remained commissioner until 1984. After that, he became president of the National Basketball Hall of Fame from 1985 to 1987. The championship trophy was renamed the Larry O'Brien NBA Championship Trophy in his honor. In 1991, Larry was inducted into the NBA Hall of Fame. So you can see, like Frank, he had a remarkable career and was successful at everything he did.

I was with Larry when the National Basketball Association and the American Basketball Association merged, in 1976. That was the year the *Sporting News* named him sportsman of the year. Under his leadership, the National Basketball Association expanded from eighteen teams to twenty-three. The officials from both leagues met on Cape Cod. Dave DeBusschere, the former NBA great, was Commissioner of the American Basketball Association. The final merger meeting started at eight in the night and lasted until six or seven the next morning. When it was over, the American Basketball Association was no more. What was left was just one league, and teams like the New York Nets and the Indiana Pacers were absorbed into the National Basketball Association.

When it came time for Larry to step away from the commissioner's job, I was there. At that time, David Stern was an attorney in the NBA Commissioner's office, and Larry groomed David to replace him as commissioner.

"You don't have to search for a new commissioner. If you want someone who can go right into my shoes, and fill them right away, get David Stern." Larry told the owners of the NBA teams.

The owners agreed with Larry, because Larry was a great lawyer and a brilliant negotiator. He had worked with President Kennedy and President Johnson. You name it; Larry had done it and done it successfully. And David Stern fit right in.

Larry was the kind of guy who kept anger to himself, just the way Frank did. He never got upset with me or in front of me, and he made me feel as though I was part of his family. In fact, when his only child, Larry, Jr., got married, Larry sat with me at the back of the church. I'll never forget what he said to me while the service was going on.

"See, it doesn't take a shotgun to get married." I tried not to laugh, but I couldn't help myself.

After the wedding, we went to Larry's suite at the United Nations Plaza in New York for the reception. Toots Shor and Jackie Gleason were there. A five-piece mariachi band played music while the guests arrived, and caterers and waiters served food. Throughout the event, I made sure I stayed near Larry so if he needed something he wouldn't have to run around himself. When his conversations were personal, I would stand back. After the reception, Larry talked to me about moving in with him and Mrs. O'Brien. That's how much they loved me. Their son was married, they were all alone, and they had a large suite at the United Nations Plaza. I couldn't do it at that time; they wouldn't have liked most of my friends.

I traveled everywhere with Larry until he passed away on September 27, 1990. The family held a private memorial service, in Larry's hometown of Springfield, Massachusetts. Mrs. O'Brien made sure I rode in the limousine behind the Kennedy family at his funeral. After the funeral, the reception was held at her sister's home. I decided to leave and went over to Mrs. O'Brien to say goodbye.

"I want you to be the last one to leave," she said. So I stayed until everyone else had gone. Mrs. O'Brien and I talked for a while and, as I was leaving, she said, "I hope our friendship doesn't end now."

I looked at her and said, "I'm going to call you and write you until the Lord calls me." To this day, I've kept my promise.

CHAPTER 21: ECHOES OF MIAMI

Frank loved Italian bread. His favorite bakery was on Mulberry Street in New York. They made Sicilian bread with different designs on top. Whenever Frank wanted bread, he called the bakery, and they flew six or seven loaves to wherever we were. If Frank and I were at the Fontainebleau, the bakery shipped the bread there. They boxed the bread and put it on a plane as though the bread were a passenger. It rode in a seat, not in the shipping compartment. I had our driver meet the bread at the airport in a limousine and drive the bread to the Fontainebleau. God knows how much it cost Frank. I wrapped the bread in warm, slightly damp towels so the loaves stayed fresh, and put them in an empty drawer in a bureau. The only part of the bread that Frank liked was the ends and the crust, so I sliced off about five inches of the heel and cut that into quarters. I then put a little butter on the bread, so Frank could dunk it. Frank loved to dunk bread in his coffee.

One night I went into the bedroom to get some bread. When I turned on the light, Sam Giancana sat up and let out a gasp, holding the sheets up around his neck.

"Jesus Christ, Tony, what are you doing here?" I had forgotten I was holding a bread knife.

"I'm sorry, Sam. Frank didn't tell me you were in here. I'm just getting a few slices of bread." I said good night and turned off the light. Now it was Sam's turn to change his underwear.

Rocky Marciano was a great friend of Frank's. Whenever Frank was performing, Rocky showed up. And, of course, Frank loved boxing. It was something that carried through from his father.

Even Frank tried to be a prizefighter, but fortunately, he saw early on that fighting wasn't the way for him to go. But Frank went to a boxing match whenever he got the chance, and for a while, he even invested in a few boxing prospects, but they were up-and-comers who never made it to the big time.

Rocky Marciano is unique in boxing history. No other fighter dominated the heavyweight division the way Rocky did. He won the heavyweight championship from Ezzard Charles in an elimination bout to fill the title vacated by Joe Louis. Then Rocky defended his title against everyone who came along. But he developed a back problem and had to retire. He was maybe thirty-one at the time. But he had had forty-nine fights and never lost a match, so he retired as undefeated heavyweight champion, which had never been done before and hasn't been done since.

One day I ran into Rocky in the lobby of the Fontainebleau Hotel. We had a great talk and then he said, "How would you like to shake Frank up?" Well, this was unusual, because it was usually Frank playing pranks on other people.

"Sure," I said.

"Go upstairs and tell Frank that you just saw me and we talked for a while and that I told you that I'm going to go back into the ring."

By that time Rocky was about forty and too old and out of shape to fight again, even without his back problem. So I told Frank that Rocky was coming out of retirement, and Frank got very upset.

"Go back downstairs and tell Rocky I want to talk to him right now. He can't do that. It'd be a bad mistake."

With Frank, I couldn't keep the story going. I felt as though I was lying to Frank, even if it was a joke, so I told him that Rocky set the story up. Frank had a good laugh and that was the end of it. But that's how Frank was with people he cared about. If he cared about you and thought you were making a mistake, he wouldn't hesitate to pull you aside and let you know what he thought. Also, Frank had a gift. He knew how to get along with different people. With Jimmy Durante, Jackie Gleason, and his pals, he was very loose and casual. But there were times Frank had to act differ-

ently. One time Ambassador Joseph Kennedy, President Kennedy's father, and Grace Kelly's father, who had become a very wealthy man in the construction business, came to visit Frank at the Fontainebleau.

When they came, we put on the elite façade: no swearing, and suit and tie required. I called the florist downstairs and ordered a roomful of different flowers, just like they did at the White House, and we had the suite organized with a formal table in the middle so people could sit and talk comfortably. I put out bowls of potato chips and peanuts, and a glass bowl with cigarettes sticking out of it. I sprayed the room with pine spray to make the suite smell like a nice, flowery forest. The piano had a bouquet on it, and the bar was set up. Frank and I put on suits and ties and entertained them.

But when guys like that weren't around, forget it. We had pictures of dogs playing poker or a Don Rickles photo that we used as a dartboard. A framed sign read, "How's your bird?" When Frank wasn't expecting formal guests, he came out in his pajamas. Frank's friends, like Jimmy Van Heusen or Sammy Cahn, might show up out of the blue wearing sport shirts. Sometimes they shaved and sometimes they didn't. Nobody cared. And that's what Frank was like. No matter the situation, Frank knew how to act. He knew what to say and what not to say. And that's why he got along with everyone on all levels of life, from cab drivers and guys selling chestnuts on the corner to Queen Elizabeth and the president of the United States. The only people Frank didn't get along with were reporters and photographers.

Another time Prince Rainier of Monaco, Grace Kelly's fiancé, came to visit. Grace and Frank were starring in a very successful movie called *High Society*. Prince Rainier as a guest was *High Society* come to life, believe me. He was a lovely, gracious man, and Frank adored him. He was from a different world, but Frank associated with people on many levels and knew how to act. Frank was gifted. He felt comfortable with people, and he would make them feel at ease at the same time. After filming *High Society,* Frank had a two-week engagement at the Sands Hotel. He invited Prince Rainier and Grace Kelly as his guests for two or three days. This

was shortly before they got married in Monaco. Grace Kelly would give up her life as an actress and become Princess Grace. And what a gracious princess she was. She had that quality before she married. She was so beautiful, so pleasant, and so sophisticated—nothing put on and thoroughly genuine.

Frank always made sure that I was around to entertain his guests. After his shows, Frank did nothing but entertain the prince and Grace Kelly. He had a huge table placed in the lounge. Captains were positioned all around so no one could approach the area where Frank, Grace, and the prince were together. I can still picture Frank standing next to the prince in the lounge of the Sands Hotel.

Of course, Prince Rainier had gambling in his country, which was Monaco's major source of income. With that in mind, Frank wanted to show him what it was like in Vegas. What an immaculate looking man the prince was—the suit, the tie, and the hair. Every time I looked in back, each hair was neatly in place. He *was* a prince, this guy. I don't blame Grace Kelly for going after him. Jeez, what a handsome man he was.

"I'm so thrilled and happy to meet a prince. Not only that, but you're good-looking." I told him.

"Tony, you're not so bad yourself," the prince said.

Oh, is this guy kidding me! I thought to myself.

Usually, Frank wasn't a dinner kind of person. He would go over to Ella Fitzgerald's house or Leo Durocher's house and, once in a while, to Dean's house, but Frank would rather have dinner at a club or a restaurant. And Frank always had a comedian around to keep the party going. It wouldn't be exciting to have Jimmy Van Heusen, Sammy Cahn, or Quincy Jones sitting around with Frank. They would talk music and unless Frank was in a recording studio or doing a show, the last thing he wanted to talk about was music. He was always looking for excitement and fun. And the jokes were always funnier when everyone had a few drinks in them.

When Leo Durocher managed the New York Giants, he would come to hear Frank whenever the Giants were playing in the same town where Frank was appearing, like St. Louis, Philadelphia, or Chicago. One day

Leo happened to come early, while Frank was rehearsing. Instead of singing, Frank would whistle the songs during rehearsal to save his voice.

"Look, Frank can't even sing. He's starting to whistle now," Leo said.

What Leo said made Frank laugh, and it broke up the rehearsal.

Leo and Frank got to be friends when Leo was managing the New York Giants in the late 1940s and into the mid 1950s. That's when Frank was spending a lot of time in New York. Leo had been the Brooklyn Dodgers' manager until 1946, when he got suspended from baseball for hanging around with known gamblers. Leo played baseball for seventeen years, coming up with the New York Yankees in 1925 for a few games. Babe Ruth said that Leo was an automatic out, batting around .240 for his career. But somehow, Leo managed to stick around. After he managed the New York Giants, he managed the Chicago Cubs, then the Houston Astros. In the sixties, Leo was a coach for the Los Angeles Dodgers.

I remember the first time Frank and I visited Leo's house in 1954. Leo had moved to Beverly Hills. He had married Laraine Day, an actress and a very beautiful woman, and she needed to be near Hollywood. She never became a famous actress like Lana Turner or Ava Gardner, but she did appear in about twenty movies.

The first thing I remember about Leo's house was his bar. I liked the bar because it had baseballs from different games around the edge, and the bar stools had seats that were real catcher's mitts. Four baseball bats supported the stools.

"You can walk around, Tony, and look at the house," Leo said.

Laraine showed me Leo's closet. It was about thirty feet long and had enough room to set up a table with chairs and invite a half dozen people to have dinner in there. Leo had about seventy-five suits in his closet and thirty or forty sports jackets. I think there was a complete clothing store in there. I had never seen a closet that large before and haven't since, and I'm including Ava Gardner's closet. Ava was a woman who loved clothes and could buy as many as she wanted.

After dinner, when Frank and I were driving back to our house I said,

"Frank, what a beautiful house. And did you see all those suits Durocher has? My God."

"Tony, let me tell you something. You can only wear one suit at a time. So what if he has seventy-five suits. Remember another thing, you can only walk on one side of the street at a time. So he has ten thousand suits and you have only one. You wear one, and he can only wear one."

Frank was trying to make me feel better. I don't know why, but Frank really enjoyed Leo. He wasn't handsome or funny, but he was a straightforward type of guy, and that's what Frank liked in people. That's why Leo's was one of the few homes Frank would go to for an evening.

When Frank was at the Sands and Milton Berle was at the Riviera, they would get through at one in the morning and everybody would get together at the Sands. Milton had a million jokes, usually somebody else's. Peter Falk was another guy who would show up and not have to say a word. He would just look at Frank with his glass eye, and Frank would end up on the floor laughing. Dean Martin could tell a joke that wasn't funny, but the way he told it made it funny. Then there was Joe E. Lewis and Jimmy Durante. Those two were funnier offstage than they were on. Joe E. Lewis was the person who told Frank, "A friend in need is a pest." Those were the people Frank wanted around him. They were always a joy.

Frank was the greatest teacher for me in all different areas. I never finished school. I left high school in my first year, but I never could have gotten the education that being with Frank gave me even, if I had gone to Yale for four years and to Harvard for another four. How he knew things, I don't know. I learned from Frank and that's how I got through life. Frank taught me how to be polite and kind to people, no matter what the situation.

"You get further with sugar than you do with vinegar," Frank always said, and it worked.

And he taught me etiquette, if that's the word to use. Frank really knew etiquette. He'd say, "If someone wants to tell you something, listen to them, but don't ask them any questions. If they want to tell you something, they'll tell you. But you don't ask them."

I always had a dictionary with me, the way Frank did. When Frank would read a script and ran across a word he didn't know, he looked that word up in the dictionary. Frank always had a dictionary with him.

Frank never had a tutor; he learned everything he needed to know on his own. As I said, Frank didn't finish high school. He was self-educated. He didn't have time to go to bookstores or to a library, but he read everything he could find: five or six newspapers, *Time* magazine and *The Wall Street Journal*. He always read Earl Wilson, Jimmy Cannon, and Walter Winchell—all the great columnists of the time. Frank wasn't a very religious man, not like Peter Lawford's wife, Pat. If there was a party going on to honor Pat Lawford and it was church time, she would go to church. It didn't have to be a holy day of obligation, like Christmas or Palm Sunday. Every day was a holy day of obligation for her. Frank loved to have priests and nuns in the audience, but he didn't spend a lot of time in church.

One time at the Fontainebleau, we had a comedian named B. S. Pully who had a filthy mouth. He was well known in the Miami area and had done a few movies, including a small role in *Guys and Dolls*. Frank didn't know what the guy was about, because Frank never rehearsed with the comedians, and he was always backstage in his dressing room when they opened the show for him. This comedian came out and said, "If there are any nuns or priests in the audience, you better leave because you're not going to like what I'm going to say."

Frank heard about it and didn't like it, so he told this famous comedian, "You change or you're gone."

B. S. Pully did one show for us. He was gone so fast he didn't know what hit him.

CHAPTER 22: MOON OVER MIAMI

Frank liked his privacy. Everything was always hush-hush with Frank. He never wanted anyone to know what his telephone conversations were about unless it concerned them. Otherwise, forget it. One time at the Fontainebleau, Frank asked me to have a private line installed in our suite so that the operators in the hotel wouldn't listen in on our conversations. Frank wanted to talk to Ava and wanted to make sure no one else heard what was said. At the time, Ava was staying at the Dorchester Hotel in London. The press was already writing about Frank and Ava's ups and downs every day and Frank didn't like that. In those days, the switchboard operators could turn the key halfway and listen in to both ends of a conversation without anyone knowing.

The woman who was in charge of the telephones at the Fontainebleau was Frances Burns. She was a lovable woman. I went down to the switchboard to tell her to make sure that the operators didn't listen in to any calls coming to Frank's suite. Frances said that she would keep an eye on it. Then she showed me how operators could listen in on a phone call.

If an operator took the key and turned it all the way to the left, only the person who called and the person he or she called could hear the conversation. But if an operator turned the key only halfway, then the operator could listen in on the call without the parties knowing it.

The operators knew that Frances couldn't be there all the time to monitor the switchboard. If she was out for lunch or somewhere else, the operators could turn the key halfway and listen to what was going on. I told Frank that Frances had been alerted, but Frank wasn't sure the phone was

secure, so he stopped making phone calls from his suite. Frances assured me that any operator caught with the key half-open, listening in on calls to or from Frank's suite, would be fired on the spot. She had a notice posted right next to the time clock where the operators had to punch in and out.

As supervisor, Frances Burns would walk around and make sure that all the keys were locked in the right place. I don't know if anyone got fired, but Frank could tell by the echo when someone was listening in on one of his calls. At the Fontainebleau, they had a huge room off the lobby with about thirty switchboard operators working around the clock. They had to take phone calls for the hundreds of guests staying there at any given time. They also had to answer all the questions coming from out-side the hotel: who was staying at the hotel and who was performing on stage, information about reservations for the hotel and the restaurant, and whether cabanas were available.

To solve the eavesdropping problem, I called the Miami telephone company while Frank was asleep. I told them to come in and put in a pri-vate line that wouldn't go through Fontainebleau's switchboard and bill it directly to Frank. I told them to make certain that no one other than Frank and I knew the number, that the phone number would not be on the dial, and that the phone number be put in a sealed envelope. I didn't want any-one to have it or have access to it. The lineman came in and installed the phone, and he gave me a sealed envelope with the phone number no one else knew. I didn't know the number. Believe me, I didn't want to know it. I gave the lineman a hundred-dollar bill and he was gone.

When Frank got up, I showed him the new phone and I gave him the sealed envelope containing the phone number. Within a half hour, the phone rang. "Don't answer it. I'll answer it," Frank said.

Frank picked up the receiver and didn't say anything. I could hear someone say, "Hello, Mr. Sinatra? Mr. Sinatra, is that you?"

Frank ripped the phone out of the wall. I opened up the patio door, and Frank threw it. It bounced off the balcony below us and sailed toward the pool. I didn't watch it land. I stayed in our suite and remained inno-cent. Somebody from the phone company, or maybe the lineman who put

the phone in, gave out the number. Frank was furious, and that was the end of that telephone.

One time, Leo Durocher was living below us at the Fontainebleau. One morning Frank told me to call Leo and tell him to come outside on his balcony.

Frank said, "Tell Leo I want to say hello to him rather than talk on the phone." That was to get Leo out on the balcony so Frank could throw some cherry bombs at Leo. "Look, tell me where Leo is."

I leaned over the railing of our balcony and spotted Leo. "Frank, he's on the left side, toward the pool." Frank threw the cherry bomb opposite to where Leo was.

Leo went inside and called us on the phone. I picked it up and Leo yelled, "Dago! I know you're there. Dago, where's Frank?"

I told Leo that Frank was asleep.

"He's asleep, huh? I know it's not you throwing those cherry bombs. It's him. Get Frank on the phone!"

"Leo, you want me to wake him up?"

But Leo knew better. "I know he's right next to you, laughing. Don't lie to me. Get Frank on the phone."

"Leo wants to talk to you."

Frank walked toward his bedroom and shouted, "I'm busy right now."

Leo heard Frank and said, "He's busy, huh? Well, you tell Frank I'm on my way up to kick his skinny Dago ass." But Leo never came up.

When Frank played the Fontainebleau, Joe E. Lewis, Don Rickles, or Jimmy Durante would be at the Eden Roc. Jackie Gleason was always around. After Jackie moved his TV show from New York to Miami in the late 1960s, he owned Miami. Whatever he wanted, the mayor and the Chamber of Commerce made sure he got it. Joe DiMaggio had a cabana on the beach. Rocky Marciano, may he rest in peace, used to come down to visit. I don't know what it was, but Frank had a following you wouldn't believe. And Frank loved it. He had a ball with all his friends. That's what kept him going. When Frank wasn't performing, he wanted his friends around to have laughs. That was the name of the game. Frank didn't want

to do two shows and go to bed, like Jimmy Durante did. Jimmy would get through performing, have a bowl of corn flakes, and go to bed. Frank, Joe E. Lewis, Sammy, Dean, and Peter stayed up until the sun came out and then went to bed.

Just outside the Fontainebleau was a shoeshine stand. One day I stopped down to have a shoeshine. Beau Jack, who was a great welterweight fighter in the 1930s and 1940s, was now shining shoes and ran the shoeshine stand. I couldn't believe it! We talked for a while, and Beau Jack told me how he ended up shining shoes. His managers took all his money, and he wound up broke. Beau Jack told me he had seven sons and was going to make sure that none of them went into boxing.

"Not after what they did to me," he said. "I was a world champion and they robbed me. I made hundreds of thousands of dollars, and now I'm shining shoes."

I went upstairs and told Frank about the situation. I knew he would want to do something, and he did. He got Ben Novack on the phone and told him to find a decent job at the hotel for Beau Jack. And, of course, Ben got Beau Jack out of the shoeshine stand and into a job inside the hotel that same day. Ben knew better than to let things slide when it came to anything that Frank wanted, especially a situation where a great fighter, a world champion, was shining shoes.

Frank loved boxers. As I've mentioned, Frank's father, Marty, was a boxer for a while, and Frank thought about becoming a fighter, too. That's why Frank had great compassion for boxers. He saw how so many of them ended up—broke, scarred, and punch-drunk. Once Frank knew something like that was going on, he would put a stop to it. If Ben didn't take care of the situation that day, he knew he would have to answer to Frank about why Beau Jack was still shining shoes. And an angry Frank was not a pleasant situation.

So many things happened at the Fontainebleau. One time Frank was having trouble with his throat. It was nothing serious, but he couldn't sing. So we went next door to the Eden Roc where his longtime friend Joe E. Lewis was appearing to ask for his help. Hollywood had made a

movie about Joe's life, *The Joker Is Wild,* and Frank played Joe in the film. In the movie, Joe E. Lewis wouldn't play in a certain nightclub, so some mobsters cut Joe's throat. I couldn't understand what they used when someone got cut to make it look so real. When they did that scene, Frank had a stand-in. They used a kind of a red liquid to show the blood that really looked like blood!

Joe agreed to stand in at the Fontainebleau for Frank. When the people arrived at the Fontainebleau, they were surprised to see Joe on stage instead of Frank. So Joe started off by telling the audience that he was sorry, but Frank wouldn't be performing that night because he had to go to Tennessee to lay a wreath on the grave of Jack Daniels. Of course, it got a laugh because everyone knew Frank drank Jack Daniels.

For the early shows, Frank would sip a cup of tea because he thought there might be young people in the audience, and he didn't want to set a bad example. But for the late show, Frank drank Jack Daniels. He'd have an old-fashioned glass with three ice cubes and a half a jigger of Jack Daniels. Frank would stir the drink with his finger until the ice cubes melted. It wasn't a very strong drink. It was a prop, something to do with his hands, just like when he would light a cigarette while singing one of his barroom ballads.

When Frank worked the Fontainebleau, the management of Eden Roc would always book a top-notch comedian. They knew better than to have another singer competing with Frank's ability to fill the house. That way people had a choice. Go see Frank one night and go to Eden Roc to see Jimmy Durante with Sonny King the next night.

One night Don Rickles was playing at the Eden Roc, and word got back to Frank that it was Don's birthday. Frank told me to order a cake and have it ready so we could visit Don at his hotel. Frank and I got there during Don's second show. The place was mobbed. But Frank walked in from backstage right in the middle of Don's monologue. I was right behind Frank with the birthday cake.

Don looked up, saw Frank, and said, "Look, I don't need you here to draw a crowd."

Don was only joking the way he always did, but for some reason Frank took it the wrong way. Frank leaned over to me and said, "Go up to Don and hit him in the face with the cake."

I looked at how red Frank's face was and couldn't believe it. But when Frank gave me orders, I followed them. If I didn't, he'd find someone else. I walked up to Don and said, "Happy Birthday, Don," and threw the cake at him. He saw it coming and ducked to the side, but the cake grazed his right shoulder and landed on the stage between him and the piano. And that was that. Frank and I walked off, and Frank didn't talk to Don for years after that.

One time while we were at the Fontainebleau, Frank was going to get subpoenaed. Who knows what it was for that time. I left our suite to head down to the lobby to pick up the mail and a few newspapers. As I rounded the corner and got near the elevator, I saw two men sitting on a bench by the elevator. There was always a bench there so people wouldn't have to stand up while waiting for the elevator.

"Fellows, the elevator's coming up. I'll hold it for you," I said.

"No, we're not getting on," one of them said.

I thought it was odd, so I asked, "Are you waiting for your girl-friends?"

The other man said, "No, we're waiting for Mr. Sinatra."

I noticed the large manila envelope in the guy's hand and that's all I needed to see. I asked, "Sinatra on this floor? You kidding me?"

"Yeah. We got something to hand him," one said.

"Oh, can I stay and watch?"

"You wouldn't be interested," the man said.

"Okay," I said and got on the elevator.

I went downstairs, got the mail, and went back upstairs. But when I came back upstairs, I didn't come up through the regular elevator. I took the laundry elevator, which was on the other side of the corridor, so the two men wouldn't see me with my arms full of mail. I went around the corner, down the corridor, and unlocked the door to our suite. They didn't even know I came back.

I told Frank, "When we head out to do the show tonight, we better go downstairs a different way, rather than use the elevator. There are two guys out there, one with a large, brown envelope in his hand. To me, it smells like a subpoena. I'm not sure, but that's what I think."

"Yeah, they're looking to subpoena me," Frank said, "for what reason I don't recall."

Having those two process servers on our floor could have been a problem because Frank had to leave the suite to go to his dressing room before doing his show. Frank said, "Get hold of Ben Novack. We're going through the laundry room on our way to the La Ronde Room."

I called Ben, told him about the situation, and told him if he couldn't come up with a plan, Frank wouldn't be able to do his show that night. Ben said that he would make arrangements to have the laundry elevator cleared. I told Ben to make sure that the elevator on our floor was empty and that just the elevator operator was waiting to bring us down. An hour later, Frank and I went down in the laundry elevator and got off in the laundry room.

Ben made sure that everything was cleared out of the way, because there was no way Frank was going to push carts of dirty laundry around, ever, especially when he was all dressed up to do a performance. We got out of the elevator in the basement where all the shops were, and we walked through the tunnel and up to the back of the stage. Frank did his show. We never saw those guys, and they never did serve their subpoena. If those guys had been smart, they would have waited for Frank in the corridor outside his suite instead of waiting next to the elevator. My job was to check on things to make certain everything was all right. If Frank had gone to the elevator, he would have been stuck. For all I know, those guys are still waiting somewhere to serve the papers.

While we're talking about Frank's adventures in Florida, I was there when Frank did the TV special in 1960 welcoming Elvis Presley back from the army. When Elvis got out of the army, he came down to Florida where Frank was playing the Fontainebleau. Arrangements were made for Frank and Elvis to do a television special together. Frank had his

daughter Nancy, Sammy Davis, and Joey Bishop on the show with him to introduce Elvis Presley and welcome him back.

At the beginning of the show, Frank turned to the audience and said, "I want to introduce a person who was a great star before he went into the army, and he's still a great star: Elvis Presley."

The audience went crazy. Then Frank and Elvis sang a duet, with Frank singing a swinging version of Elvis's hit ballad, "Love Me Tender," and Elvis singing Frank's great song, "Witchcraft."

After the show was over, there was no party and no contact. Frank had to do his regular show at the Fontainebleau, and Elvis and the Colonel may have had other commitments. But there was no get-together, which was unusual. And I don't think Elvis and Frank ever got together again or even talked on the phone. After the TV special with Frank, Elvis went out to Hollywood and became a box-office star, sometimes making two or three movies a year.

Before he left the Fontainebleau, Colonel Parker gave Frank a bull-horn, one of those things the police use to speak over the noise of a crowd. The Colonel said, "When you can't find Tony around, you press the button and call him. He'll hear you."

The thing was really loud. Later, Frank asked if I wanted it. I said, "Frank, who am I going to call? Ring-A-Ding Ding?" Right now, I don't know where the bullhorn is.

Frank gave me anything he didn't want. He would always say, "Here, clutter your house," and I would send the stuff to my house.

Through Frank, I was able to meet and spend time with famous people like Elvis Presley. The last time I saw Elvis was in Providence, Rhode Island, at the Civic Center. I took my wife, Mary, with me. While he was singing "Hound Dog," some girl threw a big, stuffed hound dog onto the stage. Elvis was so impressed with it that he picked it up, blew a kiss to the girl, and put the hound dog on the piano.

After the show, I went backstage and told Elvis what a hell of a show he had put on. He was always a gentleman, and when I introduced my wife to him, he handed her that stuffed hound dog. Mary just couldn't

believe it. Elvis then brought out one of his black silk ties and gave it to me. We talked for a while longer, but we had a long drive back to Connecticut. We said goodbye, not realizing at the time that Elvis wouldn't be with us for much longer.

When Mary and I got outside, there was the usual crowd hoping to get a glimpse of Elvis. Some of the people saw the stuffed hound dog that Elvis had given my wife. They formed a mob and tried to pull it away because Elvis had touched it. I had to get the cops to walk us to our car to keep the Elvis fans away. Of course, we still have the stuffed hound dog, but where the tie is, I really couldn't say.

CHAPTER 23: THE BIG CHEESE

Earlier, I mentioned Jimmy Van Heusen. His real name was Edward Chester. He was a great songwriter in those days along with Sammy Cahn. Anything they wrote, Frank would record and it would become a hit. Frank and Jimmy needed each other, and they got along great. One time Jimmy Van Heusen came back from England and visited Frank and me at the Fontainebleau in Miami. That day, we stayed up until five-thirty or six o'clock in the morning!

Jimmy was wearing these beautiful gold patent leather slippers with his initials etched in them, and he was telling us how expensive they were. Frank said, "Oh, they're very nice slippers, Jimmy."

"Yeah, well I bought them in England and had them made special. It's the only pair like them and the only ones I'll ever wear," Jimmy said.

He kept talking about his slippers, and while Jimmy was talking, Frank gave me a couple of winks. I thought, *Oh, Jesus Christ.* That wink meant only one thing. It was time to go into the next room and bring Frank two cherry bombs. While Jimmy was talking, Frank took one of Jimmy's slippers and pretended to examine it as though he was interested in seeing how it was made. Then he went ahead, stuck one cherry bomb in the slipper, and blew it apart.

"Thanks, Frank. Now what am I going to do? Go to California with one slipper?" Jimmy asked. Frank said, "I'll take care of it," and blew up the other slipper. We had a full-length mirror on the wall with a little hook at the top. Frank took Jimmy's two blown-up slippers and hung them on the two top corners of the mirror.

Jimmy said, "Now I'll have to walk to California barefoot."

"Don't worry, you won't have to," Frank said.

The next morning I called Brooks Brothers downstairs in the hotel and a fellow came to our suite with about twenty-five boxes of shoes. Jimmy picked out a nice pair. Later, Jimmy wrote me and said that it was the funniest thing that had ever happened to him. They had a few drinks, relaxed, and that was the end of it. That was one way to have fun.

Then there is the story of the Limburger cheese. That happened when we were playing the 500 Club, in Atlantic City. After the show, we went back to the Hotel Claridge, where we always stayed when we played the 500 Club. We had the whole first floor to ourselves. Frank didn't want anyone else on that floor so that's just the way it had to be.

On this particular occasion, we had a party with quite a few friends. Jimmy Van Heusen came by. Robert Wagner and Natalie Wood were there. We had a good time. As the night went on, around four or five in the morning, everybody started to leave. There was one girl left in the suite with Jimmy Van Heusen, Frank, and me. She was gorgeous: beautiful face and a body that had everything.

Jimmy chased women worse than Frank did. I heard Jimmy say to Frank, "Send her into my room."

Frank said, "Don't worry. When the party's all over, I will." However, Frank wanted her, too. Frank took me aside.

"Tony, go to Skinny (Skinny D'Amato was still the owner of the 500 Club) and ask him for a hunk of Limburger cheese. Get the oldest, largest piece he's got, then come back here." Limburger cheese, you might know, stinks so bad it will peel the paint off a wall.

I went to Skinny's by cab, and I told the driver to wait for me. I went into the 500 Club and told Skinny what I wanted, and he wanted to know why I wanted it. I said, "Skinny, it's for Frank, so please don't ask questions."

He took me to the kitchen and had one of the chefs give me about two pounds of Limburger cheese. God, it smelled awful. In a few minutes, I came out with the Limburger cheese and sat in the back of the cab. We

were driving along and the cab driver said, "I don't know what you got back there, but open up all the windows." We opened all the windows and the driver said, "It's a good thing we're only going to the Claridge, because if we were going any further, I couldn't do it. I'm getting dizzy."

When we got to the Claridge, I gave the driver a hundred dollars because of the trouble he went through. A hundred dollars in those days is like a thousand dollars today. The driver said, "Well, thanks a lot. I'm out of business anyway, because nobody will come into my cab. You stunk it up." Our cheese prank meant he couldn't do business for the rest of the night.

Frank was in his bedroom. "What do you want me to do?" I asked.

"Go into Jimmy's room and take the Limburger cheese and crumble it between the bed sheets. Make sure to put some under the pillow and then make the bed so it looks like nothing's been disturbed," Frank said.

When I finished putting the Limburger cheese in Jimmy Van Heusen's bed, I came back to our suite. I had to wash my hands about eight times to get rid of the smell. I used every kind of soap we had and even tried washing with shampoo. No matter what I tried, I couldn't get the smell of Limburger off my hands. It had a life of its own. I went to the doorway of our living room and nodded to Frank to let him know that everything was ready for Jimmy.

Frank and I went back into the living room where Jimmy and the woman were talking. Frank winked at Jimmy. That wink meant Jimmy should go back to his room and Frank would send the blonde in there after him.

Jimmy left our suite and went to his room. Within five minutes, I heard the door slam, everything being knocked around, and a lot of yelling and swearing. Frank told me to go see what happened. I went into Jimmy's room and he wasn't there. The smell was so bad that Jimmy couldn't stay in his own room. We later found out that Jimmy had left his room and gone to a place not far from the Claridge, called the Swan Motel, to stay overnight. The next day the maids came in to clean up Jimmy's room, and as soon as the smell of Limburger cheese hit them, they said, "We're not

working in this room. This man has a bad gas problem." Then they left for the day.

When Frank got up the next day, he said to me, "Good job!" I didn't say anything. I just kept laughing and laughing.

Later that day, Jimmy called from the Swan Motel. Needless to say, he was mad. "Tony, I know Frank made a sucker out of me. I know what it was all about, but jeez."

"Jimmy, come back. Frank wants to talk to you," I said.

Jimmy came back to the Claridge, talked with Frank, and that was that. They were good friends and worked well together. For the sake of the success of their music, they needed one another. Nobody could write like Jimmy, and nobody could sing Jimmy's songs like Frank. In the end, they stuck together.

While we're talking about the 500 Club, I remember one night in particular that we spent there in 1955. Before Don Rickles became the insult king, there was a comedian who knew no fear. Jack E. Leonard would put anyone down. He weighed at least 250 pounds, wore glasses, and was short and bald. He was also sharp, quick-witted, and would say whatever entered his mind. He did this all on live national, television. He'd be on the *Ed Sullivan Show* and call the very somber Ed Sullivan "Smiley." He played Broadway and was a mainstay on early television variety shows and late night talk shows. Jack E. Leonard was the Don Rickles of his day, which was about twenty years before Rickles was even in show business. One time, Jack E. Leonard ran into Don Rickles in a hotel lobby in Vegas. Jack stopped Rickles and said, "You know, Don, you got a great act—mine."

At one point, Jack E. Leonard was a guest on the *Ed Sullivan Show*. This was when TV was truly done live. Jack was asked to do an eight-minute segment. He got his ideas and jokes ready, but then one of the producers came up to Jack and told him that the show was running long. He asked if Jack could cut his part down to five minutes. Jack said he could cut three minutes from his act.

"I'll do five minutes. Don't worry. I'm happy," Jack said.

He began the process of figuring out his five-minute monologue. The show continued and other acts were still running too long, so the producer came back to Jack.

"Look, Jack, we haven't got time for you to do five minutes. What can you do in three minutes?"

Jack looked at the producer and said, "In three minutes I can boil two eggs." With that, Jack left the set and the theater entirely. When I told Frank the story, it really broke him up.

Jack E. Leonard was a constant guest on late night TV, and people loved him because they never knew what he was going to say or who his next victim was going to be. One night, Frank was singing a beautiful ballad on stage at the 500 Club. I can't remember which song Frank was singing, but everything was quiet. You could have heard a cotton ball land on a marshmallow; it was that quiet. The audience was so focused on Frank that I thought they had stopped breathing. Everything was so incredibly still.

I was standing offstage in the wings like always in case Frank needed something, like a glass of water or a cup of tea. I was watching the blue smoke rise from Frank's cigarette in the spotlight when all of a sudden, fat-ass Jack E. Leonard yelled from the other side of the stage.

"Hey, Frank. I've lost more weight than you weigh."

Frank was in the middle of a song. You never know how things are going to go with Frank. Normally no one would dare to interrupt him like that. Luckily, this time it broke Frank up. He was on the floor laughing.

You never knew who was going to show up at the 500 Club. One night it was Rocky Marciano and Toots Shor. Another night, it was Natalie Wood and Robert Wagner. Frank's life was in high gear and every night was a surprise. There were parties all the time and plenty of women. When a star came into town to see Frank perform during the week, he was there. In fact, they wouldn't even have to look around for a room since Frank liked to reserve the entire first floor of the Hotel Claridge. To keep things under control, we had a guard sitting outside the elevator. If someone got

off the elevator, the security guard would stop that person and find out where they were going. No one had a room on the first floor other than Frank unless it was one of his close friends.

CHAPTER 24: THE RAT PACK

Humphrey Bogart and Lauren Bacall had a group of friends in the 1950s that they called the Rat Pack. The group included Judy Garland, Swifty Lazar, Sid Luft, Joey Bishop, and Frank. Frank's Rat Pack evolved when they were all playing in Vegas. Dean Martin was at the Riviera, Frank was at the Sands, and Sammy Davis Jr. was at The Star Dust. After their shows were over, they would gather at the Sands until daybreak. I don't know who came up with the title, the Rat Pack. They were a close group and the name just stuck.

Like I said before, in all my years with Frank, through all the nights and days, I never saw Frank drunk—may he rest in peace. He only drank a little. When he was tired from work or when he wanted to relax, I would get a glass and put two or three ice cubes in it. Then I'd add a half shot of Jack Daniels. Frank would start stirring the ice cubes with his right index finger while we talked. In a few minutes, the old-fashioned glass was three-quarters full and it would be mostly water.

Sammy Davis was exactly the opposite. He would get a tall glass and fill it with Jack Daniels and Coke. If you can imagine the size of a beer glass, Sammy would have something like that half-filled with Jack Daniels and half-filled with Coke. That's got to be a really strong drink. However, the alcohol never seemed to have any effect on him. It never bothered Sammy at all. He went out, did the show and never forgot a word, and he danced and played the drums. He did absolutely everything he needed to. He kept the crowd going because he was a great entertainer. Cigarettes— Sammy always had these long cigarettes. I don't know where he got them.

He smoked one almost to the end, dropped it, and immediately lit another. He had at least one cigarette going all the time. Sammy had a suitcase he always carried with him, and the only items in it were cartons of cigarettes.

There is a lot I can say about Sammy. When it came to being the complete entertainer, Sammy was it. He could sing, play drums, dance, lead the orchestra, and do amazingly accurate imitations of Jimmy Stewart, Nat King Cole, James Cagney, and even Frank. And Frank loved it. Sometimes Dean would get under Sammy's skin, but that was before Sammy realized that Dean never lived a serious moment. Whatever he said, it was meant to be funny. Frank was ultimately responsible for Sammy's becoming a star. Let's face it, Sammy always had star quality, but Frank opened the doors.

Early on, Sammy performed with his father and uncle. They were known as the Will Mastin Trio. They opened for Frank at the Capitol Theater in New York. It was in 1947, long before Sammy got into the car accident that cost him his left eye in 1954. When that happened, Sammy was certain that his show business career was over. That's when Frank showed up at the hospital and offered Sammy his Palm Springs house to recuperate in. Frank kept in touch with Sammy and kept his morale going.

People too often forget what it was like in those days. Sammy could play a show in a club or hotel in Miami that still had separate bathrooms: one for blacks and one for whites. When the Will Mastin Trio played in a hotel, Sammy, his father, and his uncle had to use the back entrance.

In Vegas, Sammy played at the Diamond Horseshoe. At the entrance to the Diamond Horseshoe, they had a million dollars in authentic United States currency sitting in a glass case. It was meant to attract attention and get people to go inside and gamble. Sam would perform there, but he wasn't allowed in the lounge, and he couldn't sleep in the hotel. The whole situation was pure insanity. When Frank got wind of it, he immediately put a stop to it.

Frank told Jack Entratter, the president of the Sands, "If Sammy and Nat are good enough to perform here, they're good enough to sleep here."

Frank told Jack that if he couldn't work things out for Sammy, Nat

King Cole, and every other black performer, Frank would never perform in Vegas again. Well, that was it. Word got around to the other casinos quickly. Frank brought in a lot of money, a lot of high rollers, and a lot of heavy oil money wherever he performed. The next thing you know, Sammy was in the lounge and had a suite in the hotel, just as though it had always been that way. When anyone looks back on that history, they'll find Frank's voice behind promoting equal treatment for performers. It wasn't just in Las Vegas; it was something Frank believed in all his life.

Because of what Frank had done for him, if Sammy was booked at a theater and Frank needed Sammy at the Copa, Sammy would tell his theater manager that he wasn't going to perform that night and immediately fill in for Frank. That's how close they were. Sammy would do anything for Frank, and that's why Frank stuck with Sammy through most of those years. I say most of the years, because in 1959 when Sammy did a late-night radio interview with Jack Eigen, he said that Frank was a great friend and a great entertainer, but he liked to step on people. That was the end of it for Frank. He was angrier than I had ever seen him. He felt betrayed, and he couldn't understand why Sammy would say what he said.

Frank said to me, "Maybe Sammy was stoned. Whatever it is, if he calls I am not here. I'm never here from now on."

That was a tough one to deal with. Sammy called and called after that—sometimes four or five times a day. I loved Sammy, but I had to tell him that Frank was out of town, or rehearsing, or recording, while Frank was standing right next to me. It took years, but those two finally got back together.

Unfortunately, there was always a little cautious distance between them. Sam was like a puppy wanting to be loved—all forgiveness and innocence—but Frank had been stung, and he did not want to open himself up for it to happen again.

Of course, there was another problem that came up during Sammy's career. He had fallen in love with a Swedish actress named May Britt. It was a situation Frank didn't want to get involved in, but Sammy came to him anyway.

"You're going to ruin your career because she's all done. She's not going to make any more movies," Frank told Sammy.

"Okay, I'll think it over," Sammy said.

Still, when Sammy decided to go ahead and marry May, Frank was right by his side as his best man. He stood up there with Sammy even though he knew that the marriage wasn't going to last. My God, it's incredible to think we were still living in a country where people had to drink out of different water fountains. An interracial marriage in those days was a tough thing to endure. But Frank stuck with Sammy. That's the kind of friend Frank was. When there was controversy, he didn't just disappear; he stayed loyal to his friends. He expected loyalty from them, and he felt they should expect the same from him.

One day while we were in Palm Springs, Sammy came to our house and gave Frank a dog. It was a Saint Bernard puppy, and it was already big. Frank named him Charley Dog. One morning, Frank and I were having breakfast together. I had finished my breakfast so there was nothing I could give the dog, but Frank was still eating. The dog was near Frank, begging for food, but Frank wasn't paying any attention. All of a sudden, as Frank picked up a cup of coffee, the dog jumped up and the cup went flying. That was more than enough for Frank.

He very quietly said, "Tony, call up Sammy and tell him to come back and get this dog. I don't want him anymore. Come and get him."

Frank loved dogs, but because the dog had jumped up while Frank had a cup of hot coffee in his hand, it upset him. That was the last of Frank's days with the Saint Bernard. Sammy came by later and picked up Charley Dog.

When Sammy came to the Oakdale Theater in Wallingford, Connecticut, he and his third wife, Altovise, stayed at the Park Plaza Hotel in New Haven. That Altovise was a beautiful woman. What a good friend she was for Sammy as well. After Sammy's performances at the Oakdale, we stayed up all night and partied just like we did in Vegas. After he finished his stay at the Park Plaza, Sammy and Altovise went back to the Waldorf-Astoria in New York. As usual, I checked out their hotel room. I always

made sure that nothing was left behind. In all my years with Frank, Dean, Peter, and Sammy, I was always the last one out of the suite. This time I found Altovise's purse. I waited an hour and a half before I called them. That's how long it took them to get from New Haven to the Waldorf. I finally got hold of Sammy and told him I had found Altovise's purse.

"Tony, Altovise has been so upset, and we couldn't turn around."

In those days, of course, very few people had telephones in their cars. I told him, "Sam, look, tell Altovise not to worry about her pocketbook. I have it in my hand. I'm leaving for New York right now to bring it to you."

When I showed up at the Waldorf, Sammy handed me some money. I looked at him and said, "Sam. If I take this, I will never want to see you again."

"No, that ain't gonna happen," Sammy said and took the money back and that was the end of it.

Frank taught me early on that you don't do things for friends if money is involved. Years earlier, I had been going with a woman from Meriden, Connecticut. She was crazy about Sammy. He was starring on Broadway in *Mr. Wonderful* at the time. I wanted to show her how close I was to Sammy, so I called the theater. Sammy got on the phone and talked with this woman for fifteen minutes. Normally, when people are working in the theater they won't get on the phone unless it's very important. That's how close we were.

Another time I remember being with Sammy when we were campaigning for Jack Kennedy in 1960. Frank, Bobby Kennedy, Peter, and I were in Hawaii at Diamond Head. We were staying at Bobby Kennedy's house. Sammy flew in from California on his way to Sydney, Australia, just to perform for free at a fundraising concert. Sammy was always on the go, always hurrying, and always running late. I showed Sammy the room in the house where he was going to stay overnight. He went into one of the spare bedrooms, threw his suitcase on the bed, and ran back out to get to rehearsal. There was only one problem.

When Sammy threw his suitcase on the bed, he didn't have it locked right, and the suitcase sprung open. Gaming chips flew into the air and

rolled across the room, under the bed, and under the bureau. I picked them up one at a time. Most of them were white, which meant they were five-hundred-dollar chips. I think I counted around thirty thousand dollars in chips. I could have taken a mess of them, and I don't think Sammy would have ever missed them. I straightened out his clothes and put the chips back in Sammy's suitcase. When I found Sammy, I told him what had happened.

"Sammy, you didn't lock your suitcase."

"What happened?" he asked.

"When you threw your suitcase on the bed, it opened and all the chips flew out. I hope you know how much was in there, because I put everything back."

He laughed and thanked me. I told him how much money in chips there was and asked if he wanted to count them.

"Tony, I don't have to count the chips. We don't worry about anything when you're around. That's why you're with us."

That's how it was with those guys. They were making so much money; they didn't even know how much they had. It meant absolutely nothing to them. Good times, laughs, and staying up all night—that's what was important to them. When Sammy was leaving, he gave me a ukulele as a gift to remember what I did for him. I gave the ukulele to my sister Sarah. In those days, I gave everything away. If I had known that at some point I was going to get married and have a family, I would never have given anything away. Needless to say, I don't do that anymore. If I have an old shoe and somebody wants it just because I hung around with so many famous people, I won't even give him the shoelace.

Here's another story. Sammy was on stage with Frank, Joey Bishop, and Shirley MacLaine at the 1960 Democratic National Convention. They were singing the national anthem together. While they were singing, the delegates from Mississippi were heckling Sammy. They didn't think it was his place as a black man to be at the convention, much less to be on stage. Joey Bishop spoke up and said that Sammy was part of the group, and the group was there to entertain.

"If you're enjoying the group, you'll have to enjoy Sammy, because he's part of the group."

Joey went on to say that Sammy wasn't brought there to break any barriers, but just to entertain. Joey was shrewd—a very smart man. Of all the members of the Rat Pack, he outlived everyone.

The Mississippi delegation didn't bother Sammy at all after that. Sammy knew he was being heckled, but he had to take it because he had a job to do for the Democratic Party. Sammy was a guy who once couldn't enter through the front doors of nightclubs where he was performing, so he was used to dealing with certain attitudes. Luckily, he had a champion in Frank. Frank opened doors for Sammy and stood by him even when some of Sammy's friends and family members didn't want anything to do with him because he was planning to marry a white woman.

Even the so-called liberal Kennedys backed off when they heard that Sammy Davis was going to marry May. That's the reason Sammy wasn't at Jack Kennedy's inauguration. Bobby Kennedy thought having a black man with a white woman would be, at the very least, a distraction from the stars and the speakers. Sammy even went out of his way to postpone his wedding until after the election and the inauguration, but the Kennedy clan still didn't welcome him. That's a big part of why, in his later years, you often see Sammy with Richard Nixon. Sam was very hurt by the way the Kennedys treated him, especially after he went on the campaign trail and worked so hard to get Jack Kennedy elected.

In 1990, when Sammy found out he had throat cancer, he told Frank. The reality took a while to set in. Frank couldn't believe it. Sammy was given a choice, if you could even call it that. He could have an operation that might cut out the throat cancer, but it would require cutting out his vocal chords. In that scenario, Sammy would never be able to sing again. The alternative was chemotherapy. What a terrible choice. I think Sammy was paralyzed with fear. He decided to take his chances with chemotherapy, but it didn't work out.

Overall, 1990 was a bad year for Frank. In January, Ava Gardner died. She was young—only sixty-seven—when she passed, and I know

she loved Frank right to the very end. After that, Sammy died in May. He had gone through with the throat operation and the doctors told him that they had removed the cancer, but they were wrong. All those years, all those cigarettes—that's what they did to him.

First Ava, the love of Frank's life, dies. Then Sammy, his close friend for more than forty years, goes. Frank kept it all inside, just like he did with anything difficult. Believe me, he had some heavy burdens, but he never fell apart and he never complained. He just went on.

After Sammy died, Frank learned that the government was going to take away Sammy's house because he owed more than a million dollars in back taxes. Frank stepped in, quietly paid the government, and made sure that Altovise and Sammy's mother could keep the house. Nobody knows what happened with all of Sammy's money. He earned millions upon millions, but Sammy was also a great spender. In fact, Frank had to get his own accountant to help Sammy with his money. If Sammy earned $100,000 at the Sands, Sammy would spend $150,000. Sammy spent money as if there was an endless supply. I don't think even Sammy knew where it all went.

If Frank knew a friend was in financial trouble because of some unfortunate situation, Frank would take care of it. Frank took care of Woody Herman, paid for the medical expenses and funerals of a few of Count Basie's musicians, for comedian Bud Abbott, and for so many others that no one will ever know about because Frank handled that kind of thing on the quiet. Who was he going to tell? Remember, Frank hated newspaper reporters and photographers. The way Frank thought about it, money was something that was printed every day. The best thing about money for Frank was that he could use it to help people. And believe me, that's exactly what he did.

CHAPTER 25: AMERICA'S GUEST

People were always trying to get close to Frank, Dean, and Sammy. They were an attractive group. If Frank didn't want someone around, he would say that he had a meeting to go to or something like that. Frank would find some good excuse so as not to hurt someone's feelings. Here's an example. A guy used to hang around that had connections. Frank didn't like him. He didn't fit in for a lot of reasons. The guy was an outsider wanting to be an insider. According to Frank, that was the worst kind. We didn't want him around, but Frank didn't want to come right out and tell the guy to get lost, because he had friends in the nightclub business that could cause problems for Frank. I found out that the guy hated Chinese food and passed the word to Frank. Frank clapped his hands to get everyone's attention.

"We're going out to have Chinese food. Let's go," Frank announced.

The guy comes up to Frank and says, "Please forgive me tonight, but I don't like Chinese food. I'll take a rain check."

That's what Frank liked about me. I was always working on ways to make his life easier. Instead of letting him worry about various situations, I saw to it that I had everything worked out in advance.

Of course, in those days, there was no shortage of women, and Frank loved woman, but there was one thing about them that he really couldn't stand. He hated the smell of perfume. When a lady friend came in smelling of perfume, I would say to her as politely as possible, "Frank loves to have you around to have a good time, but Frank can't stand the smell of perfume. If you expect to stay a long time and socialize with Frank, get rid of the perfume."

I suggested that she take a shower, and showed her into my room where she could have some privacy. I hate to mention some of the women I made this suggestion to, because a lot of them are famous. I made sure that the women knew, because Frank was very shy in some ways, and he didn't want to be the one to tell them about their perfume. He had me do it instead. Frank hated the smell of men's cologne as much as he hated perfume. He never used deodorant of any kind. Frank showered at least two or three times a day. He changed his clothes no less than twice a day. He was fastidious about the way he wanted to appear to others.

One time, Frank and I were staying at the Sands Hotel. Frank got through doing the show, and on the last night of an engagement, Frank always had a party. This time, Frank didn't want to have the party in the lounge, so we had it in our suite. Stars filled the large room: Dean Martin and his wife, Jeanne, came by; Judy Garland; Peter Lawford and his wife, Pat; Shirley MacLaine; Jimmy Van Heusen; Ernie Kovacs; and Edie Adams.

Ernie was a creative genius in early television and one of a kind. He did a few movies, too, but his television shows were works of art. He died very young, maybe in his early forties, when he drove home drunk after a poker game and missed a turn.

Usually, Ernie and Frank didn't move in the same circles, but on this night, Ernie was sitting on the floor with a round ice bag on his head to numb a booze-induced headache. Ernie was smoking a cigar and telling jokes. He was hung over from who knows what. Everybody was doing something to keep the party going, and I kept pouring drinks for everyone. When the sun came up, the party was still going strong.

It got to be about five in the morning, and everybody was still drinking like hell and having a ball. Jeanne Martin came up to me and asked, "Where's Dean?"

I told her, "You know something, I didn't even know Dean was missing."

"Would you go look for him because I want to get home?" she said.

I went through all the rooms, and finally I went into Frank's suite. I

found Dean standing in the shower in Frank's bathroom and asked, "Dean, what are you doing?"

"I'm taking a shower."

"How can you take a shower when you don't have any water coming out?" I asked him.

To make the whole scene weirder, Dean was still wearing his suit—that's how stoned he was. I found Jeanne and told her about the situation and she just laughed. She went in, got him, and eventually took Dean home.

Around five-thirty in the morning, Pat Lawford got up and said, "I'm going to leave now. Please excuse me. I have to go to church." She was a Kennedy and a devout Catholic. They had early church services in Las Vegas, so she left, and Peter stayed. The party finally broke up around nine in the morning.

Shirley MacLaine was close to Frank. They both enjoyed and indulged in using foul language, because they couldn't talk that way in public. In fact, Shirley probably swore more than Frank did. Shirley's husband was a film producer in Japan. I don't know how the hell they ever got to see one another, so she had to find a way to have fun with somebody. She knew Frank always had exciting people around, so she showed up all the time. That's why Shirley latched onto Frank and Dean. It was through Frank and Peter that Shirley got to be friends with the Kennedys. Joey Bishop was the only one that didn't hang around. Joey did his show and then went home. He never stayed after hours in the lounge to join in the fun.

Judy Garland was part of the Las Vegas crowd, and she and I were close. Judy was a great entertainer who worked hard all her life, but even as a child star she didn't have anyone around her to say, "Wait a minute, that's my daughter. She's worked long enough today." She was a Hollywood star in her early teens and rose to fame with the Andy Hardy movies in the 1930s, and, of course, *The Wizard of Oz.* Some of Judy's other great films were *A Star is Born, Easter Parade,* and *Meet Me in St. Louis.* To top it off, she had a pair of lungs on her, and she knew how to put a song over. Judy could do it all, except stay away from booze and pills.

I fell in love with Judy when she came to New Haven with Mickey Rooney to promote one of their very popular Andy Hardy movies. Judy and Mickey were the top box office stars. Every movie they made brought in a lot of money, and they were both only kids at the time. When they arrived at Union Station, you couldn't get near them. The huge crowd followed the motorcade right up to the Bijou Theater. Years later, I met Judy through Frank at the MGM commissary. She was a beautiful woman and so full of life. Unfortunately, the years caught up with her very fast. She worked hard without resting and turned to booze and pills to keep her going.

One night Judy, Peter, and I were at the Beverly Hilton in California, but Frank wasn't there. Peter and Judy had gone out to dinner, but Judy was drinking like it was going out of style. She loved vodka. Judy got stoned that night—really bombed—let me tell you. Peter leaned over and asked me to drive her home. She lived in Brentwood, and we were in Beverly Hills. It took a while, but I got Judy into my car and began to drive her home. Somewhere along the way, I saw Judy reach over to try to open up the car door. I was certain that she was going to jump out.

I said, "Judy, stop! Please! What are you doing?"

She was frantic and depressed, so I pulled over to the side of the road and managed to calm her down. I got Judy home around five in the morning. I brought her inside where her maid and her daughter Liza Minnelli were waiting for her.

I told Liza, "Take care of your mom." Before I left, I made certain that everything was all right.

On the way back to the car, I heard glass breaking and people screaming, but I kept walking. I didn't go back inside because this had happened before. I had enough problems to deal with, without asking for more. I got in my car and drove back to the Beverly Hilton.

When I got back to our suite, Peter asked how everything had gone. I told him about the screaming, and Peter said that sometimes Judy got that way. We both knew it wasn't Judy's fault. What brought her to that point was her husband, Sid Luft. Whatever money she made, he invested in sure-

fire inventions to make a fortune, but the money always went down the drain. If somebody invented a new nail clipper, Sid would put a fortune into it. None of his investments ever worked out.

Sid Luft drove Judy crazy. I was close enough to see that. If Judy had found a husband who was more caring, thoughtful, and able to protect her, she would never have committed suicide. Believe me, she would never have done all that drinking and everything else she did. Sid drove her to drink. She worked hard all her life, and the people around her just wore her out. She never had anyone to protect her. One time while Judy was in England she tried to commit suicide by cutting her wrists, but she was discovered and taken to the hospital in time to save her life. She ended up in critical condition.

Frank found out and told me. "You know, Judy almost killed herself."

I said, "Yeah, I heard about it."

Frank said, "Send her a wire."

I asked Frank, "What do you want me to put in the telegram?" I thought he would have to use a lot of words to express how he felt.

You know, "Get Well. We're thinking about you. Crap like that. Just put: 'Dear Judy: WIN! Love, Frank.'"

"What else do you want me to say?"

"That's it."

Judy recovered and whenever Judy and I saw each other, she mentioned that telegram. Frank did everything he could to help her, but, sadly, in the end, Judy was just out of control and out of reach.

Somewhere in the 1970s, Frank got seriously ill and ended up in the hospital. He had twelve feet of intestines taken out. I sent him the same wire he asked me to send Judy. "Dear Frank: WIN!" When Frank got the telegram, he said he couldn't stop laughing. I knew it would make him feel good. That was my job and I worked hard at it—for thirty years, I kept him in shape and got him out of his moods, so he could do his shows and cut his records. I always knew what to say and when to say it and what not to say.

No mater where I went, I never had to pay for anything. As I said be-

fore, all I had to do was sign, "TC for FS" or if I were with Dean, "TC for DM." The same was true when I was with Peter and Sammy.

Frank said, "We're going to name you 'America's Guest.'" That's how I got that nickname.

CHAPTER 26: THE KENNEDY YEARS

When Jack Kennedy was running for President in 1960, he traveled across country on the campaign trail, and sometimes Frank performed during campaign stops. Frank brought Dean and Sammy with him to do a show and introduced everyone to the next president. If Frank didn't go, Dean and Sammy didn't go; Frank was the leader. If Dean or Sammy were doing shows and asked Frank to join them, Frank would think about it. If he felt like doing it, he might do it.

However, when Frank said to Sammy and Dean, "We're going to Athens, Ohio, to do a show," they went—no questions asked.

In the early days of the campaign, Frank was the draw. He brought in the big crowds. Kennedy was just some young senator from Massachusetts. The crowds weren 't there to see Jack Kennedy; they were there to see Frank. That's how the campaign started. Before Jack Kennedy spoke, Frank, Sammy, Dean, and the rest of the Rat Pack put on a show, and people crowded around to see them. After Frank, Dean, and Sammy performed, Jack Kennedy came on stage to make a campaign speech. Kennedy had it made.

Frank would tell the crowd, "If you like whatever it is I do, let's get behind the future president." Then he'd introduce Jack Kennedy. Of course, Peter Lawford was Jack's brother-in-law, so the whole thing tied together.

Here's another Kennedy story. One time, the president, Frank, and I were staying at the Carlisle Hotel in New York. When the president left, it was my job, as usual, to check everything thoroughly to make sure nothing was left behind.

I went through all the drawers in the president's room, and I found three shirts. I called Evelyn Lincoln, President Kennedy's personal secretary, at the White House and told her that I had found three of the president's shirts.

I asked, "What should I do?"

Evelyn said, "Wait until I call you back."

About twenty minutes later Evelyn Lincoln called me back and said, "A limousine is coming to pick you up and bring you to the airport."

For the sake of only three shirts, the limousine picked me up and brought me to the airport. At the airport, they put me on the *Caroline,* which was the president's private plane, and flew me to Washington. From there, I was driven to the White House in yet another limousine.

A week later, Evelyn Lincoln wrote a letter on White House stationery thanking me. She wrote:

Dear Tony:

It was so nice to meet you yesterday and the President appreciated very much your bringing his shirts to Washington. I hope the next time you are in Washington; you will stop by the White House to see me.

Sincerely,

Evelyn Lincoln, Personal Secretary to the President.

During the Kennedy years, I would call the White House from time to time to ask how Evelyn and the Kennedy family were. Somebody from security saw my name and asked Mrs. Lincoln, "Who is Tony Consiglio? He is always calling the White House."

Mrs. Lincoln said, "His name is on the gold board. You don't interfere with his phone calls."

Evelyn Lincoln was a kind and caring woman. She was very close to President Kennedy, and she was the one who pleaded with him not to go

to Dallas on November 22, 1963, the day he was assassinated. Evelyn Lincoln stayed true to President Kennedy until the very end. She wrote a book about her years with Jack Kennedy later on, but she kept it dignified. Despite everything that came out about the President and his relationships with many women, Evelyn never said a word. She was truly a lovely person who went to her grave with all her secrets.

To show you what kind of a guy Jack Kennedy was, one night when we were all at the Carlisle Hotel, the Secret Service was looking for him. The president had sneaked out a back door, slipped past the Secret Service, and attended a Broadway play alone. Peter Lawford told me about it the next day. I don't know how the president managed to get by the Secret Service, but he just wanted to go to a play without the usual fanfare and all those guards standing around.

Jack loved being around people. He drove the Secret Service crazy while he was on the campaign trail. He would often leave the podium and go right out into the crowds. There was no way anyone could have protected him when he decided to do things like that. He had this real need to get close to people, and people loved him. He was young and full of life, and there was a real sense that he was going to revitalize the country. He brought music, culture, and an appreciation of the arts to the White House. He and Jackie were so young and beautiful. Their time together at the White House started out with so much hope.

The day of Kennedy's election, November 8, 1960, I drove up to Hyannis Port. I remember it was pouring rain, and it was impossible to make the speed limit because the visibility was so bad. When I got to the Kennedy compound, the Secret Service agents at the entrance wouldn't let me through.

One agent said, "Move away or we'll pinch you."

I told him, "I'm a friend of the Kennedys, and they invited me to come here. Call down to the house. Tell them Tony Consiglio is here. If they don't want to see me, I'll leave."

I always loved doing this. After I stopped working for Frank, I would go to where he was performing and ask to go backstage to see him. The

security people didn't know me from Adam. They thought I was just an-
other fan trying to con my way in. They always came back in a state of
shock and then escorted me directly to Frank's dressing room. The same
thing happened at the Kennedy compound that day. The agent went away
and called the main house. In a few minutes, he came back.

"They want to see you right away. You're one of the family," he said.
Then he told me to follow him and I did. He drove ahead and directed me
to Ambassador Kennedy's house.

Next door was Bobby Kennedy's house, and across the way was Jack's
house. Right behind Jack's house there was a little store called Sally's that
sold souvenirs. Between the three houses and the waterfront stood the field
where the Kennedy family gathered and played touch football. I parked my
car in front of Ambassador Kennedy's house. That's where most of the
family and friends had gathered to listen to the election returns. In Bobby
Kennedy's house, teletypes were set up to relay the voting results from
different states. As the returns were coming in, I went next door and
brought the news back to Ambassador Kennedy's house.

We stayed up all night and well into the morning hours. The election
hung in the balance until Illinois went to Kennedy. It was a close elec-
tion, with less than 120,000 votes separating Kennedy from Richard Nix-
on. When the results were in and Jack Kennedy had been elected presi-
dent, I was so excited. I wondered how I was going to prove to anyone
back home that I was with the Kennedy family at their compound on
election night.

After the win Ambassador Kennedy said, "Here, take a picture with
me." He was in his pajamas and bathrobe. I had a camera with me, so one
of the Secret Service agents took a photo of us. That's the same picture you
see in my collection today. I slept at the compound until about two-thirty in
the afternoon. I ate breakfast, and then drove to New Haven. I would have
stayed longer, but a million photographers and reporters were swarming
around like flies on shit. It was a madhouse, so I got out of there.

From time to time, I went to Washington while Jack Kennedy was
president. As part of his inaugural celebration on January 19, 1961, I was

in charge of all the stars that performed in honor of President Kennedy at the inaugural ball at the D.C. Armory. Frank coordinated the entertainment, with the help of Roger Eden, a Broadway producer. We used the *Caroline* to fly different performers in from various parts of the country.

Most of the stars stayed at the Statler-Hilton. I instructed the hotel management that any food ordered by performers at the inaugural who were staying in the hotel would be covered. The room service waiter would have to stop by my suite so I could sign, "TC for FS" for anything that went to their rooms; the stars were not allowed to pay for anything. The Democratic Party paid the various bills. Harry Belafonte, Jimmy Durante, Ella Fitzgerald, Louis Prima, Keely Smith, Lawrence Olivier, Ethel Merman, Milton Berle, Leonard Bernstein, Al Hirt, Nat King Cole, Gene Kelly, Janet Leigh, Tony Curtis, and Frank were among the stars that were there to perform that night. Frank wanted every great star he could round up to perform at the inaugural ball at the armory, but several of them couldn't appear because they had contracts to perform somewhere else. Ethel Merman would have been one of those, since she was on Broadway performing in *Gypsy* at the time, but Frank paid for all the seats in the theater and closed the show for one night so she could be at Kennedy's inauguration. Frank had two Broadway shows closed so people could perform for the new president.

Frank told both managers, "Tell me what it costs to close the show, then close it and send me the bill."

It was January 19, 1961, the night before the inauguration of John Fitzgerald Kennedy, and a traffic-halting, shut-down-the-airport blizzard raged in Washington, DC. I had so many things to do that night that I forgot Frank's tuxedo back at the hotel. I remembered the tux when I got to the armory.

When I saw Frank, I told him that I had left his tuxedo back at the Statler-Hilton.

"Frank, I'm trying to do too many things," I said.

Frank said, "I can understand that, but you take care of me first. Go back to the hotel. You better leave now because of the way it's snowing."

I got into a cab and told the cabbie he had to take me back to the Statler-Hilton immediately and that I'd take doubly good care of him. Even if he got pinched, he didn't have to worry, because I would pay for any traffic tickets.

"Go up one-way streets; do anything you have to do. I'll take care of you. If the fare is twenty dollars, I'll give you a hundred." I'd do anything to get Frank off my neck.

The snowplows hadn't even begun to get the snow out of the way. It was a wild ride through a blizzard and abandoned cars, but I got to the hotel, grabbed the tuxedo, and got back to the armory in time for Frank to get dressed and do the show. In the end, we had a grand time.

It was my job to make sure that the stars always had what they wanted, including Jimmy Durante, who loved to smoke cigars.

Jimmy came to me and said, "Tony, I need a cigar."

"Where am I going to get a cigar?" I answered. We were in the armory, at an inaugural ball, and there was a blizzard outside.

"I gotta have a cigar," Jimmy said.

I told Jimmy I'd see what I could do. I remembered that Milton Berle smoked only the best Havana cigars, so I went up to him and said, "Milton, I need a cigar," but I didn't tell him who it was for.

Throughout the day I got at least four of them for Jimmy. Finally, Jimmy said in his gravelly voice, "Tony, where are you getting these wonderful cigars?"

"From Milton Berle."

"Aw, now you put me in a jackpot."

I asked him why.

"Now I'm going to have to send Uncle Miltie a whole box to make up for this," Jimmy said.

Even with a blizzard, the forgotten tuxedo, and everything else that could have gone wrong, it was really a terrific night. The music was great, and when Jackie and Jack Kennedy came in, the place just glowed with the joy and anticipation of a new era. He was the youngest man ever elected president and the room was full of energy. Once in a while, if the

President remembered, he would call me Tony. If he didn't remember, he would call me, the Dago. There we were, Frank and me in our tuxedos, running the show. What a night to remember.

Ella Fitzgerald flew in all the way from Sydney, Australia, to perform at the inaugural. Frank greeted her and introduced her to everyone, including the president and Jackie. While we were sitting around having dinner, Frank asked Ella if he could do anything for her. Ella said that she would like to have the chair President Kennedy was sitting in.

Frank turned to me and said, "Tony, you got a problem. When the president gets up, you go up there, take the chair, bring it downstairs, and have it packed for shipment."

We had the chair that President Kennedy sat in mailed to Ella Fitzgerald's home in California.

Here's another inaugural story. Frank and I were on our way to President Kennedy's inauguration. I was in the limousine with Frank. The outgoing president, Dwight D. Eisenhower, wore a heavy winter coat, but Jack Kennedy was there in a suit without an overcoat. Once again, I wanted something to prove that I was there, so I decided to ask our limousine driver if I could have the special inaugural license plates. Frank was in charge of the inauguration, so I told the driver that Frank said I could have the two license plates for souvenirs.

The driver said, "If I give them to you, how am I going to drive around Washington, DC, without license plates?"

I quietly told him, "You don't have to give them to me, but I could tell Frank, and Frank could tell the president that we couldn't get the plates."

The driver said, "Okay, okay. I don't want a problem. I'll give you the license plates. I'll bring the limousine back and get another one with regular plates."

That's exactly what he did, and that's how I happened to get the inaugural license plates. Not only did I get the plates, I got the Connecticut flag on the stage where President Kennedy took his oath of office.

I asked one of the security people for the flag. Again, I used Frank's name. The man said, "Well, if Frank wants it, he can have it," and he

gave me the flag, which I gave to my late brother Sally, may he rest in peace.

When the inauguration was over, Dick McGuire, the treasurer of the Democratic National Committee, came up to me.

"Tony, for the job you did at the inauguration, making sure everyone was taken care of, here's a signed, blank check. Fill in the amount you want and keep it.

I thanked Dick McGuire for the check, and said, "I'm so tickled to death that Jack became president and that I'm part of it. You fill in the amount and throw it to the Democratic Party," and I gave the check back.

I didn't need to ask what I should do. I was smart enough to handle it myself. Somebody told Frank what I had done and Frank said, "Tony, I'm not telling you what happened, but I'm overjoyed about the way you acted and about what you did with the blank check."

In those days, money didn't mean anything. I just did the right thing. What was money to me? If I needed anything, all I had to do was sign "TC for FS." One time, Peter Lawford and I were staying at the White House. We were walking around the living quarters upstairs. Peter whispered, "Shhh. Don't make a sound. You see that light under the door. The president is sleeping in there."

I was walking in the dark and looking at the door, when I tripped over Caroline's tricycle. It made a noise you wouldn't believe. All the lights went on, and Secret Service guys came out of the woodwork.

The president called downstairs, "Who's on my floor?"

The guard downstairs answered, "It's nothing, just the Dago and your brother-in-law."

After everything settled down, Peter went somewhere to call his wife, Pat, Jack Kennedy's sister, and I went to sleep in the Lincoln bedroom in Lincoln's canopy bed. I called my sister-in law, Flo, and told her to tell my mother that I wouldn't be home for three or four days because I was staying at the White House. I heard a thud. Flo was so shocked she dropped the phone.

Twice Evelyn Lincoln invited me to the White House for brunch. On a few occasions, I drove Judith Campbell Exner to the White House for her

visits with the president. Judith would fly in from the coast on a commercial plane. She would never use the *Caroline* because the press watched it constantly. I went there without Frank because this was after Frank and Peter had a falling-out over Jack Kennedy's stay at Bing Crosby's estate. Frank believed that he and Jack Kennedy were and would remain close friends. It was Dean who told Frank that it would never happen. People underestimated Dean, but he was a perceptive individual in spite of all the booze, and he wasn't afraid to go against Frank when he thought Frank was wrong.

Dean knew it was great to help get JFK elected president, but once he was in office, there was no way Frank and his Rat Pack friends were going to be part of the Kennedy administration. There were rumors that Frank was going to be named ambassador to Italy. Frank was too optimistic to take Dean's remarks seriously, but as it turned out, Dean saw the situation better than anyone. It was around this time that Peter and Frank were growing distant because of the way the Kennedys had slighted Frank.

At one point, there was a plan for Jack Kennedy to come to California and stay with Frank. Frank responded to the news by expanding his house and grounds to accommodate Kennedy and his entourage. Frank saw the possibility of his home becoming a West Coast White House, so he even had a heliport built. This way, the presidential helicopter could land within the walls of Frank's estate. Frank spent hundreds of thousands of dollars on these projects.

Then something happened and things began to fall apart. Bobby Kennedy didn't want Jack to stay with Frank because Frank knew some influential mob figures. Instead of coming clean about his reasons for backing out, Bobby Kennedy said that plans had changed because Frank's estate didn't meet Secret Service requirements for ensuring the safety of the president.

Pierre Salinger was one of the JFK's advisors, and he was in Las Vegas to have a good time. He and I had dinner together the night before he called Peter with the bad news. Peter and I were staying at the Desert Inn,

where Peter was appearing with Jimmy Durante. Peter wasn't much of a performer. He sang a few songs and did a soft-shoe number with Jimmy. He really didn't have much talent, but it was a payday. I took the call from Pierre and handed the phone to Peter. Pierre told Peter that they had called Bing Crosby's home, but Bing wasn't there.

Jimmy Van Heusen was staying there while Bing was in Europe. Jimmy relayed the message to Bing that President Kennedy wanted to stay at his house while he was traveling in California. Bing gave the okay, and that was that. Pierre told Peter that Jack Kennedy was going to stay at Bing's house, and it was going to be Peter's job to tell Frank. Peter was caught in the middle. Poor Peter—he was never a bright light. He could have said no, but his wife was a Kennedy. He had to choose between being loyal to Frank or to the Kennedys. Either way, Peter would lose and he knew it.

When Peter called Frank, I was with Peter and told him, "Don't tell Frank I'm here with you."

Peter told Frank about the change in plans, and Frank didn't take the news quietly. He had to blame someone, so he blamed Peter, and that was the end of the friendship. This was during the Cuban Missile Crisis between Kennedy and the Soviet Union's Premier Khrushchev. Pierre told me that it was good that we were in Las Vegas, because if there was any trouble with Russia, we were safe there. Believe me, it was nothing compared to Frank being pissed off at Peter and the Kennedys.

I was in Vegas with Peter and Pierre when Frank got the word that Kennedy was staying with Bing, so I didn't see Frank go out to the new addition, pick up a sledge hammer, and start smashing down some of the walls. If anyone had been around Frank at that moment, they would probably have been safer in Cuba.

When JFK decided to stay with Bing, a Republican, Frank was really hurt. And since he had counted on Peter to be his go-between with the president, Frank blamed him when the plans fell through. The real cause of the problem was Bobby Kennedy, but once Frank made up his mind, there was no way for Peter to get close to Frank again.

After the falling-out, Frank went back to the White House just once during the JFK years, but I went there whenever I was in the area. The President and his staff treated me like royalty.

On one of my visits to the White House I said to President Kennedy, "How can I prove I was at the White House?"

President Kennedy said, "I'm going to give you one of my guards so you can take all the pictures you want."

The guard took pictures of me in Jackie's Rose Garden and Caroline's play area. John-John hadn't been born yet. While I was there, I took pictures of everything and, fortunately, I still have them. At least I didn't give those away!

The next day, I picked up souvenirs and put them in my pockets. If it said "The White House" on it, I took it. Ashtrays, matches, I took everything I could. When I walked out of the White House, my pockets were bulging.

One of the guards looked at me and said, "Will you be able to walk to your car?" and we both laughed. I knew the president wouldn't mind me taking the souvenirs, but I left him a note anyway.

Dear Mr. President:

I wasn't brought up this way but I just couldn't help taking some souvenirs for my family.

Signed,

The Dago

Bobby was tough. If I told him I took an ashtray, he would ask me to put it back. Jack was different. He was a friendlier kind of guy. President Kennedy told Peter Lawford that he laughed like hell when he saw my letter. The president told Peter, "If there's anything more Tony wants, tell him to take it."

In September 1961, because of the work I did to get Jack Kennedy elected, Peter Lawford took me to Hawaii. We stayed at Diamond Head, at Bobby Kennedy's house. While I was down there, Peter got a call from President Kennedy at the White House. They were talking and I was only a few feet away.

The president asked Peter, "Is the Dago with you?"

"He certainly is."

"I want you to have a bathing suit made for Tony with my insignia on it," Jack told Peter. There was a man at Diamond Head who used to walk along the beach with a suitcase. He had material in the suitcase to make bathing suits and a book to record your measurements. You could pick out the material, and he would make the bathing trunks right there for you. On trunks he made for the Kennedy family, he put a paddle and an oar. That was Jack Kennedy's insignia. We were supposed to stay at Diamond Head a week, but we ended up staying a month. When Jack was assassinated, this country lost so many subtle qualities, including its hope and its innocence. I don't know exactly why, but the country has never recovered from that death. When we lost Martin Luther King Jr. and Bobby Kennedy to assassins in the spring of 1968 the spirit and hope for America's future ended suddenly for so many Americans.

I was at Jack Kennedy's funeral, and it was one of the saddest times in my life. Ask those who were alive then where they were when they heard that President Kennedy had been killed and everyone remembers. Everything stopped. We were all in shock. When Jack Kennedy was shot, Frank was working on a movie, *Robin and the 7 Hoods.* Frank was asleep when the news came on the radio. I woke him up and told him. Then I called the White House.

As you can imagine, things were terrible there. There was a deep sense of disbelief. Later that day, Evelyn Lincoln called me. She told me to come to the White House and said that there would be an envelope with special credentials waiting for me. Some people were given small, round ID badges to wear. It allowed them to get within a certain distance of the funeral. Mrs. Lincoln issued me a badge with a small pearl in it,

which indicated top clearance, and that allowed me inside the church and the cemetery.

When I got to the church, they put me next to this tall, distinguished man who wore a plain military uniform. I didn't know who he was and later asked Pierre Salinger whom I was sitting next to in the church during the funeral. Pierre told me it was French President Charles De Gaulle.

After the assassination and the days of national mourning, a lot of things were not the same. It was as though innocence and trust were lost, and people knew we would never be the same again. I was there with Jack Kennedy on the campaign trail and with the Kennedy family the night Jack Kennedy was elected. I was there when they partied into the morning to celebrate his inauguration, and there I was again with the family at the funeral. We went from elation to unfathomable tragedy in just three short years.

A few years later, I was in New York with Peter Lawford at the Savoy-Hilton. Peter was going to be on some show, and Frank asked me to go with Peter to help him. Peter didn't have a traveling companion. He had a business manager named Milton Ebbins, but Ebbins was interested only in making a buck. Peter wanted companionship, and I was the right guy for him. At the Savoy-Hilton, Peter received a phone call that his father-in-law, Ambassador Joseph Kennedy—President Kennedy's father—had just died. Peter was a very religious man. He wanted to go to St. Patrick's Cathedral to say a few prayers for his father-in-law, and he wanted me to go with him, which, of course, I did.

Peter had appeared in *It Happened in Brooklyn* with Frank and Jimmy Durante. He was born in England and his father was a British general in World War I. Peter made about thirty movies and had two successful television series. One was *The Thin Man,* based on the movie series that starred William Powell and Myrna Loy. I remember the *Thin Man* series because the show was being shot at the same studio where Frank was making *The Joker Is Wild.* I knew Peter then but I never went over to his set to visit with him. I stayed with Frank. As long as I stayed nearby, Frank didn't need me at all. The minute I left, Frank inevitably needed me.

He'd say, "Where the hell you been?" It was a funny thing, so I never traveled through the studios while Frank was on the set.

At the time, Frank knew Peter Lawford, but not very well. They were friendly but didn't become close until 1958 when Peter and then-senator Jack Kennedy came to the Sands. Jack Kennedy liked hanging around nightclubs. He would stay up until all hours with Frank, and that's how they developed their friendship. I already said that Frank often got show-girls for Jack, and back then, for a hundred dollars, you could get anyone to do anything. Believe me, Jack Kennedy spent a lot of money on women. It wasn't until we worked with him on the campaign trail that I learned he was married. That was quite a surprise.

I got to know Peter very well over the years. I knew that he enjoyed a bottle of Lowenbrau each night before he went to bed because it helped him sleep. When he got up in the afternoon, he had a glass of Crown Roy-al, and that gave him an appetite. More often than not, we'd go to Trader Vic's for dinner. Peter was a pretty good drinker. He knew how to take care of himself, but he was always broke.

Of all the members of the Rat Pack, Peter had the least talent and the least money, and he always allowed himself to be a gofer for both Frank and the Kennedys.

I was once offered money from a writer to tell what I knew about Pe-ter. The writer sent me a check and a letter that said he was sending me $500 and wanted to sit down with me and talk about my relationship with Peter and Marilyn Monroe. The writer said that he had tapes of phone con-versations between Marilyn and me, and that he had a recording of Marilyn and me from the night before she died, which was possible. Marilyn and I did talk the night before she died, but I didn't want to get involved with this guy. I wasn't sure what to do, so I called Frank.

Frank said, "Tony, if you want to help this guy write a book, go ahead, but these people don't want to write anything positive about the dead. If I were you I'd let bygones be bygones." It wasn't hard to tell that Frank real-ly meant for me to stay away from it.

That talk with Frank cured me, and I sent the check back immediate-

ly. I didn't know the writer, but I knew there was no way that Peter would want me to sit down with a stranger and talk about his life. Frank said not to do it, and I always listened to Frank. He and Peter had their differences, and Frank might have disliked Peter at that stage of the game, but he disliked reporters more.

Peter told me his father had been a general in the English Army when he met his future wife. I can't remember if Peter's father was knighted for something, or if his mother was from royalty. What I do remember was that she held the title of Lady. When I met her, she was working in a jewelry store in Los Angeles. It didn't make any sense to me. What was she working for? Peter was a big star. One day I was with Peter when he went to visit his mother at the jewelry store. The people at the store told Peter that they hadn't seen her for two days. He couldn't reach his mother at home, so he called the police department. The police found Peter's mother at home. Why she didn't answer the phone, I still don't know.

Anyway, Peter made sure that she was okay. It was so strange that she was working in a jewelry store. I just couldn't figure it out. That would be like Frank's mother working in a restaurant as a waitress. Maybe Mrs. Lawford wanted it that way, or maybe she didn't get along with Peter.

Peter had a deformed right hand. I don't know what happened, but every time you saw Peter in a movie, you saw the left hand and not the right hand. Although he could still use the hand, two or three fingers were bent and immobile. I never asked Peter what happened, because one thing I learned from Frank was, don't ask. If Peter wanted me to know, I'm sure he would have told me.

As I said, I was in two movies with Peter. In *Dead Ringer,* I drove the death car. The other movie was *Advise & Consent.* We were shooting the film in Washington, DC. The director, Otto Preminger, was also Frank's director in *The Man with the Golden Arm.* Preminger was a tough taskmaster who wanted everything done his way and done perfectly on the first take. He would lose his temper in no time at all if things weren't going according to plan. Frank wasn't in the movie, but he showed up one after-

noon. Otto Preminger wasn't on the set at the time, so we hid all the cameras on him.

"Tony, take these two cameras and roll them into another room," Frank said and, of course, I would have done anything for Frank, so I pushed the two cameras into another room.

The cameramen came in and couldn't find the cameras. When Otto showed up, one of the cameramen said, "Otto, don't ask me what happened, but the cameras aren't here."

"What do you mean?" Otto said, getting excited.

"The room is empty. Somebody broke in and stole the cameras," the cameraman said. "We can't film. We've got to get more cameras."

I thought Otto was going to have a stroke right there on the set. Otto called around the building and, obviously, nobody knew where the cameras were.

Finally, Otto and the cameramen left the set to check and see if the cameras were with security. That's when Frank called. He was actually calling from security.

"Tony, while Otto's running around the building, move the cameras back and leave them exactly the way they were before."

I moved the cameras back into the room. When Otto returned, followed by a contingent of security people, he was yelling about the vanished cameras. They came onto the set, and the cameras were right where they were supposed to be. The security people looked at Otto as though he had lost his marbles. This only made Otto furious. He demanded that security get to the bottom of the disappearing and reappearing cameras. I don't think they did much about it, and nobody connected with the production company ever found out who moved the cameras.

Another time in Washington, Peter and his manager, Milton Ebbins, had to go to Chicago. Frank was in town to visit with President Kennedy, along with Larry O'Brien and Kenny O'Donnell, two of Kennedy's chief aides. Milton Ebbins had bought a box of expensive cigars for his trip with Peter. Frank and I arrived at Peter's apartment, and while Milton and Peter were in another room, Frank told me to get a common pin and

take the top row of cigars and punch holes from the tip where Milton would light the cigar down to the middle of each of them on both sides. I went into the bathroom, locked the door, and made the pinholes. Then I put the cigars back in the box so they looked like they hadn't been touched.

Just before they left for Chicago, Milton told Peter to wait a minute while he grabbed a handful of cigars. I wasn't on the plane, but Peter told me what happened. Milton took out a cigar and tried to light it, but it wouldn't light. He saw the holes and held his fingers on them. He looked like he was playing a flute the way he was trying to plug all the holes. He took out another cigar and kept puffing away, trying to light it, but that one wouldn't light either. Milton got more and more frustrated, and Peter started laughing. Then people across the aisle started laughing because Milton was huffing, puffing, and getting red in the face. Finally, after four or five cigars, he just gave up.

Milt caused close to a riot on that plane—he wasn't the type of guy who could take a joke. By the time he got to Chicago, he was furious. The next time I saw Milton we were in Washington. He wanted to know who poked holes in his expensive Havanas.

"Milt, don't accuse me." I told him. "If you accuse me, I'm going to tell Frank and we're all going to be in trouble."

I had an honest look on my face, almost angelic, but Milt knew I did it. He wasn't going to yell at me because he knew Frank would jump all over him. Peter couldn't wait to tell Frank the story, and when he did, they laughed like hell at the thought of Milton Ebbins puffing away, trying to fit his fingers over all the holes.

Peter was usually broke. He borrowed money and spent it as though he were a millionaire. He had an image to protect, but he did things that made you wonder what he was thinking. When he lived across the hall from us at the Fontainebleau Hotel, Peter would throw his dirty shirts into Frank's laundry bag. When the laundry came back, we found shirts with "PL" on the pockets.

I said to Frank, "I don't know how these shirts got in here."

"Tony, you tell that bum, if he can't pay for his own laundry, not to bring it in here." That was the last time Peter tried to do that.

Peter was always low on money. When I registered him at a Hilton hotel, Peter would tell me to get a thousand dollars and have it put on his bill. He must have done this a dozen times. Peter and I were the only other passengers with Baron Hilton on his private plane when Baron talked to Peter about the loans. Baron was heir to all the Hilton hotels.

"All those loans come to around $25,000. I want you to know I've taken them off the books." That was Baron Hilton's way of telling Peter that he couldn't take out any more loans when he checked into one of Baron Hilton's hotels.

Another story I can share about Peter Lawford happened one Sunday afternoon when Peter and I were at his house in Santa Monica. Peter was in the garden picking flowers. He made a nice little bouquet, got in his little Jaguar, and asked me to go for a ride with him. He drove for a long time until we ended up in a cemetery. It was about four or five in the afternoon, and the gates were closed.

"Peter, the cemetery is closed," I said.

"That's why I brought you along. You climb up the gate, go over the top, and when you jump down, I'll hand you the flowers. Then I'll tell you where Marilyn's vault is."

"Whose vault?"

"Marilyn Monroe's."

I climbed the fence, jumped down into the cemetery, and landed on concrete; the bottom of my feet stung. Peter pointed to a large crypt, and I walked over to it. It said:

Marilyn Monroe: Born 1926

A huge, beautiful bouquet of flowers, like you wouldn't believe, sat on top with a card from Joe DiMaggio that read, "Love, Joe."

There were two vases built into the side of the vault. I put Peter's flowers into one of them, and then I turned to look for Peter, but he and the

Jaguar were gone. I figured Peter was playing a prank by driving off and leaving me in the cemetery. When I turned around and didn't see the car, I figured I was stuck there. It was getting to be late afternoon, but I finally spotted Peter about a half mile away at another gated entrance. Peter didn't want me to walk from there across the cemetery all the way to Marilyn's vault and thought it was easier for Peter to give directions to Marilyn's gravesite from the first gate. Peter tooted the horn, and I walked across all the other graves to the car. That was Lawford for you. Sometimes he could drive me crazy.

Marilyn was a strange case. She could never say no to anyone. One time Peter, Marilyn, and I were in the lobby of the Savoy-Hilton in New York waiting for a limo to pick us up. We were standing near the desk where a man was talking to the bell captain.

"I don't know what I'm going to do. I've got all this champagne cooled and now no one is going to show up," he said.

Marilyn didn't know the man from Adam, but she went over to him and started a conversation when she heard the magic word: champagne.

"Tony, you better grab her and get her over here. Otherwise, she'll be up in that guy's room in five minutes drinking all his champagne," Peter said.

I went over to Marilyn and the stranger. "Excuse me, but the limo is here and we have to go," I told her.

I grabbed her arm to pull her away while she kept talking to the man and telling him about how nice it was to meet him. For Marilyn, anyone who had champagne or wore long pants was an absolute pleasure to meet. If he had champagne and also wore long pants, then you might as well forget about seeing Marilyn again until either the champagne or the guy with long pants ran out. The only way you could slow Marilyn down was to put speed bumps between her and a bottle of champagne.

A few people know that I was one of the last people to talk Marilyn Monroe before she died. Peter and I were staying at the Beverly Hilton. At some point in the night, Marilyn called our suite, yelling and screaming.

At first, I didn't recognize her voice because she wasn't making any

sense. I didn't know if she was sick or whether someone was hurting her. I always had it on my mind that the FBI was taping our calls, so I passed the phone to Peter, and then I left the room. Believe me, I have been in enough situations to know when it's time to leave, and this sounded exactly like one of those situations. Some people want to know more than what's out there. They buy books on how to win friends, how to live longer, how to know themselves, how to be more compassionate, how to drink chicken soup, or how to find their cheese. I'm just the opposite in life. With the people I was hanging around with in 1962, the less I knew the better off I was going to be. Living in denial is always the best defense, and so is playing dumb: "Yes, officer. You say Peter was with Marilyn. Marilyn who? The actress? And she was with Peter? Peter who?"

After Peter hung up the phone, he left the suite in a hurry, saying he'd be back in an hour. I don't know where Peter went, but I thought it was probably to calm Marilyn down. With any of those guys, I never asked questions. Believe me, it was better not to know everything. If I told everything I knew, I'd be up the creek for a hundred years. I didn't see Peter until about nine the next morning, when he ran into our suite really shaken up.

"Tony, we're checking out right now," he said.

We packed everything in five minutes and left for Peter's house in Santa Monica. Whatever we left behind, the maids could keep as far as we were concerned. I didn't follow the news in those days, but the next day the news of Marilyn's death was all over the place. I was really shocked. I didn't call Frank, because I didn't want him to think that I had gotten myself in a situation that would cause a lot of publicity. Frank didn't like that type of behavior at all. Everybody tosses things around to make a buck, so what happened with Marilyn will always be up in the air. However, I'm pretty sure Peter was one of the last people to see Marilyn alive, if not the very last. Whether she was alive or dead, I don't know. Like I said, I didn't ask questions. That's why they called me the Clam.

Nothing stopped Frank. He kept doing movies, making great records, and doing shows. Slowly, Peter's career went downhill until his attraction

as the fair-haired young man with the beautiful English accent was no longer. The movie roles faded away and Peter was reduced to making rare appearances on *Fantasy Island* and other television shows. Peter also tried his hand as a nightclub act, but he couldn't sing, and he definitely couldn't tell jokes. It was sad to watch him try. Peter was always a haunted, lonely man. Even his mother disowned him in the end. The Kennedys did everything to help him, but with all the people behind him, Peter just couldn't keep it going.

The deaths of first Marilyn then his brother-in-law, JFK, really wore Peter down. He divorced Pat in 1966, and that was the end of his friendship with the Kennedy family. Because of his falling-out with Frank, Peter didn't have his old friends like Dean and Sammy to pal around with. Peter was a man who tried not to look old and to get by on charm. I saw less and less of Peter over time. I eventually lost touch with him, and then he was gone. I guess his liver gave out when he died in 1984. He was only sixty-one.

CHAPTER 27: THE FINAL FLING

Around 1965, Frank met Mia Farrow on the set of *Von Ryan's Express.*
Mia, a kind, sweet individual, was very young—only nineteen. Frank
talked to her about the things he liked and didn't like, and he warned her
about how reporters could take a sentence and make it into a story. Frank
knew that if he said three words, like "I love her," reporters would take
those three words and blow them up into something else, and Frank
didn't like that. Reporters were out to sell papers and didn't care what
damage they caused.

Here's what I mean. One day Frank and Mia were at Martha's Vine-
yard in a yacht Frank had leased when something happened. Two crewmen
were coming back to the yacht when the boat they were in got swamped
and sunk. One of the men died. At the time, Lyndon Johnson was president
and something big was happening in the country. Johnson signed a number
of civil rights bills that outlawed housing discrimination and made it illegal
to deny anyone the right to vote. Instead of Lyndon Johnson being the
headline article, newspapers had Frank's story, something like:

SINATRA'S LOVE BOAT CREW MEMBER DROWNS AT THE CAPE

President Johnson had just signed major legislation that would alter the
course of America forever, and Frank was the headline. Frank sold news-
papers—Johnson didn't! When Frank and Mia married in 1966, everyone
talked about the thirty-year difference in their ages, but it didn't matter to
Frank. He loved her, and maybe he knew it wouldn't last, but they were
very much in love.

Like Ava Gardner and Juliet Prowse before her, Mia was an actress. At that time, she was best known for her role as Allison Mackenzie on the successful television series *Peyton Place*.

They both worked for Twentieth Century Fox at the time. Mia stumbled onto the lot where Frank was shooting *Von Ryan's Express*. Maybe Mia stumbled, or maybe she didn't, who knows. *Von Ryan's Express* was a movie set in Italy during the Second World War. It was a good movie that had Frank saving the lives of some soldiers on a train while he lies dying after being shot by the Nazis.

This was a particularly strong time in Frank's career. He was in *Come Blow Your Horn* and *The List of Adrian Messenger* in 1963. *4 For Texas* and *Robin and the 7 Hoods* were produced in 1964. *None but the Brave, Von Ryan's Express,* and *Marriage on the Rocks* came in 1965. *Cast a Giant Shadow, The Oscar,* and *Assault on a Queen* were released in 1966. Those were ten very successful movies that he did in less than five years.

Frank and Mia had only one problem. Mia didn't know how to say no. If someone from the press asked her a question about Frank and her, Mia gave them a direct, honest answer. Frank had learned the hard way that he had to guard himself from the press. He knew the damage they could cause, but Mia did not. She was from a different generation and not as experienced when it came to expressing herself when dealing with the media. There was an innocent vulnerability about her, and she believed that the truth could never hurt her. I wonder if she still feels that way now.

Frank saw the world differently. He could recall operators listening in on his phone calls and reporters taking a few words and turning them into a major story. Frank didn't want any of that ever again. Besides, Frank didn't need the press; he was already famous. He had hit records and he owned a very successful record company. His movies were box office winners and each and every one of his concerts sold out. How much fame did he really need? Frank was at the top of his game. He didn't need the press, but the press sure needed him.

Of course, that other problem came around again. Frank didn't like his women to have careers. In this way, Nancy Sr. was the perfect wife for

Frank. While he toured, Nancy was home, taking care of the children and staying out of the limelight. That's how Frank saw married life, and he took great comfort, while he was on the road, in knowing that he had a home and family waiting for him. Then there was Ava—a totally different story.

I'll say it again: Ava was beautiful and the type of woman who drew attention. If Frank walked into Madison Square Garden with Ava Gardner and there were two guys fighting in the ring, the crowd wouldn't even care about the fighters. The crowd would turn and look at Frank and Ava. That's what Frank liked. In those lean days of the late 1940s and early 1950s, Frank liked a lot of publicity because he thought he needed to keep the Sinatra thing going. Frank would do anything for publicity.

Frank talked to me a lot about Ava. He believed that their marriage failed mainly because she wanted to keep her career going. Who could blame her? She was a beautiful woman with a fiercely independent nature. Ava did what she wanted. If Frank said she had to stay in New York, Ava would fly to Spain and make certain that photographers took pictures of her with handsome and young bullfighters and actors.

When Frank saw the photographs, he didn't care if he had a recording session or a show to do. On a moment's notice he was gone, flying to Spain to confront her. Sometimes Frank would go to her even if it meant missing concerts and not taking care of business, which was something Frank had never done before and never did again after Ava. They wore each other out emotionally.

That's why with Juliet Prowse and Mia, Frank tried to get them to give up their careers. He needed someone to be there for him a hundred percent of the time. I know with Juliet, her career was the main reason behind the breakup. Juliet was a beautiful, joyful woman who was a pleasure to be around. She was a great dancer with long, lovely legs that seemed to go on forever. She loved Frank, but she loved performing, too. That was the only problem between them, but it was one big enough to drive them apart.

Things began to unravel quickly for Frank and Mia. Mia was a strong-

willed girl who cherished her freedom, and she was often away shooting movies. So Frank made a deal with Mia. They decided they would shoot a movie, *The Detective,* together. Mia was working on the set of *Rosemary's Baby,* in New York, and the shooting ran longer than she had expected. In the meantime, Frank was cooling his heels in Los Angeles, waiting to shoot *The Detective.* Finally, Frank got frustrated and told Mia to drop her movie and come back to California. Unfortunately, Mia felt that she couldn't leave the set of *Rosemary's Baby* unfinished and still keep a career. You would think that Mia's professionalism would be something that Frank would admire, but he was too emotionally involved to appreciate it. More than that, Frank never liked anyone saying no to him, so he put it all on the line. Mia had a choice: choose Frank or choose her career. Frank demanded a deep loyalty. It was "All or Nothing At All" again, and Mia couldn't understand that aspect of Frank at that time.

I think the final blow to Frank and Mia's marriage came when Frank was in London. We had a houseboy named George Jacobs. He worked for Frank around the house, but he rarely traveled with us. He was handsome and married with six children. While Frank was in England, Mia wanted to go to a discotheque, so George took Mia out dancing. I have always wondered about that situation. Frank could have set it up because he wanted out of the marriage. It's possible he had George take Mia dancing, which gave Frank the excuse he needed to get Mia out of his life. Frank was not always gracious when he wanted to dump someone. It didn't matter if it was a woman he had spent one night with or someone close to him, like Juliet, Nancy, or Mia. I don't know how these things get around, but someone saw Mia with this handsome guy on the dance floor at a discotheque and called Frank at the Dorchester Hotel, in London. Someone told him that Mia was out on the town partying with one of his employees, and that was all Frank had to hear to make his next move.

When Frank came back, he asked Mia whether she had a good time while he was in England. Mia said that she had kept herself busy around the house. Of course, Frank already knew how she had kept herself busy. Frank seldom asked a question unless he already knew the answer. As far

as George was concerned, it was strange that Frank didn't fire him or say anything at the time. Frank never kept people around once they crossed him. This is why I questioned the situation. George might have been doing what Frank had told him to do.

Whatever the truth was, it didn't matter. Frank took it out on Mia. To make matters worse, Mia chose that moment to tell Frank that she wanted to go to India to study with Maharishi Mahesh Yogi. The Maharishi was an Indian mystic who founded Transcendental Meditation. No one would ever have heard about him if the Beatles hadn't spent time with him at his ashram. When they returned from India, they brought the Maharishi's views into prominence. It seemed that everyone wanted to take up or do anything the Beatles were doing. Suddenly, Transcendental Meditation (TM) was all the rage. Some Hollywood types had picked up on TM and that's when Mia said she was going to India.

"I don't want you to go," Frank told Mia.

Mia made the mistake of saying, "I'm going whether you like it or not." That was her swan song.

"Good," Frank said. "Go!"

Mia's mother, Maureen O'Sullivan, was a gorgeous actress who starred in many movies, including playing Jane in the Tarzan movies. I'm certain Maureen advised Mia on what to do and not to do. Even after being married to André Previn and Woody Allen, Mia still says she loves Frank. It's funny how some things never work out, and you can't say this is so-and-so's fault, and that was so-and-so's fault. Nobody tries to fail at love. The same was true with Frank and Mia.

When Frank passed away, Mia was interviewed on television and said that she had always loved him. He always kept in touch with her—which was true. Frank was not the kind of a guy who, once he dumped you, forgot you. He kept in touch with Nancy Sr. all those years afterwards, and he kept in touch with Ava, too. Frank kept in touch with Mia, but socially, he kept far away.

CHAPTER 28: THE KINDNESS TO STRANGERS

Frank tried retirement in 1971. It lasted only a year or so. That was all it took for him to realize that going in front of an audience, making records, and acting were his life. That's what got him where he was, and he just couldn't get along without working. So Frank went back into the studio. I remember he wore a T-shirt that read, "Ol' Blue Eyes Is Back!" That was the title of his first album after he came out of retirement in 1973. Frank came back bigger than ever.

Frank had some very successful records in the 1960s including, "That's Life" and "Summer Wind." They were both beautiful songs. He also recorded with his daughter Nancy, who had become a major star in her own right. They recorded "Somethin' Stupid," and it went right to number one on the charts.

When Frank came out of retirement, he played all the old clubs, including the Fontainebleau and the Wedgwood Room at the Waldorf-Astoria. He did a show in Brazil that had a hundred thousand people in the audience. He went to Sydney, Australia, then on to England where Frank did another performance for Queen Elizabeth's children's charities. Later, President Anwar Sadat of Egypt invited Frank to perform outdoors at night, surrounded by the pyramids. What a concert!

A lot of people played Frank's music on the radio, including Sid Mark and Jonathan Schwartz. The first one to dedicate entire shows to Frank's music was William B. Williams. Make no mistake about it; it was William B. Williams who gave Frank the nickname, "Chairman of the Board." Frank loved the guy, and he would do a lot for people he cared for. One

time, Williams invited Frank, Dean, and Sammy to a television show starring Soupy Sales. Soupy Sales had a huge following on afternoon television, mostly with very young children, but the show had also begun to catch on with grownups. Soupy had crazy characters, like Onions Oregano, White Fang, and Black Tooth. He also had a bunch of crazy sayings. One that I always remembered was, "If you're true to your teeth, they won't be false to you."

Soupy Sales was zany, like the Marx Brothers, with a lot of crazy acts, but one thing you could count on was that someone was going to get a cream pie in the face before the show was over. He started out in television in the early 1950s and was on the air off and on for the next twenty-five years. One time he told the kids watching his show to go into their mommys' pocketbooks, take out all the green pieces of paper, and mail them to him. In a few days, thousands of dollars were being mailed to the TV station, WNEW in New York. Soupy got suspended and promised never to do that again.

For a brief time, Soupy Sales was on network television. Frank arrived at the station and must have known what he was getting into. Soupy and Frank had a nice discussion, and the next thing you know, everyone was throwing pies at each other. Cream pies were flying all over the studio, and Frank took a few hits right in the kisser. The place was a mess, and how Frank went along with that, I don't really know.

Most of the time, Frank would never go along with that kind of jazz. Maybe Frank did it because of his friendship with Williams, or because they got Frank on a day when he was in the right mood. If you tried to pull something like that, you had to catch Frank on the right day, in the right mood, or you would get nothing. But that was the 1960s. I never thought I'd see Frank in beads and Nehru jackets either, but that was a very free and optimistic time in America, and you could sort of expect the unexpected. It was before the Vietnam War heated up during the Lyndon Johnson–Richard Nixon years.

At that time, I didn't see Frank nearly as much. In the early days, it was just the two of us. By the early 1970s, he had a grown-up family and

an entourage to protect him and take care of him. That's when I became a traveling companion of Lawrence O'Brien.

As Frank did less and less touring, he increased his charity work. When somebody called to say they needed something, he would go out and help them. The thing about Frank was that he never wanted publicity from it. He never wanted that at all. I remember Frank sitting by his swimming pool reading a newspaper and circling different articles. I never asked why.

One day I asked Gloria, Frank's secretary, what was going on with Frank and his newspapers.

"What he's doing is putting circles around those who need money," she said.

Frank put a circle around a name, and then sent five hundred dollars to the cause or person. That's what Frank did. If he read about a family who lost their home in a flood or had hospital bills that they couldn't pay, he'd tell Gloria to send them money, but only Gloria knew what Frank was doing. He never told anyone. Gloria told me this on the QT.

Frank was always doing charity concerts. In England, there was the British Red Cross, The Playing Fields, and the Children's Sunshine School For the Blind. Maybe it was something from his own childhood, but if it was a charity involving children, Frank was there. He was the most generous man I've ever known. I remember hearing that in Frank's lifetime, he raised more than a billion dollars for his charity work, and I don't doubt it.

I remember one time we were playing at a club in Kentucky that had gambling. Frank and I went into the casino and stayed for an hour between shows. When Frank got through, he had won fifteen hundred dollars.

"Here, split the money up with your captains," Frank told the maître d'.

Whenever Frank played with an orchestra on the road, he made certain he had gifts for every member, everything from inscribed cigarette lighters to cuff links. That's just the kind of a guy he was. Frank enjoyed using his money to buy things for others—he really cared about people.

As far back as 1949, there was a benefit concert held for the NAACP at Carnegie Hall. Some of the management around Frank told him that ap-

pearing at the concert for the NAACP wouldn't be a good move for his career. Believe me, Frank did a lot of things that were not good for his career. Not only did Frank perform at the concert, he waived his fee and donated a large sum of money. Another time, Sammy Davis was doing a benefit at the Apollo Theatre in Harlem, around 1963. Frank showed up unannounced and performed for free. He would do anything for Sammy.

Frank was no stranger to Harlem. He and I would go to various clubs to hear Duke Ellington and Count Basie perform. Frank met Duke Ellington at the Cotton Club in the late 1930s, and they became good friends. Eventually, Frank signed Duke to a long-term contract on his Reprise label, and they cut an album together, called *Francis A. and Edward K.* He gave Duke complete artistic freedom. Other big name performers and stars took the easy way out, but not Frank. He was a person with strong beliefs and he lived by them. He knew there would be a price, but that was all right with Frank. That is how he lived. Not halfway—all the way.

Joe Louis was a great heavyweight champ during the 1930s and into the late 1940s. He held the heavyweight championship for twelve years, which is longer than anyone has ever held it. Joe Louis fought everybody who came along, including Billy Conn, Jersey Joe Walcott, and Max Schmeling. He must have defended his title fifty times.

Then World War II came. Joe joined the army and gave boxing exhibitions throughout various camps to entertain soldiers. He gave up his boxing career in his prime when he could have easily made millions of dollars defending his title. Any place the government asked him to go, Joe Louis went. No questions asked.

After the war, the goddamn Internal Revenue Service said that this great champion and hero owed the government hundreds of thousands of dollars in back taxes. You know how the fight game can be; the fighters do all the work, take all the punishment, and eventually they walk away with nothing at all. Just like Beau Jack, who ended up shining shoes outside the Fontainebleau until Frank stepped in and straightened that situation out.

Joe—this wonderful, generous, dignified man who was past his prime—tried to raise money by becoming a professional wrestler and a

referee. Obviously, it didn't work out. He was broke and had to file for bankruptcy in the end.

Frank found out about Joe's situation, so he talked to a few people in Las Vegas and got Joe a job as Ambassador of Goodwill at Caesars Palace. As Ambassador of Goodwill, Joe would greet people and pal around with the high rollers who liked to be seen with celebrities. Because of Frank, Joe was able to get the government off his back and get his life back. Joe was popular at Caesars Palace. People came just to see Joe and have their pictures taken with him. Frank also made certain that Joe had an assistant, so that when things got too hectic or when Joe got tired, someone would step in for a while.

Frank loved and respected Joe. In 1938, Frank and I went to see Joe defend his title at the old Madison Square Garden, on Fiftieth Street and Eighth Avenue. He fought a guy from Hamden, Connecticut, Nathan Menchetti, who fought under the name Nathan Mann. Frank got there ahead of me, but I knew where he was sitting.

As I walked in people were yelling, "We got a new champeen, a new champeen," thinking that this guy could actually take out Joe Louis.

Joe Louis was so powerful that if he swung and missed a fighter's jaw by six inches, the fighter would still go down. The fight didn't last one round. Joe Louis hit Nathan Mann with one shot to the head and down Mann went. I think by the time Frank sat down, the fight was over. As Frank and I walked out of Madison Square Garden, the people who had been yelling about the "new champeen" were now standing around being very quiet.

A few years after Frank got Joe the job at Caesars, Frank heard that Joe needed heart surgery. Joe had no money for the procedure. I'll be truthful with you—Joe was completely broke. The Internal Revenue Service had taken everything, and it seemed like they just kept taking. There was no government medical insurance to apply for in those days, no Medicare or Medicaid, nothing at all. Frank saw to it that Joe was sent to the Methodist Hospital in Houston, Texas, where heart surgeon Michael DeBakey was conducting research on the causes and cures of heart disease. DeBakey was

so famous that when President Eisenhower had his first heart attack in 1956, DeBakey was the specialist the White House called in to take care of Ike. You can imagine the demand for Dr. DeBakey, but Frank took care of everything and made certain that Joe had the best. Frank also paid for Joe's wife to stay in a hotel near the Methodist Hospital, so she could be next to Joe while he was in the hospital. Frank picked up the complete tab.

Frank did the same for Lee J. Cobb, a great actor who did movies and played the role of Willie Loman when Arthur Miller's *Death of A Salesman* premiered on stage in 1949. Lee J. Cobb had fallen on hard times in the early 1950s and ended up in the hospital with a serious heart condition. He didn't have the money to pay for his hospital bill, and when Frank heard about it, he took care of it.

Frank did a lot of things through his secretary, Gloria Lovell. A lot of times, even I wasn't aware of the number of people Frank took care of. Frank told Gloria about Lee J. Cobb and his problem and asked her to take care of everything. That was Gloria's job, to take care of things. Gloria never had to call back and ask Frank if she should also take care of the hotel bill or anything else. When Frank said, "Take care of it," he meant take care of everything, no matter what it cost. If you were smart, you didn't go back and ask him, because then you would be in trouble.

There was the time when I got a call at the Waldorf-Astoria saying that a member of the chorus line from the Copacabana was in Mount Sinai Hospital, in New York. She had gotten sick and couldn't pay her bill, so the hospital wasn't going to release her. She said that she knew Frank and needed his help. I mentioned her name to Frank, and he said he didn't know her. When I explained the situation to Frank he said, "Take care of it."

Frank signed a blank check, and I immediately went to the hospital and took care of the bill. About a month later, a woman called the Waldorf-Astoria and asked to talk to Frank. I asked her what it was about. She told me her name and said she wanted to thank him for something. I remembered her name. It was the Copa girl. I asked Frank if he wanted to talk to her. He took the phone and told her that he was happy she was out.

"Stay healthy. I'll see you again," he said quickly, and that was it. Nobody but Frank, Gloria Lovell, and I knew about it.

Then there was the great actor George Raft, who played a lot of gangster roles in the movies—parts for which he had plenty of experience. He was a hustler and a runner in his teens while growing up in New York. His most famous movie role was in *Scarface,* where he played Guido Rinaldo, the coin-flipping mobster. Early on, George Raft and Humphrey Bogart played gangsters. Bogart was lucky enough to get out of playing those roles, but George never could.

In real life, he owned a casino in Europe and another one in Cuba. Then Castro came along and closed down George's casino in Cuba, in 1959 or '60. When George Raft was in New York, he would get involved in floating craps games. He loved to gamble, and like most gamblers, George wasn't careful where his money went. He figured he could always fall back on his movie career, but at a certain point, the movie roles stopped coming his way.

Frank learned that George was staying in England because he owed tax money to the United States Government. Frank found out how much George owed and paid the taxes, around $50,000. No questions asked. When it was all straightened out, Frank called George in England.

"You can come back to the States now. You're clear."

So George Raft returned to the States. One morning, about four o'clock, Frank and I were at Danny's Hideaway, which was a club Frank liked to go to after he performed at the Copacabana. George Raft walked in and when he saw us, he came over and shook Frank's hand.

"Frank, thanks so much for what you did. Don't worry, I'll make it up to you."

"George, you just did. We're even."

"What do you mean, we're even?"

"You just shook my hand, and we're even," Frank said, and that was the end of it.

Frank was extremely loyal to his friends, especially those people who helped him during the early years. Frank appeared at Skinny D'Amato's

500 Club, in Atlantic City, when he wanted to get out of doing one-nighters and perform for weeks at a time at one location instead. It worked out for both Frank and Skinny. Frank became a nightclub singer, and Skinny's 500 Club became a major nightspot.

Too bad Skinny was a heavy gambler who would go to Miami and do some serious damage. There was a place there where you could play cards for big stakes. And Skinny was the worst god-damnedest poker player in the world. He was always losing money left and right. One time in the 1960s, Skinny told Frank that he was going to have to close the 500 Club because he owed some people in Florida thousands of dollars. They were beginning to lean on him hard. Frank looked Skinny in the eye.

"No, you're not," Frank said.

"Frank, I have to, I owe a lot of people."

"I'll go up there and do a week for you," Frank told him. "Handshake. No money. Okay?"

Frank bailed Skinny out and that was the end of it, at least until the following year. Skinny had dug himself yet another hole, and the people he owed were not exactly the most patient people in the world. They would get something out of Skinny one way or another. The 500 Club would have become a parking lot overnight, and people would have looked around and wondered where Skinny went. Skinny was in a desperate situation, and Frank knew it, so he performed at the 500 Club for a week to bail Skinny out. It also helped Frank, because Skinny put up huge billboards along the interstates and on top of buildings:

SINATRA AT THE 500 CLUB

That was the deal and there was no money involved. Skinny gave me a few hundred dollars at the end of one of Frank's performances.

"Look, I don't want you to tell Frank, but this is from me as a gift," he said.

As I mentioned before, Frank also paid for a lot of funerals. One of

those was for Bud Abbott, of Abbott and Costello. That was a great comedy team. They made fifty films together and starred in their own television show. Their "Who's on First" routine was one of their very own creations, and a recording of them performing it is in the Baseball Hall of Fame in Cooperstown. They were box office wonders, but there was just one problem: they couldn't stand each other. They never spoke to each other off stage. I remember one time I wanted to have my picture taken with them, but it didn't work out because they didn't want to be seen in the same photograph together. That's why I have two photos, one with Bud, and the other with Lou. After Lou and I took the picture together, I tried to walk away with his bowler hat, and he threatened to break my legs if I didn't put it back right away.

Bud Abbott and Lou Costello split up in 1957. They tried having separate careers, but they just weren't funny without playing off one another. Lou died first. He was only fifty-three. Years later, pretty much a forgotten man, Bud Abbott died in Arizona in 1974. It was really sad how that all worked out. Here was a man who had been at the top of show business, successful in movies and television, but he died broke. Frank heard about it and took care of the funeral.

Another guy Frank helped out was Danny Thomas. Frank loved working with Danny. They were socially very different, but they got along well. When Danny got through performing, he wouldn't stay out and party. He was a family man above all, which was something Frank respected him for. Early on, when Danny was struggling as a comedian on the radio, he prayed to Saint Jude, the patron saint of lost causes.

"If you help me with my career, I will build a hospital in your name."

And that is exactly what Danny Thomas eventually did. Not only did he become big in nightclubs, but he also had several hit TV series, including *Make Room for Daddy*. True to his word, Danny Thomas built St. Jude's Hospital in Memphis, Tennessee. It is a tremendously successful hospital, dedicated to cancer research for children. In the early years, when the hospital was just getting started, Frank appeared at benefits out of respect for Danny and because the hospital was dedicated to researching the

causes of cancer in children. Frank helped Danny a lot, but Frank always told him not to talk about anything Frank gave him, outside of his appearances at the benefits. That was Danny's project, and Frank didn't want to steal the publicity. On the other hand, Danny appeared at Frank's Palm Springs golf tournament to raise money to build a wing at a hospital that bears Frank's name. A lot of stars helped Frank with the tournament, but they didn't want any publicity. They knew whom the project belonged to and mostly stayed in the background.

Let me tell you about Frank's golf tournament. If you wanted to be involved in the tournament, it would cost you $17,000 for the weekend. In its last years, the tournament was held to benefit the Barbara Sinatra Children's Center.

In 1998, if you wanted to go to the dinner, it would cost you $10,000. Right up until his last breath, Frank dedicated his life to various charities. Along with the invitation that Frank sent me in 1998, I still have a note from Dorothy Uhlemann, Frank's personal assistant, which reads:

Dear Tony:

If you would like to come out, Frank will take care of all expenses.

Everyone who knows Frank's music knows that Frank was crazy about the Count Basie Orchestra. Frank loved the Count's music from way back, and that's why he recorded two albums with him. Unfortunately, Count Basie had a few band members who had habits that absorbed all their money. When a member of the band passed away, Frank was alerted that so-and-so, the trumpeter, or the saxophone player had died broke. Frank would have Dorothy Uhlemann take care of all the funeral expenses.

I know Frank took care of at least two musicians who died penniless. There may have been more. As I said, if I had the money that Frank took care of people with, I wouldn't be a millionaire, I'd be a billionaire. When Frank performed for Queen Elizabeth's charities, he would pay for the band's transportation there and back and their hotel bills and give the

entire gate to the Queen. I'm talking about millions of dollars that were donated over the years. Frank performed once a year for the Queen's charities. He paid for everything. That's how Frank did things. Not only did Frank take care of show business people who fell on hard times, he also took care of people he ran into in the street. People he didn't know and would never see again. Let me tell you a few quick stories. One day, in 1958, Frank and I were coming to New York from California.

When we arrived at Idlewild Airport, which is now JFK, our limousine driver wasn't there.

"Don't waste time, grab a cab," Frank told me, so I did.

The cabbie took us to the Waldorf-Astoria, and I gave him a hundred-dollar bill because that's all I had on me. The cabbie got our bags out of the trunk and put them on the sidewalk for the doorman to take upstairs to our suite. The cabbie started making change, and Frank waved, which meant, "Come on."

So I tell the cab driver, "That means Frank wants no change. Keep the hundred."

The cabbie says, "That's great. My day is made. I'm going back to the garage," and he left. Frank made more days for cabbies than anyone.

Money was just paper as far as Frank was concerned. If he heard that someone was in some kind of trouble, Frank took care of it. Frank knew if he needed $25,000 right away, he could call Ben Novack, and have it sent, because Ben knew Frank would be coming to the Fontainebleau and would sell out the place night after night.

Frank was extremely generous with anyone who genuinely needed help, but he was not interested in helping a gambler who went to Las Vegas and lost $25,000. This happened from time to time. Some really well known people tried to put the touch on Frank. If a gambler went to Frank for money, Frank wouldn't offer even a dollar.

On the other hand, if a chorus girl couldn't pay her hospital bill, even if Frank didn't know who she was, he would take care of it. If Frank did help you out and you told anyone about it, that would be the last time Frank would help you. Frank valued his privacy in everything he did.

Here's another story about Frank's generosity. Frank loved roasted chestnuts, especially on cold, wintry nights around Christmas. We were in New York around 1947 or '48. In those days, there were vendors on just about every street corner selling roasted chestnuts.

"Tony, do me a favor. I would really like to have some chestnuts. See if you can get me two or three dozen," Frank said.

Of course, Frank couldn't go out alone. You can imagine the mob scene. Frank said no matter what the chestnuts cost, I should give the guy a fifty-dollar bill. In those days, fifty dollars might have been two weeks' salary for some of those vendors. I went out, found a vendor, and bought three-dozen chestnuts. I gave the vendor a fifty-dollar bill. The guy looked up at me as if I was crazy and said he didn't have any change. I told him I didn't want any change.

"Forget it," I said and simply walked away.

Another time, Frank and I were in New Orleans playing a benefit for the Children's Hospital. Dean Martin was supposed to be there, but he didn't show. Frank and I were in the limousine, driving in from the airport in pouring rain that looked like a monsoon. The driver stopped at a light, on a corner where a vendor was selling apples and a few other things. All he had to cover himself with was a big umbrella, but it wasn't working. The rain was soaking him, and he wasn't getting any business. Frank saw the fruit vendor with his clothes soaked all the way through.

"Tony, you've got a problem," Frank said.

Right away, I thought I did something wrong. In my mind, I started going through all the things I had to have ready to see if I had forgotten something.

"See that guy selling fruit? Let's take care of him. When the driver drops us off at the theater, instead of you going inside with me, you stay in the car. The driver knows his way around New Orleans. Have him take you to a store and buy the guy a good raincoat with a hood. When you get back to the vendor, give him the raincoat, buy two apples, and give him a hundred dollars."

I usually had five or six hundred dollars of Frank's money on me.

When I ran short, Frank would give me another pack of money. Our driver knew his way around New Orleans, and he took me to a store that sold rain apparel. I bought the best raincoat I could find.

I remember it was bright yellow. Then we drove back to where the fruit vendor was. We drove right up to him in the pouring rain, and he watched me as I got out of the limo. Right away, he must have thought that I was a wealthy guy.

I handed him the raincoat, held the umbrella over him, and said, "Here's a raincoat. Don't ask questions. Just put it on."

He put the raincoat on and it fit him perfectly. He thanked me and said, "I can't pay you for it."

"Listen. Don't think about it. Also, I want two apples," I told him. He gave me the two apples, and I gave him a hundred-dollar bill.

"Look, buddy, I don't have change for this."

"Don't ask questions," I said. "Wear the raincoat, enjoy the hundred, and I'll see you later."

I got back into the limousine and drove back to the auditorium. I'm sure the fruit vendor was trying to figure it all out. I told Frank that everything worked out, and he was very happy that the guy was taken care of.

One time in 1952, Frank was appearing in Detroit. He sent me out to pick up something, I can't remember exactly what, but I do remember it was a cold, gray day, and I saw four girls outside the auditorium crying by the ticket window—really bawling. I asked them what happened. They were really upset, and I thought maybe one of them had gotten hurt. But the problem was a simple one: they couldn't get tickets to see Frank. They had waited in line for hours, but the place was sold out before they got to the ticket window. I went backstage and told Frank about the situation. Frank called the manager of the theater and told him that he was going to send me out to the front of the auditorium and that the manager should meet me there with four tickets.

"Put the girls someplace," Frank said. "Get them in."

I went back outside under the marquee and told the four girls to stick

around because Frank was going to get them seats. They didn't believe it. In a few minutes, the manager came out.

"Are you Tony Consiglio?"

"Yes."

"Are these the four girls?"

"Yes," I told him, and he escorted them into the theater. Before they went inside, each of the girls gave me a kiss. That's how excited they were to get out of the bad weather and to see Frank.

That's the kind of person Frank was; he worried about everyone. Frank made a lot of good things happen. He had a good heart. If anybody needed a helping hand, Frank was there to give one. He was there when you needed him, and I miss him terribly.

CHAPTER 29: MARRIAGE AND OTHER HOBBIES

Frank married Barbara Marx in 1976. She was a very important woman to Frank, and of course, Frank was very important to her as well. One time, we were at a dinner and I saw her tap his arm three times. Frank immediately got up.

"Good night, everybody. See you later," Frank said.

He loved her very much. Before she and Frank were married, she used to drive by his house on Wonder Palms Road, in Palm Springs. Frank had the first house on the first tee at the country club. Barbara would drive by Frank's house in her convertible and slow down to five miles an hour. Her bleached hair glowed in the sunlight as she passed by and when Frank saw her, he'd eat his heart out.

Another thing Frank loved was trains. Over the years, he collected many sets of electric trains. In the house on Wonder Palms Road, he had a room that was thirty feet by thirty feet filled with train layouts. Frank would put on his railroad cap and sit by the controls. The trains would go from top to bottom dumping logs, delivering milk cans on a platform, unloading cattle from a freight car, blowing whistles, and making smoke. All of those trains probably cost Frank about two hundred thousand dollars. Where those trains are now, I really couldn't tell you. When Frank wanted to relax, he would go to the control room and play with his trains for an hour or two. Frank had been interested in electric trains for years.

Tommy Dorsey was a great lover of electric trains, too. Frank often went to Tommy's house in New Jersey, and when he saw Tommy's train layouts, he fell in love with them. Early on, Frank could never put a train

layout together because he was too busy with his career, too involved with one-nighters. At that time, he spent lots of time traveling around with Tommy's band. Frank was seldom home until he stopped doing one-nighters and began to work for one week at one club and for two weeks at another. It's easy to see how Tommy had a lot of influence on Frank's life, everything from learning how to sing in long phrases to getting him interested in electric trains. Frank owned the first train made by A. C. Gilbert, who made American Flyer trains. He also had the newest ones on the market that were made in Germany.

When he wasn't playing with his trains, Frank would play with his five little dogs. One was named Luigi, one was named after me, and another one was named after his mother, Dolly. Each puppy had its own air-conditioned doghouse.

"If my mother was alive and she knew that I named a dog after her, she'd kill me," Frank once told me.

I tell you, I've seen Frank with a lot of beautiful women, but Barbara wasn't one of them. She wore too much makeup and had dyed hair that was sprayed as stiff as marble. Ava, on the other hand, was really something to look at. But Ava played with Frank's emotions more than Barbara ever would—or could. Whenever Ava wanted to get Frank jealous, she would start a rumor. She would tell a reporter that she was spending time with some guy, knowing that eventually word would get back to Frank, and he would be furious. She counted on him getting on a plane and going to wherever she was. Whenever something like this happened, I stayed behind. I didn't want to get caught between the two of them when one of them was in a jealous mood. Luckily, Ava never tried to make Frank jealous while he was making a movie. That would have interrupted his concentration, and she didn't want that.

If we played the Fontainebleau or the Chez Paree in Chicago or Vegas, Ava would do things to get Frank's attention and make him jealous. Ava would time it so it was toward the end of a run when Frank was getting ready to close a week or two-week commitment. She didn't want Frank to disappoint his fans. She never wanted to hear, "Sinatra will not appear to-

morrow night because he had to fly to Africa to see what Ava was up to."
She loved him too much to let it go that far.

Frank once told me, "Tony, if you have to go to war with a country, maybe you stand a chance of winning. When you're at war with a woman, you don't have any chance. The best you can hope for is an occasional truce."

It didn't help matters that Frank got angry in no time over absolutely nothing. One time we were at the Lyric Theater in Bridgeport, Connecticut. This was while Frank was still with Tommy Dorsey. Frank told me to find a restaurant and get him a fried egg sandwich on white bread. That was back in the days when there was very little or no money. I would meet Frank and help him out, but I was strictly on my own financially.

I left the Lyric Theatre, and I remember it was a cold March night. The air was damp and the wind was wicked. I was wearing a short jacket without a topcoat. I finally found this little diner around the corner from the Lyric and ordered the sandwich. The cook wrapped it in waxed paper and put it in a brown paper bag. The sandwich cost fifteen cents total.

When I got back to the theater, I handed the sandwich to Frank. He smelled it and told me that the sandwich was cooked wrong. He wouldn't eat it because he didn't like the smell of the oil. Now I don't know if the Lyric Theater is still standing, but if it is, that egg sandwich is still stuck to the backstage wall.

That Ava—she knew how to get under Frank's skin. Why she did it, I don't know. Maybe she constantly needed Frank to prove he loved her. Every time Frank made a new record, she would get the first copy off the press. She wouldn't go to bed at night without playing a stack of his records. That's how she would fall asleep. Even years later, in 1960, when Frank started Reprise Records, the first album that was printed always went to Ava.

If Frank and Ava hadn't both been so passionate and easy to set off, they would have stayed together in the end. However, Ava had a bad temper just like Frank, and she would imagine that Frank was looking at

every other woman while Ava and he were out to dinner or at a club. Believe me, you would never want to be caught in the same room while they were angry with each other—you'd probably get hit upside the head with a whiskey glass or worse. But through all the battles, through all the passionate fights and the cease-fires, right up until the time Ava passed away, the love was still there.

One night Ava, Frank, and I went to the recording studio in New York City to watch Frank record a song called "American Beauty Rose." Ava and I were sitting in the front row with Frank and the musicians. Frank had his back to us, and was singing into the microphone. The musicians were on the ball. They always rehearsed Frank's songs before he came to the studio, so they would be ready to record when Frank showed up. Frank liked to cut the song perfectly as fast as possible and get out of there. The band was facing Ava and me, and Ava was wearing a very low-cut dress. Ava was considered the most beautiful woman in America at that time and she wasn't shy or afraid to show it. Ava always had to prove she was attractive, so she would often tease men and lead them on. She liked to do it in a way that made Frank notice, and that's exactly what she was doing that day in the recording studio. She knew how to set Frank off—she had all the qualifications.

When Frank made a record, it was usually done in only one or two takes. This time Frank and the orchestra tried five or six takes, but the musicians couldn't get it together. They couldn't record that song for anything in the world. Frank couldn't figure out what was wrong.

"What the hell is going on here? It's never happened like this," Frank finally said and turned around to see Ava sitting in her dress with her lovely tits almost hanging out of it. Frank knew then what the problem was. He pointed at us.

"You and you, out of the studio and into the control booth." Ava and I went into the booth and sat there.

Frank turned back to the band. "Okay, are we ready, boys? Let's go." In one take, the song was wrapped. "American Beauty Rose" was what Frank recorded for her that day. He should have recorded "Hey, Jealous Lover."

Frank and Ava were married in November 1951. Two years after that, they had stopped living together. There was a short period of time when they got back together, but there was always the recurring turmoil, jealousy, and passion. Frank and Ava loved each other, but there was just one problem: they couldn't get along. I think if you counted the days they actually lived together, it would probably be less than two years. Their divorce took four years, which meant their divorce process lasted longer than their marriage. It took Frank a long time to get over the divorce, and he never really got over Ava.

Ava's help in getting Frank the role of Maggio in *From Here to Eternity* and his success in that movie really turned his career around. He won an Oscar for Best Supporting Actor, got a new contract from Capitol Records, and from that point on, there was no stopping Frank.

In *From Here to Eternity,* Maggio is the kid who is bullied and eventually beaten to death by Fatso, the character played by Ernest Borgnine. In reality Frank and Ernie were friends. Both had been brought up in Italian communities during the Great Depression, and Ernie and Frank had a lot in common.

One night I happened to be over East, and I invited Ernie to come to Sally's restaurant for a quiet evening of pizza. He came in and said hello to everyone. Then, as he was going back to his booth to sit down, two teenaged girls recognized him. Ernie said hello.

"You know, we hate you," one girl said as she started to cry.

Ernie didn't know what to make of that. "Why, what did I do?"

"For what you did to Frank. You beat up our favorite singer," she said, and then both girls started crying.

Ernie and Frank's acting was so strong and believable that these girls thought Ernie really hurt Frank. Ernie tried to explain that it was just a movie and nothing had really happened.

"Even if it was in the movies, we didn't like that part at all."

Ernie turned to me and said, "See, Tony, by coming in to see you, I've lost two more fans."

As I said, Frank fell on hard times during his early days with Ava.

Frank was so in love with her, but he was also very jealous of the success that Ava was having in her acting career at that time. By the time he got back on his feet, won the Oscar for his role in *From Here to Eternity,* and got a new recording contract with Capitol Records, Ava was gone. Frank couldn't stand himself when he was facing so many failures, and Ava couldn't handle it when Frank was so successful. Even though theirs was one of the great passionate romances of our time, it was amazing that they didn't kill each other.

After the divorce, Ava left Hollywood and didn't make a movie for a few years. Before she ever married Frank, Ava was married to Mickey Rooney and Artie Shaw. After Frank, Ava never married again, but Frank and Ava kept in touch with each other right up until the time she died. Very few people know that Frank paid for Ava's entire funeral. However, Frank had nothing to do with handling the money directly. He had the money funneled through Jilly Rizzo so Barbara wouldn't get upset. That's how much Ava and Frank meant to each other.

Ava wasn't the only love in Frank's life. Years later, he was in love with Juliet Prowse, a sweet, beautiful woman whom I loved being around. Every place we played, Juliet would be in the audience and would shout, "Hello, ba-by." Frank would turn around and start laughing and smiling, because that was her signature with Frank. Frank and Juliet were going to get married, but she didn't want to get out of show business, and Frank didn't like the idea. He asked Juliet to leave show business, but she told him, "No, Frank. This is my life."

One day, Frank gave me a big box to bring to Juliet's suite in the St. Moritz on Central Park South. I was curious as to what was in this box, so when I brought her the box, I waited.

"Juliet, do you mind if I stay around to see what's inside the box?"

"No, go ahead, Tony."

She opened it and inside was a full-length white mink coat. I guess back in those days it probably cost between ten and twelve thousand dollars. Today, it would cost between forty and fifty thousand dollars. Alongside the coat was a note:

"This is your swan song. Frank."

That was all it said.

When I left Juliet's apartment, I was down in the dumps because I loved her, and because I knew Frank loved her, but it just wasn't meant to be. That's how Frank did things when he broke up with a woman— quickly. There was no, "Let's get together again. I'm so sorry." With Frank, when it was over, it was over.

When there was a problem, Frank had me do the dirty work for him. If he wanted to get back at Jimmy Van Heusen or Jimmy Durante, or pull a prank on someone, Frank knew he could always rely on me. But sometimes, when the tasks weren't pranks, things could get a little rough. I remember one night at a party in our suite at the Claridge, in Atlantic City, Frank was with this gorgeous woman who was staying at the hotel. She was just starting out in the movie business then and was definitely not as famous as she is now.

When it got late, people began drifting out, and by three in the morning, there was only Frank alone with his woman. I was in my room on the other side of the living room. They were talking about politics, and anyone who knew Frank knew he had very strong opinions about politicians, so it was usually a good idea to avoid talking politics at all. This particular woman kept talking, and I could hear the conversation getting louder by the second. Frank finally called me in. He wanted to order something to eat, and the woman said she would love some spareribs. Frank told me to go out, find a place that was still open, and get the spareribs.

When I got back to our suite, Frank was fuming and the woman was gone. I put the food down, but Frank told me to take the spareribs and go to the actress's room. When she opened the door, Frank wanted me to throw the ribs in her face. I hated those situations, but Frank was my boss, so I had to do what he told me to do. It was either that or I was completely out of a job. I went to her room and knocked on her door. She opened the door wearing a beautiful light blue chiffon dressing gown over a transparent white negligee. She looked beautiful and ready for a long night. I told her that I was sorry to bother her and that Frank had insisted that I deliver the

spareribs. When she reached out for the plate, I hit her in the face with the ribs, sauce and all. I apologized again and went back to our suite.

Frank asked, "Did you do what I told you?" I nodded yes.

About five minutes later, there was a knock on our door. Frank put his right index finger to his lips and backed away from the door. More knocks followed. A stern-sounding man's voice announced that he was the hotel detective and wanted to talk to Frank. We never answered the door. The next morning, the woman checked out, and we didn't hear anything more about it.

To this day, every time I see her in a movie, either romantically involved with James Garner or some other handsome lead from the 1960s, I can't help but see her the way she looked that night—in her beautiful blue dressing gown, her lovely legs showing beneath her white negligee, her hair glowing, her blue eyes radiant with some mysterious inner light, and the ribs and steak sauce oozing down her face and the slopes and curves of her remarkable body. It really ruins the movie for me.

For a while, Frank had a romance going with Lady Adele Astor. God, what a gorgeous woman she was. Frank became close to her because every year when Frank went to England to do the benefit for Queen Elizabeth's children's charities, Lady Adele Astor would be there. Lady Adele Astor loved Frank, and he loved having her around because she was as good-looking as Ava. Also, Frank wanted Ava to know he was seeing Lady Astor, hoping that it would cause a little friction.

Frank and Lady Astor spent time together in England, so Frank invited her to the Fontainebleau, which is where I met her. Lady Astor wore very little make-up, took baths in oil, and had such a dark tan she looked almost golden. She was also soft-spoken and elegant. She knew Frank didn't like to talk or have his ears bent by people constantly gabbing, so she kept things low key. When Frank asked her a question, she answered it. Frank never wanted to get into small talk. That's the way he was. If Frank talked to me, I talked to him. I never said things like, "Frank, did you see that golf tournament today?"

Lady Adele Astor was a completely different style of woman for

Frank. She wasn't in the movies, and she didn't like staying up all night playing practical jokes. If I had to think of a recent comparison, I would have to say that Lady Astor had the grace and style of Princess Diana, but Lady Astor was much more beautiful. However, Lady Astor had the breeding, the culture, and the dignity—qualities rarely found together in a single person. Frank would never think of taking her to see a Rocky Marciano or Jake LaMotta fight. Instead, he would take her to the Fontainebleau to sit at the front table. He would never even consider taking her out for Chinese food. She was the elite, classy type, and Frank played to those characteristics.

Lady Astor and Ava had a relationship with Frank around the same time. I remember this, because on one particular occasion Lady Astor was at the Fontainebleau with us when I got a call from Ava from the Dorchester Hotel, in England, where Ava was staying. She asked if Frank was available. I always used the excuse that he was going on stage or getting ready, and I'd have him call her right back. This time was no different. I told Ava that Frank was tied up, and I'd have him call her.

"If he wants to call me, okay," she said, "but I'm leaving the Dorchester Hotel in an hour to catch a plane to Miami. Tell Frank I'll meet him at the Fontainebleau tomorrow."

Well, this was certainly interesting news. I took Frank aside and told him that Ava had called and that she was flying from England. That meant that Frank had maybe twelve hours to clear the way, because Ava arriving in town was like a storm front coming through. Usually, Frank had me give the bad news to people, but this time he took care of it. I don't know what he said or how he said it, but he asked Lady Astor to leave, and she took the news graciously. I know for a fact that neither Frank nor Lady Astor wanted Ava to pop in and find them together. The next morning, I rode with Lady Astor in a limousine to the airport and made certain she got on the plane back to England. It must have been all right because Frank and Lady Astor continued to see each other from time to time after that. About five or six hours later, Ava showed up. If the timing hadn't been right, there would have been hair and furniture flying everywhere.

Another woman Frank cared about deeply was Lauren Bacall. After Humphrey Bogart died, Frank felt a growing attachment to her. Maybe it was out of his love and respect for Bogart, or because Lauren was exquisite and had a really deep and sexy voice. All I know is that for a while, Lauren and Frank were close. When they went out, I didn't go with them. I don't know what happened, but I can tell you this much: Frank and Lauren talked about getting married one day.

We had a big Christmas party and Lauren came, and I could tell by the way Frank looked after her that they had grown close. Frank made sure that all his attention was on her. Sometime after that, Frank had a big argument with Lauren. The plan was that Frank and I were going to leave the Fontainebleau and go to Chicago to see Carmen Basilio fight Sugar Ray Robinson for the middleweight championship. I didn't know part of the plan was to meet Lauren there. Before we left for Chicago, Louella Parsons, the gossip columnist, talked to Lauren in her home in California. I don't know what condition Lauren was in alcohol-wise, but Lauren opened her mouth and told Louella that she was going to marry Frank, which was all Louella needed to hear.

The result of that interview came in the form of the headline:

SINATRA TO WED BACALL

Louella Parsons was a syndicated writer, which meant the story was in more than two hundred newspapers across the country. Every newspaper carried the story. Everybody who knew Frank, knew that the last thing he wanted was publicity for his personal life, especially when he never trusted reporters.

I could live to be a hundred and still never forget that moment. As usual, I went down to the lobby to pick up the newspapers. Several of the newspapers had the same headline:

SINATRA TO WED BACALL!

I thought, *Jesus Christ, I'm going to have a bad day.* That story was

like a bomb. When I got to our suite, I put the papers upside down. I knew Frank would be upset if he saw the headlines; he would blow his stack for sure.

I always did my best to keep Frank calm in the morning. Like anyone else, Frank got up drowsy, especially after being up all night with his friends and having too much of a good time. But on this particular morning, there was nothing I could do. If I hid the newspapers, Frank would know something was wrong, and he would be even more upset if he thought I was trying to keep something from him. The minute Frank sat down on the couch he looked at me.

"What's the story this morning? You've got the papers upside down." Frank knew that when I put the newspapers upside down there was something in them that was going to cause him a problem.

"Frank, when you look at the headlines," I said, "you're not going to like what you read."

Frank turned the newspapers right side up, looked down at the headlines, and finally said, "What the hell is this?"

Every paper had the same headline. Frank didn't say a word to me. He went straight into his bedroom, began dialing the phone, and then closed his bedroom door.

Even with the door closed, I could hear Frank say, "Because of what you did, forget it. I'm not even coming to Chicago to see you. Go by yourself. It's over!"

That's exactly what I heard that day. Frank hung up the phone, and that was the end of the deal. It disturbed Frank that Lauren would go to the press, to a gossip columnist of all people, without discussing it with him first. Maybe she was gassed, because when Lauren had a few drinks she became very friendly with everyone. Everything in the world was right and nothing could go wrong when she was like that. If Lauren hadn't gone to Louella, Frank and she might really have gotten married. Then again, maybe the Louella Parsons story was exactly what Frank needed to get out of the affair. This all happened after Ava. It goes without saying that Frank and I didn't end up going to Chicago to see the

Basilio-Robinson fight. We didn't have to go to Chicago for a fight. There was one on the phone right there in our suite. It lasted one round. When Frank came out of his bedroom after talking to Lauren Bacall, you can bet I didn't ask Frank what happened.

I was in the living room, and Frank was in his bedroom. When he came out, I waited for him to calm down for a bit before I talked.

"Frank, you know the last time we were in New York, before we came to Florida, I meant to tell you something. While we were there, I had to go someplace and I had to take a bus to get there. I got on the bus, and right behind me was a guy who was so drunk he couldn't even stand up. He staggered up the aisle and sat next to a poor, old woman across from me. He was drunk and stoned. The bus kept going and the poor, old woman kept looking at the drunk, sort of sizing him up. Finally, the old woman said to the drunk, 'You know, you're going to Hell.' The drunk got up and said, 'Jesus, lady, I'm on the wrong bus.'"

Frank rolled over and laughed and laughed. I had to hit him with a funny story at just the right time. It was my job to get Frank out of his moods.

CHAPTER 30: JILLY

I haven't said anything about Jilly Rizzo so far, but he was very important to Frank. Jilly grew up in lower Manhattan and had a sixth-grade education. He was streetwise and knew how to survive, even if survival meant hijacking a couple of trucks full of women's clothes and selling them to cross-dressers who hung around gay bars in the Village.

Jilly was Frank's enforcer during the latter stages of Frank's career. Pat Henry, Frank's opening act, always said that Jilly got kicked off the track team because when the coach shot his starter gun, Jilly shot back. Pat also said that Frank once took Jilly to a wake just to see what a person who died of natural causes looked like. The truth is that Jilly was a rough guy. He once blew up someone's car, and he sent a lot of pests to the hospital. At one point, some comic was bugging Frank about a gig. He just wouldn't leave Frank alone. Seeing the problem, Jilly put a gun in the guy's mouth and asked him to leave. As you can imagine, the guy left. Frank loved Jilly because he knew how to solve problems.

Jilly was blind in his left eye. Some people said he had a glass eye. In any case, there was a problem with it. When Jilly and I were talking, he sometimes fell asleep, but his left eye would twitch open. I was so afraid of Jilly that I kept talking to the eye, just in case he was awake. I didn't want him to think I was ignoring him.

Frank had two friends, Sammy Davis and Jilly, who had each lost an eye. One Christmas Frank decided to buy binoculars for Sammy and Jilly.

He bought one pair, had the binoculars sawed into two pieces, and sent one piece to Sammy and the other piece to Jilly.

The Roseland Ballroom was where big bands, like Woody Herman, Count Basie, and Benny Goodman played. After they got through playing, the musicians would go to a restaurant directly across the street from the Roseland Ballroom. The restaurant on 252 W. Fifty-Second Street was called Jilly's, and Jilly Rizzo and his wife, Honey, ran it. The restaurant was famous for its Chinese food, which of course, Frank loved.

When Frank and I went in there, Jilly had a table set up for us way in the back. When Frank started to go to Jilly's it boosted business. After awhile, Jilly told Frank to let him know if he ever needed any help and Jilly would travel with Frank. Once in a while, Frank would tell Jilly, "We're playing at the Copacabana for a week. Why don't you come by?" Jilly would leave the restaurant for Honey to run and meet up with Frank wherever he was playing.

In Miami, Jilly had a houseboat called *The Yen* that was anchored close to the Eden Roc. If you got off the boat and crossed the street, you would be at the Eden Roc, or you could go to the Fontainebleau, which was just next-door. Frank and I went to visit Jilly on his boat one day. I wasn't paying attention and walked onto the boat with my shoes on. Right away, Jilly got upset.

"You want to come on this boat? Take off your shoes."

What the hell is this? I thought to myself.

"This is a Japanese-type boat," Frank said. "Jilly wants us to live by Japanese rules."

I took off my shoes and stayed for a while, but not too long. I don't know what Jilly's interest in Japanese culture was. You could rarely get Frank to go to a Japanese restaurant, but he would go out for Chinese any day of the week.

On the other hand, Peter Lawford loved Japanese food. I remember one time Peter and I went to a Japanese restaurant in New York City. We had to take our shoes off there, too. You would have thought there would be health rules in New York against that. There were no chairs, so Peter

and I sat on pillows without shoes and with our legs crossed. They gave us the sticks that you're supposed to eat with. I went once, and after that, I didn't want to go anymore.

Frank and Jilly became fast friends. As the months and years went by, Frank needed someone for protection to stop people from bugging him. Jilly tried it, latched on, and became one of Frank's best and most protective friends. If someone wanted to get close to Frank, they had to go through Jilly first. If Jilly said okay, then you got to see Frank. Jilly knew who to let Frank see—and not see. If Jilly didn't know who someone was, he would say to Frank, "Joe Brown is out there. Do you want to see him?" If Frank said, "No," Jilly would tell the person, "Look, don't bother coming around. Frank's not interested." That would be the end of it, because people knew Jilly took no prisoners.

One night Sonny King came up to me at the Copacabana.

"Jeez, I'm in deep trouble," he said. "I know Frank will help me. I need a thousand dollars right away."

I told Sonny, "I've got to talk to Jilly first."

"Forget it. I don't need it," Sonny said, and walked away.

Frank liked Jilly because he didn't ask Frank what he should do; he took care of a problem without involving Frank.

After a certain point, wherever Frank appeared, Jilly was there by his side. With Jilly around, Frank had no worries about walking on and off the stage or upstairs to his room. Jilly followed Frank, and when he was around, people knew better than to bug either of them. Jilly was about 5' 10", and about two hundred and ten pounds. He was muscular and very rough. In other words, Jilly didn't use someone else to take care of pests who caused problems—he took care of that himself. And if it meant getting rough, he enjoyed it all the more.

Eventually, Jilly bought a house in Palm Springs because he wanted to be near Frank. Together they opened a restaurant in Palm Springs that they decided to call Jilly's West. The doorknobs were made of real gold. The restaurant was successful for a while, but then Jilly lost interest, and Jilly and Frank closed it down.

I remember the day Jilly died. It was his seventy-fifth birthday. He was driving a friend's Jaguar through an intersection. The other driver, who had been arrested a few weeks earlier for DUI, ran a red light, broadsided the Jaguar, and it blew up. The car had two gas tanks that exploded on impact. There was also some sort of problem with the doors. They locked automatically and only the driver could unlock them; however, Jilly was knocked unconscious by the accident, or at least I hope he was. They couldn't get Jilly out, and that was how his birthday turned out. The guy that hit Jilly's car drove off, went home, had a few drinks, and then called 911. He was a lot of help.

After Jilly died, Frank was never the same. He didn't want to do concerts because he didn't have Jilly around to make sure people didn't bother him. Frank would perform at Foxwoods Casino in Connecticut, for two or three nights, and then he would follow that up by performing at a few other places for another two weeks. When Jilly died, Frank had no confidence in traveling anymore, and he cut his performances down to very few. After Jilly, Barbara traveled with Frank to just about all of his performances. Let's face it, though, Barbara was no Jilly Rizzo. On top of it all, she was a lousy drinking buddy. When Jilly was alive, Frank used to go out and unwind with Jilly and a few friends after a performance. With Barbara around, you can bet that there was very little unwinding taking place.

CHAPTER 31: THE POINT OF NO RETURN

As time went on, Frank did less and less touring. I had gotten married and started traveling with Larry O'Brien. Frank seldom traveled east and I seldom went west, but he told me that whenever he came east he would call me, and we would work together just as we had done through the years. One time Frank was playing in Providence. This was in the mid-seventies. I was with some friends, and I asked the security guard to please let me through because I was a friend of Sinatra's.

"Look, get out of here before I throw you across the street," the guard said.

"Now wait a minute. I've got to see Frank."

The guard started pushing me. To this day, I still don't know who went by, but someone said to the guard, "Let him in. He *is* Frank's friend."

When I got backstage Frank and I hugged each other. Then I told him about the incident.

"Frank," I said, "you know I was really embarrassed tonight. I told the fellow at the gate that I was here to see you and to get a message to you that I was here, but the guy shoved me and pushed me. My friends who were with me were afraid that we were going to have a fight."

"Who is he?" Frank asked, and I pointed to him.

"The one over there."

Frank turned to one of the stage managers and said, "You see that guy? He's gone. Now! Before I perform, he is gone!" They fired him right there, on the spot.

There was another incident when Frank played at Radio City Music

Hall. Maybe it was 1983. My wife Mary and I were sitting down front with Tony Bennett. Barbara Sinatra sent someone over to tell me that Frank wanted to see me. The messenger led my wife and me out of the theater and over to the elevator to take us upstairs to Frank's room. It just so happened that Barbara was waiting at the elevator, and Tom Selleck was with her. While we were going up in the elevator to see Frank, Barbara turned to Tom Selleck.

"You see this man standing near you. He's closer to Frank than I am," she said.

I looked at my wife and thought she was going to go through the elevator. She was all shook up. I went into Frank's dressing room, and we talked by ourselves for a while. Soon, people began to gather, and I knew Frank didn't like that, especially before a show.

"Frank, it's starting to get a little too crowded. I'll see you later."

As soon as I left, Frank moved into another room and everybody else moved away.

Yet another time, Frank played at the New Haven Veterans' Memorial Coliseum. I was sitting with Burt Reynolds, Governor Ella Grasso, and New Haven Mayor Bart Guida. During intermission, I went backstage and told Frank which dignitaries were in the audience so he could introduce them.

"Stick around, I want you to bring me my tea when I give you the high sign," Frank said.

When Frank came back on stage, he started singing, "Look down, look down that lonesome road . . . " which was my signal to bring him his cup of tea. There was only one show that night, which ran from eight o'clock to ten-thirty. There were a lot of young kids in the audience, so tea was going to be the drink of choice.

I got the tea ready, put a little honey in it, and gave it to Frank's pianist, Bill Miller, who put the cup and saucer on the piano.

Frank turned to the audience and said, "Well, I've done one half of the show. Before I go on to the second half, I want to say hello to my dear and closest friend, Tony Consiglio. He's standing right there."

With that, Frank pointed at me. When I went backstage, I turned to Jilly Rizzo and told him how embarrassed I was.

"There are a lot of famous people out there, and Frank didn't mention them." Jilly told me to forget about it.

Frank always did what he wanted to do, and the rich and the famous didn't mean more to him than any of his friends did, ever.

Frank played a few runs at the Foxwoods Casino. He opened the Fox Theatre on November 17, 1993, and there's a plaque commemorating the event outside the building. The last time Frank played at Foxwoods, I got there too early and ran into Dorothy Uhlemann, Frank's secretary. She said Frank was still asleep, so I told her not to bother him. I told her to just let him know we were on the same floor, and I would see him later. I went downstairs with my wife and two sons to have dinner before we saw the show. They have a number of restaurants at Foxwoods, so we went inside the closest one we could find and asked the maître d' if we could have a table.

"Sorry. These tables are reserved for the high rollers only."

I said, very quietly, "I'm with Frank Sinatra."

"Look, don't bother me, I'm very busy, and there's no room," the maître d' said.

That's all I needed to hear to start the ball rolling. I went over to the phone, called Dorothy Uhlemann, and said, "Dorothy, my wife and my boys want to have dinner here before we see the show."

"What's the problem?" she asked.

When I told her that the maître d' told me there was no room, Dorothy said, "Tony, wait fifteen minutes and go back to the maître d'." I waited fifteen minutes, and then I went back to the maître d' and said, "My name is Consiglio."

The maître d' must have had a brain transplant, a personality injection, and a distemper shot all in fifteen minutes. I couldn't believe it was the same guy. He literally bowed down.

"Mr. Consiglio, it is an honor to have you with us. We're ready for you. Right this way, Mr. Consiglio."

The maître d' was beside himself. He couldn't do enough for us. Of course, there was no check. I was still America's Guest. After dinner, I went back upstairs to help Frank get ready for the show the same way I did in the days when we first started out in 1942 at the State Theater in Hartford and the Paramount Theatre in New York City. My wife Mary and our sons Anthony and Christopher came with me to Frank's suite. While we were there, Frank gave my sons two ten-dollar gambling chips with Frank's picture in the center of the chip. While Frank was performing there, you could play with the chips that had his picture on them. Throughout the casino, Frank's recordings played twenty-four hours a day. Barbara wanted to go down to the casino to gamble, just to relax, and I went with her to keep her company and to make sure no one bothered her.

Frank always had roses in his suite. He loved flowers because they brightened up the room. He gave my wife a rose, which she still has pressed in a book somewhere. After my wife and sons talked with Frank, they left the suite and went downstairs to sit at a table near the front of the stage. Then Frank and I were alone in the suite, getting ready for his performance and making sure everything was just right. This time, though, I could tell that things were different. When we first started out together, we were in our teens. Now, Frank seemed tired, which he normally never was at the start of a performance.

At one point during the show, Frank began to sing "Night and Day," and Frank Jr., who was conducting the orchestra, leaned over and said, "The band is playing 'Summer Wind.'"

That was the beginning of the end, and it was happening right on stage in front of me. Frank would pride himself on never making a mistake like that, but that night he did. I don't know who noticed it, but of course I did because I had been with Frank for such a long time.

When Frank died, the family didn't want me to go out there. Frank Jr. called and he said, "Tony, don't come out. You'll get lost in the shuffle. Whatever happens, you'll get everything."

They sent me the program, which had a special gold-trimmed dish

with a picture of Frank on it. Barbara sent me a thank-you card, and Frank Jr. sent me a note. Nancy Jr. also sent me a card. A note, a card, a dish with Frank's picture on it—that was it? I know they had their own grief, but Frank and I were together through all the one-nighters when no one thought the skinny kid with the busted eardrum could make it. It was just Frank and me skipping school, hiding in movie houses, and eating in all-night cafeterias where the old came in from the cold and where just the two of us still had our dreams.

CHAPTER 32: AFTER WORDS

Muhammad Ali and I became friends many years ago. Frank was a great fight fan, and he loved Ali. If you can find a copy of *LIFE* magazine from March 19, 1971, it has a cover photo of Muhammad Ali fighting Smokin' Joe Frazier. The photographer who took the photo on that cover was none other than Frank Sinatra. Frank was allowed to lean right on the apron of the ring with his camera, just as if he were one of the press photographers. Muhammad Ali lived at the Fontainebleau for a while, so Frank, Muhammad Ali, and I go back at least twenty-five years.

Of course, when Ali refused to fight in the Vietnam War because of his religious beliefs, he lost his heavyweight title. He was out of the ring for five years, and when he came back, he wasn't the "float like a butterfly, sting like a bee" Ali. He was slower and never truly regained his old endurance, but he was still strong enough and smart enough to beat Joe Frazier and take the title away from George Foreman.

I hadn't seen Ali in a long time. He had developed Parkinson's disease, and over time, that has taken away much of his physical mobility. Despite it all, he is still the most recognizable sports figure in the world. In February of 1998, David Stern, who succeeded Larry O'Brien as the Commissioner of the National Basketball Association, invited my family and me to the All-Star Weekend in New York City. David Stern was an attorney in Larry's office when he was the NBA Commissioner. David Stern took care of the hotel, the limousine, the meals, and everything else we could possibly have needed.

One morning I was on my way to breakfast, and I saw Muhammad Ali sitting way off in the distance with his wife, Lonnie. I started walking to-

ward him, but two very big bodyguards stood in the way and wouldn't let me go near him.

"I'm a dear friend of Muhammad Ali," I told them.

One of the bodyguards said, "Yeah, everybody's a dear friend of Muhammad Ali."

Ali couldn't talk very loud but he said something to his wife, Lonnie, and he gestured toward me. Lonnie saw me, and said, "Let him through. Muhammad wants to see him."

I went to Ali, and he asked me to sit down with him. Lonnie said, "Ali wants you to stay and have breakfast with him."

"I adore him, but maybe I shouldn't stay. I imagine there are more than two thousand people who want to see him," I told her.

Before I could even finish what I was going to say, Lonnie said, "No, Ali wants you to stay near him." So that morning I sat with him and had breakfast.

Imagine, we were in this huge ballroom with all these very important sports figures like Michael Jordan, Larry Bird, Kareem Abdul-Jabbar, and Magic Johnson, and I was the only one allowed to be with Muhammad Ali. The guards wouldn't let anyone else near him. There I was, having breakfast with Muhammad Ali as the great and famous passed by, wishing they could get close to him, and wondering whom the bald, sawed-off Italian sitting next to him was.

I whispered in Muhammad's ear, "You always were a champion, and you're still the champion." I really enjoyed that moment.

After breakfast, Ali must have thought I was going to leave because he grabbed my hand and wouldn't let go. Lonnie asked if I would stay until he let go of my hand, and I told her, "I will because I am so thrilled to see him again."

She said, "You don't know it, but you're making him very happy."

"Believe me, I'm happier than he is."

Later she said, "If you want, you can have your picture taken with Muhammad; he would like that."

That's just what we did. It was pretty tough leaving him that day.

He was getting tired, but I watched him for a while. What a remarkable man.

On May 14, 1999, a year after Frank's passing, there were memorial masses celebrated in Frank's honor. There was one held in Philadelphia that was put together by Fran Casella, one of Frank's most enduring fans. She was at the Paramount Theatre back in 1942 when Frank sang there for the first time. She remembers me handing out Hershey Bars to all the kids to make sure they had something to eat. All through the years, Fran went to every Frank Sinatra performance she could get to, which must have been thousands. At the 500 Club, each and every night we were there, Fran came with a bunch of girls. She flew to Las Vegas, to Miami, and to New York to watch Frank perform on *Your Hit Parade*. Fran worked in a hospital and saved her money all year long to see Frank perform. If Fran came to a show that was already sold out, she would ask someone to call backstage. Frank knew her, and he would have her seated in the front row every time.

When Frank passed away, Fran wrote Barbara:

"You know, everybody got something from the memorial service, but I haven't heard from you."

Sure enough, Barbara sent Fran a package with notices and mass cards. It was the same thing that all of Frank's closest friends received. Fran had a mass given in Philadelphia. People came from all over to remember Frank. As a way to advertise the mass, Fran ran an announcement in the *Philadelphia Inquirer* with a picture of Frank. The announcement read, "The First Anniversary Memorial Mass. Come Fly With Us."

That mass was very personal. There was a large photograph of Frank on the altar. Fran Casella didn't have hymns sung. Instead, she had nothing but Frank's music playing. Near the end of the service, Fran had Frank's "Ava Maria" played, and that started some people crying. The final song was "Put Your Dreams Away," and that finished everybody. It's hard to believe, but fifty-five years after the first Paramount show, there are still people around who were there and continue to write to me.

CHAPTER 33: NANCY

There is one person who I haven't discussed much yet—Frank's first wife Nancy. Nancy is still alive and is living in Beverly Hills. At one time Walt Disney lived across the street from her. She lives within easy reach of her children—Nancy Jr., Frank Jr. and Tina. Nancy Sr. wants nothing to do with any publicity. She always kept out of the papers. Her last name was Barbato, and she was born in Jersey City. Frank and Nancy were teenagers when they first met on a beach; Frank's parents and Nancy's parents' families had beach houses on the Jersey shore. I think there were seven or eight girls in the Barbato family.

Nancy wasn't Frank's first love. Before Nancy, he was going with this gorgeous German girl who worked in the Tootsie Roll factory. Frank had just gotten into singing and that Tootsie-Roll-factory girl didn't want Frank to go on the road, so Frank packed it in with her. That was at a very young age—he was maybe twenty-two or twenty-three. Soon after, Frank and Nancy became very close. The girl from the Tootsie Roll factory found out about Nancy and told Frank that she didn't want to see him anymore.

Frank said, "Okay, forget it," and from then on Frank's romance with Nancy grew.

After Frank became a star, I met the girl from the Tootsie Roll factory one night at Frank Dailey's Meadowbrook. That's when Frank told me that she was his first girlfriend. The only other time I saw her was back in the Paramount days, within a year of her breakup with Frank. She came backstage and talked with him for a while. He was polite to her, and then he told me to tell her to get lost. After Frank ended his relationship with the

girl from the Tootsie Roll factory, he fell in love with Nancy. If not for Ava Gardner, Frank would never have left Nancy.

In the early days, I didn't socialize very much with Nancy because I was always with Frank. That was during the early '40s, when Frank and I were on the road or performing somewhere almost every night of the year. Frank was seldom home. I visited Nancy and the two kids every chance I got. Tina hadn't been born yet. Even after Frank and Nancy went their separate ways, I visited Nancy a lot and spent time with Nancy Jr., Frank Jr., and later Tina.

After dinner, Nancy would say, "Okay, it's time for music lessons."

Each child had his or her own soundproofed study room upstairs with a piano in it. That way, they wouldn't interfere with one another's playing. They had to practice for an hour and then do their homework. There was no going here and there.

If there were a problem, Nancy would say, "I'm calling your father," and that would be the end of it.

This all took place in Beverly Hills. Nancy raised those children right. All three of them went on to attend college.

When Nancy and Frank moved to Beverly Hills, some of Nancy's family moved there as well. Soon, there was a Sinatra Cleaners as well as a Sinatra Drive-In Restaurant in Beverly Hills with pictures of Frank on the walls and a jukebox with his records. There were five or six businesses using his name.

One day Frank said, "It looks like I've got a little city of my own here—everything's Sinatra." Frank wasn't happy with Nancy's relatives using his name, but what could he say that wouldn't cause a problem? So he went along as though he didn't care.

Even before they split up, Frank was away so often that Nancy had to be mother and father to her children. With all the money they had, Nancy never wanted to have a nanny or anything like that. That wasn't what she considered part of raising a family. Even though Frank was away so much, she remained very loyal to him. Whatever Frank told her to do, Nancy did. She didn't go out and socialize very much.

If Nancy needed to get in touch with Frank when he was on the road, she called Gloria Lovell to tell Frank to give her a call. Gloria always knew when and where Frank was playing. If Gloria couldn't reach Frank directly, she left a message. Frank would call Nancy as soon as he could.

"What's the problem?"

Nancy might say, "You better talk with Nancy (Jr.)"

Frank would then say, "Get her on the phone."

Believe me, the kids didn't want to hear that.

Nancy was a woman who never spoke out against Frank, no matter what the situation was. She wouldn't allow reporters to get in touch with her. There might have been stories between Nancy and Frank that she could have told, but she was above that. She wanted people to respect Frank and to respect the family because it was nobody else's business what went on. If anything was in the papers, Frank knew it didn't come from Nancy. If Nancy read something unflattering about Frank, she never believed it.

Nancy knew that newspaper people printed every move that Frank made and even some he didn't make. After all, Frank was news, and news was money for reporters.

"If there is anything in the paper that is true," Frank once told her, "I will call you ahead of time and tell you that you're going to read about this and that, and it's true. But if I don't call you don't believe it. It's not true."

That's how they kept in touch with each other, even after Frank married Ava, Mia, and Barbara. Frank still kept in close contact with Nancy after all those years apart.

When Frank admitted that he had very strong feelings for Ava, Nancy asked for a legal separation. I remember it was on Valentine's Day of 1950. Nancy was a serious Catholic, so for her, divorce was a mortal sin. It meant excommunication from the church, and she didn't think she could handle that. Frank wanted to marry Ava, and Nancy's refusal to divorce him made it difficult. Everything seemed to be going wrong at the same time for Frank—his voice was gone, his recording contract was done, and his acting career was in decline. Frank's relationship with the head of

MGM studios, Louis B. Mayer, was impacted by Frank's affair with Ava. Mayer didn't like the idea of one of his stars being involved in extramarital affairs. He wanted to project a family image for his studio. When Frank didn't straighten out, Louis B. Mayer cut him loose. The lawyers argued over the divorce settlement for over a year. Frank could hardly take the pressure of so many things going wrong at once. I think this is what eventually made Nancy agree to a divorce. She loved Frank so much that she put her religious beliefs aside and let Frank have the divorce. Nancy couldn't stand to see Frank hurting himself. Nancy and Frank had an agreement. Frank would give her one third of what he was making until Nancy Jr., Frank Jr., and Tina reached the age of twenty-one.

At the time, Nancy Jr. was around eleven, Frank Jr. was six or seven, and Tina was three. All of this happened because Frank was madly in love with Ava Gardner. Ava never told Frank to leave Nancy or to marry her; I know that for a fact. Ava was smart that way. She never told Frank what to do or what not to do. That's all any woman had to do with Frank to guarantee becoming history.

I can say this now because Frank is gone, and it doesn't bother me like it used to. I would always go to Nancy's on Sunday afternoons. Frank would be resting at the Cold Water Canyon house, so I'd take the Thunderbird and drive over to see Nancy in Beverly Hills. Sometimes I'd take Frank Jr. to a movie, and then we'd go back to Nancy's for supper. Nancy made great lasagna.

One night, Tina and Nancy Jr. were sitting on one side of the table, and Frank Jr. and I were sitting on the other side of the table. Nancy sat at the head of the table, and at the other end of the table was a place setting in front of an empty chair.

Nancy looked at me and said, "You see that chair? That's where Frank should be sitting."

After dinner, the kids went upstairs to their rooms to practice piano. While the kids practiced piano, Nancy and I talked about a lot of little things, like how Frank should be around. I left Nancy's house around eight-thirty and headed home. While I was driving home to Cold Water

Canyon, I thought about how wonderful it was to be with Nancy and the children, and somehow I got it in my head that if I talked to Frank, maybe I could bring Nancy and Frank back together. What a mistake that was.

When I got back to Cold Water Canyon, Frank said to me, "How was it?"

"Frank, I had a dish of lasagna and Nancy sent you a dish."

I gave him the lasagna, and he enjoyed it very much. I always waited until he was through eating before I talked to him. Frank didn't like to talk when he was having a meal. It was a contemplative way he had about him.

When Frank finished the lasagna, I said, "Frank, we had such a good time. The family sat around the table, but Nancy had an empty chair sitting there and she looked at it and said, 'That's where Frank should be sitting.'"

Frank turned around and looked at me with daggers in both eyes and said, "Do you want to go there to eat again, any time you want to?"

"Yeah," I said.

"Don't come back here with stories. It's water over the dam." Frank said, and that ended that. I knew exactly what he meant. It was his polite way of saying, "Tony, shut up!"

After that incident, I still went to visit Nancy and the children on Sundays. I'd take the children out to play or to a movie and come back in time for one of Nancy's amazing dinners. We would sit around and talk, especially after the children had gone upstairs. Nancy would tell me how much she had always loved Frank, but how Frank had done this and that. I would listen. She needed a good friend to talk to, and I was glad to be that friend. I once told Nancy that I had mentioned something to Frank about them getting back together. I wanted her to know that I passed the word on and that Frank turned on me. Nancy knew his temper. As much as I wanted Nancy and Frank to get back together, you can bet that whatever Nancy said about her feelings for Frank, I never went back and repeated it to him. When Frank said something, I listened. I was there to make his life easier, not to add to his problems.

I think at that time the spark was starting to grow between Frank and Ava. When you're surrounded by glamorous movie stars, forget it. Temptation is there, and there's nothing you can do about it. You'd like to overlook it, but you just can't. He'd get invited to this screening or that, big shindigs with glamorous women who wanted to latch onto a rising star like Frank. This was no Hoboken; it was a different world out here.

If a woman just starting out in pictures wanted to get publicity and become a star, all she had to do was be seen with Frank. After that photograph hit the stands, she had it made. Sometimes MGM arranged it to help promote some of their up-and-coming stars. Before you knew it, there would be a picture in the paper and a story in some of the gossip columns written by Hedda Hopper, Louella Parsons, Walter Winchell, or Earl Wilson about Frank dating so-and-so.

You can be sure that Frank didn't go to the press with any stories. It was the actresses who went to the newspapers. They were called starlets in those days—good-looking babes who would do anything to get into a movie, and I mean anything. There were times when a relatively unknown actress would go to several of the gossip columnists and tell them that she was having a romance with Frank, when Frank hardly knew who she was.

Frank became famous and started hanging around with glamorous women, and that's what took him away from Nancy. Other than that, Frank was a good family man. He took care of everything as though Nancy and he were still living together. Frank had to socialize, but Nancy was a regular housewife who came from a hardworking, down-to-earth family. Nancy and Frank came from the same background, but Frank had more desires. He wanted to change. Nancy wanted to be herself, and that didn't fit in with Frank's new social life. Nancy was a beautiful woman with a good heart who always made you feel welcome, but she didn't want to be glamorous in the Hollywood way. That just wasn't her.

If Frank invited her to the Academy Awards and told Nancy that if she didn't go they wouldn't give him an award, Nancy still wouldn't go. As much as she loved Frank, that's how much she disliked the Holly-

wood scene. She couldn't play that game, so Frank, to keep his career going, went to all the parties and the press conferences alone. The more he socialized, the more involved he got with that crowd. The more involved he got with the stars, the less involved he was with Nancy. He started hanging around with Ava and Lana Turner, and that's how it all started to fall apart.

When Frank was on location, he would call up Nancy to ask if she needed anything, and then he made certain that he talked with each of his three children. When he was on the road and Nancy needed something, Frank had various phone numbers for her to call. In addition, Frank's itinerary was laid out in his office, so at any time Gloria Lovell knew where Frank would be in case he was needed. He kept in touch with Nancy and the children constantly. If Nancy needed a new car, she would call Gloria at Frank's office and it would be taken care of. Whatever Nancy needed was provided for her, and she didn't even have to go through Frank to get it. She had his okay to do it on her own. This went on for years after the divorce and right up to the time of Frank's death.

In the late 1950s and 1960s, Frank often called Nancy Jr. The first thing he'd ask was, "How's your mother?"

Also, when Frank Jr. and Nancy Jr. began their singing careers and were going out on the road, they had to report to Gloria Lovell and tell her where they were going to appear. That way, when Frank wanted to reach Nancy Jr., all he had to do was check with Gloria. If Frank wanted to reach them on the spur of the moment, Frank didn't have to wait all day for his children to call him. On the other hand, if Frank called Nancy Jr. at four in the afternoon, Nancy wouldn't wait until ten at night to call Frank. Within an hour, they would be in touch.

I was very close to Nancy throughout the years. One time I slept over at her house in Hasbrouck Heights. At the time, Frank was singing at the Wedgwood Room in the Waldorf-Astoria. This is something I'll never forget.

When I showed up that night, Nancy asked, "Where's Frank?"

"He's got a meeting with TV people tomorrow and he wanted to stay in the city," I told her, but she knew what the real story was.

"Were the TV people blonde or brunette?"

The next morning I was on my way back to the Waldorf-Astoria. Nancy said she had to buy some clothing for Frank, so she came to Manhattan with me. Frank would never walk into a store to buy clothes. Nancy knew his sizes and did all of the shopping for him. I thought Nancy and I would go into the city in a limousine. Instead, we got on a bus in Hasbrouck Heights. We paid fifty cents each, sat in the back of the bus, and got off at the port authority in New York City. Then we walked! I couldn't believe it, but we walked all the way to the Waldorf-Astoria. Can you imagine, Frank is playing at one of the most exclusive places in New York, doing radio shows and movies, making thousands of dollars a week, and Nancy is riding a bus. But she knew New Jersey and she knew her way around New York, too.

We walked to Cy Martin's, which was a store that sold men's clothing. Frank had an account there, so we shopped for a few hours together until it got to be around five o'clock. Then Nancy said, "Tony, I don't think you ought to come back to Hasbrouck Heights with me. Frank might need you."

When I got back to the Waldorf, Frank was already up. He hadn't ordered breakfast so I got on the phone with room service. I felt bad.

"I'm sorry. Nancy and I went shopping and I lost track of time."

Frank said, "That's all right, as long as you were with Nancy."

I gave him the shorts and socks that Nancy picked out, and he was happy to have them. He always loved getting new clothes. Nancy took care of everything for Frank, so he didn't have to think about things. She knew what he liked and made sure that his life was as easy and as good as she could make it. That's the kind of person she was.

In the photos I have of Nancy Sr., if you look at her clothing, you notice that it wasn't Gucci or Christian Dior or any other famous fashion designer label. Nancy bought simple clothes. She came from a hard-working, middle-class family, people who had survived two world wars and the Great Depression. Nancy never forgot those early, tough days with Frank when there was little money coming in. Who knows, maybe Nancy feared that

those days would come back again. She never got caught up in the glamorous side of Frank's world. She wasn't beautiful like Ava. She was beautiful like Nancy. Lovable, strong, and fiercely loyal to Frank. Frank never found another woman like her.

I kept in touch with the family throughout the years. I always kept in touch with Nancy Jr., and when she was performing in a place I could get to, I'd go see her. I'm the same way with Frank Jr. He is a wonderful performer. Whenever he comes east, I am there. With Tina, it's a little different. Tina is the behind-the-camera member of the family; she ended up producing a powerful and honest film biography of her father.

Nancy Jr. has kept the Sinatra name, but her two daughters are named Lambert, after their late father. Hugh Lambert was the choreographer for numerous shows on television, including the *Jackie Gleason Show* and *Laugh-In*. He worked with the June Taylor Dancers, which was one of the most creative dance groups on television. The Gleason show always opened with an overhead camera showing the June Taylor Dancers. When the dancers performed, it was like watching a kaleidoscope. They would form flowers and all kinds of geometric shapes. The choreography was the work of a genius. Frank loved Hugh Lambert right from the start, and I met him once backstage when Frank was playing the Sands. What a terrible loss it was when he passed away. He was still very young.

Before marrying Hugh Lambert, Nancy Jr. was married to a singer named Tommy Sands. He recorded for Capitol Records and had one hit record titled "Teenage Crush." The marriage didn't last long. I think Tommy wanted Nancy out of show business. That was not going to happen—who could take Nancy out of show business? Nancy said no, and that was that. It took a few years for Nancy to make it big. She hooked up with Lee Hazelwood and recorded a few of his songs, like "These Boots Are Made For Walking" and "How Does That Grab You?" Those recordings sold millions.

Lee Hazelwood had been in the record business for a number of years. He was the producer behind the guitar legend Duane Eddy. Lee Hazelwood also came out with one of the earliest concept albums ever produced, called

Trouble Is a Lonesome Town. Lee Hazelwood's songs were huge hits for Nancy and helped her make it as a performer. It was around this time that Nancy and Frank sang together on "Somethin' Stupid," another huge hit. Both of their careers were going strong, and it was so good to see Frank and Nancy have hit records at the same time.

One time Nancy performed at The Sting, a great nightclub in New Britain, Connecticut. I went up there to help her out. Frank called me and said, "Go along with Nancy, and make sure the magazine is not signed where it's not supposed to be signed."

I knew what he meant. This was just after Nancy's famous nude *Playboy* shoot. I think Nancy must have caught Frank when he was out to dinner one night. She was going out on tour, and the publicity she would receive from the *Playboy* shoot would bring out the crowds. Frank and I never talked about the shoot, but it's my guess that he might have asked Nancy Jr. how much *Playboy* was going to pay her. Whatever it was, Frank said, double it, figuring that *Playboy* would refuse to pay her that much. He was hoping that would be the end of it. Instead, they paid the amount she asked for, so Nancy's legendary nude shoot went ahead, and Frank wasn't happy about it at all.

After her performance at The Sting, Nancy announced that she would sign autographs. I knew that this was going to be a problem, but Frank had talked to me, so I knew what to do. A lot of guys brought copies of *Playboy* and wanted Nancy to sign the nude photos of her. Some of them had three or four copies of *Playboy*. I stood beside her and every time someone showed up with a copy of *Playboy* I would say, "I see you have your *Playboy*. Close it!"

Some guys would say, "No, I want to have her sign here."

"If you don't close it, or if you open it when Nancy's about to sign it, she won't autograph your magazine at all," I would tell them.

I've known Nancy since the day she was born, and to this day, I would still do anything to help and protect her. If you were to look through my photo albums, you would see as many pictures of Frank and Nancy and their children as you would find of my brothers and sisters.

That's how close we all were. Nancy Jr. idolized her father, and Frank really loved his children. Nancy was the oldest, so Frank spent more time with her than with Frank Jr. or Tina.

One thing about Frank, though, was that he never wanted to be called grandpa. It made him feel as though he was an old man. Frank was afraid of only two things: death and getting old. Frank didn't like going to wakes because he cared for his friends so much. He wanted to remember them as they were the last time he saw them alive, not laid out in a coffin. If Frank didn't go to the wake of a friend, he made sure that everything was done as though he were there. Frank didn't like visiting people in hospitals either. The only time Frank went into the hospital was when he was forced to go, like the time he was touring in Europe and had terrible stomach pains. That was when the doctors had to remove twelve feet of intestines. While Frank was in the hospital I called Dorothy Uhlemann every day to check up on Frank, and each day she would tell me that he was improving.

While Frank and I traveled together, if he needed a physical checkup, Frank would have the doctor, his equipment, and his staff come to his house. Frank didn't care if it cost $10,000. He would pay it. To him, anything was better than going to a doctor's office or checking into a hospital. Money meant nothing to him as long as he got the service he wanted. You'd think that Frank had a printing machine in his cellar. He gave away hundreds like singles.

One afternoon Frank bit into a bagel that was a little hard while we were staying at the Fontainebleau in Miami. Frank's teeth were capped and one of the caps broke. This happened just after Frank woke up. That night, Frank canceled the show, but in the meantime, he called his dentist in New York. The dentist canceled the rest of his patients for that day, got on a plane, and had the necessary dental equipment he needed shipped to Miami. We actually had him picked up in a limo at the airport and driven to the Fontainebleau.

When the dentist arrived at our suite, we got a big sofa chair with thick, soft pillows so Frank could lean back while the dentist worked on his broken cap. The dentist had a small, handheld electric drill, cotton, tiny

mirrors, and picks—even anesthesia in case Frank couldn't take the pain. He was able to do everything exactly the way he would have in his office. He recapped Frank's tooth right there in our suite at the Fontainebleau, and Frank went out that night and did his show. Within twenty-four hours, the dentist had come from New York, taken care of Frank, and gone back home.

The only time I remember Frank going to see anyone in the hospital was after Sammy Davis Jr. had his car accident. That's when Sammy lost his left eye. The last person you'd think would show up in a hospital was Frank, but he went in. Believe me, he broke into a cold sweat. He hated the white halls and all the smells. Frank told Sammy that he was going to be all right, and because Sammy didn't have a place to go, Frank told Sammy he could stay at Frank's Palm Springs house until he was ready to go on the road again.

CHAPTER 34: STILL AMERICA'S GUEST

Frank was the singer that changed music, and Emeril Lagasse is the chef who changed cooking. Emeril now has restaurants in New Orleans, Las Vegas, and Miami, and he does his cooking show out of a TV studio in New York, on 59th Street. He tapes several shows in the afternoon, and the shows don't go on until months later.

I called Emeril's office a few weeks ago and asked how I could get tickets. They didn't know who I was, and I didn't use any of my connections. The woman I spoke with told me that there were no tickets available for the next two years. This guy is famous, so I wrote Emeril a letter and told him how much I enjoyed his show. For some reason they ended up sending me tickets, and I never even mentioned I had been a friend of Frank. They don't like when you say that because it seems like you're just dropping names.

Frank told me many times, "No matter who you are or who you know, you've got to make it on your own."

It was after I received the tickets that I mentioned my years with Frank and that Frank and I had dined at Emeril's restaurant in New Orleans. They had a signed photo of Frank up on the wall. When the secretary heard that I traveled with Frank for thirty years and had been to Emeril's restaurant with Frank himself, she must have passed the word onto Emeril.

The next thing I knew I was going to get VIP tickets. She even told me that she was going to put my wife and me up front where they have the two tables, one on each side of Emeril, where you can sample Emeril's cooking. They sent me a note:

"Dress is casual and comfortable. No jackets and no ties. Solid colors are preferred. A security check will take place. And although the thought is appreciated, we cannot accept gifts or money."

After all these years, I guess I'm still America's Guest, because when I went down there, they gave my friends and me the red-carpet treatment.

You would have thought that I was Sinatra that day. I walked in and they brought us into the VIP room. They had sandwiches and drinks laid out and let me tell you, it was really something. When I went on set for the taping of the show, Emeril put me in one of the seats to his right, shook my hand, and thanked me for coming to the show.

"Tony, I know you don't drink, so I made you a special mint julep without the alcohol." Everything was "Tony, Tony, Tony."

While Emeril was preparing the food, he asked me, "Can I tell the people here and the people watching this show who you are?"

"Go ahead," I said.

"This is Mr. Tony Consiglio. He was Frank Sinatra's traveling companion for thirty years."

Everybody in the studio stood up, clapped, and cheered. Of course, I stood up and took a bow in return. At the end of the show, Emeril told me not to leave the studio. He brought me into the back room and there were signs all over the place that read, "No Cameras Allowed." I for one always have a camera with me. The staff knew I had a camera when I went in.

One staff member said, "Tony, we know you have a camera, but don't use it during the show." I promised her that I wouldn't.

However, after the show, Emeril took me backstage and let me take pictures of him. Eventually, I handed the camera to a friend to take a picture of Emeril with me. How else was I going to prove that I was there? A little boy about twelve was backstage with us that day. He was dying of cancer and wanted to meet Emeril.

"Tony, would you do me a favor?" Emeril asked. "Would you take a picture of this little boy and me together?"

Well, Emeril didn't have to ask twice. I took the pictures with the same

camera I bought just after we got out of Grand Central Station. It was a disposable that I had paid ten dollars for. After I took the pictures, I told Emeril that the camera was only worth ten dollars.

"No, Tony, it's not worth ten dollars. It's worth a million dollars."

He said that because of the pictures I took of him with that young boy. A few months later, Emeril threw a birthday party for me at the studio. It was beautiful seeing Emeril again that afternoon in New York. On the way out, Emeril asked me to be a guest on his show again sometime, and I said I would. Since then, I've been on *Emeril Live* at least a dozen times. He even featured me on his salute to Las Vegas and the Rat Pack, where I talked about the favorite foods of Frank, Dean, Sammy, Peter, and Joey. I had a ball.

CHAPTER 35: THE VERY GOOD YEARS

After Frank died, I saw Frank Jr. at the Oakdale Theater in Wallingford, Connecticut. I told him how much I missed his father.

"Tony, you can't feel sad all the time. Life goes on," he told me.

I told Junior that if Frank were still alive, he would be very proud of him. Frank Jr. is carrying on the name of Sinatra, and he has never sounded better. Frank Jr. is performing his father's songs using the original arrangements. He has brought Bill Miller, Frank's accompanist for forty years, to perform with him. Their arrangement of "One For My Baby" is amazingly good. You can close your eyes and hear Frank singing it.

That's what Frank always wanted Junior to do. He wanted him to stay in show business and carry on the Sinatra name. Frank told me, "This kid is hurting me. I can't believe he doesn't want to get married. Once I go, the name 'Sinatra' is out the window."

Another time at the Oakdale, Frank Jr. reserved the whole row of front seats for my family and friends. The theater was packed. There were some empty seats in our row, but Frank Jr. didn't want anybody next to us. When my son Chris and I arrived at the Oakdale, one of the managers told us there was no room and no tickets.

"I'm not here to start a hassle. I've known Frank Jr. his entire life, and I worked for his father. Tell him I'm here. If he doesn't want to see me, I'll leave." The manager gave me a look, but he went and checked it out anyway.

In a few minutes, the manager came back and said, "Are you kidding? Not only does Mr. Sinatra want to see you, he said to lay down a red carpet as you walk. I'll take you to his suite."

People started gathering around me like bees around honey. The manager said, "Not only are you a friend of his, but now you're a guest of the Oakdale today."

The night started out with, "No tickets, who are you?" The next thing I knew, the manager couldn't do enough to make me happy.

My son Chris said, "Dad, I don't believe you."

When I went in to see Frank Jr., he hugged me and we talked for a while. I took some pictures. Next thing we knew, someone announced on the loud speakers in the lobby,

"Paging Tony Consiglio. Paging Mr. Tony Consiglio."

"I'm not going to answer the page," I told Chris.

"Why not, Dad?"

"Because I want people to know I'm here."

Frank will always be remembered. He is a legend. He was a professional, and he had a heart as big as this world. He was always there when people needed him, and he never turned his back on anyone. There will never be another singer like Frank Sinatra. He did so many things throughout his career, and he worked until he got a song or a role in a movie just right. He performed benefit concerts for everyone and never took a dime. Right up to the end, he asked if there was anything I needed or wanted. Then he'd ask my wife Mary the same thing. All you had to do was name it, and Frank would take care of it. Wherever he was performing, Frank would invite me up to his room. There would be only two people there, Frank and Jilly.

Frank would fold his arms and ask me, "Anything I can do for you?"

If there was something, Frank would say, "Jilly, take care of it," just like Frank used to tell me to take care of things fifty years earlier. That's the kind of man he was; always concerned about people.

Frank especially liked regular people. He was polite to the politicians and to the club owners, but he was more comfortable around his friends. All he wanted was for people to remember him as a great man, and I can say for certain that he was.

So you see, Frank and I traveled everywhere together. Through all of

the successes, the hotels, the theaters filled with screaming fans, the marriages, and the tough times, I was right there. He was my lifelong best friend, and I was his. I miss him every day.

Tony Consiglio passed away on June 24, 2008. Tony used to tell me not to include certain stories about Frank because he didn't want to have any problems with Frank when they got together in Heaven. So far, so good.

Franz Douskey